Time and Trace: Multidisciplinary Investigations of Temporality

The Study of Time

Founding Editor

Julius T. Fraser†

VOLUME 15

The titles published in this series are listed at *brill.com/stim*

Time and Trace: Multidisciplinary Investigations of Temporality

Edited by

Sabine Gross and Steve Ostovich

BRILL

LEIDEN | BOSTON

Cover illustration: *Broken Obelisk* by Barnett Newman with The Rothko Chapel exterior in Houston, Texas. Photo by Hickey-Robertson, reproduced with kind permission from The Rothko Chapel.

Want or need Open Access? Brill Open offers you the choice to make your research freely accessible online in exchange for a publication charge. Review your various options on brill.com/brill-open.

Typeface for the Latin, Greek, and Cyrillic scripts: "Brill". See and download: brill.com/brill-typeface.

ISSN 0170-9704
ISBN 978-90-04-31562-4 (hardback)
ISBN 978-90-04-31572-3 (e-book)

Copyright 2016 by Koninklijke Brill NV, Leiden, The Netherlands.
Koninklijke Brill NV incorporates the imprints Brill, Brill Hes & De Graaf, Brill Nijhoff, Brill Rodopi and Hotei Publishing.
All rights reserved. No part of this publication may be reproduced, translated, stored in a retrieval system, or transmitted in any form or by any means, electronic, mechanical, photocopying, recording or otherwise, without prior written permission from the publisher.
Authorization to photocopy items for internal or personal use is granted by Koninklijke Brill NV provided that the appropriate fees are paid directly to The Copyright Clearance Center, 222 Rosewood Drive, Suite 910, Danvers, MA 01923, USA. Fees are subject to change.

This book is printed on acid-free paper and produced in a sustainable manner.

Contents

Acknowledgements VII
Contributors VIII

Introduction 1
 Sabine Gross and Steve Ostovich

1 Time and Traction: Blazing the Trail 8
 Frederick Turner

PART 1
Narrative Tracing: The Work of Criticism

2 The Chaotic Trace: Stoppard's *Arcadia* and the Emplotment of the Past 21
 Jo Alyson Parker

3 Beyond the Forensic Imagination: Time and Trace in Thomas Pynchon's Novels 40
 Arkadiusz Misztal

4 Time, Trace, and Movement in Stravinsky's *Three Japanese Lyrics* 61
 Helen Sills

5 Tracing Space in Time: Morton Feldman's *Rothko Chapel* 83
 Orit Hilewicz

PART 2
Looking Back: Tracing History

6 Traces of Viking-Age Temporal Organization 111
 Lasse C.A. Sonne

7 Time and Memory in the *Odyssey* and *Ulysses* 130
 Stephanie Nelson

8 Time, Cognition, and Attic Performance: Tracing a New Approach
 to Theatre History's "Vexing Question" 152
 Erica W. Magnus

PART 3
Thought Traces: Philosophy, Memory, and the Human Mind

9 A.N. Prior's Ideas on Keeping Track of Branching Time 181
 Peter Øhrstrøm and Thomas Ploug

10 Psychoanalysis and the Temporal Trace 197
 John S. Kafka

11 Memory: Epistemic and Phenomenal Traces 215
 Carlos Montemayor

PART 4
Leaving Traces: Society and Ethics

12 Heredity in the Epigenetic Era: Are We Facing a Politics of
 Reproductive Obligations? 235
 Michael Crawford

13 The Trace of Time in Judicial Reasoning: A Case of
 Conflicting Argument in the High Court of Australia
 (Al-Kateb v. Godwin, 2004) 256
 Rosemary Huisman

14 Time, Waste, and Enlightenment, or: On Leaving No Trace 276
 Raji C. Steineck

 Index 299

Acknowledgements

The editors wish to acknowledge the assistance and contributions of the many people who helped make this volume possible but whose names may not appear in the book. First mention goes to the Orthodox Academy of Crete for providing a lovely and stimulating venue as well as a fine example of Cretan hospitality. In particular, Ioannis Papadopoulos, our coordinator at the Academy, made substantive as well as administrative contributions to our work.

Daniela Tan (Zurich) offered most welcome assistance, doing major work on the index of this volume. Publishing with Brill, home to the *Study of Time* series for many years now, is always a pleasure: our thanks go to Arco den Heijer, Joed Elich and Teddi Dols.

We thank the anonymous reviewers of the papers submitted to the volume for their insightful (and quickly returned) comments. Their professionalism and commitment are evidence of the health of scholarly life in and beyond the ISST, as they brought to bear their knowledge and experience to make this a far better collection than it would have been without their contributions. They offered their expertise generously, knowing they would leave their traces in this work through their influence on and improvement of these essays without being named.

To the authors whose work makes up this volume go our thanks for the patience and enthusiasm with which they embarked on—sometimes extensive—revisions. The additional work they have been willing to invest has been essential in shaping this volume.

Finally, one of the editors, Sabine Gross, was supported in her work on this volume by a sabbatical leave from the University of Wisconsin–Madison.

Contributors

Michael Crawford
is Professor of Biological Sciences at the University of Windsor in Canada. He researches the genetic events that underlie the early mapping of a body plan that occurs during embryogenesis. He also has interests in genome organization, evolution, epigenetics, ethics, and evolving history and language of the Genome Projects. He is a long-standing member of the ISST.

Sabine Gross
is Professor of German at the University of Wisconsin-Madison, where she teaches literature and theater and directs the Letters and Science Honors Program. She has published widely on literature of the eighteenth through the twenty-first centuries, Enlightenment aesthetics, Bertolt Brecht, narratology and stylistics, the reading process, image-text relations, the human experience of time, semiotics, film and theater, perception and synaesthesia. A past ISST council member, she serves as editorial advisor for *KronoScope* and *Time and Society* and is Book Review Editor of *Monatshefte*.

Orit Hilewicz
is a Ph.D. candidate in Music Theory at Columbia University. Her research interests include post-tonal music, musical temporality, form in twentieth-century music, music in multimedia works, and musical aesthetics. She earned her M.A. in music theory at the University of Washington, where she served as an assistant editor of the journal *Perspectives of New Music*. Currently, she is serving as associate editor of *Theory and Practice*, the annual journal of the Music Theory Society of New York State.

Rosemary Huisman
is Honorary Associate Professor in English at The University of Sydney. She has published widely on poetry and poetics (as in *The Written Poem, Semiotic Conventions from Old to Modern English*, 1998, 2000) and, most recently, on different temporalities in English literary narrative and on the relevance of linguistic modality to concepts of legal relations. Her own poetry was published in *The Possibility of Winds* (2005). She is the current Chair of ISFLA (International Systemic Functional Linguistics Association).

John S. Kafka
is Emeritus Professor of Psychiatry and Human Sciences at George Washington University School of Medicine; Supervising and Training Analyst at the Washington Center for Psychoanalysis; and a past Vice-President of the International Psychoanalytical Association. He has published widely on psychoanalytic theory and technique, time and psychoanalysis, trauma, schizophrenia, and the Holocaust. His book *Multiple Realities in Clinical Practice* (Yale University Press, 1989) has been translated and published in French, German, Italian, Romanian, and Russian.

Erica W. Magnus
received her Ph.D. in Theatre Arts and Performance Studies from the University of Pittsburgh and earned a dual M.F.A. degree at Bennington College in both acting and directing. Her work has been supported by an Andrew Mellon Fellowship, a Deutscher Akademischer Austausch Dienst (DAAD) scholarship and a fellowship from the American Society for Theatre Research. An Equity actor, director and teacher, she has been active in the professional and academic theatre for over 30 years. She currently teaches at the University of New England and is a past member of the ISST Council.

Arkadiusz Misztal
is Assistant Professor in American Studies at the University of Gdańsk, Poland. His research and teaching interests focus on contemporary American fiction, literary theory, and the philosophy of time. He has published on Auster, Beckett, DeLillo, and Pynchon, and is currently completing a book on time, narrative, and temporal representation in works by Thomas Pynchon.

Carlos Montemayor
is Associate Professor of Philosophy at San Francisco State University, where he teaches philosophy of mind and epistemology. He has published on the perception of time, consciousness, and attention, and is the author of *Minding Time: A Philosophical and Theoretical Approach to the Psychology of Time*, and *Consciousness, Attention, and Conscious Attention* (with H.H. Haladjian).

Stephanie Nelson
is Associate Professor in the Department of Classical Studies at Boston University and currently Director of their Core Curriculum. She teaches widely in Greek and Latin literature and in the Classical tradition. She is the author of *God and the Land: the Metaphysics of Farming in Hesiod and Vergil* and of a

work on Greek comedy and tragedy entitled *Aristophanes and His Tragic Muse: Comedy, Tragedy and the Polis in 5th Century Athens*. She has written on and given numerous talks on the relation of Joyce's *Ulysses* and the *Odyssey* and is currently at work on a monograph on the subject.

Peter Øhrstrøm

is Professor of Information Science at Aalborg University, Copenhagen, Denmark, where he teaches philosophy of science, logic, applied ethics, artificial intelligence, and system design. His research interests include the philosophy of time, the history and philosophy of logic, philosophical and applied ethics, and persuasive design. In particular, he has published on A.N. Prior's logic and philosophy and on the history of temporal logic.

Steve Ostovich

is Professor and Chair of the Philosophy Department at the College of St. Scholastica in Minnesota (USA). His research and teaching interests include Critical Theory, political theology, philosophy of science, Existentialism, and reason in messianic history. He is a member of the group ATG (*Alltagsgeschichte*) 26, the co-authors of the forthcoming book *Ruptures in the Everyday* (Berghahn), and is a past editor of *KronoScope: Journal for the Study of Time*.

Jo Alyson Parker

is Professor of English at Saint Joseph's University in Philadelphia, where she teaches courses in the eighteenth- and early nineteenth-century novel, narrative, and literary theory. She is the author of *The Author's Inheritance: Henry Fielding, Jane Austen, and the Establishment of the Novel* (1998), *Narrative Form and Chaos Theory in Sterne, Proust, Woolf, and Faulkner* (2007), and essays dealing with narrative and time. With Michael Crawford and Paul Harris, she co-edited *Time and Memory* (The Study of Time XII, 2007) and with Paul Harris and Christian Steineck, she co-edited *Time: Limits and Constraints* (The Study of Time XIII, 2010). She is the Managing Editor of *KronoScope: Journal for the Study of Time*.

Thomas Ploug

is Professor of ICT Ethics at Aalborg University, Copenhagen, Denmark. His research spans several fields of applied ethics but he also has a vested interest in key issues in moral philosophy such as freedom of choice/free will and the metaphysical and logical models that may enlighten these debates. He has taught courses on ethics, philosophy of science, and logics.

CONTRIBUTORS XI

Helen Sills

is an independent scholar and researcher who writes and lectures on music and time. Her research interests include the spiritual beliefs of 20th-century composers, particularly those of Igor Stravinsky, and the relationship of an artist's spiritual beliefs to their creative techniques. Since gaining her Ph.D. in 1992, she also has followed the fast-developing neuroscience research into the effects of music on the brain. Helen is also a freelance violinist with a special interest in performing chamber music, and gives regular concerts as the violinist of the Plaegan Piano Trio.

Lasse C.A. Sonne

is Associate Professor of History at the Saxo Institute, University of Copenhagen. His research is on the early medieval period of Scandinavia and the use of calendars. Research topics include the pre-Christian religion of Scandinavia and the introduction of Christianity, social rhythms, pre-Christian calendars, and political history.

Raji C. Steineck

is Professor of Japanology at the University of Zurich (UZH). His research interests combine medieval and contemporary history of concepts in Japan and the general philosophy of culture. His works include *Fundamental Structures of Mystical Thought* (2000) and *The Critique of Symbolic Forms: Symbolic Form and Function* (2014), both in German. He co-edited, with Jo Alyson Parker and Paul Harris, *Time: Limits and Constraints* (The Study of Time XIII) and with Claudia Clausius, *Origins and Futures: Time Inflected and Reflected* (The Study of Time XIV), and has served as ISST's President since 2013.

Frederick Turner

is Founders Professor of Arts and Humanities at the University of Texas at Dallas, and was educated at Oxford University. A poet, critic, interdisciplinary scholar, public intellectual, translator, and former editor of *The Kenyon Review*, he has authored over 30 books, including *Shakespeare and the Nature of Time, Genesis: an Epic Poem, Beauty: The Value of Values, The Culture of Hope, Hadean Eclogues, Shakespeare's Twenty-First Century Economics, Paradise: Selected Poems 1990–2003, Two Ghost Poems*, and *Epic: Form, Content, and History*. His many honors include the Levinson prize for poetry and the Milan Fust Prize, Hungary's highest literary honor. He is a past member of the ISST Council.

Introduction

Sabine Gross and Steve Ostovich

> Someone passed by here. The trace invites us to pursue it, to follow it back, if possible, to the person or animal who passed this way. We may lose the trail. It may even disappear or lead nowhere. The trace can be wiped out, for it is fragile and needs to be preserved intact; otherwise, the passage did occur but it did not leave a trace, it simply happened. […] Hence the trace indicates "here" (in space) and "now" (in the present), the past passage of living beings. It orients the hunt, the quest, the search, the inquiry.
>
> RICOEUR 1988, 120

∴

The essays in this volume originated as papers delivered at the Fifteenth Triennial Conference of the International Society for the Study of Time (ISST). The conference took place at the Orthodox Academy of Crete on the northwest coast of that island from June 30–July 6, 2013. The theme of the conference was "Time and Trace," and the group of international scholars attending the conference worked to develop a more sophisticated understanding of the concept of "trace" especially paying attention to its temporal dimension.

Traces can be subtle, hardly discernible, yet have dramatic effects. Chemically speaking, trace elements can represent two poles on the spectrum of desirability: the rare and the coveted, and the harmful, disturbing, potentially fatal. The term has a rich history in philosophy, as a glance in a philosophical dictionary or encyclopedia will demonstrate. As term and concept, "trace" cuts across the boundaries of the temporal and the spatial—philosopher Emmanuel Levinas called it "the insertion of space in time" (2003, 42). Paired with "time," as in this volume and its contributions, it is a wonderfully fertile term—especially in English, where it links to both past and future more strongly than in most other languages.

Traces can constitute a residue or a visionary preliminary giving of shape. The Latin term for "trace," *vestigium*, refers to traces as remnants and indeed vestiges, which of course has remained one of the meanings of the term. Traces provide evidence of a past, encouraging us to decipher them and thereby to make discoveries that happen in the present and may affect the future. Traces can be followed, and they can lead us back in time. Tracing back, discovering

origins and causes, we broaden and ascertain knowledge. Yet one can also trace the outlines of a plan, literally or metaphorically charting a course, mapping the future, casting forward. A trace can be left *by* someone or something as well as mark the preparation *for* something. In deciphering or making traces, we can forge connections both to the past and to the future. The richness of this term can be traced in the essays in this volume.

This collection begins with an essay by Frederick Turner, "Time and Traction: Blazing the Trail." Turner's essay presents the reflections of a wide-ranging and creative scholar-poet about the topic of trace. It frames the important issues addressed by the contributions that follow in a more general way and at the same time sums up the spirit of the conference in the way it links different spheres of knowledge and experience with an emphasis on the spirit of human discovery.

Turner works from the etymological connection between trace and other words like "trail" and "track," extending it into a map of human endeavors. He introduces a word from the African Bantu language, *chijikijilu*. Metaphorically, this word is used for fundamental religious symbols, but literally, "it means a blaze, the mark one would cut on a tree in order to find one's way back from unknown territory—to blaze a trail, to trace a path," as Turner writes below (9). One cuts a mark, a trace, precisely at the boundary between what is familiar and a place unknown, so that one can both leave home and find the way back. This relates to Turner's broader concern: how do we cross the boundary between ourselves and the world which is not us in a manner that enables us to overcome the limits of our language for communicating our experience and understanding of that world? The *chijikijilu* as a trace is what enables us to break out of the circle of what we know and about which we can meaningfully speak by giving us the courage that comes from knowing we will not become lost as we move out into new territory. The future need not be restricted to what has been the case in the past, and at the same time, we need not fear the future will be so unfamiliar that we will have no home in it: meaning is possible even if finding it takes time, and there is a horizon that will continue to surround us as we venture forth, expand our knowledge, and join experience to language.

In reading traces, we orient ourselves. The trace is both powerful metaphor and a material sign that can unlock dimensions of knowledge. In a relatively recent volume on the topic, Sibylle Krämer (2007) associates the trace with a "semantics of the material object" (*Dingsemantik*), placing the trace at the joint where non-meaning turns into meaning (13). Krämer emphasizes the significance of reading traces/clues as a fundamental process of knowledge and meaning production, going beyond "not only the archaic residue of

'savage knowledge', nursery of metaphysics, textless stage of hermeneutics and instinctual embryonic form of symbolic grammars": in her view, it "can itself be traced in *all* developed practices of signification, discovery, and interpretation," in addition "dovetailing everyday practice and scientific procedure" (2007, 11; trsl. SG/SO). The trace allows us to follow our coming to language.

We are cutting the *chijikijilu* at the border between the known domain and *terra incognita*—between the past and the future. This makes the trace a matter of the present and of presence. Yet "trace" marks an absence as well. As Levinas puts it, "the significance of the trace consists in signifying without making appear" (2003, 41), since what has caused the trace is no longer present. Traces are a special challenge to our powers of observation and discovery in that they do not show what is absent, but instead show its absence (Krämer 2007, 15). The trace always reminds us of what we have not witnessed and have to approach via conjecture.

In this sense, "trace" is largely synonymous with "evidence," or—if we combine the fields of history, hunting, and detective work for a moment—with "clues." Levinas (2003, 41) sums this up:

> A detective investigates everything that stands out on the crime scene as a revelatory sign of the criminal's voluntary or involuntary work, the hunter follows the trace of the game that reflects the activity and the path taken by the animal he is tracking, the historian discovers ancient civilizations on the horizons of our world from vestiges of their existence. Everything lines up in order in a world where each thing reveals the other or is revealed with regards to it.

Such detective work marks a form of history—the work of Carlo Ginzburg, Italian historian and eminent theorist of the trace, comes to mind—that is anthropologically inflected rather than exclusively text-oriented, although documents can also harbor traces. Yet in the specific context of history, traces provide evidence that is different from documents intended for posterity. Paul Ricoeur, a thinker very much influenced by Levinas, calls them "involuntary testimony" (1988, 117), while Levinas (2003, 41) affirms the special status of this testimony that stems from its being outside of human volition and intentionality: the trace "signifies outside of all intention of making a sign." It is the "reader" or de-coder who turns it into a sign in her or his quest for meaning or knowledge. Ricoeur names it a "sign-effect" due to this peculiar doubling that calls on us to rise to its "double allegiance": "the trace combines a relation of significance, best discerned in the idea of a vestige, and a relation of causality, included in the thing-likeness of the mark" (1988, 120).

Levinas also influenced another French philosopher, Jacques Derrida, and it is Derrida whose work often comes to mind for scholars in literary criticism and cultural studies on hearing the word "trace." At the same time, it would be misleading to write about Derrida's "understanding" of trace, even though the word is centrally important for him. Trace cannot be reduced to a concept inasmuch as it relates to what in experience always remains beyond the power of our naming, "the unnameable movement of *difference-itself*, that I have strategically nicknamed *trace*" (Derrida 1991, 53). Trace does not enable understanding; it promotes thinking.

> The trace cannot be thought out on the basis of a simple present whose life would be within itself; the self of the living present is primordially a trace. The trace is not an attribute; we cannot say that the self of the living present "primordially is" it. [...] Sense being temporal in nature, as Husserl recognized, is never simply present; it is always already engaged in the "movement" of the trace [...]. (Derrida 1991, 26–27)

Derrida borrows a phrase from Levinas to describe the trace as a "past that has never been present" (Derrida 1991, 74): it both calls for our critical response and reveals itself as irreducible to a concept naming something present to our understanding. Thinking about the trace makes us aware of how "by interrupting the weaving of our language and then by weaving together the interruptions themselves, another language comes to disturb the first one. It doesn't inhabit it, but haunts it" (Derrida 1991, 414).

A trace for Derrida is something very different than it is for Turner, a difference that can be summed up in their understandings of a common image: leaving a trace. For Turner, this is exactly what it means to cut the *chijikijilu* and leave behind the marker that enables and encourages moving from the known to the unknown space and into the future in order to make what is other than us familiar and potentially understood. Derrida, on the other hand, thinks along with Levinas again here as Levinas reflects on the divine "name" and "a sort of absolute anachrony of the wholly other that, although incommensurably heterogeneous to the language of the present and the discourse of the same, nonetheless must leave a trace of it" (Derrida 1991, 412). For both, the trace calls for thought, a thinking that for Turner takes place in terms of the transcendental categories that give us the confidence to think in the first place by offering us the hope for understanding what is strange to us now, while Derrida follows Heidegger in writing, "Thinking is what we already know we have not yet begun" (Derrida 1991, 53).

The essays that follow are evidence of how broadly applicable and productive the conjunction of "time and trace" has turned out to be. Selected from among many excellent papers presented on Crete, they have been thoroughly revised and in most cases significantly expanded. They demonstrate how this topic can serve to transcend the boundaries of individual disciplines and to link them in new ways, beyond its usefulness in a number of disciplinary arenas. Some of them focus on moments, others track influences and ideas over generations or across centuries. Many include a focus on our perception—of time, and of how time relates to other experiences and sensory impressions.

The topics touched upon in this Introduction resonate in various forms in the essays: Parker's examination of the "strange attractor" concept from Chaos Theory is echoed in Levinas's statements on how the trace shows absence even as Parker connects this point to the work of Hayden White; Misztal takes us through the ambiguity of "evidence" in Thomas Pynchon's writing, including his detective novels, and traces the connections outlined above by Levinas while also joining Parker in demonstrating the forensic aspect of looking for the trace; Sonne's contribution is a fine example of turning textual traces into historical testimony; Kafka helps us think some more about traces at work outside intentionality; and in conclusion, Steineck asks us to consider how to "leave no trace."

This is not a monograph, and the individual contributions or sections do not build on one another—readers are encouraged to select and read in any sequence. You will find, as did we, rich and sometimes unexpected resonances among the texts: they engage in a dialogue that extends across sections—and indeed, across different disciplines and arts. It turns out that Øhrstrøm and Ploug's investigations of temporal logic and Steineck's assessment of environmental ethics converge in the thought of a medieval Japanese Zen Buddhist, while Japan—and *japonisme*—is referenced again in Sills's exploration of Stravinsky's music. Sills joins Hilewicz in offering contributions that highlight inter-arts connections in the way music can generate intermedial transpositions and engage with spatial experience and representation in creating a complex spatiotemporality. Hilewicz, in turn, links up with Magnus in the way both explore sacred-ritual aspects of encounters with and at specific sites.

Writing is an essential form of the trace, and several contributions highlight literary texts and traditions. Nelson investigates the intertextual link, across centuries, between Joyce and Homer. Several authors present work on literary texts in ways that also engage other media or discourses. Misztal discusses Pynchon and photography, Parker links Stoppard's theater with contemporary physics. The investigation of theater extends to the traces we have of its

ancient practice in Magnus's contribution, where classical Greek theater also serves as the venue to explore cognitive shifts. Magnus's historical lens on cognitive processes complements contemporary ones by Kafka (on psychoanalysis) and Montemayor (in philosophy). Literary texts, it turns out, can also provide what may be the only traces of historical time management, as evident in Sonne's text; while Huisman's essay focuses on the legal management of time and the way time as represented in language can confound juridical thinking. The possible impact of legal discourses is also investigated in the area of genetics, as Crawford links epigenetics to the social dimension of biology. Several contributors—Nelson, Montemayor, and Kafka—address the topic of memory. Øhrstrøm/Ploug and Parker demonstrate that logical quandaries and the complexities of time can be approached via formal logic as well as via artistic representation. Similarly, Misztal's treatise on Pynchon's work and Kafka's essay on the psychoanalysis of memory both zero in on "clock-time" and the forms of resistance it engenders, and Misztal's contribution, in turn, links up briefly not only with Nelson—in a comparison of Pynchon with Joyce—but also with Sonne in a detailed aside on the Vikings.

We have grouped the contributions in a way that combines disciplinary, temporal, and thematic orientation, as the section titles indicate. As interdisciplinary as the ISST as a whole is, it has been our experience working among our colleagues in the ISST that sometimes interdisciplinary work gains greatest traction precisely where scholars work from within and thereby come up against the borders of their own disciplines. We think this is demonstrated in what follows.

Some of you may have noticed that Fred Turner's essay inhabits the place formerly occupied by the "Founder's Lecture," a place made vacant by the death of Julius Thomas Fraser, the ISST's co-founder and a friend and mentor to many of us. We miss him. But his model of time continues to make us think, a blaze giving us courage to think in new ways in and about time and an inspiring reminder of the work that needs to be done. You will be able to trace Fraser's presence in the essays that follow and in the ongoing collaborative work of the ISST.

July 2015
Madison, WI and Duluth, MN (USA)

References

Derrida, Jacques. 1991. *A Derrida Reader: Between the Blinds*, edited by Peggy Kamuf. New York: Columbia University Press.

Gawoll, Hans-Jürgen. 1995. "Spur." In *Historisches Wörterbuch der Philosophie*, edited by Joachim Ritter and Karlfried Gründer, vol. 9. 1550–1558. Darmstadt: Wissenschaftliche Buchgesellschaft.

Ginzburg, Carlo. 1989. *Clues, Myths, and the Historical Method*. Trans. John and Anne C. Tedeschi. Baltimore, Md.: Johns Hopkins University Press.

Krämer, Sibylle. 2007. "Was also ist eine Spur? Und worin besteht ihre epistemologische Rolle? Eine Bestandsaufnahme." In *Spur. Spurenlesen als Orientierungstechnik und Wissenskunst*, edited by Sibylle Krämer, Werner Kogge and Gernot Grube. 11–33. Frankfurt am Main: Suhrkamp.

Levinas, Emmanuel. 2003. *Humanism of the Other*. Trans. Nidra Poller. Urbana and Chicago: University of Illinois Press. [Humanisme de l'autre homme, 1972]

Ricoeur, Paul. 1988. *Time and Narrative*. Vol 3. Trans. Kathleen Blamey and David Pellauer. Chicago and London: University of Chicago Press. [Temps et récit, vol. 3, 1985]

CHAPTER 1

Time and Traction: Blazing the Trail

Frederick Turner

Abstract

A cross-cultural analysis of some important words and metaphors used to explain time, as in the cognates of the Latin *trahere*—to draw, drag—a group including "trace." In Ndembu, a Bantu language, the word *chijikijilu*, literally a blaze or trail-marker, illuminates how humans negotiate the paradoxes of getting traction when passing from the known into the unknown.

Keywords

time – trace – trail – track – draw – blaze – *chijikijilu* – metaphor – ritual – True Thomas – Shakespeare – Wittgenstein

One of our most powerful metaphors for time itself appears when we explore the etymology and usage of the word "trace." The past is the trace of what was before, and in memory we retrace our steps. We seek a track that we can trace into the future, we decide which path or "trace" or trail we shall make or follow into unexplored territory (in the sense of the Osage Trace, the Spanish Trace, Hull's Trace, the Chisholm Trail, the paths made by the American western pioneers). This paper proposes a cross-cultural semantic and philosophical analysis of this word that is used by humans to explain the phenomenon of time: an etymologically related group of words and concepts in the Indo-European family of the Latin *trahere*—a group that includes "trace."[1]

To trace is always laborious to some extent, even if the toil is a mere trace. This becomes obvious when we look at the cognates of the word—drag, draw, traction, trail, track, draught, trace in the sense of a draught animal's harness. The word always carries notions of mechanical difficulty and the relation of objects being moved or moving themselves through a resistant medium. What is time-consuming is what offers resistance or difficulty or opacity; what is

[1] See the Online Etymological Dictionary entry "tract."

quick and momentary is what is slick or slippery or light and transparent and thus slips by or is passed through without complications. The paradox arises that for a self-moving entity to move along, it must get purchase on its environment, and purchase is afforded only by a resistant medium. To swim we must push against the very water that allows our passage. We walk by pressing against the ground that brakes our inertial passage across it. One important form of slickness or difficulty is cognitive—it is easy and quick to get through or see through something that is known, and hard and slow to get through or see through something that is unknown. Problems that are heavy and thick ("dense," French *lourd*, German *schwer*) take up time; clear solutions to lightweight problems are foregone conclusions. Thus the boundary between the known (and thus easy) and the unknown (and thus difficult) is basically that between past and future, and it is an important locus for understanding our fundamental intuitions about time.

These linguistic associations and the implicit philosophical concepts that underlie them are not confined to the Indo-European languages, and indeed for me the clearest explication of their logic is found in an African Bantu language. Among the Ndembu people, as the anthropologist Victor Turner explains in his book *The Ritual Process* (15), the term for a fundamental religious symbol (what Catholics would call a sacrament) was *chijikijilu*. This word was itself a metaphor: in its literal sense it means a blaze, the mark one would cut on a tree in order to find one's way back from unknown territory—to blaze a trail, to trace a path. One of the most dangerous aspects of living in a hunting/horticulture society like that of the Ndembu is getting lost when one is exploring or hunting. So a *chijikijilu* is a real thing, a physical mark on a tree; it reveals real territory, previously unknown; but it also changes the landscape, adding an area—whatever is within eyeshot of the blaze—to the known territory of the village. One cuts it at the exact boundary between the known and the unknown—in linguistic terms, between the cliché, the expected and understood conversational formula, and the babble (or Babel) of gibberish. It is poetic language; but it is eminently useful, and a real feature of the world once it is made.

The Ndembu thus solve the pretty paradoxes of Ludwig Wittgenstein, in the *Tractatus Logico-Philosophicus*: "Whereof one cannot speak, thereof one must remain silent" (108) and "The limits of my language mean the limits of my world" (89). At first glance what these statements mean is that we are forever trapped within our verbal means of understanding and expression. We cannot say what we do not have words to say. There are no true discoveries. The world of nature is for us constructed by our language; our language is a dictionary, each of whose entries is glossed by other entries; and we are

imprisoned within this hermeneutic circle. Since our words only refer to other words, they are meaningless in any deep sense—and this is the fundamental idea of Deconstruction. We live in a play of signifiers, Derrida tells us, always deferring any final reference to a signified.[2]

The meaning of the blaze is that it denies the absoluteness of the barrier between the sayable and the unsayable, the limits of my language and my world. The deepest religious and poetic language is a blaze that conducts us between the known and the unknown, the sayable and the not-yet-articulable, the past and the future. It is in a sense constitutive of the present moment, to the extent that the present moment is that which mediates between the past and future.

This trailblazing, this dragging of the past into the future and the future into the past, this drawing, drawing out, or drawing forth of new things, is not confined to the human linguistic and symbolic universe. Before human beings came along to use words and visual symbols and music and pretence and masks and sacraments to step into a new kind of time, biology was doing it through that unique moment of sexual reproduction when the two different gametes come together (in a *symbolon*—that which is "thrown together") to make a new unique individual. On rare occasions that *symbolon* can be the great grand poem of a new species. And physics was already doing it when it cooked up a new element in the collapsing core of an old star.[3] Poetry is fast evolution: evolution is slow poetry.

When an Ndembu girl becomes a woman, a great coming-out ritual is celebrated for her, centered upon the Mudyi tree, which like a Christmas tree or a Mexican paradise tree, is set up in the village center.[4] Its white sap symbolizes mother's milk, male semen, matrilineal inheritance of property, female nurture, the moral qualities of innocence and goodness, and the divine creative principle. The Mudyi Tree is a *chijikijilu*. A master-metaphor or *chijikijilu* blazes a trail from the world that we know to a realm that we do not know and enables us to find our way back. The Greek root for the word "metaphor"—*meta* (beyond), *pherein* (to carry)—to carry beyond—has the same implication. (Note that the word itself is a metaphor, carrying us beyond the known physical action of carrying to the abstract idea it indicates.)

Inside Wittgenstein's hermeneutic circle of the known world are all the categories of the reasonable and the familiar—the knowable, the logically

2 Derrida, *Of Grammatology*, 269–316; see also Derrida, *Writing and Difference*.
3 http://en.wikipedia.org/wiki/Supernova_nucleosynthesis.
4 Turner, *The Forest of Symbols*, 51–54.

provable, cosmos, the connected, the ordered, the remembered or recorded past, conscious life, the defined (in terms of all the other definitions in the dictionary)—in other words, the sayable, the speakable.

But hasn't Wittgenstein already referred to that whereof one cannot speak? He himself is doing what his statement declares impossible, precisely by declaring it so. "Whereof one cannot speak" is a noun phrase denoting something, giving a name to the unsayable—but if so, then it is not unsayable. If our language truly had limits, and if limits divide off one area from another, then surely the idea of our language having limits would be unthinkable and unsayable in our language, since we could not even conceptualize what might lie on the far side of the "limits of my language," even in a negative way (because a negative way is still a way). There is an obvious connection with Gödel's little paradox, the statement "This statement is not provable," which is both true and unprovable.[5] There is a truth outside the limits of an axiom-based system of reasoning that makes what is inside them meaningful. Maybe we could not conceive of death—the boundary of our lives—without conceiving of "something after death," as Hamlet says, something on the other side of "that bourn ["limit," but also, "river"] from which no traveler returns."[6]

And if what is inside the circle is not what is outside it, we can understand what is outside it in at least a negative way. Recalling our little list of the characteristics of home territory, we can describe what is on the other side as: the unsayable ("whereof one cannot speak"), the unknowable, the unprovable, the irrational, chaos, the disconnected, the future, sleep/dream/death, the undefined. It is into this region that the shaman or poet makes his or her perilous adventure.

So somehow the boundary of our language must be able to be overcome; but this cannot be so, because then the boundary would now include what was previously unsayable. So the boundary of what is knowable must somehow *expand*. And is this not what happens when an explorer cuts a blaze?

Shakespeare may help us to see the deep wisdom of the Ndembu sages. Theseus at the beginning of Act v of *A Midsummer Night's Dream* has just listened to the strange but strangely consistent account of what happened to the lovers in the forest. Was it merely a dream? And are dreams "mere"?

5 See *The Stanford Encyclopedia of Philosophy*: <http://plato.stanford.edu/entries/goedel-incompleteness/>.

6 *Hamlet*, III.i. 78. All quotations from Shakespeare are from *The Riverside Shakespeare*.

> More strange than true: I never may believe
> These antic fables, nor these fairy toys.
> Lovers and madmen have such seething brains,
> Such shaping fantasies, that apprehend
> More than cool reason ever comprehends.
> The lunatic, the lover and the poet
> Are of imagination all compact: [...]

They all "carry things beyond" the bounds of good sense.

> One sees more devils than vast hell can hold;
> That is the madman. The lover, all as frantic,
> Sees Helen's beauty in a brow of Egypt.
> The poet's eye, in a fine frenzy rolling,
> Doth glance from heaven to earth, from earth to heaven;
> And as imagination bodies forth
> The forms of things unknown, the poet's pen
> Turns them to shapes, and gives to airy nothing
> A local habitation and a name.[7]

That "turning to shapes" is the task of both the epic hero and the poet. It traces a path, it blazes a trail into the forest, it is the hard work of getting traction in the as yet unformulated.

Let us pull all these ideas together into a single question: where does it make sense to cut a blaze? Not within the circle of the known world, the expected and comprehensible range of ordinary statements. The explorer still knows where he is at that point—a blaze would be useless. Niels Bohr, the great quantum physicist, is reputed to have said: The opposite of a true statement is a false statement; but the opposite of a profound truth is another profound truth. The shaping fantasy apprehends more than cool logic comprehends: what it sees is true but not provable. The explorer is not trying to get from one familiar place to another, but is headed into unexplored territory. He is trying to see the game he has always lived in as just a game. Art that cuts blazes inside the circle can only be pretty or charming or craftsmanlike, but never great or transforming or redeeming—at worst, it is trite.

If it is useless to cut the blaze inside the circle, should he not cut it outside the circle? After all, that is the only alternative, no? But if he cuts it outside the circle he is already lost. The purpose of a *chijikijilu*, like the clue (the ball

7 *A Midsummer Night's Dream*, v.i. 7–17 (*Riverside Shakespeare*).

of string) that Theseus unwound as he penetrated the Minotaur's labyrinth, is to show him his way back home. Cutting the blaze outside the circle only helps him find his way from one place where he is lost to another where he is equally lost. One who cuts a blaze outside the circle of the known has already kicked himself loose from the earth, and, as Marlowe says of Kurtz in *Heart of Darkness*, "Confound the man! he had kicked the very earth to pieces."[8] This blazeless "kicking loose" has been the nemesis of much avant-garde art in the last hundred years or so.

There is only one place to cut the blaze—where it is a true blaze—and that is at the exact edge of the circle, just when the explorer crosses into *terra incognita*. And now something marvelous happens. A new space opens up—whatever is within eyeshot of the blaze. It is neither one side of the line nor the other. And this space is a temporal space. We must now redescribe what is outside the circle by means of the odd little word "yet". It is unsayable *yet*, unknowable *yet*, irrational *yet*, chaotic until now, etc.

The present moment, in other words, ceases to be just a demarcation between past and future (the knowable and the unknowable), and instead takes on a territory of its own. Within that specious present one can go back

FIGURE 1 *Blaze diagram.*

8 Conrad, *Heart of Darkness*, 183.

and forth at will in one's mental and imaginative time machine. That space is the space of art, of new scientific hypothesis, of grace, of moral discovery. It is within the region of the previously unsayable, the unknown, the future, but is within eyeshot of the blaze. It is still in itself unknown and unexplored, but its contents can be located, referenced and identified by metaphor, which acts as a sort of verbal triangulation or trigonometry, providing their vector and distance, so to speak, in terms of a new relation between fixed points within the known world. This space is Shakespeare's fairyland, his midsummer night's dream, of which Bottom says:

> I have had a most rare vision. I have had a dream, past the wit of man to say what dream it was. Man is but an ass if he go about to expound this dream. Methought I was—there is no man can tell what. Methought I was, and methought I had, but man is but a patch'd fool, if he will offer to say what methought I had. The eye of man hath not heard, the ear of man hath not seen, man's hand is not able to taste, his tongue to conceive, nor his heart to report, what my dream was. I will get Peter Quince to write a ballad of this dream. It shall be call'd "Bottom's Dream," because it hath no bottom; and I will sing it in the latter end of a play, before the Duke.[9]

But note that Bottom doesn't stay out there in the forest. He comes back to Athens and tries to make a ballad of it, to put it into words, to give to airy nothing a local habitation and a name. Bottom has cut his blaze in the right place, for all his bumbling.

It is well known to etymologists and linguists that languages grow—that is, develop vocabularies for talking about new things and ideas—by means of metaphor. Metaphors—especially grand metaphors—*chijikijilus*—create new language for us to think in. The old Scottish "Ballad of True Thomas" or "Thomas the Rhymer"—almost a mini-epic in itself—gives a very clear picture of how this works. Thomas is sitting under a tree at a crossroads—perhaps a crossroads in his life, like Dante's dark wood at the beginning of the *Divine Comedy*[10]—and the queen of fairyland rides by. Mistaking her for the Queen

9 IV.i. 204–217 (*Riverside Shakespeare*).
10 E.g. in John Ciardi's translation (Dante, *Inferno*):

> Midway in our life's journey, I went astray
> from the straight road and woke to find myself
> alone in a dark wood. How shall I say
> what wood that was! I never saw so drear [...]

of Heaven (Mary) he kneels to her, but she corrects him and offers a kiss, with the proviso that the kiss will make him her slave. Of course he kisses her, and is taken up behind her on her magic white horse. They come to another crossroads, a place where three roads branch off: one is the steep rocky path to heaven, one is the broad, pleasant, well-trodden path to Hell, but the third is something else:

> And see ye not yon bonny road
> That winds about the fernie brae?
> That is the road to fair Elfland,
> Where thou and I this night maun gae.

The road to Elfland is explicitly not the legalistic road of moral salvation or damnation, but one that is aesthetic or artistic ("bonny")—one that is essentially free, though it requires specific disciplines. Thomas, like Tamino and Papageno in Mozart's *Magic Flute*, is enjoined to silence in the magic realm. They ride across a river full of the blood of the dead, and through a dawnless darkness, like the darkness Gilgamesh endures in his search for his dead friend Enkidu. Finally they come to a delightful garden, where Thomas serves his mistress. At the end of his indentured servitude, she gives him an apple from the tree in the center of the garden, as his reward, implying that he cannot leave unless he eats it, and telling him that if he does so he must tell the truth always thenceforth. Thomas cavils at this:

> "I dought neither speak to prince or peer,
> Nor ask of grace from fair ladye!"—
> "Now haud thy peace, Thomas," she said,
> "For as I say, so must it be."
> "My tongue is my ain," true Thomas he said;
> "A gudely gift ye wad gie to me!
> I neither dought to buy or sell
> At fair or tryst where I might be.["][11]

When Thomas is in fairyland he is not permitted to speak—but when he returns, he is given the great, and embarrassing, power to tell the truth always. And he does it in rhyme, and so he gets his other name as well, Thomas the Rhymer. When he returns, even if it seems to him that he has spent but a single

11 Quiller-Couch, *Oxford Book*, 402.

night or a single week in fairyland (depending on which version of the ballad one reads), seven or seventy long years have passed. We can now see that this time-dilation is nicely predicted by the operation of the blaze, which expands the present moment. Outside the circle is that whereof one cannot speak—but if one has cut one's blaze, entered that eternal present, and returned, one is able to make a ballad of one's vision.

There is a structural parallel in this story with the ancient Greek story of Orpheus, who, another poet, likewise goes to the underworld and is able to return. The mysterious prohibition this time is that he must not look back to check to see if his dead wife, Eurydice, is following him—he must not seek perfect certain knowledge here, for this is outside the realm of the provable. When he does look back, he loses his wife forever. And this myth may derive in part from the oldest extant poem in the world, *The Epic of Gilgamesh*. Gilgamesh goes to the underworld to bring back his dead friend Enkidu and find the secret of immortality. He also breaks one of those arbitrary rules (thou shalt not sleep), and comes back empty-handed—but with the gift of new knowledge and enduring words.

Virgil describes the passage between the known and unknown world in the *Aeneid*:

> facilis descensus Averno;
> noctes atque dies patet atri ianua Ditis;
> sed revocare gradum superasque evadere ad auras,
> hoc opus, hic labor est.[12]

In Dryden's translation:

> The gates of hell are open night and day;
> Smooth the descent, and easy is the way:
> But to return, and view the cheerful skies,
> In this the task and mighty labor lies.[13]

Aeneas' key to the underworld is the plucking of the golden bough, which resists his action—the word Virgil uses for its reluctance to yield, its difficulty, is "cunctatem," "delaying." It is Aeneas's labor, his difficulty, dragging or drawing

12 The *Aeneid*, VI.126–129. Virgil, *Opera*.
13 Eliot, *Virgil's Aeneid*, 216.

it from the tree in the forest of Avernus, that enables him to go down into the land of the dead and return. He has left his blaze, blazed the trail, and traced our way.

References

Alighieri, Dante. *The Inferno*. Translated by John Ciardi. New York: New American Library, 1954.
Conrad, Joseph. *Heart of Darkness*. London: Penguin Classics, 1975.
Derrida, Jacques. *Of Grammatology*. Translated by Gayatri Chakravorty Spivak. Baltimore: Johns Hopkins University Press, 1997.
———. *Writing and Difference*. Translated by Alan Bass. Chicago: University Press of Chicago, 1978.
Eliot, Charles W., ed. *Virgil's Aeneid, Translated by John Dryden*, Vol. 13. New York: Collier, 1909.
Online Etymological Dictionary under "tract" http://www.etymonline.com/index.php?term=tract (last accessed Feb. 16, 2015)
Quiller-Couch, A.T., ed. *The Oxford Book of English Verse*. Oxford: Clarendon Press, 1900.
Shakespeare, William. *The Riverside Shakespeare*. Boston: Houghton Mifflin, 1974.
Sidgwick, A. ed. *P. Vergil Maronis Opera*. Cambridge: Cambridge University Press, 1907.
The Epic of Gilgamesh. Translated by Andrew George. London: Penguin, 2003.
The Stanford Encyclopedia of Philosophy: <http://plato.stanford.edu/entries/goedel-incompleteness/> (last accessed Feb. 18, 2015).
Turner, V.W. *The Forest of Symbols*. Ithaca: Cornell University Press, 1967.
———. *The Ritual Process*. Chicago: Aldine, 1991.
Virgil [Publius Vergilius Maro]. *P. Vergili Maronis Opera*. Edited by A. Sidgwick. Cambridge: Cambridge University Press, 1907.
Wikipedia http://en.wikipedia.org/wiki/Supernova_nucleosynthesis (last accessed Feb. 16, 2015)
Wittgenstein, Ludwig. *Tractatus Logico-Philosophicus*. New York: Dover Press, 1999.

PART 1

Narrative Tracing: The Work of Criticism

∴

CHAPTER 2

The Chaotic Trace: Stoppard's *Arcadia* and the Emplotment of the Past

Jo Alyson Parker

Abstract

Tom Stoppard's 1993 play Arcadia features dual time periods, and it both references chaos theory and draws on a key chaotic figure (the strange attractor). Through its skewing of temporal order and its chaos-theory focus, it demonstrates how we attempt to make sense of the traces coming to us from times past and why it is important that we do so.

Keywords

Tom Stoppard – Arcadia – emplotment – narrative – dual time periods – temporal order – chaos theory – strange attractor – Hayden White – Paul Ricoeur

∴

> We will never reconstruct the past. We can only create a representation of what exists now today.
> JULIEN MONNET in *Cave of Forgotten Dreams*

∴

> Why should historical research not also remain incomplete, existing as a possibility and not fading into knowledge?
> PETER ACKROYD, *Chatterton*

∴

> Time was different.
> TOM STOPPARD, *Arcadia*

∴

The popular 2011 Broadway revival of Tom Stoppard's 1993 *Arcadia* shows that, despite what might seem a somewhat dated explanation of elementary chaos theory, the play still resonates for audiences today. It has been called Stoppard's "masterpiece" (Delaney 2001, 34), his "best play" (Gussow 1995, 107), and the play that helped Stoppard shake "the reputation of being all head and no heart" (Bilson 2003, 24). Seamlessly blending the comic and the tragic, *Arcadia* deals with two separate time periods (1809/1812 and the early 1990s), with its concluding moments bringing the two together in a dynamical dance.

As the dual time periods might indicate, *Arcadia* very much engages the temporal through both structure and content. It deals explicitly with the narrativizing impulse—that impulse whereby we attempt to shape the traces of the past into a meaningful pattern, creating a plot. Furthermore, it implicitly connects this pattern-making activity with the work done by chaos scientists, particularly as they map the behavior of chaotic dynamical systems along the Cartesian coordinates of what is called "state space," wherein each point represents one possible unique configuration of the system at a specific point in time. By skewing temporal order and drawing on a key figure from chaos theory (the strange attractor), the play demonstrates both how we attempt to make sense of the traces that come to us from times past and why it is important that we do so.

1 Time

In *Arcadia*, Stoppard draws upon two distinct time periods in order to create a complex and compelling plot. The scenes set in 1809/1812 focus upon an amorous young tutor, Septimus Hodge, and his teen-aged charge, Thomasina Coverly, a prodigy who anticipates the second law of thermodynamics and key ideas of what is popularly known as chaos theory long before they become accepted by the scientific establishment.[1] The scenes set in the 1990s deal

1 The second law of thermodynamics was first formulated by Sadi Carnot in 1824. Pioneering work in chaos theory (more precisely, dynamical systems theory) was done in the 1960s by Edward Lorenz in papers such as "Deterministic Nonperiodic Flow" ([1963, 1984] 1985) although the work "languished in obscurity" for a decade, as Ian Stewart has noted (1989, 134). In the 1980s, the work of the Dynamical Systems Collective was key to the establishment of chaos theory, and their article "Chaos," published in *Scientific American* (Crutchfield et al. 1986) provided one of the first comprehensive discussions of it. Ilya Prigogine and Isabelle Stengers's *Order out of Chaos* (1984) and James Gleick's widely read *Chaos: The Making of a New Science* (1987) brought chaos theory into the public eye. Stoppard credits the latter as inspirational: "I thought, here is a marvelous metaphor [chaos theory]" (Nathan 1994, 263).

with the attempt of two academic researchers, Hannah Jarvis and Bernard Nightingale, to construct plausible narratives from the traces left of these past events. Bernard wants to prove that Lord Byron, while a guest at Sidley Park (where the play is set), seduced the wife of poetaster Ezra Chater, killed Chater in a subsequent duel, and fled Britain.[2] Hannah wishes to use the anonymous Sidley hermit, an apparent madman who took up residence in the garden's hermitage in the early nineteenth century, as a symbol of "[t]he whole Romantic sham [...] The decline from thinking to feeling" (27).[3] Their attempts are paralleled in the scientific realm by Valentine Coverly, a modern-day chaos mathematician, who is trying to construct a scientific model of grouse populations by drawing on the estate's game books.

Unbeknownst to either Hannah or Bernard, it is Septimus whom they seek. As the audience discovers in the course of the play, he dallies with Mrs. Chater, is challenged—twice—to a duel by Mr. Chater (a duel that never occurs), and, presumably driven mad by the death of Thomasina and the implications of her

My colleague Dr. Kersti Tarien Powell has brought to my attention a handwritten note from Stoppard's son Oliver (who was pursuing an undergraduate degree in physics), which appears on a photocopy excerpt entitled "Mathematical Chaos and Strange Attractors": "Dad: here it is." The excerpt is in the inventory of Tom Stoppard's papers at the Harry Ransom Center, University of Texas, Austen, catalogued under 53:11: (http://research.hrc.utexas.edu:8080/hrcxtf/view?docId=ead/00179p1.xml). The piece on strange attractors was originally published in Douglas Hofstadter's "Metamagical Themas" column in *Scientific American* 245.5 (November 1981): 22–43; an extended version of the piece was republished as "Mathematical Chaos and Strange Attractors" in Hofstadter 1985, 364–395.

2 Lord Byron, the only actual historical figure in the play, is imagined as staying at Sidley Park in the 1809 sequence. He is an absent presence in the play, for, although he is discussed by the other characters, he never makes an appearance. Peter Graham notes that, when he saw the 1993 touring version of the play with other academics headed to the International Byron Conference, the protagonist "Septimus (at least as played by Rufus Sewell) look[ed] so Byronic that one initially suspect[ed] disguise of identities" (1995, 318).

3 Note: Subsequently, all citations from *Arcadia* are given with page number in parenthesis in the text.

Critics such as Fleming (2001) and Zeifman (2001) have argued that the emotionally restrained Hannah represents the classical temperament and the flamboyant Bernard represents the Romantic temperament. Stoppard himself has said, "I don't think *Arcadia* says very much about these two sides of the human personality or temperament. I don't think it's in the play. And yet, it's firing all around the target, making a pattern around the target" (Gussow 1995, 91). The classical/Romantic dichotomy most clearly appears in the discussions about the history of the Sidley Park garden, whose "whole sublime geometry was plowed under by Capability Brown" (Stoppard 1993, 27) in 1760, according to Hannah, and which is being transformed into a site of ostensibly "untamed nature" (25) in 1809.

heat-exchange diagram, becomes the hermit who covers thousands of sheets of paper "with cabalistic proofs that the world was coming to an end" (27).

Although each time period in the play proceeds chronologically, past and present scenes become increasingly entangled as the play progresses. Act One comprises a past scene, a present-day scene, a past scene, and a present-day scene; act two comprises a present-day scene, a past scene, and a final scene that shifts back and forth between past and present and ultimately brings them both together, visually but not interactively. The overarching plot might thus be summed up as follows: Septimus's juggling of romantic entanglements, growing appreciation of Thomasina's insights, and (in the 1812 segment) reciprocated but unconsummated love for her serve as fodder for the latter-day investigators, one of whom (Bernard) jumps to humiliatingly wrong conclusions and the other of whom (Hannah) eventually discerns what "really" happened, information that perturbs her grand theory.

Through its plot, *Arcadia* explores the constructing of narrative(s), specifically written narrative or what Paul Ricoeur terms "diegetic composition" (36).[4] What I want to emphasize is that the play's impact and meaning depend crucially on the medium of drama, through Stoppard's manipulation of dramatic space and time. As Tom Stoppard has stated: "A play is not a text. [...] The theatre turns out to be an event which has to be carefully manipulated. It is crowded with variables which have to be put into balance" (Gussow 1995, 109–12). As I demonstrate in the following section, various effects in *Arcadia* can be achieved only through its staging.[5] Both past and present-day scenes

4 In his discussion of Aristotle's *Poetics* in the first volume of *Narrative and Time*, Ricoeur argues for narrative (muthos) as an "encompassing term" ([1983] 1984, 32)—one that would, in fact, include drama, epic, and history. "To avoid any confusion" as he explores Aristotle's discussion of epic and drama, Ricoeur distinguishes between "narrative in the broad sense, defined as the 'what' of mimetic activity, and narrative in the narrow sense of the Aristotelian *diēgēsis*, which I shall henceforth call diegetic composition" (36). *Arcadia* is thus a narrative in Ricoeur's broad sense, but it deals with narrative in the narrow sense. In the past several decades, narratologists have expanded the definition of narrative to include not only the diegetic but also the mimetic. Seymour Chatman, for example, argues that "any text that presents a story—a sequence of events performed or experienced by characters—is first of all a narrative. Plays and novels share the common features of a chrono-logic of events, a set of characters, and a setting" (1990, 117).

5 As critics such as Ryan Claycomb have argued, "it becomes important to analyze not only the mimetic narratives presented in performance [...] but also how the printed text for performance operates in particular ways" (161)—although such an analysis goes beyond the scope of this particular study. See Manfred Jahn's "Genres" diagram, which differentiates between play-, film-, opera-scripts and the performances based on them (2001, 675). Drawing

are set in the same space, a large room in the Sidley Park manor that serves as a schoolroom in the past and a gathering-place for the researchers in the present. In his stage directions, Stoppard specifies, "[b]oth periods must share the state of the room, without the additions and subtractions that would normally be expected. The *general* appearance of the room should offend neither period" (15). Certain props, however, take on, in Lucy Melbourne's term, a "transtemporal" quality (1998, 562): Septimus's glass of wine, from which Hannah later drinks, a desk-bound tortoise (Plautus in the past and Lightning in the present, which may indeed be one-and-the same), an apple that the mute young genius Gus Coverly gives Hannah and that Septimus later eats.[6] Gus, indeed, becomes key to Stoppard's visual transtemporality. The role is played by the same actor who plays the role of Augustus Coverly, Thomasina's brother. In the final, time-mixing scene of the play, Augustus asks Septimus for a drawing that Thomasina has made of the latter with Plautus; later in the scene, Gus, dressed in Regency costume à la Augustus, presents Hannah with the drawing—as if, but *only* as if, the nineteenth-century character has taken up the drawing and thereafter time-traveled across the years to offer it up in the present.[7]

There is no actual time travel here, however. Although Stoppard intermingles past and present-day characters in the final scene of the play, they never actually interact. Nevertheless, a striking visual simultaneity of past and

on Jahn's taxonomy of interpretive approaches to drama, I would locate myself in the "Reading Drama" school, "which envisages an ideal recipient, who is both a reader and a theatergoer," whose "interpretive strategies include performance-oriented textual analysis, paying particular attention to the 'secondary text' of the stage directions, and comparing the reading of plays to the reading of novels" (662). I have had the happy experience of seeing four productions: the 1996 Philadelphia premiere at the Wilma Theater, the 1998 production at Temple University, the 2011 New York revival at the Ethel Barrymore Theater, and the 2014 production at the Lantern Theater in Philadelphia, productions that have varied widely. I should point out that while my analysis depends on the written text, I also address at certain points how the play might be perceived by an audience.

6 Derek Alwes points out that "Septimus is eating an apple that won't be picked for nearly 200 years. In the world of the play, 'there's an order things can't happen in,' and of course Septimus is unaware of the anomaly, but we are again reminded that our god's-eye view of events transcends temporal distinctions, achieving simultaneity" (396). The play also features an aural transtemporality: for example, the thump of Mr. Noakes's steam engine and the strains of music from a piano, which are occurring in both time periods.

7 Enoch Brater notes: "The timescape is further complicated when a character in the present (Gus) is called upon to play his ancestor in the past [...]" (2005, 164). I would point out that the assumption of Regency costumes by the present-day characters provides an amusing instance of metadrama, for it drives home the fact that what we are watching is simply a group of actors substituting one set of costumes for another.

present takes place so that, for example, Septimus and Hannah turn the pages of Thomasina's lesson book "doubled by time" (78), as the stage directions specify. In the last moments of the play, Septimus and Thomasina, Hannah and Gus "join" in a waltz. Likewise, in the sequence doubled by time, characters in different time-frames seem to be responding to one another as, significantly, they discuss Thomasina's "diagram of heat exchange" (93), which points to the heat-death of the universe. Valentine's explanation that "everything is mixing the same way, all the time [...] till there's no time left" (94) is interrupted, for example, by Septimus's seeming rejoinder, "Oh, we have time, I think" (94).[8]

The alternating time periods, transtemporality, and dialogue across past and present necessitate an unsettling relationship between cause and effect. While arguing for his wrong-headed notion that Lord Byron killed Chater, Bernard states: "Because time is reversed. Tick, tock goes the universe and then recovers itself, but it is enough, you were in there and you bloody *know*" (50). Of course, time does not reverse itself for the characters on the stage, a point underscored by Thomasina's prescient grasp of the second law of thermodynamics, which presupposes a unidirectional arrow of time. In fact, Bernard's inability *actually* to be there occasions his misreading of the evidence that he discovers, as I discuss at greater length hereafter. The audience, however, does indeed "bloody *know*" what has happened (or, at least, may surmise it) because of the "You Are There" nature of the scenes set in the past. Enoch Brater makes the valid point that "the dual time structure is carefully manipulated to show cause *after* effect" (2005, 163). So, for example, in the 1809 scene 1, Septimus receives a letter from Chater challenging him to a duel over Mrs. Chater's honor, but he manages to flatter Chater into calling it off; in the present-day scene 2, Bernard produces not one but two separate challenges from Chater; and in the 1809 scene 3, Chater issues a second challenge once he realizes that Septimus has written an unflattering review of his poetry book. After the present-day scene, the audience may thus be anticipating the second challenge that has been issued nearly 200 years previously.

Certainly, what happens in the present does not cause what happens in the past. Roland Barthes, however, remarks upon readers' "confusion of consecution and consequence, what comes *after* being read in narrative as what is *caused by*" ([1977] 1982, 266), and it may very well be that audience members watching *Arcadia* regard what happens in the present as, in some sense, influ-

8 In *Indian Ink* (1995), the play that followed *Arcadia*, Stoppard similarly employs two time periods, with characters from each appearing on the stage simultaneously yet not interacting. The play also deals with a scholar thwarted in his attempts to discover certain truths about his subject, but I do not see the stakes as being as high as they are in *Arcadia*.

encing what happens in the past or, at least, enveloping it with a meaning it might not otherwise have. Of relevance to a play dealing with historical traces is David Wittenberg's comment on "the psychological ground of historiography itself" as "the ineluctable and fertile ambiguity between the past as *causing* and as *caused*" (2013, 232). In the present-day scene 5, Bernard envisions "a platonic letter [from Byron to Septimus] which confirms everything" and which concludes with the instruction "P.S. Burn this" (57). In the 1809 scene 6, the audience sees that Septimus indeed has received a letter from Byron, which he burns unread—but the letter would have put paid to Bernard's thesis rather than confirmed it. The most striking instance of the present day impacting on the past occurs when we learn from Hannah in scene 7 that Thomasina "burned to death [...] the night before her seventeenth birthday" (76). When in the final scene, Septimus predicts that Thomasina's discoveries "will make me mad" and warns her to "[b]e careful with the flame" of the candlestick, his words resonate poignantly, as do the kisses and waltz that the two lovers share—which the audience realizes are both first and final, for this is, in fact, the very night of which Hannah spoke.[9] Stoppard biographer Ira Nadel points out that for Trevor Nunn, director of the original London production of *Arcadia*, "the play became one about 'the collision of two different worlds,' showing how two sets of people might change each other in the course of the action" (2001, 440). Although past and present characters never actually interact, for the audience, with its transtemporal vantage, they do indeed impact upon one another.

2 Chaos

Elsewhere, I have argued that a scrambled chronology may signify "a chaotic narrative" in the sense of our contemporary understanding of chaos as disorderly order or deterministic chaos (2007, 25–26). Rather than story events being ordered linearly, as if on a time line, a chaotic narrative may intermingle past, present, and even future events, and we may have difficulty discerning

[9] In a conversation with Michael Hollinger, Stoppard comments on the emotional impact of this particular moment in the play: "the audience knows something the characters don't. And it's deeply moving to see the innocence of characters who are either marching forward or dancing forward or strolling forward, *falling* forward into events of which they know nothing and the audience knows everything" (1997). As critics have noted, Thomasina, who has predicted the heat-death of the universe, will succumb to a form of heat-death herself.

the initial conditions that gave rise to current conditions. We see such an intermingling in a chaotic figure such as the strange attractor, which I discuss below.

With its intermingling of past and present (an intermingling exacerbated in the final scenes) and its explicit references to chaos theory, *Arcadia* invites a chaos-theory reading. Stoppard draws upon its key ideas, in both the 1809/1812 scenes, wherein Thomasina anticipates chaos theory, and in the present-day scenes, wherein Valentine explains Thomasina's proto-chaos-theory work to Hannah and attempts to analyze the chaotic dynamical system of grouse populations. At one point in the play, Thomasina speculates about fractal forms, those irregular, self-similar geometric forms that—in the words of Ian Stewart—"present us with a new language in which to describe the shape of chaos" (1989, 222). Thomasina queries, "if there is an equation for a curve like a bell, there must be an equation for one like a bluebell, and if a bluebell, why not a rose?" (37). And, indeed, she comes up with a "rabbit equation" that "eats its own progeny" (77) in an attempt to discover a "New Geometry of Irregular Forms" (43). As Valentine, examining Thomasina's mathematics lesson book, tells Hannah, "every time she works out a value for y, she's using that value for x. And so on. Like feedback. She's feeding the solution back into the equation, and then solving it again" (44). Essentially, Thomasina has come up with a recursive iterated algorithm to "mak[e] pictures of forms in nature" (47), as Hannah apprehends—the same type of equation, used by chaos scientists, that Valentine is searching for in order to chart the growth and decline of the grouse population at Sidley Park.[10]

Stoppard also addresses the fact that Thomasina's nineteenth-century formulations required twentieth-century technology to come to fruition. As Valentine explains to Hannah, Thomasina would have been thwarted by a lack of tools, specifically, computers: "And what I've done in a couple of months, with only a *pencil* the calculations would take me the rest of my life to do

10 Drawing on the classical/Romantic dichotomy that threads through the play, some critics have argued that chaos theory is presented as the scientific equivalent of Romanticism. See, for example, Edwards (2001) and Fleming (2001). We need to bear in mind, however, that chaos theory does not represent "[t]he decline from thinking to feeling" (27), which is how Hannah characterizes Romanticism. It is predicated upon the same rigorous scientific and mathematical principles that classical science uses. Jernigan makes a similar point: "Chaos theory is not, however, as postmodern as Lyotard believes nor is it even as Romantic as suggested by Gleick and Stoppard. Indeed, in many respects it is a prototypically classical science that purports to describe the world. For while chaos theory concedes that the complete description becomes a practical impossibility given the complexity of the equations that are necessary to track chaotic systems, determinability yet remains a theoretical possibility" (2003, 27).

again—thousands of pages—tens of thousands" (51)—a description that reminds us of the thousands of pages covered in "cabalistic proofs" that are found in the hermitage. Indeed, we might even say that computers enabled the discovery of deterministic chaos because of their ability to perform a vast number of iterations in a brief span of time.[11]

Although Thomasina's New Geometry of Irregular Forms serves as the most extensive reference to chaos theory, Stoppard not only references chaos theory and thematizes it, but he also structures the play according to a chaos-theory model, as critics have noted.[12] What has not been discussed in any detail, however, is the way in which Stoppard draws upon a particular manifestation of deterministic chaos—the strange attractor—in order to characterize how past events come to us as traces and how we thus discern a pattern.

An attractor is not something that attracts but rather a state-space simulation of the behavior manifested by a dynamical system—what the system is attracted to.[13] A system such as a pendulum exhibits classically deterministic behavior in that the plotted trajectory of its motion will always fall upon the same attractor—a fixed-point attractor that represents the system's evolution toward ultimate stasis. A strange attractor occurs within certain kinds of chaotic dynamical systems wherein the attracting point or points have become unstable, both attracting and repelling the system's trajectory. When explaining chaos theory to Hannah, Valentine mentions deterministic but unpredictable systems: "We can't even predict a dripping tap when it gets irregular. Each drip sets up the conditions for the next, the smallest variation blows prediction apart, and the weather is unpredictable the same way, will always be unpredictable" (48). We can, however, map the system, discerning an overall pattern. Significantly, when we map in state space the behavior of the weather or a dripping faucet undergoing a chaotic transition, we end up with, respectively, a Lorenz/butterfly strange attractor and a Rössler/funnel strange attractor.[14]

11 One of the earliest manifestations of chaotic behavior in weather systems was discovered by Edward Lorenz feeding iterated equations into a computer. See the chapter "The Butterfly Effect" in Gleick (1987, 9–31) and the chapter "The Weather Factory" in Stewart (1989, 127–44) for this history.

12 The play's chaotic structure (or disorderly order) is addressed by such critics as Antor (1998), Demastes (2011), Edwards (2001), Fleming (2001), Jernigan (2003), Melbourne (1998), and Vees-Gulani (1999).

13 I make the caveat because some critics, perhaps drawing on an interchange between Valentine and his sister about amorous attraction as "[t]he attraction that Newton left out" (74), have tended to confuse attractors and attracting points.

14 For a discussion of the weather as a chaotic system, see Lorenz ([1963, 1984] 1985). For a discussion of the behavior of the dripping faucet, see Shaw (1984). Both of these

The orbit hovers around certain coordinates within a basin of attraction (and is thus deterministic), but we cannot predict when the orbit will move closer or further away from those coordinates; there are fixed global limits with infinite variations occasioned by the many variables for which we cannot account, as Valentine makes clear with his dripping tap example and as we see when we try to determine whether a summer day in Philadelphia will hit the record high of 104 degrees or conform to the average 87. The strange attractor evolves in the multidimensionality of state space; the memory of the initial conditions that gave rise to it is lost, replaced by new information. Indeed, this loss of initial conditions does in part make for its strangeness.

Septimus might be regarded as the unstable attracting point about which both Bernard and Hannah construct narrative trajectories. Although a key character to the audience, he is, in the main, inaccessible to the two researchers. However, he is the solution to the mysteries each attempts to solve: the duel involving Chater and the identity of the Sidley Park hermit. The audience knows that Chater has sent letters challenging Septimus (rather than Byron) to a duel—but the letters have neither an addressee nor a signature. The audience knows that Septimus, not Byron, writes the damning reviews of Chater's poetry volumes for the *Piccadilly Recreation*—but these reviews are unsigned. The audience knows that Thomasina draws a picture of an imaginary hermit "like the Baptist in the wilderness" (14) in the sketchbook showing the projected hermitage—but there is nothing to indicate to the present-day researchers that it was not "[d]rawn in by a later hand" (25), that is, once the hermitage has actually been built and contains the actual hermit (presumably Septimus). There is also a good deal of information unavailable not only to the characters but to the audience as well: What was in the three letters that Septimus burned? What exactly were the "cabalistic proofs" (also burned) upon which the hermit was working—Thomasina's rabbit equation, her heat-death diagram, both? Why did Byron flee England in 1809 (a true-life mystery that the fictional Bernard is attempting to solve)?

The historical evidence upon which Bernard and Hannah must rely, although tangible, is scanty, stripped of context, and possibly misleading. Just as the memory of the initial conditions that give rise to a strange attractor is lost, the actual truth of the events that took place at Sidley Park must

dynamical systems (as well as the scientists Lorenz and Shaw) are also discussed in Gleick (1987). The best way to view a strange attractor is to watch a trajectory evolve under its influence. For a view of a Lorenz/butterfly attractor, see https://www.youtube.com/watch?v=97ryBYOTQ00. For a view of a Rössler/funnel strange attractor, see http://demonstrations.wolfram.com/TheRosslerAttractor/.

always remain beyond the reach of the two present-day researchers—even as new evidence comes to light. Septimus exists for them as but a shadowy figure, the undistinguished tutor of Thomasina, but he, or rather the traces he has left, nevertheless attract them. They are, however, concurrently blocked (or, in scientific terms, repelled) by the interference—the "*bloody noise*" (62), in Valentine's words—comprising gaps in information, ambiguous references, and undreamed-of accidents. The strange attractor maps the evolution in state space of a dynamical system over time, the traces of its past states driving the action in the present. Just so, do past and present become entangled in the theatrical (state) space of the play, the traces of the former part of an ever-evolving pattern. The dynamical dance, wherein past and present characters trace intersecting trajectories across the stage in the final moments of *Arcadia*, serves as an appropriate figure for this process.

3 Trace

Valentine's invective about the "bloody noise" underscores a problem faced by all researchers who must depend on mere traces from the past as they emplot a narrative of what "really" happened. Hayden White speaks to this problem:

> The dynamics of historical inquiry, representation, and analysis arise from the disparity between our desire for some equivalent of a visual perception of objects and processes that are apprehendable only by traces of the "sounds" they once emitted [...], only in the extent to which they "speak" to us or can be made to respond to our verbal interrogations of them [...]. The peculiar problematic of historical knowledge is laid down by the circumstance that we know 'the past' only by its 'words' and the 'historical process' only by its effects. ([1991] 2010b, 253–54)[15]

Stoppard demonstrates this desire for historical knowledge through the actions of his researchers Hannah and Bernard. They know the past history of Sidley Park mainly through its "words" and "effects," those traces that have come down to them—three letters inserted in a book, a poet's inscription, an old primer, two unsigned reviews, game books, a sketch, a memorial to Thomasina, and (ultimately) a brief paragraph in a garden book.

15 Although Martyniuk references White in her essay (2004, 266–67), the point is brief, and her overall argument is more concerned with how Stoppard creates community with his readers rather than the narrative construction of the past.

Yet, although Hannah and Bernard yearn for knowledge of the past, as Stoppard also demonstrates, the initial conditions of the traces are unavailable—except, of course, to the audience with its transtemporal perspective, and even we do not know all the variables. White says of the past: "Although there is indubitable evidence—in the form of monuments, relics, remains, and documents—that the past once existed, these traces of the past can be said to be effects whose original causes have ceased to exist" ([1999] 2010c, 308). White's point about our knowledge of the past being based only on its effects may remind us of how the strange attractor appears as an effect whose initial conditions have become unavailable. So, too, does Septimus—an initial condition to so many of the effects that Hannah and Bernard discover—remain hidden.

So if all we have to go on are traces of past events, if we must deal with the noise, how do we make meaning? Valentine's discussion of how dynamicists do so is instructive:

> It's all very very noisy out there. Very hard to spot the tune. Like a piano in the next room, it's playing your song, but unfortunately it's out of whack, some of the strings are missing, and the pianist is tone deaf and drunk—I mean, the *noise*!
> Impossible!
> [...] You start guessing what the tune might be. You try to pick it out of the noise. You try this, you try that, you start to get something—it's half-baked but you start putting in notes that are missing or not quite the right notes, and bit by bit... (*He starts to dumdi-da to the tune of "Happy Birthday".*) Dumdi-dum-dum, dear Val-en-tine, dumdi-dum-dum to you—the lost algorithm! (46)

Significantly, this notion of guessing the tune pertains to Valentine's discussion of his chaos work with grouse populations, Stoppard thus suggesting that even the objective realm of science is subject to the subjective—that the pattern can be discerned only when the dynamicist brings his or her interpretative skills to it. During a 1981 symposium on order and disorder Edgar Morin noted that "the real field of knowledge is not the pure object, but the object viewed, perceived, and co-produced by us" (1984, 106). As I have argued elsewhere with regard to the strange attractor, "[i]t is a *figure* (in the sense of a trope) of the system's dynamical behavior, created by the dynamicist's manipulation of parameters in state space" (2007, 23).[16] This is not to say, however, that any evidence out

16 See also Thomas Weissert (1995, 128–29; 1997, vii–viii) for a discussion of the dynamicist's involvement in the creation of chaotic patterns.

THE CHAOTIC TRACE 33

there is simply manipulated willy-nilly by the dynamicist. As Valentine makes clear, there is a tune being played, and the dynamicist works with the available evidence (flawed though it may be) to discover a pattern that approximates the reality of the dynamical system.

The action of historical interpretation in which Hannah and Bernard (and historians in general) engage is analogous to that of finding a pattern in the scientific realm, as Valentine has described it. From the traces—"the chaotic form of 'historical records'" (White 1987, 4)—they attempt to discern a pattern. They engage in what Paul Ricoeur felicitously terms "the dynamic of emplotment" (1983, 53). As with Valentine and his grouse studies, Hannah and Bernard must rely on guessing what the tune might be despite the piano's missing strings. When discussing Byron's supposed duel with Chater, Bernard speaks of "a visceral belief in yourself. Gut instinct" (50). And although Hannah argues against Bernard's theory, she later draws on gut instinct herself, insisting that a Henry Fuseli sketch is of Lord Byron and Caroline Lamb, despite a Fuseli expert's argument to the contrary.[17] As the 1809/1812 scenes demonstrate, Bernard's gut instinct leads him astray while Hannah's is seemingly validated, yet in both cases such instinct is not simply subjective desire (although it is that as well) but an ability to discern a pattern—an ability that might be regarded "as grounded in a pre-understanding of the world of action, its meaningful structures, its symbolic resources, and its temporal character," a point that Paul Ricoeur makes about plot composition (1984, 54).

We might, in fact, consider that the differing interpretations of the past that Bernard and Hannah put forward are part and parcel of historical inquiry, as White's comments on historical narrativity suggest: "It is the fact that they [real events] can be recorded otherwise, in an order of narrative, that makes them, at one and the same time, questionable as to their authenticity and susceptible to being considered as tokens of reality" ([1980] 1987, 20). Bernard advances his hypothesis about "Byron's urgent reasons for leaving England" (53) based on the scathing unsigned reviews of Chater's work that appeared in the *Picadilly Recreation*, surmising that the reviews led Chater to challenge Byron to a duel. But Hannah and even Valentine can provide alternative explanations. Valentine, for example, subjects the reviews to a computer analysis and finds that "they aren't a very good fit with Byron's other reviews" (60).

17 Vees-Gulani makes an interesting argument that chaos theory sanctions the place of intuition in historical research: "When one understands the course of the world as organized according to the principles of chaos theory, the mixture of intuition and historical evidence as an approach to the past becomes possible and acceptable" (1999, 421). Her focus here, however, is "the self-similar structure that connects the past with the present" (422) rather than the strange attractor.

Bernard dismisses this evidence—"You can't stick Byron's head in your laptop!" (60)—although earlier he had spoken of his "inexpressible joy" (19) when a fellow academic's claim about a possible Lawrence short story had been demolished by a computer analysis.

Although he ends up with egg on his face regarding Byron's supposed killing of Chater, Bernard nevertheless does discern a meaningful pattern of events. After all, Byron, like Septimus, does have a sexual liaison with Mrs. Chater; Mr. Chater just doesn't happen to learn of it. And Byron does end up fleeing Sidley Park (although not England) when Lady Croom, the lady of the house, finds Mrs. Chater in his bed. Unfortunately, Bernard misses a crucial piece of evidence, which Hannah opportunely discovers, that demolishes his theory—the paragraph in Lady Croom's garden book that makes clear that Ezra Chater the would-be poet who stayed at Sidley Park in 1809 and Ezra Chater the would-be biologist who died in Martinique of a monkey bite in 1810 are one and the same. Bernard does make a contribution to Byron scholarship nevertheless, establishing that the renowned poet was at Sidley Park: "Between the Byrons and the Coverlys there was no social equality and none to be expected. The connection, undisclosed to posterity, until now, was with Septimus Hodge [...]" (54). But he continues to get things wrong. Once his hypothesis has been undermined, Bernard ("Grasping at straws," as Stoppard says in the stage directions [89]), attempts to salvage some bits of it: "Yes, two completely unknown Byron essays—*and* my discovery of the lines he added to 'English Bards.' That counts for something." When Hannah "tactfully" suggests that his argument is "persuasive," he rejoins, "I've proved Byron was here and as far as I'm concerned he wrote those lines as sure as he shot that hare" (89). Although a notation in one of the game books does indeed place Byron at Sidley Park, the audience knows from the past scenes that Septimus wrote the lines and that Augustus actually shot the hare—yet more undermining of Bernard's (almost plausible) version of history.

Just as Bernard's hypothesis is undermined by a crucial piece of evidence, Hannah's implicit one is bolstered by such evidence—the portrait of Septimus with the tortoise that Augustus/Gus brings her, seemingly across time. Before receiving it, she would seem to have reached a dead end in her research. In response to Chloe Coverly's angry question, "What do you know about anything?," she responds, "Nothing" (95). She tells Bernard that, although she has a good idea about the identity of the hermit, she lacks proof. When Gus, in the final moments of the play, hands her the drawing, she receives the proof she lacked: "I was looking for that" (97). Hannah can now make out enough of the notes to construct the "Happy Birthday" song—if she so desires. Interestingly, the information would seem to complicate her initial hypothesis

that the Sidley Park hermit stands for "[a] mind in chaos suspected of genius. [...] The decline from thinking to feeling" (27).

The audience may assume that Hannah has now surmised what the historical evidence has seemed to present—that Septimus, devastated by the death of Thomasina, retreated to the hermitage, where he spent the remainder of his life in an homage to his lost love, covering endless sheets of paper with equations pertaining to chaos theory and the second law of thermodynamics. For what Stoppard does is involve the audience in the meaning-making process as well. Although he gives the audience access to the past that the present-day characters (and historians in general) lack, such access does not provide an ultimate truth. Graham points out that, significantly, there is no actual evidence put forward that Septimus becomes the Sidley Park hermit (1995, 317). There are indeed many unknowables, but the audience, like Bernard and Hannah, is encouraged to engage in a dynamics of emplotment, to make meaning of what has been presented, to fill in the gaps. Although audiences engage in interpretative acts with every play-viewing, Stoppard's dual time-scheme foregrounds the audience's implication in the act of emplotment, its attempt to map "the dynamical system" that Septimus sets in motion.

White asserts, "[s]tories are not true or false, but rather more or less intelligible, coherent, consistent, persuasive, and so on. And this is true of historical, no less than of fictional, stories" (2010a, 236). Through the fiction of *Arcadia*, Stoppard confirms this statement, showing how the traces of the past are put together in a way that is coherent, consistent, persuasive—or not. Stoppard shows us as well that sometimes, as the past recedes further, more of its traces may come to light—a game-book that confirms that Lord Byron visited Sidley Park, a letter in a gardening book that makes clear that he didn't kill Chater in a duel—traces that enable the construction of more persuasive plots. The temporal set-up of *Arcadia*, whereby past and present share the same space, reinforces this point. Perhaps in some imaginary future of Sidley Park, additional long-buried pieces of evidence might appear.

But if we can know history only through its emplotment in a narrative, if the initial conditions are always inaccessible, what does it have to teach us? Stoppard provides us a possible answer through something Hannah tells Valentine, when he is smarting from an anti-science diatribe by Bernard: "It's *all* trivial—your grouse, my hermit, Bernard's Byron. Comparing what we're looking for misses the point. It's wanting to know that makes us matter. Otherwise we're going out the way we came in" (75).[18] Shortly thereafter,

18 Stoppard makes a similar point in a conversation with Blanka Ziska, director of the East coast premiere of his *The Invention of Love*: "Housman [AEH in the play] puts the case

Valentine shows her the "Coverly set," a computer model of Thomasina's rabbit equation: "In an ocean of ashes, islands of order. Patterns making themselves out of nothing." Hannah exclaims, "Oh!, but ... how beautiful!" (76). The narrativizing impulse is, after all, an attempt to construct a meaningful pattern out of the seeming disorder of our lives. As White explains in his discussion of historical narrativity, "narrative strains for the effect of having filled in all the gaps, of having put an image of continuity, coherency, and meaning in place of the fantasies of emptiness, need, and frustrated desire that inhabit our nightmares about the destructive power of time" (1987, 11). That destructive power cannot be stopped, but narrative can help make us matter in the face of it.

In conclusion, I want to return to the play as a play, particularly *its* conclusion. As I have said, although exploring the nature of (written) narrative, *Arcadia* itself is a drama, and its overall meaning and, if you will, magic come to us through this medium. In the final moments of the play, as Septimus and Thomasina waltz joyously on what we know is the eve of Thomasina's death, Hannah and Gus tentatively begin to waltz as well, the couples thus seeming to exist in the same temporal space. J.T. Fraser, in an essay providing the rationale for the study of time, notes that "at the very foundation of being human" is "the conflict between the knowledge of an end of the self and the desire to negate that knowledge" (2004, 204). In a play that deals not only with the premature death of one of its key characters but also with the eventual heat-death of the universe, Stoppard imaginatively mediates the conflict by letting the dead past mingle with the living present, by concluding with a doomed Thomasina alive to the possibilities that the future may hold—a future in which her discoveries gain new life. Through the intricate temporal structure of Stoppard's play, we discern the pattern-making activity that makes us matter, that makes beauty out of an ocean of ashes, that mitigates the destructive power of time, and that, even in the presence of death, gives us a glimpse of Arcadia.[19]

for the acquisition of knowledge for its own sake. Unless you live trying to know more, then you're going out the way you came in" (1997, 3). In the play itself, AEH says that scholarship is "where we're nearest to our humanness. Useless knowledge for its own sake. [...] which is only to shed some light, it doesn't matter on what, it's the light itself, against the darkness, it's what's left of God's purpose when you take away God" (1997, 71). As Fleming notes, "*Arcadia* is a celebration of the human struggle to obtain knowledge, with meaning arriving as much out of the process as the product" (2001, 200).

19 I wish to thank the Saint Joseph's University Board on Faculty Development for granting me a sabbatical, during which I was able to work on this project. I also wish to thank the 2013 Summer Writing Group, Barbara Torell, the two anonymous referees, and the editors of this volume for their input on this essay.

References

Alwes, Derek B. 2000. "'Oh, Phooey to Death!': Boethian Consolation in Tom Stoppard's *Arcadia*." *Papers on Language and Literature* 36: 392–404.

Antor, Heinz. 1998. "The Arts, the Sciences, and the Making of Meaning: Tom Stoppard's *Arcadia* as a Post-Structuralist Play." *Anglia* 116: 326–54.

Barthes, Roland. (1977) 1982. "The Structural Analysis of Narrative." In *A Barthes Reader*, edited by Susan Sontag, 251–95. New York: Hill and Wang.

Bilson, Fred. 2003. "Tom Stoppard's *Arcadia*." In *British Writers Classics*. Vol. 1, edited by Jay Parini, 23–39. New York: Charles Scribner's Sons.

Brater, Enoch. 2005. "Playing for Time (and Playing with Time) in Tom Stoppard's *Arcadia*." *Comparative Drama* 39: 157–68.

Chatman, Seymour. 1990. *Coming to Terms: The Rhetoric of Narrative in Fiction and Film*. Ithaca: Cornell University Press.

Claycomb, Ryan. 2013. "Here's How You Produce This Play: Towards a Narratology of Dramatic Texts." *Narrative* 21: 159–79.

Crutchfield, James P., J. Doyne Farmer, Norman H. Packard and Robert S. Shaw. 1986. "Chaos." *Scientific American*, December, 49–57.

Delaney, Paul. 2001. "Exit Tomáš Straüssler, enter Sir Tom Stoppard." In Kelly 2001, 25–37.

Demastes, William. 2011. "Portrait of an Artist as a Proto-Chaotician: Tom Stoppard Working His Way to *Arcadia*." *Narrative* 19: 229–40.

Edwards, Paul. 2001. "Science in *Hapgood* and *Arcadia*." In Kelly 2001, 171–84.

Fleming, John. 2001. *Stoppard's Theatre: Finding Order amid Chaos*. Austin: University of Texas Press.

Fraser, J.T. 2004. "Reflections Upon an Evolving Mirror." *KronoScope* 4, no. 2: 201–23.

Gleick, James. 1987. *Chaos: Making a New Science*. New York: Viking.

Graham, Peter W. 1995. "Et in *Arcadia* Nos." *Nineteenth-Century Contexts* 18: 311–19.

Gussow, Mel. 1995. *Conversations with Tom Stoppard*. New York: Limelight Editions.

Hofstadter, Douglas. 1985. *Metamagical Themas: Questing for the Essence of Mind and Pattern*. New York: Basic Books.

Hollinger, Michael. 1997. "The Good Words of Tom Stoppard." *Seven Arts* (January). Reprinted as Wilma Theater flyer.

Jahn, Manfred. 2001. "Narrative Voice and Agency in Drama." *New Literary History* 32: 659–79.

Jernigan, Daniel. 2003. "Tom Stoppard and 'Postmodern Science': Normalizing Radical Epistemologies in *Hapgood* and *Arcadia*." *Comparative Drama* 37, no. 1: 3–35.

Kelly, Katherine E., ed. 2001. *The Cambridge Companion to Tom Stoppard*. Cambridge: Cambridge University Press. Cambridge Collections Online. http://cco.cambridge.org/uid=3804/extract?id=ccol0521641780_CCOL0521641780_root.

Lorenz, Edward N. [1963, 1984] 1985. "Deterministic Nonperiodic Flow." In *Chaos*, edited by Hao Bai-Lin, 282–93. Singapore: World Scientific. Previously published in *Journal of the Atmospheric Sciences* 20 (1963): 130–41.

Martyniuk, Irene. 2004. "'This is not science. This is storytelling': The Place of the Individual and the Community in A.S. Byatt's *Possession* and Tom Stoppard's *Arcadia*." *Clio* 33: 265–86.

Melbourne, Lucy. 1998. "'Plotting the Apple of Knowledge': Tom Stoppard's *Arcadia* as Iterated Theatrical Algorithm." *Modern Drama* 41, no. 4: 557–72.

Morin, Edgar. 1984. "The Fourth Vision. On the Place of the Observer." Translated by Pierre Saint-Amand. In *Disorder and Order: Proceedings of the Stanford International Symposium (Sept. 14–16, 1981)*, edited by Paisley Livingston, 98–108. Saratoga, CA: Anma Libri.

Nadel, Ira. 2002. *Tom Stoppard: A Life*. New York: Palgrave Macmillan.

Nathan, David. 1994. "In a Country Garden (If It Is a Garden)." In *Tom Stoppard in Conversation*, edited by Paul Delaney, 261–64. Ann Arbor: University of Michigan Press.

Parker, Jo Alyson. 2007. *Narrative Form and Chaos Theory in Sterne, Proust, Woolf, and Faulkner*. New York: Palgrave MacMillan.

Prigogine, Ilya and Isabelle Stengers. 1984. *Order out of Chaos: Man's New Dialogue with Nature*. Toronto: Bantam.

Ricoeur, Paul. 1984. *Time and Narrative*. Vol. 1. Translated by Kathleen McLaughlin and David Pellauer. Chicago: University of Chicago Press. Originally published 1983 as *Temps et Récit*. Paris: Éditions de Seuil.

Shaw, Robert. 1984. *The Dripping Faucet as a Model Chaotic System*. Santa Cruz: Aerial Press.

Stewart, Ian. 1989. *Does God Play Dice? The Mathematics of Chaos*. New York: Basil Blackwell.

Stoppard, Tom. 1993. *Arcadia*. London: Faber and Faber.

———. 1995. *Indian Ink*. London: Faber and Faber.

———. 1997. *The Invention of Love*. New York: Grove Press.

Vees-Gulani, Susanne. 1999. "Hidden Order in the 'Stoppard Set': Chaos Theory in the Content and Structure of Tom Stoppard's *Arcadia*." *Modern Drama* 42: 411–26.

Weissert, Thomas P. 1995. "Dynamical Discourse Theory." *Time and Society* 4: 111–33.

———. 1997. *The Genesis of Simulation in Dynamics: Pursuing the Fermi-Pasta-Ulam Problem*. New York: Springer.

White, Hayden. 1987. "The Value of Narrativity in the Representation of Reality." In *The Content of the Form: Narrative Discourse and Historical Representation*, 1–25. Baltimore: Johns Hopkins University Press. First published 1980.

———. 2010a. "Historical Pluralism and Pantextualism." In *The Fiction of Narrative: Essays on History, Literature, and Theory 1957–2007*, edited by Robert Doran, 223–36. Baltimore: Johns Hopkins University Press. First published 1986.

———. 2010b. "Ideology and Counterideology in Northrop Frye's *Anatomy of Criticism.*" In *The Fiction of Narrative*, 247–54. First published 1991.

———. 2010c "Postmodernism and Textual Anxieties." In *The Fiction of Narrative*, 304–17. First published 1999.

Wittenberg, David. 2013. *Time Travel: The Popular Philosophy of Narrative.* New York: Fordham University Press.

Zeifman, Hersh. 2001. "The Comedy of Eros: Stoppard in Love." In Kelly 2001, 185–200.

Zizka, Blanka. 2000. "The Invention of the Play: A Conversation with Tom Stoppard and Blanka Zizka." *Open Stages: The Newsletter of the Wilma Theater*, January/February, 1–3.

CHAPTER 3

Beyond the Forensic Imagination: Time and Trace in Thomas Pynchon's Novels

Arkadiusz Misztal

Abstract

This essay discusses the relation between trace and time in Thomas Pynchon's novels, first from the perspective of forensics and subsequently by considering alternative ways of articulating and conceptualizing time in Pynchon's narratives. I argue that the forensic imagination finds compelling application in Pynchon's texts, which attempt to reconstruct the past on the basis of mute or distorted evidence available as relics or inscriptions in the present. However, in the opaque reality of Pynchon's narratives the efficiency and range of the forensic method are limited. Apart from the factual physical evidence, Pynchon also employs more subtle traces to articulate his ideas of time: light traces in photography. Thus in his 2006 novel *Against the Day* he creates complex temporal "scapes" by the convergence of light and time. Pynchon, I argue, returns in this novel to the "natural magic" of early photography to explore the marginalized and overlooked timescapes of modernity. The restoration and celebration of these temporalities constitute an integral part of his strategies of resistance to systematized clock-time and machine-time. They are also indicative of what Pynchon recognizes in postwar literature as "the modern Luddite imagination" and its "impulse to deny the machine."

Keywords

narrative time – Thomas Pynchon – forensics – timescape – photography – Luddism

1 Introduction: "Some Say It's the Trace"[1]

"There's a faint glow, after a while you notice it—some say it's the trace, like radiation from the big bang, of the memory, in nothingness, of having

[1] I would like to thank the volume editors, Sabine Gross and Steven Ostovich as well as the anonymous reviewers for their thoughtful and detailed comments that helped to improve the clarity of this paper.

once been something..." (Pynchon 2013, 359). This quotation from Thomas Pynchon's novel *Bleeding Edge* illustrates the temporal complexity involved in approaching and tracking traces in all of his fictional works. The author of eight novels and of a collection of short stories, Pynchon has been a major figure in postwar American literature at least since the publication of his most celebrated work *Gravity's Rainbow* in 1973. In the 1980s Pynchon was, in the words of the editors of the *Cambridge Companion* to his work, "canonized as the foremost American postmodernist" and he has since become "a staple of academic reading lists dealing with the period" both in the United States and in Europe (Dalsgaard, Herman and McHale 2012, 1). The encyclopedic scope of his narratives and bewildering range of reference, as well as his keen interest in art, history, and science not only confirmed Pynchon's position in the literary canon but also earned him, relatively early in his literary career, comparison to such writers as Dante, Rabelais, and Melville. Pynchon has also often been compared to James Joyce, the great modernist who explored the complexities of time in consciousness and consciousness in time.[2]

Human temporality and time have been among Pynchon's major concerns in all of his texts, from the early short stories written in the 1960s to his most recent novel *Bleeding Edge*, published in September 2013. Some of Pynchon's non-fictional texts, which I examine below, also address problems and puzzles about time in literature. The central focus of this paper is the multifaceted relation between trace and time, which I first discuss from the perspective of "the forensic imagination" and then later by considering alternative ways of articulating and conceptualizing time in Pynchon's narratives. Taking Matthew G. Kirschenbaum's study *Mechanism, New Media and the Forensic Imagination* as the point of departure, I argue here that the forensic imagination finds compelling application in Pynchon's texts, especially his detective narratives, *The Crying of Lot 49* and *Inherent Vice*, which attempt to construct legible records of what happened on the basis of mute or distorted evidence of the past available as relics or inscriptions in the present. However, in the opaque reality of Pynchon's narratives the efficiency and range of the forensic method are limited. Apart from the factual physical evidence, Pynchon also employs more subtle traces to articulate his ideas of time: light traces. Thus in his 2006 novel *Against the Day* he creates complex temporal "scapes" by the convergence of light and time.

By exploring the temporal multilayeredness of the photographic image, Pynchon, I argue, returns to the marginalized and overlooked timescapes of

2 For a brief discussion of Pynchon's place in literary history, see Cowart (2012).

modernity.[3] The restoration and celebration of these temporalities are integral parts of Pynchon's strategy of resistance to systematized clock-time. They are also indicative of what Pynchon calls "the modern Luddite imagination" and its "impulse to deny the machine." I will delineate these lines of resistance in the concluding part of my essay.

2 The Forensic Imagination: "Every Contact Leaves a Trace"

As a legal and scientific enterprise, the forensic imagination has its origins in the 19th century, the era that produced the great inscribing engines of modernity such as the gramophone, film, and the typewriter. Forensics, as Matthew Kirschenbaum argues, is thus "a signature discourse network of modernity at the juncture of instrumentation, inscription, and identification" (Kirschenbaum 2008, 250) as evidenced by the new technological media (photography, microscopy) and the work of two pioneers in forensic science: Francis Galton, who devised a method for classifying fingerprints, and Edmund Locard, who formulated the basic principles of forensic science. Pynchon's narratives not only outline the emergence of the new "technoscapes" but also playfully employ forensic sensibilities to reconstruct what "has once been something." Centered on revealing the materiality of experience in its temporal dimension, Pynchon's texts often encourage the reader to retrace the past through objects in the present. As in Michael Leyton's description of the detritus from a deserted subway platform, Pynchon regards traces as examples of "mute material evidence of the past impinging on the present" (quoted in Kirschenbaum 2008, 251). A crushed can points to an absent grip, a dented trash can to a kick from a long-gone limb, a coffee stain to a spill, scuffmarks on the floor to the tread of many feet. "Like the subway station," Leyton concludes "the present is a silent chamber that has a history that we cannot experience. It is only from

3 My analysis of these temporal scapes owes much to Barbara Adam's work, especially her *Timescapes of Modernity*, where she studies "the complex temporalities of contextual being, becoming and dwelling" (Adam 1998, 11). Unlike other scapes such as landscapes, cityscapes and seascapes, which reveal the spatial qualities of past and present activities and interactions of organisms and matter, "timescapes emphasise their rythmicities, their timings and tempos, their change and contingencies" (11). Thus, she concludes, "[a] timescape perspective stresses the temporal features of living. Through timescapes, contextual practices become tangible. Timescapes are thus the embodiment of practiced approaches to time" (11). This perspective is also applicable to Pynchon's treatment of time, as from the early texts to the most recent, he consistently emphasizes the contextual, irreversible temporalities of life, its contingencies and the complexities of the human experience of time.

the content of this chamber that we might be able to infer prior events [...]. We can examine only what we possess in the present, the relics that surround us" (quoted in Kirschenbaum 2008, 251).

If there is a common thread that runs through all of Pynchon's narratives, it is perhaps his meticulous attention to "the relics that surround us," even the trivial and overlooked ones, and an attempt to infer from them the past that one could not directly experience. In one of Pynchon's very early stories, "The Secret Integration" (first published in 1964), a group of boys successfully investigates the harassment of the Barringtons, an Afro-American family that has just moved into a previously all-white neighborhood, by literally reading clues in the garbage thrown on the front lawn of their imaginary friend's house.

> When they got to Carl's house they found the front lawn littered with garbage. For a while they only stood; then, as if compelled to do so, began kicking through it, looking for clues. The garbage was shin-deep all over the lawn, neatly spread right up to the property line. They must have brought it all in the pickup. Tim found the familiar A&P shopping bags his mother always brought home, and the skins of some big yellow oranges an aunt had sent them as a gift from Florida, and the pint box of pineapple sherbet Tim himself had bought two nights ago, and all the intimacy of the throwaway part, the shadow-half of his family's life for all the week preceding, the crumpled envelopes addressed to his father and mother, the stubs of the black De Nobili cigars his father liked to smoke after supper, the folded beer cans, always with the point coming in between the two e's of the word "beer," exactly the way his father did and had taught him how to do—ten square yards of irrefutable evidence. (Pynchon 1985, 190)

It is a breakthrough moment as the boys come to realize that it is their own parents who are behind these actions. Likewise, yet on a much larger scale, in his most recent novel, *Bleeding Edge* (2013), Pynchon explores the detritus of popular culture, science, and art to address momentous contemporary events and phenomena such as 9/11 and the Internet. Set in New York City in the months before and after the World Trade Center attacks, the novel is centered around Maxine Tarnow, a fraud investigator, as she looks into the dealings of hashlingrz, a dotcom company run by Gabriel Ice, the novel's villain. Yet the generic conventions of detective fiction are soon challenged and subverted as the book, in the manner Pynchon readers have come to expect, invokes the tones of other genres: science-fiction, political and social satire, chick and teen literature.

The forensics that we encounter is ostentatiously playful, self-ironic, and self-deprecating. Early in the book Maxine declines the request to investigate Ice's dotcom by pointing out the limited efficiency of forensic method in the Information Age: "'Cause see, if all you want's an asset search, you don't need a forensic person really, just go on the Internet, LexisNexis, HotBot, AltaVista, if you can keep a trade secret, don't rule out the Yellow Pages—" (Pynchon 2013, 9). Further in the novel she is helped by Conkling Speedwell, "a freelance professional Nose, having been born with a sense of smell far more calibrated than the rest of us normals enjoy" (Pynchon 2013, 190). Yet the promise of nasal forensics to solve the murder of one of Maxine's clients is soon abandoned, as Conkling, obsessed with Hitler's aftershave, starts an affair with Maxine's best friend Heidi and drifts away from the investigation.

3 Pynchon's California Cycle

Much more pronounced forensic sensibilities and an attention to reading material clues that can be insistent to the point of being obsessive and paranoid are found in *The Crying of Lot 49* (1966) and *Inherent Vice* (2006), which together with *Vineland* (1990) constitute Pynchon's California cycle. One of the recurring themes of this cycle is the exploration of the dark landscape of the Sunny State, its shadowy history and power relationships hidden behind the scenes.

All three novels in this cycle are Pynchonesque explorations of the 1960s, and both *The Crying of Lot 49* and *Inherent Vice* feature detective figures. In *The Crying of Lot 49* Oedipa Mass, an amateur detective, negotiates the maze of California highways, roads and freeways hoping that "behind the hieroglyphic streets there would either be a transcendent meaning, or only the earth. [...] Another mode of meaning behind the obvious, or none" (Pynchon 1996, 125). The peculiar quality of Californian urban complexes dawns on her as she is driving to the fictional San Narciso: "Like many named places in California it was less an identifiable city than a group of concepts—census tracts, special purpose bond-issue districts, shopping nuclei, all overlaid with access roads to its own freeway" (Pynchon 1996, 14). It is here that she experiences for the first time an unexpected insight and begins to regard the California landscape in terms of a printed circuit design:

> The ordered swirl of houses and streets, from this high angle, sprang at her now with the same unexpected, astonishing clarity as the circuit card had. Though she knew even less about radios than about Southern

Californians, there were [sic] to both outward patterns a hieroglyphic sense of concealed meaning, of an intent to communicate. There'd seemed no limit to what the printed circuit could have told her (if she had tried to find out) [...]. (Pynchon 1996, 14–15)

Similarly in *Inherent Vice*, the hippie PI Doc Sportello traces the unsettling designs on the sunny map of California attempting to help his ex-girlfriend and break a case, which with each chapter, in typically Pynchonesque manner, becomes more complex and obscure. Despite all appearances, Sportello, who wears gumshoes, smokes pot and runs an office called "LSD Investigations," is a professional well versed in forensic science. At one point, facing his LAPD nemesis, Detective Bjornsen, he explicitly quotes Edmund Locard's Exchange Principle: "every contact leaves a trace." Locard, also known as the Sherlock Holmes of France, developed a sophisticated methodology of detection, which he published in his monumental seven-volume work, *Traité de Criminalistique*. The efficiency of Locard's method relies primarily on the minute attention given to factual evidence, as illustrated by the following passage from his work:

> Wherever he steps, wherever he touches, whatever he leaves, even without consciousness, will serve as a silent witness against him. Not only his fingerprints or his footprints, but his hair, the fibers from his clothes, the glass he breaks, the tool mark he leaves, the paint he scratches, the blood or semen he deposits or collects—all of these and more bear mute witness against him. This is evidence that does not forget. It is not confused by the excitement of the moment. It is not absent because human witnesses are. It is factual evidence. Physical evidence cannot be wrong, it cannot perjure itself, it cannot be wholly absent. Only human failure to find it, study and understand it, can diminish its value. (quoted in Kirk 1953, 4)

Accordingly, Oedipa and Doc concentrate in their investigations on all available traces and clues, even the seemingly unimportant and unrelated ones. Both *The Crying of Lot 49* and *Inherent Vice* reveal close intimacy with mundane objects and peripheral systems of storage and communication.[4]

It is thus possible to analyze these detective quests into the 1960s against the background of the conjectural epistemological model discussed by

4 One needs only to think of an underground mail system known as W.A.S.T.E. in *The Crying of Lot 49* or the predecessor of the global Internet from *Inherent Vice*, ARPANet, which came on-line in 1969 with a mere four routers and an initial running speed of 50 kb/second.

Carlo Ginzburg in his well-known essay "Clues: Roots of an Evidential Paradigm" (1989). Pynchon's appreciation of details, discarded information and marginal data naturally lends itself to what Ginzburg calls the "venatic" model of deduction: the ability to construct from apparently insignificant experimental data a complex reality that cannot be experienced directly (Ginzburg 1989, 103).[5] Pynchon's narratives also invite close scrutiny in the manner of the Morellian method, named after the Italian art historian who in the late 19th century developed the technique of tracing paintings with incorrect attributions to their real creators. Morelli maintained that he was able to distinguish originals from copies and to discover the artist behind a painting by shifting the focus from the most conspicuous characteristics to the most trivial details such as earlobes, fingernails, or shapes of fingers and toes. As Ginzburg reminds us, "Morelli identified and faithfully catalogued by this method the shape of the ear in figures by Botticelli, Cosme Tura, and others, traits that were present in the originals but not in copies" (Ginzburg 1989, 97).

While Pynchon's novels hint at the existence of deeply rooted relationships that supposedly explain all the connections uncovered, they are also to a considerable degree narratives not only of detection but also of deception. The venatic model of deduction has a limited scope of application: the opaque reality of Pynchon's novels does not provide privileged zones—signs or clues—that allow the detective and the reader to penetrate it once and for all. Even when we manage to find Pynchon's fingerprints in his narratives, for instance in places where he skillfully mixes history and fiction, employing elements from diverse sources, we are not discovering any privileged patterns or designs. The narrative patterns detected do not impose any interpretive totalization; their structure is open and can easily be expanded into new, unforeseeable directions. Frequently, even its smallest element is a potential "entryway." Moreover, the venatic form of deduction presupposes not only a cause-and-effect relation but also that of parts in relation to a whole, and this is what makes the application of the venatic model problematic in Pynchon's texts. Furthermore, in their investigations Oedipa and Doc Sportello cannot absolutely reject the idea of interconnectedness, yet simultaneously they are unable to establish a clear hierarchy of importance among the clues they have uncovered. Thus the efficiency and range of the above modes of detectability are limited.

5 Ginzburg traces this form of deduction back to hunting, to the ability to read the traces left by animals, and accordingly calls it "venatic." Furthermore, he argues that "venatic thinking" contributed in the course of human history to the invention of pictographic representation and divination in ancient cultures such as the Mesopotamian one (Ginzburg 1989, 103).

4 Temporal Freeze

Pynchon's detective quests also bring to the fore the problematics of perspective and visual epistemology, especially the way images can be used to elicit knowledge about a particular subject or object. His narratives explore the potential of images as an epistemic medium by examining their potential to encode information, and in general terms his works investigate how visual techniques generate and represent knowledge. To fully appreciate visualization as a mode of knowledge production, one needs not only to recognize what Harald Klinke calls "the particular logic of images" (Klinke 2014, 1), but also, as Johanna Drucker points out, one needs to acknowledge visualization in its procedural, generative, and emergent dimensions. This particular logic of images, which fundamentally differs from that of language, addresses "the organizing principles of all images for the ways they encode knowledge through visual structures and rhetorics of representation" (Drucker 2011, 3). Yet one must also recognize the importance of our interpretive sensibilities, fundamental in the conception and expression of visual knowledge, as well as the ensuing dynamic in which subjectivity and objectivity are closely related. "No image is self-evident. We learn to interpret through the situated and the subjective condition of perception whereby an encoded expression provokes a response for cognitive processing" (Drucker 2011, 6).

In Pynchon's detective quests this dynamic takes on a paradoxical character. Oedipa and Doc Sportello relentlessly pursue their cases and, while discovering a multitude of clues and leads, they quite often—to use Doc's phrase—overthink themselves to brainfreeze. Although they are incredibly perceptive, their gaze is fixed and the perspective they adopt is more central than peripheral or panorama-like. This fixation translates itself also—using Doc Sportello's language—into a kind of temporal freeze incapable of surveying diverse, interrelated, and often overlapping timescapes. The brainfreeze fixes (to use J.T. Fraser's terminology from his model of nested temporalities) the detective's gaze to "one level-specific reality," which is only a part of the complex "temporal *umwelt* of man" (Fraser 1987, 368).

Centered on the materiality of experience, the forensic perspective is not well suited to examining the contextual and irreversible temporalities that Pynchon, in his introduction to *Slow Learner*, calls "that human one-way time we're stuck with locally here" (Pynchon 1985, 15). In other words, the perspective fails to capture "the intricate intersecting of the rhythms, beats, sequences, beginnings and ends, growth and decay, birth and death, night and day, seasonality, memory, and so on that constitute the embedded temporality that is part of everything" (Hassan and Pursuer 2007, 12). Most notably forensic sensibilities

do not do justice to the specific sociotemporality that the novels evoke. J.T. Fraser's conclusion regarding the incapacity of sociobiology to study the complexities of social time(s) also applies to forensics. Both approaches are bound to remain incomplete and incompletable as they cannot fully "address behavior rooted in the mental manipulation of future and past through imagination, and the consequent creativity and destructiveness of individuals" (Fraser 1987, 214). Moreover, the temporal fixation cannot reveal "the dynamic of intentionality peculiar to collective responses to the call of symbolic causes, which is a hallmark of sociotemporal reality" (Fraser 1987, 214). What is lost in this fixation is the coexistence of multiple times: the times of the social collectivity and the environment, the times embedded in social interactions, practices, and knowledge (Adam 1995, 6).

The Crying of Lot 49 and *Inherent Vice* are Pynchon's most elaborate social and political statements about the American '60s and their legacy. As David Cowart remarks, Pynchon's visions of the West Coast often concern the idea of the frontier, not merely the literal, geographical end of the American frontier but also the temporal one: "just as [Frederick Jackson] Turner once conceptualized the closing of the American frontier, so does Pynchon imagine a succession of low dishonest decades, to paraphrase Auden, displacing one bright with promise" (Cowart 2011, 122–3). Thus these two of Pynchon's texts, especially when read together, are to a considerable degree shaped by the concern "about how the Psychedelic Sixties, this little parenthesis of light, might close after all, and all be lost, taken back into darkness..." (Pynchon 2009, 254).

As I have argued elsewhere,[6] Pynchon's resorting to noir aesthetics in these texts allows him to articulate some of the unresolved anxieties of the waning sixties and to place them against the contemporary landscape of California.[7] While, as Leslie Fiedler has shown, the American West has the capacity of a mythological "stepping outside history" (quoted in Fine 2000, 18), noir visions of California's past and future, as Mike Davis argues, have "come to function as a surrogate public history" (Davis 2006, 44). In the first chapter of his *City of Quartz* Davis remarks: "Virtually alone among big American cities, Los Angeles still lacks a scholarly municipal history—a void of research that has become the accomplice of cliché and illusion. [...] Los Angeles understands its past, instead, through a robust fiction called *noir*" (2004, 36). On a similar note, David Fine recognizes this pecularity of California noir and points out that the local detective story has never shaken off the burden of the past. The detective

6 See Misztal (2014).
7 For a comprehensive discussion of the sixties in Pynchon's California novels, see Cowart (2011, chapter 4).

fiction inevitably centers on excavating the past and recovering memory and past time: "History is not so much absent [in Los Angeles] as displaced; it exists as a different geography" (Fine 2000, 16). Both *The Crying of Lot 49* and *Inherent Vice* survey these different geographies and their diverse temporal scapes.

5 Plurality of Times: Orthogonal Time, Dream Time, and "Video Time"

Pynchon's most explicit argument for a plurality of times is his 1993 *New York Times* essay on sloth, in which he explores the idea of time that accompanied and contributed to the transformation of America into "a Christian capitalist state." Indicative of the emerging mechanized and industrial capitalist order, this new time ruled early American city life. A case in point for Pynchon was Philadelphia, which already in the late 18th century answered less and less to the religious vision of William Penn, for whom it was "The City of Brotherly Love," a haven for Quakers and other oppressed Christians seeking religious freedom. "The city was becoming a kind of high-output machine, materials and labor going in, goods and services coming out, traffic inside flowing briskly about a grid of regular city blocks. The urban mazework of London, leading into ambiguities and indeed evils, was here all rectified, orthogonal" (Pynchon 1993, 57). Sloth, in this urban high-output machine, was not so much a sin against God as against the new orthogonal time: "uniform, one-way, in general not reversible." Sloth was thus redefined as a sin against clock-time. As Pynchon puts it, "[b]eneath the rubato of the day abided a stern pulse beating on, ineluctable, unforgiving, whereby whatever was evaded or put off now had to be made up for later, and at a higher level of intensity" (Pynchon 1993, 57).

In this context Pynchon brings up the figure of Benjamin Franklin, who perfectly exemplified the new attitude towards economy and time.[8] Franklin's autobiography appears to be one of the very first works on time management and personal productivity published on American soil. Looking at the daily agenda it includes, Pynchon notes that Franklin was allowing himself only a few hours for sleep. The remaining hours were meant to be spent productively, except maybe for the block of time between 9 pm and 1 am devoted to the

8 Pynchon seems to follow here Max Weber's argument from his monumental work *The Protestant Ethic and the Spirit of Capitalism*. Weber regarded Benjamin Franklin as an exemplary exponent of eighteenth-century Capitalism and cited a long passage from Franklin's short essay, "Necessary Hints to Those that would be Rich" (written in 1738). See Weber (2001) 15–16.

Evening Question, "What good have I done this day?". "This must have been the schedule's only occasion for drifting into reverie—there would seem to have been no other room for speculations, dreams, fantasies, fiction. Life in that orthogonal machine was supposed to be nonfiction" (Pynchon 1993, 57). Time in that machine was regular, predictable and linear: "every second was of equal length and irrevocable, not much in the course of its flow could have been called nonlinear, unless you counted the ungovernable warp of dreams [...]" (Pynchon 1993, 57).

Antithetical to this overriding capitalist chronometry,[9] dreamtime is, for Pynchon, a mode of resistance, offering a non-linear, imaginative awareness which does not translate time into money. It is the time of fiction and writers, whom Pynchon jocularly calls "the mavens of sloth," selling their dreams. The writers are the ones who have long since contested the idea of time as commodity and its direct convertibility into money. Herman Melville's *Bartleby the Scrivener: A Story of Wall-Street* (1853) provides a good example of this non-compliant attitude. Its title character, located in the very center of robber-baron capitalism, refuses to be a part in the Wall-street money-making machine and develops a kind of secular *acedia*, which by that time was no longer a spiritual vice, but an offense against the economy.

Later in this essay, Pynchon points to another strategy of resistance made available in the 20th century, "video time,"[10] which allows reshaping temporality at will and seemingly exploiting it forever. "We may for now at least have found the illusion, the effect of controlling, reversing, slowing, speeding and repeating time—even imagining that we can escape it" (Pynchon 1993, 57). While the "video" (i.e., visual) experience offered by the cinema and television could easily hypnotize the viewer into mental idleness, it can also, as Pynchon somewhat perversely suggests, foster "a more non-linear awareness" (Pynchon 1993, 57) which requires some inner alertness that can transform the passive gesture of sloth into a more mindful posture of resistance to orthogonal temporality.

9 For a comprehensive overview of the research literature on the subject of capitalist production and its organization to the time of the clock, see Adam (1995, chapter 4).

10 Pynchon employs this term in his 1993 *New York Times Book Review* essay to characterize the kind of temporality that is generated by visual storage media such as the VCR and others.

6 The Mysteries of Time: "Photography and Its Convergence of Silver, Time, and Light"

In *Against the Day* Pynchon explores the concept of visual time, mostly but not exclusively in photography. The title of the book is the translation of the French term *contre-jour*, "a photographic effect that refers to photographs where the camera is pointed directly toward the source of light, creating backlighting of the subject" (PynchonWiki).[11] Accordingly, the book, another of Pynchon's encyclopedic narratives,[12] retraces some of the early history of photography. The novel's timeframe overlaps with the period of 1880–1917, which Sarah Greenough, in her study *On the Art of Fixing a Shadow*, calls "photography's coming of age." The conspicuous presence of this new visual medium in a novel that intends to capture the new *Zeitgeist* is not surprising as the camera became an integral part of the American 19th-century technoscape and, to extend Matthew Kirschenbaum's argument, one of the great inscribing engines of modernity. As Merry Foresta puts it, "[t]he invention of photography and the birth of the modern age were simultaneous. The momentum of the industrial revolution advanced photography, a medium for which a blend of art and technology is fundamental" (Foresta 1989, 34).

The new medium, as the German photo-historian Bernd Stiegler argues in his book *Philologie des Auges: Die photographische Entdeckung der Welt im 19. Jahrhundert* (2001), radically transformed the cognitive picture of the world. Studying the mutual relation between photography and the history of perception as it developed in the nineteenth century, Stiegler contends that the proposed theoretical models of perception in that period were essentially the theories of photography and that by the beginning of the twentieth century "seeing was photographic" (68). In this new mode of perception, as Cristina Cuevas-Wolf has observed, "the camera's image either determined or extended what the eye could see. The camera's eye symbolized this

11 "Q-weapon and Photography," *PynchonWiki*, last modified February 27, 2007, http://against-the-day.pynchonwiki.com/wiki/index.php?title=Q-weapon_and_Photography.

12 Edward Mendelson introduced the critical category of "encyclopedic narrative" in his paper on *Gravity's Rainbow*, "Gravity's Encyclopedia," and he further elaborated the concept in a later essay, "Encyclopedic Narrative from Dante to Pynchon." It might be worth noting at this point that one of the salient features of encyclopedic narratives is that they "attempt to render the full range of knowledge and beliefs of a national culture, while identifying the ideological perspectives from which that culture shapes and interprets its knowledge" (Mendelson 1976, 1269).

photographic seeing, which defined what was perceived and imagined about the world" (Cuevas-Wolf 2006, 158–9). This transformation also affected the conceptualization and representation of time. In *Camera Lucida* Roland Barthes, reflecting on the first cameras developed in the nineteenth and early twentieth centuries, calls them "clocks for seeing" (Barthes 1982, 15). The cameras satisfied the scientific fascination with the passage of time and perfectly answered to the need to objectively capture the ephemeral.

Barthes's idea of cameras as "clocks for seeing" is perhaps most clearly visible in the experiments conducted by Étienne-Jules Marey and Eadweard James Muybridge. The former, a French bio-physicist, used photographic images in 1883 to study force by arresting individual instants of time and superimposing them on each other. Marrey aptly called this method "chronophotography," literally "the photography of time": "a method which analyzes motions by means of a series of instantaneous photographs taken at very short and equal intervals of time" (Kern 2003, 21). Similarly, Muybridge used cameras for his extensive and detailed studies of movement, paving the way for motion pictures. His "zoopraxiscope," a machine for projecting a series of photographs in rapid sequence, is the forerunner of the movie projector.[13]

In *Against the Day* Pynchon resorts to photography to study the modern temporal dimension of culture (clock- and industrial time) and its knowledge frame grounded on the conceptual principles of Newtonian physics, the idea of linear causality and reversibility. On the other hand, the novel breaks with the prevailing knowledge of clock-time by deconstructing the idea of "a slice of time" (a snapshot or decisive moment) and replacing it with more complex visions revealing the temporal multilayeredness of the photographic image. It seems to me that Pynchon returns in *Against the Day* to the term originally used to characterize photography at the moment of its invention: Fox Talbot called it photogenic drawing, which means literally "drawing originating in light." Similarly, James E. McClees, a Philadelphia daguerreotypist, defined the new medium as a "way of writing with light" (Trachtenberg 1989, 3).

Photography as "drawing and writing with light" enables Pynchon to create temporal scapes by exploring the potential inherent in light traces. As the novel explicitly suggests, one approach to the problematics of time can be "by way of photography and its convergence of silver, time and light" (Pynchon

[13] Michael O'Malley in *Keeping Watch: A History of American Time* points to the overlooked connection between Muybridge's studies of motion and Fredrick Winslow Taylor's practice of scientific management, "the extraordinary connection between standardized time, scientific management, and the later evolution of motion pictures" (O'Malley 1991, 204).

2006, 454). While Pynchon recognizes in the early photographical experiments a scientific fascination with fixing the transient (there are, for instance, explicit references to Jules Marey's chronophotography), he regards cameras as time-proposing devices, paying close attention to how time is either embedded or embodied in the photographic image. It is, after all, photography that allows Merle, one of the main characters in *Against the Day*, to study "The Mysteries of Time": "to bring it [time] a little closer to his face, squint at it from different angles, maybe try to see if it could be taken apart to figure how it might actually work" (Pynchon 2006, 454).

A motif introduced early in the novel is that of Iceland spar, a form of clear, colorless calcite that was originally discovered and named after Eskifjörður in Iceland. Because of its flawless transparency and the fact that it occurs in huge crystals (up to 7 meters long), the calcite was used in various optical instruments throughout the 20th century. It was, for instance, "a strategic mineral during WWII used for the sighting equipment of bombardiers and gunners" (PynchonWiki).[14] It is also worth mentioning that Iceland spar might be, as some historians have recently argued, the "sunstone," a magical item mentioned in Norse sagas, which aided Viking sailors in navigation.[15] Iceland spar is often used to demonstrate the phenomenon of double refraction: it causes light to divide into two rays that are bent into two different angles (known as angles of refraction). A person viewing an object through the crystal will see its two images.

In *Against the Day* the crystal is closely connected to the novel's central theme and concept, light, which Pynchon explores from different angles and

14 "Iceland spar," *PynchonWiki*, last modified April 28, 2014, http://against-the-day.pynchonwiki.com/wiki/index.php?title=I.

15 Iceland spar is a birefringent crystal: a ray of light falling on the calcite is split by polarization into two rays taking different paths. An object viewed through the spar will not only be doubled, but the two images will have different brightness levels, depending on the polarization of light. As Bárbara Ferreira explains in the Geolog blog, the calcite used as a polarizer of a light from the sky would allow a Viking navigator to locate the sun's position: "Sunlight becomes polarised as it crosses the Earth's atmosphere, and the sky forms a pattern of rings of polarised light centered on the Sun. Changing the orientation of calcite as light passes through it will change the relative brightness of the projections of the split beams, even when the Sun is hiding behind clouds or just below the horizon. The beams are equally bright when the crystal is aligned to the Sun." In their recent study Guy Ropars and colleagues suggest that Vikings could have built a simple device to enhance the accuracy of navigation by the crystal. The experiment confirmed also that the spar as a navigational aid can be employed even when the Sun is largely below the horizon. For a detailed account, see Ropars et al. 2011.

standpoints: scientific and parascientific, historical and fictional. The spar in his novel is related to "the doubling of creation" and contributes to the creation of double and parallel worlds. To give the most obvious example, the third part of the novel is called "Bilocations," and indeed many characters in *Against the Day* appear simultaneously in two or more locations. As Heinz Ickstadt notes, "the creation of double- and counterworlds via the double refraction of light in Iceland spar is a central metaphor in *Against the Day* since it points not only to the doubling of the world in the moving images of film and television but also, in metafictional reference, to the doubling power of fiction in general and to the intertwining of the apparently real with its double- or counterimage" (Ickstadt 2008, 214). In this context, or better in the light of Ickstadt's perceptive comment, the photographic term that Pynchon employs as the title of his novel takes on a new meaning.

Jorge Lewinski, in the entry on *contre-jour* in his *Dictionary of Photography*, points out the change of focus and a kind of stereoscopic effect produced by the against-the-light technique. Shooting into the light enables "stronger concentration of interest on the main subject" and adds "a three-dimensional quality to the image" (Lewinski 1987, 34). Pynchon not only allows for stronger, more intensive concentration of interest on the main subject matter, but also adds a fourth dimension to it. He is thus able to articulate the temporal multi-layeredness of the photographic image and "navigate that dark fourth-dimensional Atlantic known as Time" (Pynchon 2006, 415). This multi-layeredness reinforces the idea of temporal fluidity: "Past, present and future," as Ickstadt observes, "are fluid categories [in this novel]; in fact, they interact and mirror each other. Events that happen in narrated time resound in the narrating time that is the reader's present" (Ickstadt 2008, 214).

It is worth noting at this point that Pynchon might also be exploring the potential of another photographic phenomenon: the ghost image, an example of which even appears on the novel's cover. As perceptive contributors to *The Pynchon Wiki* noted, not only are such ghost images produced by the double refraction of light in Iceland spar, but they also appear in multiple typefaces. Pynchon's reported involvement in the design of the dust jacket, with its combination of traditional serif fonts with modern sans-serif ones, suggests a deliberate invocation of this temporal fluidity and interaction, which reviewers of the novel back in 2006 and 2007 experienced as reading "against the present."[16]

[16] Thus, for instance, Keith Gesen in his *New York* review concludes: "The fun of Pynchon's books [...] has always been to read them into the present. *Gravity's Rainbow*, while ostensibly about World War II, was actually about American Cold War hegemony and

7 Haunting Time

The ghost images on the novel's cover foreshadow another temporal realm that Pynchon surveys by means of photography: "haunting time." Pynchon employs this new visual medium to invoke the parascientific and the irrational as counterbalances to the rationalized worldview of rampant capitalism at the turn of the 20th century. *Against the Day* clearly juxtaposes the late capitalist reconfiguration of space and time with alternative views on time. To express this juxtaposition, Pynchon returns to the time of the "natural magic" of photography, when it was practiced in theatrical magic as the art of illusionism.

In the early years of the 20th century, as Matthew Solomon shows, magician-filmmakers were still taking advantage of the photographic image and cinema, and exploiting "the deceptive possibilities inherent in montage and mise-en-scène to produce new marvels" (Solomon 2010, 2). One need only think of Jean Eugène Robert-Houdin, who claimed to have discovered "the specific tenses of vision"[17] or Georges Méliès, the inventor of special effects in film and the last director of Houdin's *Théâtre des Soirées fantastiques*, running from 1888 to 1924 (Virilio 1995, 66).

One should also not forget in this context the phenomenon of spirit photography that appeared in the United States in the second half of the 19th century, with the intellectual and spiritual support of the religious movement known as Spiritualism. The ghosts conjured up by spirit photography (or more

Vietnam; *Against the Day* likewise works with what feels like contemporary material, though its subject is ostensibly the turn of the twentieth century" (Gesen 2007). In a similar vein, Steven Moore sees *Against the Day* as drawing "parallels between the past and present—there's a brilliant evocation of the 9/11 attacks on Manhattan, where Pynchon lives—and it's clear that the worldly author doesn't see much difference between the corruption of the late Gilded Age and that of our own era" (Moore 2006).

17 The famous American magician Harry Houdini (born Erik Weisz) was so impressed by Robert-Houdin that after having read his *Memoirs*, the young Weisz decided to adopt in his honor the stage name of "Houdini." Following a suggestion by a fellow player, he added the letter "i" to Houdin's name believing that it would mean in French "like Houdin." Later in his life Houdini lost his youthful respect for Robert-Houdin. In 1908 he wrote *The Unmasking of Robert-Houdin*, in which he called his former idol a liar and a fraud for having taken undue credit for other magicians' inventions. Houdini is mentioned in *Against the Day* in the context of "the illusionary uses of double refraction" (Pynchon 2006, 354), and there are also several references to magic tricks performed by a character called "the great Zombini."

precisely by the trick of duplicitous double exposure) were alleged not only to provide evidence of the afterlife but also, as Louis Kaplan writes in his study of William Mumler, a spirit photographer from New York and Boston, to "attest to the fact that photography has somehow opened up a virtual window into a realm freed from the constraints of time entirely" (Kaplan 2010, 28). Pynchon has not overlooked the potential inherent in "haunting time." Accordingly, one finds in *Against the Day* numerous examples of crossings-over between worlds, ghost characters like trespassers traveling back in time, and ghost light emanating from unknown sources. They all go against scientific models of time and contribute to what Pynchon calls the "modern Luddite imagination" and its "impulse to deny the machine" (Pynchon 1984, 41).

In another *New York Times* essay, published in 1984, Pynchon explores the Luddite phenomenon in the context of C.P. Snow's famous Rede Lecture on the disjunction between the literary and scientific cultures. Surveying "a broad front of resistance" to the emerging technopolitical order, Pynchon discovers in literary narratives of the early 19th century "some equalizer" to the unsettling appearance of the Age of Technology. This nocturnal undercurrent of resistance informed early Gothic fiction, which embodied the impulse to resist the new paradigm. Accordingly, Pynchon regards Mary Shelley's *Frankenstein* as an early example of what he calls "the Luddite novel." "If there were such a genre as the Luddite novel, this one, warning of what can happen when technology, and those who practice it, get out of hand, would be the first and among the best" (Pynchon 1984, 40). The craze for Gothic fiction that has continued to the present day, Pynchon notes, expresses also a deep yearning for the miraculous. "To insist on the miraculous is to deny to the machine at least some of its claim on us" (Pynchon 1984, 40).

Looking at postwar literature, Pynchon recognizes the modern Luddite imagination in such humanistic concerns as "exotic cultural evolutions and social scenarios, paradoxes and games with space/time, wild philosophical questions" (Pynchon 1984, 41). Yet the statement applies to much of his own fiction, with its multitude of irregular temporal (dis)orders, "time distortions" (Pynchon 1963, 120) and "rift[s] in time's fabric" (Pynchon 1963, 459). *Against the Day* occupies a special place in Pynchon's œuvre as it most clearly and thoroughly explores these "paradoxes and games with space/time." The novel is full of conceptualizations, models, and theories of time. There are, for instance, explicit references to John McTaggart's argument for the unreality of time and Hermann Minkowski's model of the space-time continuum. Minkowski's theory inspires the novel's characters Merle and Roswell to build an impossible device, the Integroscope, which allows for the shift from "optical to temporal

light" (Pynchon 2006, 1061). The Integroscope gives access to multiple times and spaces hidden within light by sending people in photographs "onto different tracks" and opening up "other possibilities" (Pynchon 2006, 1060).

8 Concluding Remarks: Beyond a Timeless Snapshot

It is important to note that Pynchon's Luddism reveals itself in his novels not as an ironic and self-deprecating form of technophobia but rather as an expression of his persistent concern with "what now seems increasingly to define us—technology" (Pynchon 1993, 57). Pynchon's subversive strategy in *Against the Day* is to use one of the great inscribing engines of modernity, photography, to explore the multiplicity of temporalities that the forensic imagination fails to register. Early photography becomes the medium in which "the temporal freeze" melts away, giving way to the imaginary possibilities which are fundamental in Pynchon's strategy of resistance to the "orthogonal temporality" of systematized clock and machine time. The photographic trace here is not merely a record of "having-been-there," but is also employed as the subjunctive mode to explore the realm of "what could have been." It is an integral part of Pynchon's narrative configurations, in which apparently different temporal zones slide into one another. In the formations of these zones Pynchon tries to capture cultural time (especially the marginalized and overlooked time of modernity) in its dynamic unfolding.

As Barbara Adam aptly notes, "cultural time constitutes time, entails time and is enacted in time" (1995, 39); it is not possible, as Anthony Giddens concludes, to "take a 'timeless snapshot' of a social system as one can, say, take a real snapshot of the architecture of a building" (quoted in Adam 1995, 41). Such a snapshot excludes "the embedded time of things and processes, life and knowledge" (Adam 1995, 41). It is this embedded time that Pynchon seeks to restore in *Against the Day* "by way of photography and its convergence of silver, time and light" (Pynchon 2006, 454). Approaching cameras as time-proposing devices, Pynchon deconstructs the idea of "a slice of time" and replaces it with more complex visions revealing the multifacted time that is embedded in the photographic image. Despite its playful discursiveness, the novel never loses track of temporal possibilities inherent in the "natural magic" of photography. Thus, in a sense it constitutes a prequel to *Gravity's Rainbow*, *The Crying of Lot 49*, *Vineland* and *Inherent Vice*, which exemplify the idea of "video time" in their elaboration of the relation of filming or watching films to the order of time and the relation of causality and reversibility.

References

Adam, Barbara. 1995. *Timewatch: The Social Analysis of Time.* Cambridge: Polity Press.
———. 1998. *Timescapes of Modernity: The Environment and Invisible Hazards.* London: Routledge.
Barthes, Roland. 1982. *Camera Lucida: Reflections on Photography.* London: Cape.
Cowart, David. 2011. *Thomas Pynchon & the Dark Passages of History.* Athens, Ga.: University of Georgia Press.
———. 2012. "Pynchon in literary history." In *The Cambridge Companion to Thomas Pynchon*, edited by Dalsgaard, Inger H., Luc Herman and Brain McHale, 83–96. Cambridge: Cambridge University Press.
Cuevas-Wolf, Cristina. 2006. "Nature, Technique and Perception: Twentieth-century Afterimages and Modes of Scientific Representation." *Visual Resources* XXII, no. 2: 157–170.
Dalsgaard, Inger H., Luc Herman and Brain McHale, eds. 2012. *The Cambridge Companion to Thomas Pynchon.* Cambridge: Cambridge University Press.
Davis, Mike. 2006. *City of Quartz: Excavating the Future in Los Angeles.* London: Verso.
Drucker, Johanna. 2011. "Graphesis." *Poetess Archive Journal* (PAJ) 2, no. 1: 1–50.
Ferreira, Bárbara. 2011. "Iceland spar, or how Vikings used sunstones to navigate." *Geolog, The Official Blog of The European Geosciences Union*, November 2. Accessed June 15, 2014. http://geolog.egu.eu/2011/11/02/iceland-spar-or-how-vikings-used-sunstones-to-navigate/.
Fine, David M. 2000. *Imagining Los Angeles: A City in Fiction.* Albuquerque: University of New Mexico Press.
Foresta, Merry A. 1989. Introduction to *The Photography of Invention: American Pictures of the 1980s*, edited by Joshua P. Smith, 1–6. Cambridge, Mass.: MIT Press.
Franklin, Benjamin. 1898. "Necessary Hints to Those that would be Rich." In *Little Masterpieces*, edited by Bliss Perry, 160–161. New York: Doubleday & McLure Co. Digital Edition. Accessed June 15, 2014. https://archive.org/details/benjaminfranklin01fran.
———. 1996. *The Autobiography of Benjamin Franklin.* Mineola, N.Y.: Dover Publications.
Fraser, J.T. 1987. *Time: The Familiar Stranger.* Amherst: The University of Massachusetts Press.
Gessen, Keith. 2007. "Thomas Pynchon vs. the World." *New York Magazine*, November, 25. Accessed June 20, 2014. http://nymag.com/arts/books/reviews/24728/.
Ginzburg, Carlo. 1989. *Clues, Myths, and the Historical Method.* Translated by John and Anne C. Tedeschi. Baltimore, Md.: Johns Hopkins University Press.
Greenough, Sarah. 1989. *On the Art of Fixing a Shadow: One Hundred and Fifty Years of Photography.* Washington, D.C.: National Gallery of Art.
Hassan, Robert, and Ronald E. Purser. 2007. *24/7: Time and Temporality in the Network Society.* Stanford, CA: Stanford Business Books.

Houdini, Harry. 1909. *The Unmasking of Robert-Houdin, Together With a Treatise on Handcuff Secrets*. London: Routledge.

Ickstadt, Heinz. 2008. "History, Utopia and Transcendence in the Space-Time of *Against the Day*." *Pynchon Notes* 54, no. 5: 216–44.

Kaplan, Louis. 2010. "Spooked Time: The Temporal Dimensions of Spirit Photography." In *Time and Photography*, edited by Jan Baetens, Alexander Streitberg, and Hilde Van Gelder, 27–46. Leuven: Leuven University Press.

Kern, Stephen. 2003. *The Culture of Time and Space, 1880–1918: With a New Preface*. Cambridge, Mass.: Harvard University Press.

Kirk, Paul Leland. 1953. *Crime Investigation*. New York: Interscience Publishers.

Kirschenbaum, Matthew G. 2008. *Mechanisms: New Media and the Forensic Imagination*. Cambridge, Mass.: MIT Press.

Klinke, Harald, ed. 2014. *Art Theory as Visual Epistemology*. Newcastle upon Tyne: Cambridge Scholars Publishing.

Lewinski, Jorge. 1987. *Dictionary of Photography*. London: Sphere.

Melville, Herman. 1995. *Bartleby, the Scrivener: A Story of Wall-Street*. Minneapolis, MN: Indulgence Press.

Mendelson, Edward. 1976. "Encyclopedic Narrative from Dante to Pynchon." *MLN* 91: 1267–1275.

Misztal, Arkadiusz. 2014. "LSD Investigations: The End of Groovy times and California noir in *Inherent Vice* by Thomas Pynchon." In *Crime Scenes: Modern Crime Fiction in an International Context*, edited by Agnieszka Sienkiewicz-Charlish and Urszula Elias, 123–132. Frankfurt: Peter Lang.

Moore, Steven. 2006. "The Marxist Brothers." *Washington Post*, November, 16. Accessed June 15, 2014. http://www.washingtonpost.com.

O'Malley, Michael. 1991. *Keeping Watch: A History of American Time*. New York: Penguin.

Pynchon, Thomas. 1963. *V., a Novel*. Philadelphia: Lippincott.

———. 1984. "Is it O.K. to Be a Luddite?" *The New York Times Book Review*, October 28, 40–41.

———. 1985. *Slow Learner: Early Stories*. London: Jonathan Cape.

———. 1993. "Nearer, My Couch, to Thee." *The New York Times Book Review*, June 6, 3, 57.

———. 1996. *The Crying of Lot 49*. New York: Vintage.

———. 2006. *Against the Day*. New York: Penguin Press.

———. 2009. *Inherent Vice*. London: Jonathan Cape.

———. 2013. *Bleeding Edge*. London: Jonathan Cape.

Ropars, Guy, Gabriel Gorre, Albert le Floch, Jay Enoch and Vasudevan Lakshminarayanan. 2011. "A depolarizer as a possible precise sunstone for Viking navigation by polarized skylight." *Proceedings of the Royal Society* 468, no. 2139: 671–684. Accessed May 28, 2014. doi 10.1098/rspa.2011.0369.

Solomon, Matthew. 2010. *Disappearing Tricks: Silent Film, Houdini, and the New Magic of the Twentieth Century.* Urbana: University of Illinois Press.

Stiegler, Bernd. 2001. *Philologie des Auges: Die photographische Entdeckung der Welt im 19. Jahrhundert.* Munich: Fink.

Thomas Pynchon Wiki: Online Encyclopedia. Accessed April 15, 2014. http://pynchonwiki.com.

Trachtenberg, Alan. 1989. *Reading American Photographs: Images as History.* New York: Hill and Wang: Noonday Press.

Virilio, Paul. 1995. *The Art of the Motor.* Translated by Julie Rose. Minneapolis: University of Minnesota Press.

Weber, Max. 2001. *The Protestant Ethic and the Spirit of Capitalism.* Translated by Talcott Parsons. London: Routledge.

CHAPTER 4

Time, Trace, and Movement in Stravinsky's *Three Japanese Lyrics*

Helen Sills

Abstract

Artists and poets have evolved techniques to convey depth and complexity of temporality and also movement in a two-dimensional art form. Among such art forms were the waka poetry and wood-block prints of Japan. These art forms inspired Igor Stravinsky to explore a musical analogy of two-dimensionality in *Three Japanese Lyrics*: each of the songs creates its own elusive quality of temporality by the differing actions of just two streams of movement.

Keywords

Le Japonisme – Japanese art – two-dimensionality – poetry and music – Stravinsky – movement – rhythm – ambiguous temporalities – neurological effects

1

During the years 724–736 CE, the Japanese court poet Akahito Yamanobe travelled extensively throughout some of the remoter regions of Japan with the Emperor Shomu and his entourage. As he travelled, he recorded his impressions of the wonderful sights and sounds of the natural world in brief, concisely-structured poems. In 1912, nearly 1200 years later, the essential elements of this delicate poetic form resurfaced to inspire new expression and interpretation. A poem by Akahito became the first of Igor Stravinsky's *Three Japanese Lyrics*, in which Stravinsky continued to explore a new direction he was taking in musical structure.

By the time that Stravinsky arrived in Paris with Diaghilev and the Ballets Russes in 1909, 'Le Japonisme,' the fashion for Japanese art, culture and aesthetics, had been influencing Western Europe for a generation. Since Japanese ports had opened to imports from the West in 1853, and particularly since

the Meiji Restoration in 1868, Japanese ceramics, woodblock prints, textiles, bronzes and enamels had been avidly collected by dealers and had rapidly become a source of inspiration for artists. Katsushika Hokusai's woodblock prints were first printed in black and white in the 1860s, while his *Manga*, line-drawn cartoons, famously found their way to Paris wrapped around a consignment of porcelain. At the International Exposition held in Paris in 1867, Japan had its own national pavilion showing Japanese works of art, and Japanese art also featured strongly at the subsequent International Expositions held in Paris in 1878, 1889 and 1900. The director of the 1900 International Exposition, Tadamasa Hayashi, was one of many art dealers who, from the 1870s, had been bringing to Europe thousands of Japanese prints that subsequently influenced such artists as Manet, Monet, Van Gogh, Gauguin, and Toulouse-Lautrec. It was now many years since Whistler's *Purple and Rose* of 1864, and the beginning of a fashion for Japanese costumes which inspired Monet to paint his wife in a kimono in 1878, and Van Gogh to paint *La Courtisane* in 1887, after an *ukiyo-e* print by Eisen had appeared on the cover of *Paris Illustré* in the previous year. Many art critics had travelled to Japan in order to write informed articles: thirty-six issues of *Le Japon Artistique*, a magazine commenting on Japanese art and culture, were published in Paris between May 1888 and April 1891. Composers, too, found new inspiration in Japanese subjects: Pierre Loti's novel *Madame Chrysanthème* of 1887, about a naval officer who marries a geisha in Nagasaki became Puccini's opera *Madame Butterfly* of 1904 and Gilbert and Sullivan had massive success with *The Mikado* in 1885. Among the many collectors of Japanese woodblock prints was Debussy, whose first orchestral score of *La Mer* featured Hokusai's *In the Well of the Great Wave at Kanagawa* on its front cover.[1]

The characteristic techniques of line-drawing in Japanese woodblock prints influenced not only the Impressionists but subsequently also the Art Nouveau and Cubist movements. Some of its strongest and most influential features can also be traced in Stravinsky's setting of the *Three Japanese Lyrics*. The scenes portrayed in Japanese prints often lack perspective and their rhythmic lines project outside the frame. Coupled with this, there is a love of asymmetry and irregularity, in short, a freedom of line and positioning that likes to place the subject "off-centre." Japanese prints lack shadow and delight in flat areas of strong colour that make a strong contrast to the sinuous curves of their lines and patterned surfaces. Stravinsky was well acquainted with Japanese art: suddenly caught up into the new and exotic environment of early 20th-century Paris, he found real friendship and encouragement for his newest works, away from the politics of the Ballets Russes, in a group of artists, musicians and poets

[1] See Funayama, "*Three Japanese Lyrics* and Japonisme."

called the "Apaches."[2] This avant-garde group had been meeting after concerts from 1902 onwards to play their compositions to each other and to read and discuss all things new, such as the current fashion for Japonaiserie and the new inspiration it brought. The group included Maurice Delage, Florent Schmitt and Maurice Ravel, the three dedicatees of the *Three Japanese Lyrics*. The dedicatee of the first of the *Three Japanese Lyrics*, Maurice Delage, was a particularly close friend. He, like many other business men, had often visited Japan, most recently in the spring of 1912, and he had written a number of compositions as a result of his fascination with the country.[3]

In the summer of 1912, Stravinsky had read a little anthology of Japanese lyrics—short poems of a few lines each, selected from the old poets. The impression which they had made on him was exactly like that made by Japanese paintings and engravings. He said: "the graphic solution of problems of perspective and space shown by their art incited me to find something analogous in music."[4] Later, during a visit to Japan in 1959, Stravinsky told an interviewer:

> I was attracted at the time [1913] by Japanese woodblock prints, a two-dimensional art without any sense of solidity. I discovered this two-dimensional nature in some Russian translations of poetry, and attempted to express it in my music.[5]

In 1913, Stravinsky was putting the finishing touches to the orchestration of *The Rite of Spring*. Here he had constructed a dialogue of temporalities to lead the listener from the ancient Slavs' feeling of closeness to the earth to the timelessness of ritual self-sacrifice.[6] Although the Japanese poems and prints in his possession were "two-dimensional" in nature and lacked solidity, nevertheless they too evoked a spectrum of temporalities, albeit of a very delicate and elusive kind. This paper explores why creating *temporal qualities* equivalent to those of ancient Japanese poems and 19th-century woodblock prints was a project "very close to his heart."[7]

2 See Pasler, "Stravinsky and the Apaches."
3 The Apaches met at the home of Maurice Delage: see Walsh, "Stravinsky. A Creative Spring," 186.
4 Stravinsky, *Autobiography*, 45.
5 Stravinsky, "Interview in *Mainichi Shimbun*, April 8th, 1959." Cited from Craft, *Programme Notes*.
6 Sills, "Emergent Temporalities in Stravinsky's *Le Sacre du Printemps*."
7 Stravinsky, *Autobiography*, 45.

HEIAN PERIOD			
		988	Noin b. *Compiled first surviving Utamakura handbook*
Kokin wakashu		920	
Poetry competitions		885	
			Tsurayuki ki no *a compiler of Kokin wakashu*
	after	850	**Masazumi Miyamoto**
NARA PERIOD			
		800	
Man'yoshu	after	759	
		700	**Akahito Yamanobe** (*700–736*)

FIGURE 1 *Waka poetry during the Heian and Nara periods.*

Stravinsky chose three ancient Japanese poems in his collection.[8] The author of the first poem, Akahito Yamanobe, was writing from 724 CE, during the Nara period. He was one of the four great poets to contribute to the *Man'yōshū*, the earliest surviving collection of some twenty volumes of Japanese poems, which was compiled sometime after 759 CE.[9] The author of Stravinsky's third poem was Tsurayuki Ki no, one of the compilers of the *Kokin Wakashu*, a collection of poems which, like the *Man'yōshū*, ran to twenty volumes. The author of the second poem, Masazumi Miyamoto, also contributed to the *Kokin Wakashu*, though little is known about him.

Waka poetry, as it came to be called, established a genre that became a Japanese court tradition lasting to the 14th century. Over time, it created a vast meta-narrative from poetic traces of time that expressed great nostalgia for the Japanese traditions and culture of the past. The art of *waka* (literally, "Japanese song/poem"), little known in the West, consisted of constructing poems that had rich associations with earlier poems and that also added some new and

8 Stravinsky had a collection of old Japanese poems in a Russian translation by A.S. Brandt.
9 Akahito contributed 13 long poems (*nagauta*) and 13 short poems (*tanka*), as envoys (*hanka*) to these long poems, to the *Man'yōshū*. The *Man'yōshū* was the single greatest literary achievement of the Nara and early Heian periods, and was important for being written in the Japanese language as opposed to the Chinese. With the introduction of poetry competitions (*uta-awase*) in 885 CE and the commissioning of the Kokin Wakashu by the Emperor Daigo in 905 CE, the making of short poems, formerly called *tanka* but now known as *waka*, became an important and much-prized part of Japanese life.

interesting aspect to them. Associations with earlier poems were promoted and enriched in three ways: through *utamakura*, or reference words, through explicit allusion, and through intertextuality. *Utamakura*, literally "poem-pillows" on which poets could 'rest' their associated ideas, were usually place names that had acquired a poetic status, or objects that had come to have symbolic value. They were collected into a handbook by Nōin at the beginning of the 11th century. Explicit allusions to earlier poems could also be made through variations on phrases that had come to be sufficiently well-known. Even more subtly, disparate poems could be engaged simultaneously by intertextuality, in elaborate networks of finely-wrought associations recalling theme, style, or mood.[10]

The spontaneous composition of *waka* poems became a vital social skill. It could establish one's status in society and at court entertainments and was a necessary embellishment of travel diaries. It developed into a means of shorthand communication between friends and lovers that was greatly prized. At best, *waka* poems are characterised by elegance and beauty and a poignant awareness of the pathos of life (*mono no aware*). Paradoxically, art, elegance, and beauty came to be very highly valued in a culture which aspired at the same time to the Buddhist ideal of regarding these things as ultimately of fleeting worth.

In the art of composing *waka* poetry, words are carefully selected and arranged with skilful regard to the total effect. Words can have more than one meaning, adding depth to their associations, and the recurrence of similar sounds in homonyms, homophones, alliteration and assonance can set up a counter-rhythm within its very concise structure which, sadly, is lost in translation. The genre tends to compound emotions of remembered moments with those of the present moment and express them within a strict syllabic structure as in the following poem. It was composed by the *Tosa Journal* party (which included Tsurayuki), on visiting a site previously made famous by the poet Narihira (825–880 CE):

kimi koite	5
yo o furu yado no	7
ume no hana	5
mukashi no ka ni zo	7
nao nioikeru	7

10 Kamens, *Utamakura, Allusion*, 49–50.

*The blossoms of the plum in this house that has so long survived
still yearn for their master and even now they pour forth the
same sweet fragrance as they did in times long past.*[11]

The themes of *waka* poetry were varied, but their content was usually strictly limited and structured within 31 syllables, with an upper phrase of 5 plus 7 plus 5 syllables, and a lower phrase of 7 plus 7 syllables, as in the above poem. Rhyme was considered to be a fault and there was no strict concept of "line."

The "two-dimensional" effect of this poetic form, which had attracted Stravinsky's interest, arises largely through the juxtaposition of two ideas or sentiments, more often than not with a shift of temporality between the two phrases. For example, the poet may refer to a geographical place with a poetic tradition in the first phrase, and then endow it with a new emotion as he then visits that place, in the second phrase. Or the movement may be to a new symbolism, with reference to the meaningful re-appearance of a significant object, such as a buried tree in the river. The most admired poems have an implicit ambiguity, either in subject or in outcome, so that the *movement* between the two temporalities leaves us in a temporally ambiguous location somewhere between the two, with an effect of non-solidity and spatio-temporal open-endedness.

This ambiguity of temporality may be seen in a poem by Akahito, composed probably in 725 CE and included in the *Man'yōshū*, that achieved a balance of sensation and emotion, sight and sound, that became much admired and emulated:

Waka no ura no shio michikureba kata o nami
ashibe o sashite tazu nakiwataru

*At Waka Bay, when the tide is high, there is no beach,
and so the cranes are crying as they make their way toward beds of reeds.*[12]

This is a typical *waka* poem in that it paints a two-dimensional picture while moving between two temporalities. First we are given a fresh but static picture of the coast at high tide and then we move with the flight of the cranes and the sound of their cries, toward the inland reed beds. Akahito's bleak and silent experience of Waka Bay in the here and now is contrasted with the animated, noisy flight of cranes, birds that are a symbol of great age and eternity in both

11 Kamens, *Utamakura, Allusion*, 61 (English translation by Kamens).
12 Kamens, *Utamakura, Allusion*, 47 (English translation by Kamens).

China and Japan. Although the temporal context is the constant succession of flights across the centuries, he captures the insubstantial poignancy of the fleeting moment. At the close we are left in a vague, ambiguous temporality that lies somewhere between the two temporalities of the poem.

2

The three poems that Stravinsky selected present different perspectives on Spring, a favourite subject of *waka* poetry. Each poem juxtaposes *two* images, each with its own quality of time, and creates a delicate and elusive temporality from their juxtaposition: the first tells of snow coming to cover white spring flowers, the second, the first rushes of the thawing ice floes as an image of spring flowers, and the third, the confusion of distant white clouds with cherry blossom. There is also a temporal progression *between* the three songs, passing from doubt about the coming of spring, to vivid 'here and now' sensations of its arrival, to the traditional symbolism of full blossom.

Stravinsky spoke of "succeeding by a metrical and rhythmic process."[13] The vocal line represents the first flowers of spring in all three songs. It is consistent in style, always setting one syllable of the Russian translation to one quaver and largely patterning the small interval of a third in circular motifs. To ensure that the temporal quality of each song is created first and foremost by the rhythmic flow of the *music*, Stravinsky reduced the power of the literal meaning of the words, by putting the textual accents in opposition to those of the musical phrase. He wrote to his publisher, Derzhanovsky, that as there is no such thing as accentuation in either the Japanese language or in Japanese poetry, he had eliminated the accents of the Russian translation "so as fully to achieve the linear perspective of Japanese declamation."[14]

13 Stravinsky, *Autobiography*, 45.
14 After composing the textual and musical accents to coincide in the ordinary way, Stravinsky moved them an eighth or a quarter note to the right, transforming the words into vocal "sounds" and reducing the power of their literal meaning to create their own time quality. See V. Stravinsky and Craft, *Stravinsky in Pictures*, 107–8. Stravinsky's reply to his publisher's enquiries (printed in *Muzyka* in December 1913) is given in Taruskin, "Stravinsky's 'Rejoicing Discovery,'" 170–71. Stravinsky wrote: "The most natural course was to shift all the 'long' syllables onto musical 'short' [beats]." Taruskin writes that Stravinsky is using the terms "long" and "short" in a conventional way to describe Russian tonic scansion, which is qualitative not quantitative, and also illustrates Stravinsky's accentual changes (ibid.).

The linear perspective of the vocal line is, however, articulated into fragmented phrases and recalls something of the syllabic discipline of *waka* poetry in that the notes of each discrete phrase stand in the ratios 5:3, 6:4, or 8:6. Stravinsky also captures the haunting effect of the carefully-placed Japanese syllables by setting the text to "circular" motifs that expand and contract according to the text, in the style of Russian folk-song. He arranges resonant vowels on pitches which recur or alternate at significant cross-rhythmic points of these melodic motifs. They invoke the 'natural' mood of Russian peasant singing at home or in the fields, and represent, by their pitch world, the purity of nature, in this case, the flowers that appear in spring. By contrast, the instrumental stream of sound that flows against this articulated vocal line is continuous and held distinct, and often chromatic in character. In the *Three Japanese Lyrics* Stravinsky finds an analogy for the two-dimensionality of the poems' temporal traces by juxtaposing two musical lines but holding them distinct by maximising the contrasts of timbre between them. The bright timbre of the soprano voice is set intermittently against a group of soft, often muted solo instruments, and is thereby brought to the foreground.[15] Each line or stream of sound unfolds at its own pace, with its own quality of movement, and in its own temporal world, even though, as in "Akahito," the first of the three songs, they may begin from a similar motif. The two streams of sound are to be listened to "separately," but held in tension as they describe an action vis à vis each other. This is a two-fold listening experience, in which each musical stream, like the poetic text, embodies the paradox between concise structure and freedom of movement.

3

During his visit to Japan in 1959, Stravinsky told music critic Hans Pringsheim:

> I have long been fond of Japanese art and about 50 years ago I owned some prints by Hokusai and Hiroshige. In fact I have the feeling that some of those prints are included amongst the "Views of Mt Fuji" […] and the "53 Stages of the Tokaido" […] which I have seen here today.[16]

15 The small chamber group of solo instruments comprises piccolo, flute, two clarinets, string quartet and piano. *Three Japanese Lyrics* was premiered on 14 January 1914 at the Salle Erard in Paris, in a programme including *Three Mallarmé Poems* by Ravel, written for the same instrumentation, and *Four Hindu Songs* by Maurice Delage, who was a pupil of Ravel.

16 Pringsheim, "Conversations with Stravinsky."

FIGURE 2 *Hokusai*, The Great Wave at Kanagawa.

Stravinsky became interested in the connection that he perceived between the two-dimensional effect of *waka* poetry, with its typical shift of temporality, and the open spatial-temporal effect created by the rhythmic lines of two-dimensional Japanese prints.

The fortissimo rhythms of Hokusai's engraving *In the Well of the Great Wave at Kanagawa*, and their spatio-temporal effect, for example, have made it justly famous. The curly, dancing lines of the powerful waves diminish in a three-part sequence vertically on the left-hand side of the picture, endangering three fragile boats which are being pitched about in the valleys between them. The boats create a second rhythmic line which leads us from the foreground to the background of the scene. The rhythmic movement of the waves is juxtaposed to the strong silent form of Mt. Fuji, the symbol of eternity, in the background. The interaction of these rhythmic lines in a two-dimensional medium suggests not only movement but also fragility and instability.

A photograph of Stravinsky in his living room at home in Oustilug in 1912 shows four Japanese prints hung vertically on the left-hand side of the wall behind him.[17] The bottom print is *Japonaiserie: the Courtesan* by Van Gogh, after Keisai Eisen. The top print appears to be *Festival of Lanterns on Temma Bridge in Settsu Province* by Katsushika Hokusai.[18]

17 Th. Stravinsky, *Catherine and Igor Stravinsky: A Family Album*, plate 30.
18 Hokusai often produced several versions of the same scene.

FIGURE 3 *Hokusai*, Festival of Lanterns on Temma Bridge.

Japanese woodblock artists became masters at creating movement and mass with single lines. Light, colour, and tone are subordinate to the juxtaposition of forms and linear rhythms. Hokusai's *Festival of Lanterns* juxtaposes rhythmic lines within a two-dimensional frame, and although it is at first sight harmonious, it proves to be deceptive, even unstable in its perspectives. The line of the bridge cuts across the middle of the scene, decreasing in size from right to left as does the crowd, though the lanterns do not. The bridge is asymmetrical, having six four-part supports to the middle from the right and four to the opposite shore. Counterpointing the line made by the bridge, a line of boats—also decorated with lanterns and carrying celebrating locals—floats from left to right, increasing rhythmically from a single boat to groups of three and five. There is a third rhythmic line made by the dwellings on the distant shores, which tell us that the river bends round to the left in the centre of the scene. Its rhythmic lines carry the eye outside the two-dimensional framework, so that our sense of space is expanded by the interaction of its rhythms, creating an experience of open-endedness and instability. There is a temporal effect too, for the print captures a single point in time in the long and rich history of the location, yet at the same time expands our sense of a temporal continuum by the strength of its various movements.

4

Stravinsky achieves a similarly elusive spatio-temporal effect in his *Three Japanese Lyrics*, by juxtaposing two streams of rhythmic movement that do not meet or relate to each other. The "pace" of each line of movement remains constant and distinctive, but each line unfolds independently against the other in imitation of the movements described in the texts. Stravinsky discovers a musical analogy to the shift between two temporalities of a poem, and the interaction between the rhythmic perspectives of a two-dimensional print, by juxtaposing just two streams of sound, the vocal and the instrumental, that are constructed to move independently but meaningfully *against* each other.

The poem of the first song is by Akahito Yamanobe:

waga seko ni
misemu to omohisi
ume no hana
sore to mo miezu
yuki no furereba

To one I love
want to show
plum blossoms on the plum tree
cannot be identified one from the other
because the snow fell[19]

Here we move from thought of movement to the actual movement of snow falling to cover blossom: winter has not yet given way to spring. The ambiguity of white on white, snow on blossom, is a favourite device of *waka* poetry.

In this first song the two streams of rhythmic movement move at the same quaver pace, but as in the poem, one element expands to engulf the other. Stravinsky captures the fragile impression of the poem by contracting the time-scale of its activity into a fleeting juxtaposition of the vocal and instrumental planes that lasts just 46 seconds or so. The stately soprano line is heard at the middle octave *between* the timbres of the flute and clarinet, her bright, fragmented circular motifs silhouetted against a continuous soft instrumental

19 I give a "spare" word-for-word translation to evoke the trace-like temporality of the text, rather than the less literal translation that would be used if the song were sung in English. These phrases are to be connected in the imagination.

FIGURE 4 *Akahito bars 1–3.*

background. There is little separation of movement as the first two vocal figures pattern a narrow chromatic cluster, B♭, C♭, C, D♭, D, E♭, and a high G: simply a haunting rising alternation of C♭–C and B♭–C against the downward C♭–B♭ in the wind ostinato.

The voice irregularly highlights the major third G–E♭ on successive 3rd, 2nd, and 1st beats of the bar against the regularity of the instrumental ostinato. But bars 5–8 bring a transition during which the clear instrumental ostinato is clouded by new chromatic circular figures and octave displacements in a sec-

ond clarinet, piano (marked "una corda") and muted string quartet. At the shift in temporality where the blossoms begin to be lost to sight, the instrumental group, although continuing softly, becomes more active with plucked notes and harmonics, expanding a chromatic register to surround the vocal part. As the instrumental pitch range rapidly widens, the vocal motifs rise, continuing to highlight the same interval of a third, but now alternately major, minor, major (G [A♭♭]–E♭, G♭–E♭, G-E♭). High-pitched staccato quavers on the piccolo and low cello pizzicati evoke the regular dropping and depth of snowflakes. The fragile, open-ended world of the poem vanishes with a single quaver, an acciaccatura E♭–D♭.

The poem of the second song is by Masazumi Miyamoto:

> tani kaze ni
> tokuru kohri no
> hima goto ni
> uchi-izuru nami ya
> haru no hatsuhana

> *By the mountain-valley wind*
> *of melting ice*
> *through every crack*
> *overflowing waves are*
> *first blossoms of Spring*[20]

In the second song the vocal and instrumental streams of motion move independently but now with a distinct contrast of pace. After an initial incisive chord, the instrumental ensemble evokes the furious whirling and whistling of the wind through the valley with a repeating demisemiquaver motif, and other rapid rhythmic figures characterised by irregular groupings and a great variety of timbres and textures. These include flutter-tonguing on the flute, a legato run of harmonics on the viola, muted figures on the piano, trills and both pizzicato and saltando phrases for the second violin. Anchoring these textures is a harsh D# intermittently sustained by the second violin *sul ponte*.

The stately vocal line appears only at the climactic mid-point of the song, to announce the arrival of Spring with a brief but broad statement ("largamente assai") of minor thirds recalling the ninth bar of *Akahito*. As the instrumental activity returns with renewed energy, the vocal patterning beginning

20 This poem was printed in the 20th issue of *Le Japon Artistique* (Funayama, *Three Japanese Lyrics* and Japonisme, 275).

FIGURE 5 *Akahito* bars 9–13.

FIGURE 6 *Masazumi bars 8–9.*

C#–C♮–D#–B is elongated in crotchets, as though establishing the contrasting temporal world of flowers before its quaver pace resumes.

The arrival of spring is suggested by the final five bars, in which the vocal line (as at the end of *Akahito*) rises to pattern alternating major and minor thirds and accelerates to an incisive chord which recalls the first bar of the song. The song fades with a very soft instrumental chord which is resonant with harmonics. Lasting about 52 seconds, the livelier activity of the instrumental stream in this song creates a correspondingly stronger impression of the present moment.

The poem of the third song is by Tsurayuki Ki no.

> sakurabana
> sakinikerashina
> ashibiki no
> yama no kai yori
> miyuru shirakumo

Cherry blossom
it looks like they are in bloom
between the mountains
white clouds can be seen

The cherry tree is the national tree of Japan and from the *Man'yōshū* onwards the tree and its blossom held an almost mystical position in the *waka* tradition. Various comparisons of cherry blossom to white clouds appear in at least five of Tsurayuki's poems. From its origin as a symbol of unity and solidarity among the people, it became an image of shade and peace, its full-blown blossoming seen as a symbol of Man's destiny or immortality.

In the third song, Stravinsky imitates the ambiguity between blossom and clouds in the poem by juxtaposing two similarly paced streams of quaver movement, as in *Akahito*. For this setting however, the vocal and instrumental layers create distinctively different time qualities by their contrasting pitch

FIGURE 7 *Masazumi bars 25–26.*

behaviour and motivic cycles of different duration. The expansive opening phrase for strings and clarinet spreads over three bars and three octaves with intervals of a seventh and a fourth which bend and sway towards each other. Both of the first two instrumental cycles end by highlighting the interval of a fourth: the first three-bar phrase with a flourish of demisemiquavers, like a cluster of blossom in a Japanese print, the succeeding four-bar phrase with a more slowly developing motif.

Variations of the two opening instrumental phrases follow. Against these four instrumental phrases, two short, fragmented vocal motifs stretch peacefully but irregularly, rocking gently in contrast with the expansiveness of the instrumental plane, within the small pitch range of a fifth.

As the temporality changes to become the vivid present, and the full blossoming of the cherries becomes indistinguishable from the clouds, the vocal patterning rises in pitch, as in the first two songs. The voice now joins with the instrumental line and their movements become as one for four bars. The climax is made with the vocal patterning of the major and minor third, as before: the final resolution onto the major third G♭-E♭♭ (F#-D) is heard alone.

In the two concluding instrumental phrases, the time world of the song—and the set of songs—is sealed with the soft timbres of the flute ("très lointoin"), two clarinets, and violin. They play upon the motif of bars 9–10 with its prominent fourths, now recalled with stretto entries and in rhythmic diminution. This is the longest of the songs, although its performance time is barely one minute and twenty five seconds. Despite its brief realisation in clock-time, the contrast of two slowly evolving time qualities achieves a monumental quality that mirrors the ancient Japanese association of cherry blossoms with Man's eternal destiny.

Stravinsky's interest had been caught by the movement of *waka* poetry and the rhythms of woodblock prints, and the elusive temporalities that they created within a two-dimensional framework. His intuitive solution to the challenge of finding "something analogous in music," as we have seen, was to juxtapose two streams of sound with great contrasts of timbre, pitch treatment, rhythmic character, texture, pacing, phrase lengths and continuity, and to sustain each in an unstable dynamic with the other. The two-dimensional quality of the songs arises from the fact that the two streams of sound do not meet, relate, or interact, yet our perceiving them simultaneously creates a sense of the natural movements that we experience in the physical world. Stravinsky's two streams of sound each unfold in their own time worlds, at their own pace, yet our simultaneous hearing of them produces a hybrid ambiguous temporality that belongs neither to our experience of everyday life in clock-time nor yet to the timeless world of our imagination or subjective experience.

FIGURE 8 *Tsurayuki bars 1–10.*

FIGURE 9 *Tsurayuki bars 16–20.*

5

One hundred years after Stravinsky's construction of temporalities in music analogous to the effect of instability and fragility in poetry and visual art, new neurophysiological research has begun to shed light on his innovative work and to affirm the auditory experience that it creates. In listening to the *Three Japanese Lyrics*, each stream of movement is held distinct by its contrasting musical elements: features such as timbre, repeating contours and inflections of the human voice, processed in specialized areas of the right temporal lobe, and the rapid rhythmic groups and dissonant intervals processed in specialized areas of the left lobe. Their simultaneous appeal to very different processing areas may well result in a higher level of competing activation across the brain.

Research in the field of cognitive neuroscience into the brain's response to visual art has begun to map effects of movement and implied movement that also have implications for our auditory system. For example, recent scientific studies using fMRI have found that, even if motion is not explicitly shown, observation of a static photograph of human actions that *implies* motion increases activity in the motion-associated areas of the brain (including the V5 area, middle temporal gyrus, left extrastriate body area, and left superior

temporal sulcus).[21] It has also been found that an impression of motion can be conveyed to the brain simply by presenting a part of an "action" verb or a mimic word.[22]

Building on the findings about implied motion, researchers tested how observing dynamic bodily actions portrayed in static lines activated impressions of motion in the brain using Hokusai's *Manga*. Hokusai had addressed the problem of how to imply motion in two-dimensional art in this series of line-drawn cartoons, first published in 1814, that began to circulate in the West after 1854. Hokusai sketched thousands of subjects, filling about fifteen volumes that recorded realistic scenes of the natural world and showed people engaged in the occupations of everyday life. Many of these cartoons show people, animals, and objects in a dynamic situation, because he portrayed them in a position of instability. He captures them in one fleeting, fragile moment in the process of change from a static state into a dynamic one. When we look at these cartoons, a tension is set up between the static two-dimensional picture and the movement implied by the instability of its subject matter, creating an experience of spatio-temporal ambiguity. In scientific terms, the researchers found significant activation in the bilateral inferior temporal gyrus in the extrastriate cortex (BA19) and bilateral inferior occipital gyrus (BA18 and BA19) in subjects looking at Hokusai's *Manga*. They state that "the most interesting finding obtained here was a unique activation in the bilateral extrastriate visual cortices when the participant observed an implicit motion cartoon because of instability."[23] It was also found that words heard that suggest, for example, "walking," activated the extrastriate visual cortex and superior temporal sulcus even while both eyes were closed.[24] It seems that activity is recorded in these areas of the brain even when visual stimuli are eliminated in order to focus on the *auditory* perception of movement-related stimuli. These findings may well prove to be relevant to the experience of listening to the movement of music as it unfolds.

In Stravinsky's *Three Japanese Lyrics*, we hear two delicate qualities of movement simultaneously. They have been juxtaposed in an ambiguous relationship, in which the brain attempts to find coherence. Just as the visual perception of Hokusai's static cartoon and the physical movement that it implies creates a sense of instability, the dynamic tension which Stravinsky constructs between the two differently paced streams of musical movement unfolds a

21 Proverbio et al., "Observation of static pictures."
22 Martin et al., "Discrete cortical regions." A mimic word suggests behavior to be copied.
23 Osaka et al., "Implied motion."
24 Osaka, "Walk-related mimic word."

fragile and ambiguous temporality. Stravinsky's challenge was to construct in sound (rather than in the medium of the wood-block print or the written poem) linear perspectives or planes of sound with the appropriate contrasts of musical elements and juxtaposition of rhythmic manners, to create this tension and re-present the fragile temporalities of the text.

Stravinsky's brief song cycle is evidence of how poetic and artistic traces in time persist as they are transformed in contemporary aesthetics. After the passing of so many years, the highly structured two-dimensional poetic form developed by Akahito, Masazumi and Tsurayuki, and both the rhythmic lines of two-dimensional woodblock prints and the instability of human figures explored by Hokusai, have found new expression in the work of Igor Stravinsky and his musical construction of delicate and ambiguous temporalities. The artistic techniques of constructing unstable movements and fleeting temporalities have resurfaced, coming together to find new life in music of the 20th century. They have been transformed to pioneer new ways of expanding the range of temporalities accessible in music, and to carry forward ancient traces in and of time.

Musical examples from the *Three Japanese Lyrics* © copyright 1913 by Hawkes & Son (London) Ltd. Reproduced by permission of Boosey & Hawkes Music Publishers Ltd.

The two Japanese poems, "kimi koite" and "waka no ura", and their English translations (from Edward Kamens, *Utamakura, Allusion, and Intertextuality in Traditional Japanese Poetry*, New Haven: Yale University Press, 1997) are used by permission of Yale University Press, London.

References

Craft, Robert. Programme notes for *Histoire du Soldat/Renard*. Orchestra of St. Luke's, Philharmonia Orchestra, conducted by Robert Craft. *Stravinsky Complete Works*, vol. 7: Naxos, 2007, CD no. 8557505.
Funayama, Takashi. "*Three Japanese Lyrics* and Japonisme." In *Confronting Stravinsky*, edited by Jann Pasler, 273–83. Berkeley: University of California Press, 1986.
Kamens, E. *Utamakura, Allusion, and Intertextuality in Traditional Japanese Poetry*. New Haven: Yale University Press, 1997.
Martin, A. et al. "Discrete cortical regions associated with knowledge of colour and knowledge of action." *Science* 270 (1995): 102–105.
Osaka, N. "Walk-related mimic word activates the extrastriate visual cortex in the human brain: an fMRI study." *Behavioral Brain Research*, 198 (2009): 186–189.

Osaka, N. et al. "Implied motion because of instability in Hokusai Manga activates the human motion-sensitive extrastriate visual cortex: an fMRI study of the impact of visual art." *NeuroReport*, 21 (2010): 264–267.

Pasler, Jann. "Stravinsky and the Apaches." *Musical Times*, 123, no. 1672 (June 1982): 403–07.

Pringsheim, Hans. "Conversations with Stravinsky." *Asahi Shimbun*, May 5th, 1959.

Proverbio A.M. et al. "Observation of static pictures of dynamic actions enhances the activity of movement-related brain areas." *Public Library of Science ONE* 4 (2009): e5389.

Sills, Helen. "Emergent Temporalities in Stravinsky's *Le Sacre du Printemps*." *KronoScope* 12, no. 2 (2012): 257–69.

Stravinsky, Igor. *An Autobiography*. London: Calder and Boyars, 1975.

———. *Three Japanese Lyrics*. London: Hawkes and Son, 1913.

Stravinsky, Theodore. *Catherine and Igor Stravinsky: A Family Album*. London: Boosey and Hawkes, 1975.

Stravinsky, Vera. and Robert Craft. *Stravinsky in Pictures and Documents*. London: Hutchinson, 1979.

Taruskin, Richard. "Stravinsky's 'Rejoicing Discovery.'" In *Stravinsky Retrospectives*, edited by Ethan Haimo and Paul Johnson. Lincoln: University of Nebraska Press, 1987: 162–199.

Walsh, Steven. *Stravinsky. A Creative Spring*. London: Pimlico, 2002.

CHAPTER 5

Tracing Space in Time: Morton Feldman's *Rothko Chapel**

Orit Hilewicz

Abstract

This study focuses on Morton Feldman's *Rothko Chapel* as a case of musical ekphrasis, re-presenting Rothko's chapel in Houston, Texas. The study presents an interpretation of Feldman's piece as a reflection of Rothko's aesthetic and social statement embodied in the chapel, by drawing a parallel between the experience of musical temporality in the piece and the chapel's relation to Western spirituality.

Keywords

music – Morton Feldman – Mark Rothko – Rothko Chapel – ekphrasis – musical time

1

In 1971, New York composer Morton Feldman travelled to Houston, Texas, for the opening ceremony of the spiritual center planned and designed by his recently deceased friend, painter Mark Rothko. It was during this visit that the founders of the chapel commissioned a composition to be performed in the space the following year. The resulting piece, Feldman tells in an interview, is a unique work in his repertory. While Feldman's compositions are remarkable in their dialogue with, and influence from, the works of New York expressionist painters circa 1950, *Rothko Chapel* stands out as the only piece by Feldman that bears a relationship to a specific work of art—Mark Rothko's chapel in Houston.[1] Feldman characterizes the piece as "autobiographical," and speaks in an interview of its connection to Rothko, to the chapel, and to Feldman's life.

* Winner of the 2013 ISST Graduate Student Essay Prize.
1 Jonathan Bernard's "Feldman's Painters" provides an insightful portrayal of the relationships between Feldman and New York expressionist painters.

The *Rothko Chapel* piece was a very interesting commission because it was the only score where other factors determined what kind of music it was going to be [...] When I wrote the *Rothko Chapel* [...] I saw the whole life of this guy [Rothko]. So what I decided in the *Rothko Chapel* was to treat it very—not biographical, but my identity was such that I decided to write an autobiographical piece. It was the only piece—and it will never happen again—when all kinds of facts, literary facts, reminiscent facts, came into the piece.[2]

Lydia Goehr mentions Feldman's *Rothko Chapel* and its connection to Rothko's chapel in Houston as an example of musical ekphrasis, the musical representation of another artwork.[3] Originally referring to an ancient Greek rhetorical technique described in texts from the Roman period, the term *ekphrasis* was appropriated in the late nineteenth century to refer to works of literature that represent other artworks.

My study begins with a brief review of the origin of ekphrasis and its transformations over time, from its Greek roots until the relatively recent application to musical works. Since familiarity with the object of ekphrasis (the original artwork) is a prerequisite for an ekphrastic hearing of a composition, the discussion of Feldman's piece in this paper is preceded by an interpretation of the chapel from a visitor's point of view, drawing from literary theorist Leo Bersani and filmmaker Ulysse Dutoit. Finally, I offer guide points towards a hearing of Feldman's piece as a musical re-presentation of a visitor's experience inside Rothko's chapel.

2

Ekphrasis was taught in ancient Greece as a method of speech or writing intended to describe a non-present (either existing or non-existing) subject—a rhetorical tool that "brings the subject matter vividly before the eyes."[4] Possible subject matter for ekphrasis varied widely and included not only works of art, but also scenes (such as battles), people and animals, or even objects, like the portrayal of Achilles' shield in Homer's *Iliad*, and more. Webb's comprehensive historical study traces the first use of the term to Theon's *Progymnasmata*, a first-century CE manual of exercises in rhetoric for Greek students. Exercises in ekphrasis appeared in *Progymnasmata* manuals from the first to the fifth

2 Feldman, "Interview by Fred Orton and Gavin Bryars," 244.
3 Goehr, "Two Views of (Musical) Ekphrasis," 405.
4 Webb, *Ekphrasis*, 1.

centuries CE alongside exercises in fable-telling, introducing laws, confirming or refuting a story, and other rhetorical techniques that Greek students were required to master. The key element to a successful ekphrastic description, according to the *Progymnasmata* texts, is *enargeia*—vividness—the essential quality valued in an ekphrastic speech. Notably, students were required to become skilled not only in making ekphrastic speeches, but also in listening to them. In *Institutio Oratoria*, Quintilian writes of Cicero's mastery in ekphrastic description, allowing Quintilian to imagine even details missing from Cicero's text. Webb emphasizes that Quintilian's response to Cicero's skilled *enargeia* was the expected response from a proficient listener, and remarks that a listener who failed to construct a satisfying mental image in response to a master rhetor such as Cicero demonstrated moral deficiency according to Quintilian as well as other Roman rhetoricians of the time.[5]

The term ekphrasis fell out of use until the late nineteenth century, when it started to be applied to pieces of poetry or prose that re-present visual artworks. James Heffernan defines the modern version of the concept as "the verbal representation of visual representation."[6] The modern conception of ekphrasis differs from the ancient definition in three important respects. First, the object of ekphrasis was restricted to a work of visual art, such as a painting or a sculpture. Second, while the ancient technique 'replaced' a non-present scene or object with a verbal description, the modern object of ekphrasis was, in most cases, an *existing* artwork. Most important, however, is the changed role of the reader in the act of ekphrasis: instead of imagining the non-present object of ekphrasis, the reader had to be familiar with the image in order to understand the ekphrastic relationship. While the ancient technique was meant to aid communication between a speaker/writer and listeners/readers, the modern definition of ekphrasis opens avenues of connections among artworks. Lydia Goehr emphasizes the distinction by characterizing modern ekphrasis as a "work-to-work" relation.[7]

Musicologist Siglind Bruhn was the first to apply the term to musical compositions.[8] She characterizes the relationship between an original text and the ekphrastic musical work as a transformation of "content and form,

5 Ibid., 21 and 24. Webb also mentions Dionysios of Halikarnassos, who described Lysias' powerful *enargeia* as bringing the presence of the "characters themselves" to a reader, allowing the latter to converse with them. Ibid., 22.
6 Heffernan, *Museum of Words*, 3.
7 Goehr, op. cit., 389.
8 To expand the scope of the definition of ekphrasis, Bruhn suggested defining ekphrasis as "a representation in one medium of a text composed in another medium." Bruhn, *Musical Ekphrasis*, 8.

imagery and suggested symbolic signification."[9] Drawing from Heffernan, Bruhn requires that the original text or image be representational for musical ekphrasis to be possible.[10] She argues for the representational capacities of the art, claiming that music is, in a sense, superior to language in its potential to represent other artworks—"it [music] *conveys* to its audience the sensual experience of colors and textures, rather than *referring* to them as language does."[11] Nonetheless, Bruhn posits musical narration as a central means of ekphrastic representation, drawing extensively from theories of musical narration in her interpretations of ekphrastic musical works.[12]

The musical transformation of the term, twice removed from its original meaning, combines characteristics from ekphrasis as conceived in the different periods. From the modern definition, it takes the object of ekphrasis—an existing artwork, either a piece of text such as a poem, or a visual work such as a painting. Lydia Goehr states that familiarity with the image or text of ekphrasis is a requirement for an ekphrastic hearing of a composition, and as a result a listener plays a dominant role in an ekphrastic musical work, perhaps more than a reader of an ekphrastic verbal text.[13] Indeed, the difference in the representational abilities of music, compared to language, makes the role of a listener to an ekphrastic composition as active as that of a listener to ekphrastic speech in ancient Greece; while a composition's potential for re-presentation is set up by a composer (who provides a textual reference to an image or poem in the title of a piece), it is realized in the mind of a listener who engages in a multitextual listening activity.

Ekphrastic compositions are related to another type of representational works, discussed in music scholarship under the designation of "program music," a general term for compositions based on a text created by the composer or another author, which can be published alongside the piece, but may also remain secret. When the text expressed in a composition is another

9 Ibid., xvi.
10 Ibid., 8.
11 Ibid., 26 (italics in original).
12 Ibid., 20. Following Heffernan's discussion of the "narrative energy" behind ekphrastic endeavors, Bruhn's interpretation of ekphrastic musical examples is based on the identification of narrating figures and characters rather than types of plots (Heffernan, op. cit., 5). For example, see Bruhn's discussion of Paul Klee's *Die Zwitschermaschine* and three compositions representing it in Bruhn, *Musical Ekphrasis*, 361ff. Her approach draws from Carolyn Abbate's *Unsung Voices*, which suggests the existence of a narrator's voice as evidence of musical narrative in instrumental works. See Bruhn, op. cit., 26–27.
13 Goehr, op. cit., 404.

existing artwork, such as a poem or a painting, the piece is considered ekphrastic. Programmatic and ekphrastic pieces have much in common: first, both types are composed based on an external text; second, and more importantly for this study, both allow a similar approach in listening that places the music side by side with a text (or image). However, for a listener, there is a crucial difference between ekphrastic and programmatic compositions in the degree of specificity of the image portrayed by the music—Debussy's *La Mer*, for example, would have been experienced differently had it re-presented a particular image of the sea. While both programmatic and ekphrastic compositions are constructed according to a textual program, the relationship between the music and its text in a program piece is one-sided, with the program's role limited to guidance in interpreting the piece; an ekphrastic piece, on the other hand, can be heard as an expression of another artwork as much as that work lends itself to being perceived as interpreting the music. For instance, as much as Rothko's chapel could be used to interpret Feldman's *Rothko Chapel*, the music could be employed to interpret Rothko's structure (including its paintings).

Relating compositions to other artworks, and thereby understanding a musical piece in terms of another art form, elicited critical discussions from scholars who either promoted or rejected the idea. In his essay "Music and Painting," Theodor Adorno discusses music that aims to represent paintings, warning against the loss of musical form when a composition yields control of its unfolding in time to a painting's spatial organization. The resulting piece, Adorno explains, loses its integrity by dissociating itself from its medium and becomes, paradoxically, more distant from the painting it aims to represent, since, unlike the music, the image retains its medium's aesthetic integrity:

> Music that "paints," which nearly always suffers a loss of temporal organization, lets go of the synthesizing principle through which, alone, it assumes a form approaching space [...]. The moment one art imitates another, it becomes more distant from it by repudiating the constraint of its own material, and falls into syncretism, in the vague notion of an undialectical continuum of arts in general [...] The arts converge only where each pursues its immanent principle in a pure way.[14]

14 Adorno, "Music and Painting," 67. Susan Gillespie translated this text, which Adorno included in his *Gesammelte Schriften* (Frankfurt: Suhrkamp, 1978), vol. 16. The essay, titled "Über einige Relationen zwischen Musik und Malerei," first appeared in a festschrift *Pour Daniel-Henry Kahnweiler* (Stuttgart, 1965), 33–42.

For Goehr, however, music that "paints" proves the superiority of its art form: "The extra, unnatural or artificial act [of representing another artwork] demonstrates the greater creativity and resourcefulness of *art* [the ekphrastic art form compared to the original artwork's medium]."[15] Rather than portraying ekphrasis as imitation, Goehr thinks of the relationship between an ekphrastic work and its original image as "re-presentation." The difference is significant—while Adorno views art that imitates as subservient to the imitated art, for Goehr ekphrastic re-presentation takes advantage of its art form to transform an existing artwork, resulting in a new work that bears a relationship to the original.

Rothko Chapel is unique among other ekphrastic compositions, such as Modest Mussorgsky's *Pictures at an Exhibition,* since Feldman's piece not only re-presents Rothko's chapel, but was also designed to physically integrate with it when performed inside the structure. The spatial considerations, making the chapel an optimal venue for performing the piece, are evident in Feldman's account of his choice of instrumentation and the desired effect of his composition:

> To a large degree, my choice of instruments (in terms of forces used, balance and timbre) was affected by the space of the chapel as well as the paintings. Rothko's imagery goes right to the edge of his canvas, and I wanted the same effect with the music—that it should permeate the whole octagonal-shaped room and not be heard from a certain distance.[16]

Listening to a performance of the piece inside the chapel also creates what Nicholas Cook termed an instance of multimedia—an artwork that is at the same time architectural and musical—as listeners/spectators can experience the chapel space through Feldman's music and vice versa.[17] Consequently, Feldman's piece relates to Rothko's chapel in two ways—through musical ekphrasis, and as components of a multimedia work. Both aspects will play a role in my discussion of the connection between the two works.

The effects of contrasting musical temporalities have notable significance in my interpretation of Feldman's piece. Musical time had special importance

15 Goehr, op. cit., 399 (italics in original).
16 Morton Feldman, "Rothko Chapel," 125.
17 Nicholas Cook, *Analysing Musical Multimedia,* 100.

for Feldman, whose approach to musical temporality seems to be influenced by painters:[18]

> To me the score is my canvas, this is my space. What I do is try to sensitize this area—this time-space. The reality of clock-time comes later in performance, but not in the making of the composition. In the making of a composition the time is frozen. The time structure is more or less in vision before I begin. I know I need eight or ten minutes like an artist needs five yards of canvas.[19]

The analogy Feldman draws between the form of a painting occupying space on a canvas and the composer's manipulations of musical time in the process of composition, emphatically differentiated from clock-time, illustrates his idiosyncratic approach to musical temporality, discussed by Jonathan Kramer.[20] *Rothko Chapel*, as Steven Johnson argues in his analysis of the piece, demonstrates distinctive temporal characteristics that set it apart among Feldman's compositions.[21]

My study takes a listener's point of view to examine *Rothko Chapel*'s ekphrastic qualities; how does the music relate to the chapel space? I propose a hearing of Feldman's piece as a reflection of the artistic and social statement of Rothko's chapel by suggesting some points towards a multitextual hearing of the piece as a musical re-presentation of the experience of a visitor in Rothko's chapel in Houston. This study does not aim to supply a comprehensive analysis of the piece, but rather examine connections between the two artworks using an interpretation of Rothko's chapel as an aesthetic artifact as well as a spiritual space of meditation as context for a discussion of the music.

My hearing of *Rothko Chapel* has areas of agreement with Steven Johnson's insightful analysis. Our approaches, however, differ on two central points, resulting in disparate interpretations of the piece: while Johnson focuses on Feldman's intentions in the composition of his work, relating the piece to Feldman's relationship with Rothko and his impressions of the chapel paintings, I focus on the opportunities the piece affords to a listener, and the way in

18 Jonathan Bernard relates the feeling of stasis in Feldman's pieces (specifically in *Triadic Memories* from 1981) to the tension the composer admired in Rothko's works. Bernard, op. cit., 180.
19 Brian O'Doherty, "Feldman Throws a Switch," XII.
20 Kramer, *The Time of Music*, 386. Kramer's approach to time in music, and especially his conception of temporality in Feldman's music, are the focus of section 4 below.
21 Johnson, "*Rothko Chapel*," 33.

which they relate to one's experience inside the chapel. In addition, Johnson constructs an analogy between Rothko's paintings in the chapel and structural elements in the music, while in my interpretation the piece allows a listener to create a mental image of the experience in the space through a musical expression of the meditative experience of the chapel.

3

In her monograph on Rothko's chapel project, Susan Barnes elucidates the circumstances that led to the creation of the structure. Mark Rothko began his work when he received a commission for the chapel from John and Dominique de Menil in 1964. According to his contract, he was to work with architect Philip Johnson, planner of the St. Thomas University campus, where the chapel was to be constructed. Dore Ashton recounted that Rothko came up with the idea of an octagonal structure, justifying his aesthetically motivated choice with a historical context after he learned that octagonal chapels were indeed built in early Christian times.[22] Rothko completed the design of the structure and the paintings in 1967, and remained closely involved in the construction work until his death in 1970. The conception of the chapel combined Rothko's childhood fascination with religion and spirituality with his aspiration, as a mature artist, to create an ideal environment to host his paintings. Rothko's friend Ethel Schwabacher recalls that he discussed his desire for an ideal space to present his works, and insisted on thinking of that space as a chapel rather than a museum, emphasizing the spiritual aspect of his paintings.[23] Rothko discussed spirituality in his paintings on different occasions, claiming that people who weep when they see his paintings are having "the same religious experience I had when I painted them."[24] He described the chapel's paintings as "voices in an opera," relating one to the other through the octagonal shape of the structure, which forms relations among paintings hung across the diagonal, lateral, or oblique axes of the space.[25] Rothko also designed the lighting in the chapel, which emanates from a single source—a central sky-

22 Although, according to other accounts, it was Johnson who proposed the octagonal design, and Rothko enthusiastically accepted. Barnes, *The Rothko Chapel*, 81.
23 Ibid., 44.
24 Ibid.
25 Ibid., 50.

light in the ceiling, concealed by a suspended octagonal panel.[26] After a few years in which Rothko worked with Johnson on the design, Johnson withdrew his participation following disagreements on aspects of the structure, and the chapel, eventually deemed interdenominational, was completed with architect Howard Barnstone.

In their aesthetic critique *Arts of Impoverishment: Beckett, Rothko, Resnais*, Leo Bersani and Ulysse Dutoit discuss their experience in the chapel space. Their interpretation of the chapel as both an artwork and a place of meditation will provide the familiarity with the object of ekphrasis required for interpreting Feldman's piece, and frame the chapel as a representational artwork, fulfilling Heffernan's and Bruhn's requirements. Bersani and Dutoit suggest that in the dark colors of the chapel's paintings Rothko aimed to create works of "impoverishment," as if telling spectators:

> My work is without authority. You will learn nothing from it; it will not even enhance your life with that delight or superior pleasure which, you have been led to believe, artists have the obligation to provide you.[27]

Not only do the dark-colored paintings hide themselves from spectators, but the chapel built to store them also serves to obstruct them. The central skylight is too weak to illuminate the paintings, creating what the authors term a "blinding effect." The chapel manifests, they propose, "a heuristic accord with the very existence, as a category, of religious art, in order to execute a strictly aesthetic teleology: an art destined, ultimately, not to be seen."[28] Instead of "passively" viewing Rothko's paintings, a spectator must strain to see, an experience that has been described by some visitors to the chapel as destabilizing and even hostile, and by others as somberly tranquil, religious, and meditative. One of the notes written in the chapel's guestbook provides a brief summary of the spectrum of reactions the chapel can induce: "Being in the chapel is an emotional experience in which you either face your innermost self or leave in incomprehension, possibly even fear."[29] Inside Rothko's ideal space, the darkness

26 Rothko rejected Johnson's original suggestion of a tall pyramid-like structure with ample light coming from its top, and insisted on a structure no taller than the surrounding buildings of St. Thomas University campus—a truncated pyramid. While Rothko did not oppose the idea of a central light-source, he feared the light in the chapel would be too strong. Ibid., 81–83.
27 Bersani and Dutoit, *Arts of Impoverishment*, 3.
28 Ibid., 128.
29 Barnes, *The Rothko Chapel*, 8.

that makes his paintings difficult to see contributes to a paradox in which Rothko's works dominate the inside of the structure, while at the same time submitting to it.

Bersani and Dutoit identify another aspect in which Rothko's chapel defies their expectations for a clear message:

> It was built to house his paintings, and there is nothing else in it, no other sign of the spiritual realities for which those same dark paintings appear sacrificially to withdraw themselves from our sight. There are no altars, no crosses, no torahs [sic]; there is only the art, which is the body of the chapel, its entire inner presence. In Christianity, the religion contains the art that serves it; in the Rothko chapel, the art creates the religion it serves.[30]

Rothko's chapel's lack of characteristics that would identify it with a specific religious tradition (the chapel was originally conceived as Catholic, and only later designated as interdenominational) sets it apart from another painter's well-known chapel—Matisse's Catholic *Chapelle du Rosaire de Vence*.[31] In encompassing a broad sense of spirituality, Rothko's chapel reveals another aspect of "impoverishment" in Bersani and Dutoit's sense, which stimulates a visitor to "strain to see" its spiritual meaning.

The authors sum up their experience inside the chapel as follows:

> We are given an extremely limited number of forms to read [in the paintings], and the impoverished content of opaque, minimally differentiated surfaces makes us all the more vulnerable to the effect of sameness produced by the relation of the paintings to one another and to the chapel walls.[32]

Their interpretation of the chapel is remarkable for its negative tone—the discussion is dominated by absence (of light, as well as aesthetic and religious messages). However, the chapel's different meanings of "impoverishment" result, aesthetically and spiritually, in the formation of a new sense of being. While the authors are straining to see the paintings, they become focused on their own contemplation as the images are continuously re-shaped in their minds:

30 Bersani and Dutoit, *Arts of Impoverishment*, 131–132.
31 Like Rothko, Matisse considered the chapel he designed an ideal space for his art (McPhee, *Matisse's South of France*, 89). However, Matisse's chapel contains elements of Catholic symbolism such as his painting of the Madonna and child.
32 Bersani and Dutoit, *Arts of Impoverishment*, 135.

> Rothko's paintings have absolutely nothing to say about the nature of being; they materialize difference and sameness as metaphysical properties of being striving to represent, instead of difference, differentiality itself. To see Rothko's figures both dissolving and redesigning their own figured state (to see them lose and regain their visuality) is, then, to experience nonethically and nonpsychologically our own difference, to think of the individual as an ontological category prior to the constitution of an individual subject, as a provisional consequence of the mapping of a space.[33]

Without manifesting a clear message, the chapel's artworks led the authors to experience the loss and restoration of their sense of differentiation, as they interpret the chapel's message through different senses of absence. At the same time, the authors begin to notice subtle differences between the paintings in the process of trying to see them in the dark, and they direct their reflection inward, where it is abstracted to refer to their individuality as an ontological category. As a result, in the process of reflecting on their experience, the authors become aware of their existence in the space.

Bersani and Dutoit interpret Rothko's dark chapel in the context of other, light-filled, chapels, and consider Rothko's obstructed paintings as a response to sacred art that depicts a divine message. Similarly, Feldman's music for the chapel can be thought of as a response to long-time traditions of sacred music. An examination of sacred elements in Feldman's piece is part of an ekphrastic hearing of his work both as a representation and as a musical counterpart to the structure. First, however, the following brief review of Jonathan Kramer's theory of musical time as it applies to Feldman's *Rothko Chapel* will provide context to the interpretation of the piece in section 5.

4

Fundamental to Kramer's theory of time in music is his distinction between linear and nonlinear time. Linear time involves perceived relationships of cause and effect—"the temporal continuum created by a succession [of] events in which earlier events imply later ones and later ones are the consequences of the earlier ones."[34] This sort of goal-directed temporality dominated Western musical thought until the twentieth century.

33 Ibid., 141.
34 Jonathan Kramer, *The Time of Music*, 20.

> As we listen to a tonal composition [...] each pitch event (individual note, chord, or motive) colors, to a small or great extent, our expectations of what will follow. We hear subsequent events in the context of these expectations, which are fully or partially satisfied, delayed, or thwarted. Each new occurrence, understood and subsequently remembered under the influence of prior expectations, implies the future. Thus linearity is a complex web of constantly changing implications (in the music) and expectations (of the listener).[35]

Linear time is conditioned by the perception of development and progression. In contrast, Kramer defines "nonlinear time," a comprehensive term comprising manifold musical temporalities found in pieces beginning in the twentieth century. Kramer explains nonlinear time using negation. While linear time is "processive," nonlinear time is "nonprocessive." Linear time is related to growth and development, whereas nonlinear time relates to stasis. Unlike linearity, earlier events in nonlinear temporalities are not perceived as affecting later ones. Nonlinearity can be explained as lack of a determining context, when the unfolding of events is dominated by organizational rather than contextual principles. While almost every piece of music combines linear and nonlinear aspects, the extent to which each is perceived varies. Consequently, although every tonal work is linear, each also contains nonlinear characteristics to some degree.

To elucidate nonlinear temporality in tonal works, Kramer provides a temporal analysis of Schubert's lied *Gretchen am Spinnrade*, op. 2 (D. 118). The musical representation of the spinning wheel from Goethe's poem dominates the accompaniment throughout the lied, creating a feeling of a moment frozen in time in spite of the rapid tempo, and symbolizing the contrast between Gretchen's mundane work at the wheel and her internal turbulence of emotions. The interruption in the spinning when Gretchen thinks of Faust's kiss, according to Kramer, "violates nonlinear consistency of texture and rhythmic pattern"—the disruption of the accompaniment introduces development that manifests the dramatic climax of the poem.[36] As a result, although it would be difficult to assert that *Gretchen am Spinnrade* conforms to Kramer's concept of nonlinearity, the piece depicts an interpretation of the poem through the contrast between the repetitive rhythm and texture of the piano, on one hand, and the goal-oriented harmonic progression and voice part, on the other.

Vertical time, defined as an extreme type of nonlinear time, is especially relevant to Morton Feldman's style. Kramer defines vertical time as

[35] Kramer, *The Time of Music*, 20.
[36] Ibid., 42.

[a] single present stretched out into an enormous duration, a potentially infinite "now" that nonetheless feels like an instant. In music without phrases, without temporal articulation, with tonal consistency, whatever structure is in the music exists between simultaneous layers of sound, not between successive gestures.[37]

Portrayed as a distinct listening experience that refrains from directing a listener's attention in a particular path, vertical music "allows the listener to make contact with his or her own subjective temporality. It is music of subjectivity and individuality."[38] Vertical temporality is thus related to a heightened focus—on the part of a listener—on the activity of listening itself, and in this sense Feldman's characteristic contemplative style already bears a similarity to Rothko's aesthetic as interpreted by Bersani and Dutoit.

A nonlinear piece is not always vertical.[39] However, when it comes to Morton Feldman's compositions, which the composer once characterized as "vibrating stasis," the notion of an "infinite now" corresponds with music scholars' discussions of their impressions of Feldman's works. In her dissertation on Feldman's music, Catherine Hirata explores the sense of randomness many listeners perceive in Feldman's early pieces, which place significance on individual sonorities rather than relationships between sounds.[40] She observes that Feldman's style is often characterized as lacking pulse or meter, creating—especially in his late music, which is typified by repetition—a sense of a floating pulse.[41] Kramer remarks that Feldman "perhaps best epitomizes vertical time."[42]

5

Morton Feldman revealed in an interview some of the "literary and reminiscent" facts involved in the creation of *Rothko Chapel*. He describes the piece as a process that represents the development of his musical style, including the early influence of his Jewish upbringing, and later the growing sense of abstraction in his works.

37 Ibid., 55.
38 Ibid., 57.
39 Other types of nonlinear temporality include, for example, moment form, in which the sense of hierarchy between musical events is diminished as they are heard as unrelated to one another. Ibid., 201ff.
40 Hirata, "Morton Feldman," 20.
41 Ibid., 10–12.
42 Kramer, op. cit., 386.

> The piece begins in a synagoguey [sic] type of way; a little rhetorical and declamatory. And as I get older the piece gets a little abstract, just like my own career. Then in the middle of the piece there is one thing that is really at odds with the other parts but which makes my piece a very interesting trip: where I just have the same chords, and I'm tripping for a long time, and it's very monochromey [...] Not that I'm imitating Rothko but I'm certainly closer to the late pictures that are in the Chapel in that kind of one hue of color, and the piece ends with the memory of a piece that I wrote when I was fourteen.[43]

Feldman's compositions are known for their quiet, still, and contemplative features, and *Rothko Chapel* is no exception in this regard. Amy Beal notes that avoidance of extreme differentiation or contrast is one of the expressions of the influence of New York expressionist painters on Feldman's œuvre. *Rothko Chapel*, however, is unique for combining contrasting textures, tonalities (or lack thereof), and senses of musical temporality. Steven Johnson considers the piece exceptional in incorporating contrasting senses of temporality—the music fluctuates in the spectrum between directed solo melodies, on one hand, and an extended moment of reverberating choral harmony, on the other.[44] While Johnson relates the differences to the distinct shades of the chapel's paintings, I will suggest that they can be heard as outlining a process of loss of differentiation, followed by a new understanding of one's being, similar to Bersani and Dutoit's experience in the chapel. This ekphrasis-oriented discussion of *Rothko Chapel* centers on the developing relationship between soloist and chorus, which is underlined by the tension between linear and nonlinear musical temporalities.

According to Feldman, when it comes to his instrumentation decisions in the piece, the sonic properties of the chapel's structure, as well as the visual effect of the ensemble performing inside the chapel, were important considerations:

> I went down there [the Rothko Chapel] and I just walked around the chapel. It was built in a kind of glamorous idea of his studio [...] and it just cried out—the octagonal situation—to do something at the sides. That's where the antiphonal chorus came in, and something in the middle [...] Visually too the whole battery or [sic] percussion looks nice.[45]

43 Feldman, "Interview by Orton and Bryars," 244.
44 Johnson, "*Rothko Chapel*," 33.
45 Feldman, "Interview by Ortan and Bryars," 244.

Feldman characterizes Rothko's chapel as "a spiritual environment created [...] as a place for contemplation where men and women of all faiths, or of none, may meditate in silence, in solitude or celebration together."[46] The ensemble Feldman chose for the piece contains references to sacred music of different traditions. It includes a four-part chorus, alluding to Western Christian musical traditions. The percussion section, on the other hand, includes temple blocks and a gong, used in religious ceremonial music across East and Southeast Asia.

Listening to Feldman's *Rothko Chapel*, especially when performed inside the chapel space, places the piece in the context of sacred music. Nevertheless, there is a dissonance between the traditional use of the instruments and the way in which they are featured in the piece. Most notably, the chorus has no text throughout the piece. Instead of uttering words, Feldman instructs the chorus in the score to sing "a consistent open hum throughout on the vowel 'n' [*sic*] but not too nasal." The absence of text in Feldman's chorus parallels the "impoverishment" of a religious message, which in Rothko's chapel, as well as in Feldman's piece, calls a spectator or listener to "strain to see"—to reflect on the images and sounds, interpreting each in the context of the other.

I hear the connection to the chapel in the relationship between a solo melodic line and communally sustained harmony that changes and develops throughout the piece—the loss of differentiation and new sense of individuality that Bersani and Dutoit sense in the chapel are expressed in the music through an individual voice that loses its distinct character and becomes part of a multiplicity of voices, only to finally emerge with a new melody representing a new sense of being. The relationship between the soloist and the chorus unfolds over a process in which the viola's position as soloist gradually changes in the course of its interaction with the chorus, as it merges with the ensemble.[47] The viola eventually finds a new voice and reshapes its identity distinctly from the chorus in the process of losing and regaining its differentiation from the rest of the ensemble.

The viola's voice is first established in a declamatory melodic line that opens the piece. The first phrase of the melody appears in Example 1.[48] The melody

46 Feldman, "Rothko Chapel," 125.

47 Throughout my discussion of the piece, I refer to the following recording: Gregg Smith, Jan Williams, *Morton Feldman: Rothko Chapel, For Frank O'Hara*, Gregg Smith Singers, Buffalo Center of the Creative and Performing Arts, Sony 49995, 2013, available on <https://www.youtube.com/watch?v=1ZZoDYIkaP8>. The performance is approximately 25 minutes long.

48 The opening 1'12" in the recording.

grows out of the insistent (and rhythmically uneven) oscillations in the timpani, continuously alternating B^2 and D^3.[49] The viola begins with a semitone transposition of the timpani part in the middle octave. However, once started, its solo declamations wander away from the timpani's repeating thirds and form an expressive melodic line. The melody features expansive sweeps, and its climactic note A-flat is ornamented by the vibraphone and celesta. The melody ends with a descending gesture and repose. The overall shape of the line, ascending to the climax A-flat and descending to mark the ending of the passage, conveys motion and direction.

Entering in m. 29 (presented here in Example 2), the chorus brings contrasting texture and a sense of temporality.[50] Compared to the clear declamations of the soloist, the chorus represents a multitude—it is differentiated from the solo lyrical voice by its opaque harmonies. Unlike the viola's broad tessitura and wide dynamic range, the chorus hums are smooth and soft, causing the resulting harmonies to sound somewhat muffled, as if coming from a remote source. Feldman, as mentioned above, tells that the opening viola phrases originated in his memories of the sounds inside the synagogue, representing his early experiences with music. The chorus, however, expresses the "abstraction," as Feldman puts it, that distinguishes his mature style. Compared to the goal-directed viola melody, the chorus manifests a different sense of temporality. Steven Johnson notes the somewhat static quality of the chorus harmonies, which in Kramer's terms would be considered much less linear than the viola's declamations.[51]

The soloist and chorus are juxtaposed shortly after the chorus's first entry, bringing out their contrasting qualities, and setting the scene for their conjunction. The viola's expressiveness brings it closer to human utterances, perhaps even more so than the multiplicity of human voices in the chorus. Like the chapel paintings, which are continuously reshaped in the mind of a visitor in the process of straining to see, the viola's declamations in this passage are being reshaped and formed anew after being dissolved, over and over again, by the chorus. The viola merges into the chorus for the first time in m. 70, shown here in Example 3, in which the chorus's harmonies that appeared in Example 2 are extended and repeated.[52] As if unable to complete a repetition of the gesture that closes its opening phrase (the "closing gesture" from Example 1), the viola continuously reiterates its climactic note A-flat5 from the opening phrase—this

49 The numbers in superscript next to the note-names represent octave numbers according to the range of the piano keyboard. For example, D^3 is located in the octave below the piano's middle C.
50 Starting at 2'35" in the recording.
51 Johnson, op. cit., 34.
52 Starting at 5'23" in the recording.

EXAMPLE 1 *The first viola phrase, mm. 1–12.*
Morton Feldman "Rothko Chapel"
© COPYRIGHT 1973 UNIVERSAL EDITION (LONDON) LTD., LONDON/UE 15467.

time as a harmonic—until the gesture is finally completed in mm. 76–77. The result is an extended moment, in which the viola becomes closer to the soft hum of the chorus in its tone but at the same time remains markedly distinct, conveying the tension of the delayed gesture. In this sense the directness of the viola part, compared to the chorus harmonies, is felt even more strongly.

The changes in the relations between the viola and the chorus, developing until the closing "Hebraic" melody, recreate the experience of the chapel as the music unfolds. After the first appearance of the chorus, the instrumental soloist introduces fragmentation to its opening declamations, taking the first step towards assimilating into the chorus. When the chorus is heard again at the moment discussed above, repeating its first phrase with altered durations, it is accompanied by the viola, which no longer functions as a soloist. Similarly to Bersani and Dutoit's sense of loss of differentiation, the viola soloist becomes absorbed in the multiplicity of the chorus. Later in the piece, beginning in

EXAMPLE 2 *The chorus's first entrance (2'35").*
Morton Feldman "Rothko Chapel"
© COPYRIGHT 1973 UNIVERSAL EDITION (LONDON) LTD., LONDON/UE 15467.

m. 179,[53] another facet of the potential for fluctuation between the viola and chorus is realized, when a human voice leaves the group and takes the role of a soloist. The soprano soloist assumes the role that was first assigned to the viola, joining the viola as another solo voice. Example 4a shows the entrance of the solo soprano, and Example 4b presents the change in the viola part that follows. The soprano line resembles the viola's part in its directed motion, on one hand, yet it is related to the chorus as a human voice. The viola responds to the new soloist by repeating an ascending gesture that mirrors the soprano's—the example shows that the singer's repeating gesture delineates a descending

53 12'42" in recording.

EXAMPLE 3 *The viola merges into the chorus (5'23").*
Morton Feldman *"Rothko Chapel"*
© COPYRIGHT 1973 UNIVERSAL EDITION (LONDON) LTD., LONDON/UE 15467.

interval of fifteen semitones, while the viola solo that follows outlines the same interval in the opposite direction. In m. 243, after the chorus's "monochromey" passage, the soprano and viola continue their interaction in a sort of duet, in which the soprano's declamations are combined with fragments from the viola's opening phrase. Like the paintings inside Rothko's chapel, Feldman's music contains a limited number of repeating gestures, raising a listener's awareness to the slight variations between the repetitions.

The chorus arrives at an extreme of nonlinear temporality in its "monochromey" passage, expressing, as Steven Johnson remarks, ultimate verticality.[54]

54 Johnson, op. cit., 31.

EXAMPLE 4A *The solo soprano's entrance (12'42").*
Morton Feldman "Rothko Chapel"
© COPYRIGHT 1973 UNIVERSAL EDITION (LONDON) LTD., LONDON/UE 15467.

EXAMPLE 4B *The viola's fragments following the soprano.*
Morton Feldman "Rothko Chapel"
© COPYRIGHT 1973 UNIVERSAL EDITION (LONDON) LTD., LONDON/UE 15467.

EXAMPLE 5 *Beginning of the chorus's "monochromey" passage (15'02").*
Morton Feldman "Rothko Chapel"
© COPYRIGHT 1973 UNIVERSAL EDITION (LONDON) LTD., LONDON/UE 15467.

As Example 5 shows,[55] the chorus in this section consists only of alto and soprano parts, divided into two choirs that stand on opposite sides of the chapel, with the audience sitting between them. The use of a divided chorus resonates with the traditional use of multiple choruses in Western churches,

55 15'02"–17'52" in recording.

EXAMPLE 6 *The closing melody (22'33")*.
Morton Feldman *"Rothko Chapel"*
© COPYRIGHT 1973 UNIVERSAL EDITION (LONDON) LTD., LONDON/UE 15467.

with known instances appearing as early as the Renaissance.[56] Each of the soprano and alto parts is divided into six voices, each pair of which repeats the same tone. The effect is a continuous echo (some of which can be heard in the recording, especially if using headphones), a musical contemplation of sound that takes place over an extended present, an "infinite now" in Kramer's words. As a result, while the soprano solo brings the viola and the chorus closer to one another, they are also drawn farther apart, as the stasis of this long section contrasts with the surrounding solo moments.

56 For example, Thomas Tallis's motet *Spem in alium* (c. 1570) features eight choirs.

Feldman composed the ending viola melody,[57] presented in Example 6, when he was fourteen years old. He described its modality as a characteristic that reminds him of his visits to the synagogue as a child.[58] The viola's new voice thus represents another religious element taken out of its original context, like the chorus and the percussion. Compared to the viola's line in the opening of the piece, the modal melody presents a radical change. Although still linear (and perhaps even more linear than the opening viola declamations, which lacked a tonal center), the evocative melody reflects the renewed perspective of a visitor after the meditative experience in the chapel that Bersani and Dutoit describe. In addition, the modal melody presents a style new to the piece, yet brings a sense of return to the past. In my hearing of the piece, the process of immersion into the chorus and percussion has helped the viola gain its new voice by relating its individuality to the universally sacred. The full chorus, divided into two, is heard surrounding the viola's melody with its steady harmonies.

6

Rothko Chapel differs from other ekphrastic works, since it does not contain musical imagery to complement the visual imagery of the art it represents.[59] However, it is ekphrastic in being both shaped in accordance with and designed to be heard in Rothko's chapel, thereby allowing the chapel to be considered as an originating text for the composition. Moreover, we could reverse the direction of influence and ask, in turn, how Feldman's composition contextualizes the experience inside the chapel. One way in which the piece affects the chapel takes place when one attends a performance of *Rothko Chapel* in the space, when the music and the chapel space can be experienced as a multimedia event.[60] By becoming part of the chapel in performance, Feldman's piece

57 22'33" in recording.
58 Feldman, "Rothko Chapel," 126.
59 I consider as "musical imagery" compositional techniques that illustrate the meaning of words in music (also termed "word painting"). Such techniques have been used in music throughout history; they are especially abundant in late-Renaissance madrigals, as well as in program music beginning in the nineteenth century. For a discussion of word representation in Monteverdi madrigals, see Richard Taruskin, *Music in the Seventeenth and Eighteenth Centuries*, 2–12. Siglind Bruhn discusses different forms of musical representation in Bruhn, op. cit., 27–34.
60 In his dissertation on Morton Feldman, Ryan Dohoney ("The Anxiety of Art," 244–245) writes on the first performance of the piece inside the chapel as allowing another view

supplies a sense of temporality that shapes the experience in the space. The function of the music in this case could be compared to the role of music in multimedia works, such as films.

The incorporation of music into multimedia works complexifies its potential for signification, which is also actualized in listening to an ekphrastic composition as a musical expression of another artwork. In both types of experiences, a spectator/listener generates a metaphorical space as a result of the interactions between music and other arts. In the case of Feldman's *Rothko Chapel*, the experience of listening to the composition as a re-presentation of the chapel provides an additional layer of significance to the musical composition by relating it to the experience inside Rothko's space. At the same time, Feldman's piece provides a temporal facet to the experience in the chapel by virtue of the music's temporal dimension, as well as a musical expression to the chapel's unique sense of spirituality, through the idiosyncratic manner in which sacred elements are combined in the composition. Hearing a composition as an expression of an image (or text) corresponds to Nicholas Cook's argument that any coupling between picture and music (he mentions specifically images used on album covers, chosen by record companies) creates a form of interpretation of both works, contextualizing them to produce a deepened experience of each.[61]

Lastly, let us return to the question that guided this study—how can a musical work represent another work of art? Drawing from the ancient definition of ekphrasis, music becomes representational by virtue of a listener's activity that treats ekphrastic musical works as multitextual. As a result, one is able to explore their potential as expressions of artworks from other art forms, an activity that connects sounds and images through the juxtaposition of two artworks. According to Lydia Goehr, when studying a case of musical ekphrasis, "one must ask what is musical and what is ekphrastic about it."[62] The first question opens the possibility of identifying musical ekphrasis, and musicality in general, in artworks that are not considered musical compositions. As a result, the study of ekphrasis has the potential to expand the definition of musicality through the study of musical ekphrasis.

of Rothko's paintings: "*Rothko Chapel*, in its ritualized concert setting, afforded a chance to see Rothko's paintings through Feldman's music, as the concert presentation affords reflection on the paintings apart from any specifically religious use of the space."

61 Cook, *Analysing Musical Multimedia*, 72–74.
62 Goehr, 405.

[A] painting might prove a marvelous example of musical ekphrasis as a musical work might prove a good example of poetic ekphrasis, which suggests that ekphrasis should not be solely or too rigidly qualified by hard medium distinctions between the arts.[63]

By treating ekphrasis as a relationship between artworks rather than art forms, ekphrastic investigation of musical works both draws connections between music and other arts and facilitates a concept of musicality that could be considered also in non-musical artworks. In contributing to understanding the relationship between music and the other arts, the study of musical ekphrasis marks a step in the direction of understanding the qualities that connect music, as a medium, to other art forms.

All musical examples from Morton Feldman's *Rothko Chapel* reproduced by permission from Universal Edition.

References

Abbate, Carolyn. *Unsung Voices: Opera and Musical Narrative in the Nineteenth Century.* Princeton, NJ: Princeton University Press, 1991.
Adorno, Theodor. "On Some Relationships Between Music and Painting." Trans. Susan Gillespie. *The Musical Quarterly* 79, no. 1 (1995): 66–79.
Balridge, Wilson. "Morton Feldman: One Whose Reality is Acoustic." *Perspectives of New Music* 21, no. 1–2 (1982–1983): 112–113.
Barnes, Susan J. *The Rothko Chapel: An Act of Faith.* Austin: University of Texas Press, 1989.
Bernard, Jonathan. "Feldman's Painters." In *The New York Schools of Music and Visual Arts: John Cage, Morton Feldman, Edgard Varèse, Willem de Kooning, Jasper Johns, Robert Rauchenberg*, edited by Steven Johnson, 173–215. New York: Routledge, 2002.
Bersani, Leo, and Ulysse Dutoit. *Arts of Impoverishment: Beckett, Rothko, Resnais.* Cambridge, MA: Harvard University Press, 1993.
Bruhn, Siglind. *Musical Ekphrasis: Composers Responding to Poetry and Painting.* Hillsdale, NY: Pendragon Press, 2000.
Cook, Nicholas. *Analysing Musical Multimedia.* Oxford: Oxford University Press, 1998.
Dohoney, Ryan. "The Anxiety of Art: Morton Feldman's Modernism, 1948–1972." PhD diss., Columbia University, 2009.

63 Ibid.

Feldman, Morton. "Morton Feldman: Interview by Fred Orton and Gavin Bryars." *Studio International* 192, no. 983 (1976): 244–248.

———. *Rothko Chapel*. London: Universal Edition, 1973.

———. "Rothko Chapel." In *Give My Regards to Eighth Street: Collected Writings of Morton Feldman*. Ed. B.H. Friedman, 125–126. Cambridge, MA: Exact Change, 2000.

Goehr, Lydia. "How to Do More with Words: Two Views of (Musical) Ekphrasis." *British Journal of Aesthetics* 50, no. 4 (2010): 389–410.

Heffernan, James. *Museum of Words: The Poetics of Ekphrasis from Homer to Ashbery*. Chicago: University of Chicago Press, 1993.

Hirata, Catherine Costello. "Analyzing the Music of Morton Feldman." PhD diss., Columbia University, 2003.

Johnson, Steven. "*Rothko Chapel* and Rothko's Chapel." *Perspectives of New Music* 32, no. 2 (1994): 6–53.

Kramer, Jonathan. *The Time of Music: New Meanings, New Temporalities, New Listening Strategies*. New York: Schirmer Books, 1988.

Maus, Fred Everett. "Music as Narrative." *Indiana Theory Review* 12 (1991): 1–34.

McPhee, Laura. *A Journey into Matisse's South of France*. Berkeley, CA: Roaring Forties Press, 2006.

Nodelman, Sheldon. *The Rothko Chapel Paintings: Origins, Structure, Meaning*. Austin, TX: University of Texas Press, 1997.

O'Doherty, Brian. "Feldman Throws a Switch between Sight and Sound." *New York Times* (February 2, 1964): XII.

Smith, Gregg, and Jan Williams. *Morton Feldman: Rothko Chapel, For Frank O'Hara*. Gregg Smith Singers, Buffalo Center for the Creative and Performing Arts. Sony 49995, 2013.

Taruskin, Richard. *Music in the Seventeenth and Eighteenth Centuries*. New York: Oxford University Press, 2010.

Webb, Ruth. *Ekphrasis, Imagination, and Persuasion in Ancient Rhetorical Theory and Practice*. Burlington, VT: Ashgate Publishing Company, 2009.

PART 2

Looking Back: Tracing History

CHAPTER 6

Traces of Viking-Age Temporal Organization

Lasse C.A. Sonne

Abstract

The article discusses the temporal organization of social life in Viking-age Scandinavia (*c.* AD 750–1050) and the challenges of its scholarly investigation. Based on a survey of the contemporary sources, it will be documented that three main zeitgebers were employed: the shift between day and night, the lunar phases, and seasonal changes.

Keywords

Viking-age Scandinavia – early medieval Europe – Julian calendar – social time

When the Viking age (*c.* AD 750–1050) came to an end, Christianity had been accepted as the official religion in the three Scandinavian kingdoms (Denmark, Sweden, and Norway). Following this acceptance, Scandinavia went through a process of ideological and religious integration into the Latin medieval West. An essential part of this process was the introduction and consolidation of the Church as an institution providing the necessary administrative and structural frame for the performance of the Christian religion.[1] With this new institution came also a new feature in the temporal organization of social life, namely the Julian calendar in its medieval form according to which the ritual year of the Church was organized.

At first, the new calendar was only in use within Church institutions and the social milieus attached to them, but gradually it became a major, and perhaps even the main, feature in the temporal structure of the Scandinavian societies—even to the extent that we today are suffering from what the Danish historian Kristof Glamann has labeled "calendar fetishism" (1998, 101–10). To evaluate the range of changes in the temporal organization of social practices initially following the introduction of the Julian calendar, we must begin with a

1 For the introduction of Christianity in Scandinavia see Sawyer, Sawyer, and Wood (1987), Berend (2007), and Winroth (2012).

study of this organization as it was in the period leading up to its introduction, which is undertaken in this article.[2]

Due to a long-established tradition within Scandinavian historical and archaeological research, the early medieval period of Scandinavia is termed "the Viking age."[3] For the sake of historiographical continuity, I follow this tradition here, but this should not obscure the fact that Viking-age Scandinavia was, temporally and spatially, an integral part of early medieval Europe. Ecclesiastical authors of the time did for ideological reasons construe non-Christian parts of Europe, including Scandinavia, as a pagan and barbarous Other (Goetz 2013, 1:31–232). From the point of view of a present-day historian, however, Viking-age Scandinavia should be approached as one region in the larger sociocultural continuum of early medieval Europe. This is not to say that there were no major differences between Scandinavia and other parts of Europe, as is evident, for example, from the lack of ecclesiastical institutions in Scandinavia. But the overall socio-cultural differences, for example, between Scandinavia and England may not have been larger or more fundamental than the differences between England and Italy.

1 Two Methodological Prerequisites and Some Definitions

Any student of time approaching Viking-age Scandinavia will be struck by the dearth of contemporary written sources, as these are limited to concise runic inscriptions, skaldic and eddic poems, and stray remarks by outside observers who came into contact with Scandinavians. This has led some scholars to reject the feasibility of describing the time-scheme of Viking-age Scandinavia with any degree of detail (see, for example, Lebech 1969, 5–6 and Liebgott 1973, 7). Other scholars have dared to venture into this topic with much enthusiasm and less source criticism to reconstruct elaborate, and sometimes rather fanciful, time-schemes. While the position taken here is more in line with the former studies, the following survey of the sources will show that upon closer

2 The early calendar history of Iceland presents special problems that cannot be addressed within the limits of this article. It is enough to state here that the earliest known version of the pre-Julian Icelandic calendar, as presented by Ari the Learned in *Íslendingabók* (AD 1122–1133), could not have come to Iceland with the first Norwegian settlers (Benediktsson 1968, 9–11; translated by Grønlie 2006, 5–6). Instead, it must be an Icelandic innovation from the late ninth or the tenth century (see also Janson 2011, 61).

3 Roesdahl (1994), Svanberg (2003, 1:36–38), and Lind (2012, 159–60) discuss the origins of this tradition.

reading the contemporary sources do provide clues—direct as well as indirect ones—for elements of the temporal organization of social life.

The survey and the following time-scheme model rest on two methodological prerequisites that I will explicate here by presenting a representative example of the latter studies. This will also illustrate where this study differs methodologically from studies of the latter kind. The example is the handbook on chronology by the Norwegian astronomer Jens Frederik Schroeter (1923–26, 2:§§ 166–72) working on the basis of Friedrich Karl Ginzel's monumental three-volume *Handbuch der mathematischen und technischen Chronologie* (1906–14, 3:§§ 228–30).

According to Schroeter, Viking-age Scandinavia saw the use of a solar year comprised of 365 days distributed into twelve 30-day months, each with six five-day weeks. All in all, the year had 73 five-day weeks (which, however, leaves one five-day week unaccounted for, since twelve months with six weeks only amount to 72 weeks). The year was divided into two parts: winter and summer, each with six months. Winter consisted of the months *Gormánaðr* (Blood-month or Slaughtering-month), *Frermánaðr* (Frost-month), *Hrútmánaðr* (Ram-month), *Þorri* (Running-short [of supplies]?), *Gói* (?), and *Einmánaðr* (One-month [to-go-before-summer?]). Summer consisted of the months *Sáðtíð* (Seed-time), *Eggtíð* (Egg-time), *Sólmánaðr* (Sun-month), *Heyannir* (Hay-work), *Kornskurðarmánaðr* (Corn-mowing-month), and *Haustmánaðr* (Harvest-month). Winter and summer were connected respectively to the autumn equinox and the spring equinox, although winter and summer probably were each pushed back one month in order to adapt the calendar to the northern climate, i.e., winter began around mid-October and summer around mid-April. The connection with the equinoxes ensured that each month began approximately at the same time each year, measured in accordance with the solar year.

Evaluating Schroeter's time-scheme model, two elements call for critical comments. We can first note that except for the two seasons, summer and winter, none of the elements in the model are documented in contemporaneous sources. Instead, the model is constructed on information from later Old Norse texts, including the Icelandic sagas, dating to the late twelfth century and the thirteenth century.[4] These texts are, however, an unreliable guide into the history of the Viking age (Olsen 1966, 19–54; Sawyer and Sawyer 2002, 31–43). The sagas portray an imagined pagan past as seen through the lens of learned Christian writers with the aim of serving contemporaneous political

4 Old Norse is the collective name for the vernacular Germanic languages of Scandinavia in the early and high medieval period.

and ideological purposes, as has recently been discussed, among others, by von See (1999, 307–412), Tulinius (2000), and Mortensen (2006). The following survey therefore only includes contemporary sources from the Viking Age.[5]

The second critical note relates to Schroeter's choice of zeitgebers. Schroeter detached the time-scheme from any observable phenomena, making the scheme function in a way similar to the Julian calendar.[6] Thus, if an event is set to take place on the first day of *Sólmánaðr* or on the fourth day of a week, only the calendar can tell when these points in time arrive. A prerequisite for this model is the presence of time-tools, but time-tools are—so far—not documented for Viking-age Scandinavia. The time-scheme reconstructed by Schroeter cannot, therefore, have worked as a pacer for technological reasons. In the following, the Viking-age time-scheme will be reconstructed only to the degree of mathematical and technological elaboration minimally needed to understand the information in the sources.

For the reconstruction of the Viking-age time-scheme, we should furthermore take into account the following two conclusions from comparative studies of social time. First, it is reasonable to assume that all known societies, past and present, have or have had calendric rules to guide the timing of central social activities. But only societies that are more complex in a macro-sociological perspective exhibit more elaborate normative models for social time, fixed in writing and organizing larger continuous sections of time, for example the solar year, into recurrent and uniform units (Goody 1986, 94–96; Rotenberg 1992, 24–27; Rice 2008, 278–79).

Second, the prescriptive nature of calendars connects them with social authorities, as control over the temporal organization of social life not only functions to maintain temporal order, but can also be interpreted as a means to secure additional social control (Lauer 1981, 99–102; Adam 1990, 104–26; Rutz 1992, 4–7). The influence of a calendar on the timing of social rhythms, therefore, depends on the presence of social authorities willing and capable of enforcing the temporal order of the calendar in a community or organization, for example, for political, economic, and/or ideological motives.

For the readers convenience, I will here present my definitions of the main technical terms employed in the following. The term *calendar* is defined as a normative model for the timing of central social rhythms within a community or organization. As normative models, calendars belong to a group of schedules characterized by Allen C. Bluedorn as rhythmic templates that "prescribe behavior in terms of patterned repetition" (2002, 146). The term *time-scheme*,

5 For the account of Adam of Bremen see Bolton (2006) and Sonne (2013a, 139–68).
6 See further on the Julian calendar below in section IV.

or simply *scheme*, is defined as a descriptive model for the timing of existing social rhythms within a community or organization. The term *zeitgeber* is defined as a cue from a pacer that signals the time for an event or an act.[7] We can differentiate between two types of pacers: the *internal pacer* and the *external pacer*. The former gives the cue for an act or an event in which the pacer will be involved or somehow manipulated, while the latter gives the cue for an act or an event in which the pacer will not be involved or manipulated. The term *time-tool* is defined as a tool or instrument employed to read off or register zeitgebers.

2 The Individual Traces

I will begin the survey with sources referring to the four seasons. In skaldic poetry the temporal markers used to date past events within the solar year are primarily the seasons during which the events took place.[8] According to poetry from the end of the tenth century and the eleventh century (Whaley 2012, 1:460; 2:558, 583, 597), late Viking-age Scandinavia recognized four seasons: spring (*vár*), summer (*sumar*), autumn (*haust*; with the literal meaning: harvest), and winter (*vetr*).

A more precise dating occurs in the poem *Vellekla* composed by Einarr skálaglamm for the Norwegian earl Hákon Sigurðarson. Hákon held the political lordship over Norway for around a quarter of a century until AD 995, albeit in the first part of his rule under the overlordship of the Danish king Harald Bluetooth. The poem, composed *c.* AD 975–985, presents the military and political victories of Hákon. In stanza 26, we hear of a battle that is not otherwise known from contemporary sources and therefore cannot be dated with any precision within the reign of Hákon. In the first half of the stanza, the time of the battle is presented in relation to a specific natural phenomenon during the winter season: "And the generous king of the earth of the dark forest wanted at the time of the frost to test the battle-elf who came from the north" (*Ok við frost at freista | fémildr konungr vildi | myrk- Hlóðynjar -markar | morðalfs, þess's kom norðan*) (Whaley 2012, 1:315). We should probably not assume that Hákon timed his attack to the coming of the winter frost, but since the battle is dated according to this specific natural phenomenon, we can reasonably assume

[7] This definition of zeitgebers builds on Ancona and Chong (1996, 253). See also Whitrow (1980, 142–43).
[8] For an overview of the skaldic poetry see Frank (2005).

that the presence of frost was the most salient temporal marker for the time of the battle in the poet's hindsight.

The agricultural season of autumn was also used to temporally locate judicial assembly meetings as documented in an eleventh century runic inscription from Södermanland in Sweden. The inscription (Sö 196) comes from a rune-stone erected by Ingifriðr to commemorate her father Øyulfr (Brate and Wessén 1924–36, 1:169–71).[9] The purpose of the rune-stone is presented in the first part of the inscription: "Ingifriðr had this stone and staff erected after Øyulfr, her father" (**hlikfriþr lit r?isa sain þna iftiʀ ayulf faþur sin auk staf**). The last part of the inscription is less clear, but according to the most recent interpretation (Källström 2007, 105–11), it mentions a manslaughter committed by Øyulfr at an autumn assembly: "Øyulfr did it at the autumn assembly: killed Assurr. He took revenge for the betrayals in the west" (**ayulf? ... kiarþi þat i ausþiki hiuk asur ifnti kina uistr**). Following this reading, a legal assembly had taken place during the autumn.

In the high medieval period, legal assemblies could meet at regular and regulated times as well as *ad hoc* when required, for example, to deal with more urgent judicial matters (Brink 2003, 62). The only more elaborate contemporaneous description of Viking-age legal assemblies in Scandinavia comes from *Vita Anskarii* (c. AD 870), where the visit of the Christian missionary Ansgar to the Swedish town of Birka in the beginning of the 850s is reported (Trillmich and Buchner 1961, 88–93). It is not clear whether the assemblies providing Ansgar with permission to perform missionary work were of the former or the latter kind, although a case can be made for the latter. The possibility that a dual temporal structure for assemblies similar to that of the high medieval period also existed in the Viking age can, however, not be excluded. Nonetheless, we cannot infer from the inscription on Ingifriðr's rune-stone which type of assembly Assurr was killed at, since the inscription can read "Øyulfr did it at *the* autumn assembly" as well as "Øyulfr did it at *an* autumn assembly." In any case, the author of the runic inscription used the harvest season to temporally mark the assembly, while the zeitgeber for the assembly remains unknown.

The sources surveyed so far relate to seasonal changes in the environment during the solar year. Since the economy of Viking-age Scandinavia was primarily built on agriculture and animal husbandry (Jørgensen 2002, 130–38; Hybel and Poulsen 2007, 197–223), it is reasonable to assume that these seasonal changes had an important influence on the temporal organization of social activities throughout the solar year since the many different tasks on the farms were performed when required. Thus for these tasks, the zeitgebers

9 For the Viking-age practice of erecting commemorating rune-stones see Sawyer (2000).

came from primarily seasonal and biological pacers. This temporal organization of social practices is identical with the task-oriented time described by E.P. Thompson (1967, 58–60), where the task defines the time.[10]

The economic basis in agriculture and animal husbandry was a common feature for all of western and northern Europe in the early medieval period. The prominent influence of the farmers' task-oriented time was therefore not limited to Scandinavia during this period, but an integral part of a general early medieval time-scheme as highlighted by earlier studies of Hohn (1984, 17–68) and Zoll (1988, 72–78). Dmitri Starostine has also noted for the Carolingian kingdoms that "[c]harters from large monasteries suggest that peasants and monastic administrators alike often thought about time in terms of seasons; winter and summer, autumn and spring" (2006, 478). Thus, the seasonal changes visible in nature were salient pacers in the temporal organization of social activities all over northern and western early medieval Europe.

In addition to pacers connected with agricultural and pastoral activities, the Scandinavian sources attest to the existence of other pacers, primarily the Moon providing cues at new moon and full moon, although the sources are ambiguous. In the eddic poem *Alvíssmál* (st. 14), the Moon is referred to as year-counter (*ártali*), while the eddic poem *Vǫluspá* (st. 6) relates that the gods gave names to the night, the waning moon, the morning, the midday, the midday meal, and the evening to count the years (*nótt oc niðiom / nǫfn um gáfo / morgin héto / oc miðian dag / undorn oc aptan / árom at telia*). The eddic poem *Vafðrúðnismál* (st. 23) relates that the Sun and the Moon cross the sky every day so humans can count the years (*himin hverfa / þau scolo hverian dag / ǫldom at ártali*), and according to the same poem (st. 25), the gods for the same purpose created the waxing and waning moon (*ný oc nið / scópo nýt regin / ǫldom at ártali*) (Neckel and Kuhn 1983, 2, 48–49, 126). Here, the counting of years is a poetical reference to tracing time. Regarding the Moon, the waxing and waning moon is specified in all three instances, although it is not mentioned which social practices were timed in accordance with this.[11]

The rhythm of the lunar phases is the only uniform and recurrent temporal rhythm documented for Viking-age Scandinavia longer than the shift between day and night and shorter than the solar year. The seven-day week is only

10 See Glennie and Thrift (2009, 42–47) for a recent evaluation of Thompson's influential study.

11 The dating of eddic poems is a matter of much controversy, cf. Fidjestøl (1999). Space limitations preclude a discussion of the dating of the three relevant poems here, but we may note that at least *Vafðrúðnismál* and *Vǫluspá* traditionally are ascribed Viking-age dates.

documented from the eleventh century onwards (Sonne 2014) and it is highly probable that it was introduced as a result of the official acceptance of Christianity. We can consequently hypothesize that the lunar phases were important for the temporal organization of social activities performed on short-term intervals.

Regarding the Sun, the single reference in *Vafðrúðnismál* is so general that the text could just as well refer to the changing seasons during the solar year or to the shift between day and night. Although we cannot follow Andreas Nordberg (2006, 66–70) in his interpretation that these three instances provide evidence for a lunisolar time-scheme, as no connection between the different rhythms is inferred, the instances do, however, suggest that at least the Moon was a pacer by providing zeitgebers in the form of new moon and full moon.

In addition to these three eddic poems, we have an obscure reference to the worship of the star Sirius found in a work on the world's geography by the thirteenth-century Persian scholar Zakarija ibn Muhammad ibn Mahmud al-Qazwini. In this work, al-Qazwini quotes an earlier eleventh-century text by the Spanish Arab Ahmad ibn Omer al-'Udri who had written down the oral account of an older contemporary Spanish Arab, Ibrahim ibn Ahmad at-Tartuschi. The latter had in the second half of the tenth century visited the Danish town Hedeby located at the bottom of the Schlei fjord where the Jutland peninsula meets the continent (in modern-day Germany).[12] In an excerpt provided by al-Qazwini from the work of al-'Udri, at-Tartuschi describes the population of Hedeby, including some of their religious practices. Al-Qazwini introduces this excerpt by stating that Hedeby consists of a minority of Christians and a majority of pagans, the latter worshipping the star Sirius (Jacob 1927, 29; 1896, 33–34).

In so far as al-Qazwini's statement is trustworthy we have here a unique piece of evidence for astrological awareness in Viking-age Scandinavia. However, there are important source-critical issues with the statement, since it is not part of the quoted account attributed to at-Tartuschi. We therefore do not know whether the information on Sirius goes back to at-Tartuschi or whether it is al-Qazwini's own interpretation, or rather a learned guess, based on information in at-Tartuschi's account. It is furthermore possible, as suggested by the Norwegian translator of al-Qazwini, Harris Birkeland (1954, 159),

12 For the transmission of at-Tartuschi's account see Hægstad (1964, 82–84). Hægstad, however, argues unconvincingly that at-Tartuschi is not describing Hedeby, but instead the town of Jumne located where the Oder River flows into the Baltic Sea. For the history and archaeology of Hedeby see Laur et al. (1999).

that the reference to the worship of Sirius is simply a way of stating that the majority of the population in Hedeby is pagan.

At-Tartuschi's account of the rituals performed in Hedeby does not mention when the rituals took place, which is characteristic for the majority of the sources documenting religious practices in Viking-age Scandinavia. Some rituals were clearly performed *ad hoc* when circumstances required them, but evidence also suggests that some religious practices took place at predetermined and fixed times. This applies, for example, for the annual pre-Christian Yule feast, although the Yule feast is poorly documented in contemporary sources (Simek 2006, under "Jul").

The oldest and only pre-Christian reference appears in the skaldic poem *Haraldskvæði* composed by Þórbjǫrn hornklofi for the Norwegian king Harald Finehair around AD 900. In the poem, Þórbjǫrn praises Harald's achievements in war, including Harald's distaste for the comfortable indoor life (st. 6): "The courageous leader wants to toast the Yuletide out at sea, if he alone has his way, and practice the sport of Freyr [i.e. war]. (When) young he grew tired of cooking by the fire and sitting indoors, of a warm women's chamber and of mittens filled with down" (*Úti vill jól drekka | ef skal einn ráða | fylkir inn framlyndi | ok Freys leik heyja. | Ungr leiddisk eldvelli | ok inni at sitja | varma dyngju | eða vǫttu duns fulla*) (Whaley 2012, 1:99).

The next reference to the Yule feast comes from a skaldic poem by Sigvatr Þórðarson composed in the latter half of the 1020s and dealing with the chieftain Erlingr Skjálgsson. Here, the Yule feast is again associated with drinking, but Sigvatr, like Þórbjǫrn, provides no information on the timing of the feast (st. 8) (Whaley 2012, 2:640). Sigvatr is primarily known for his connection with the Danish king Canute the Great and the Norwegian king Óláfr Haraldsson, the later Óláfr the Saint, and it is therefore possible that the Yule feast referred to by Sigvatr, in fact, was the Christian celebration of the birth of Christ on 25 December. Indeed, after the introduction of Christianity, the Old Norse name for the pre-Christian Yule feast (*jól*) was used to name the Christmas feast (cf. modern Danish, Norwegian, and Swedish *jul*). This suggests that the pre-Christian Yule feast took place in winter at a recurrent and fixed time.

It is, however, not clear how the Yule feast or other temporally fixed religious rituals were timed. In the light of the previously quoted stanzas from the three eddic poems, a connection with the lunar phases appears likely, but more locally determined zeitgebers are also a possibility. Only the chronicle of the German bishop Thietmar of Merseburg, written over a period of six years up to December AD 1018 when Thietmar died, specifies the time of a ritual feast. In connection with a description of Henry the Fowler's military victory over the Danes in AD 931 or 934, followed by the acceptance of Christianity by the

Danish king, Thietmar adds an excursus on the pagan practices of the Danes at the site of Lejre on the island of Seeland. According to Thietmar, the Danes stopped their pagan ritual practices as a consequence of their defeat by Henry:

> In those parts, the centre of the kingdom is a place called Lejre, in the region of Seeland. Every nine years, in the month of January, after the day on which we celebrate the appearance of the Lord, they all convene here and offer their gods a burnt offering of ninety-nine human beings and as many horses, along with dogs and cocks—the latter being used in place of hawks. (Warner 2001, 80; Warner's spelling Leire is here rendered Lejre)

> (*Est unus in his partibus locus, caput istius regni, Lederun nomine, in pago, qui Selon dicitur, ubi post viiii annos mense Ianuario, post hoc tempus, quo nos theophaniam Domini celebramus, omnes convenerunt, et ibi diis suimet lxxxx et viiii homines et totidem equos, cum canibus et gallis pro accipitribus oblatis, immolant.*) (Holtzmann 1955, 22–24)

Thietmar's main source for the events in AD 931 or 934, the chronicle of Widukind of Corvey, does not mention the pagan rituals of the Danes (Rotter and Schneidmüller 1981, 94–97), but it has been tentatively suggested that Thietmar's source for the pagan sacrifices at Lejre was the Danish bishop Odinkar the Older whom Thietmar had met in Dortmund in July AD 1005 (Sonne 2013b, 124–26).

The account appears exaggerated on several points, for example, the high number of sacrificed humans.[13] This is partly explained by Thietmar's reason for including the former pagan practices of the Danes in his narrative, namely to emphasize the righteous deeds of Henry the Fowler, but as the original context of the description is unknown (if Odinkar indeed is Thietmar's source), we lack a clear understanding of its original purpose. This also hampers our interpretation of the time of the religious feast. Thietmar specifies that it took place after the Christian celebration of Epiphany on 6 January, but the exact number of intervening days is not mentioned. Furthermore, as the Julian calendar was not in use among the Danes in the first half of the tenth century, we

13 The practice of human sacrifice in Viking-age Scandinavia is contested, but where the evidence, primarily archaeological excavations, suggests the performance of human sacrifice or ritual killings of humans, the number of humans is limited to a few individuals, often only one person. These killings are primarily connected with funeral ceremonies (Simek 2006, under "Menschenopfer"; Price 2008, 266–67).

are confronted with the methodological problem of converting the approximate time of celebration from one known time-scheme to another, by and large unknown time-scheme. It is therefore impossible to clarify which precise zeitgeber the ritual feast was timed after. The suggestion by Nordberg (2006, 106–7) of a connection between the ritual feast at Lejre and the pre-Christian Yule feast is, however, unlikely since Thietmar notes that the celebration at Lejre only took place every ninth year.

3 From Traces to a Time-Scheme Model

Having surveyed the contemporary sources for traces of the temporal organization of social activities, we can now attempt a synthesis of these traces to reconstruct a model for the time-scheme of Viking-age Scandinavia. A more detailed model is precluded by the limited source material, but we can lay out the basic structure of the scheme. To conclude from the survey, social activities were temporally organized in accordance with the lunar phases and seasonal changes relevant for agricultural and pastoral activities. To these we should also add the general influence of the shift between day and night. More localized changes in nature than the larger seasonal changes relevant for agriculture and animal husbandry may also have marked the time for social activities—such as, perhaps, noticeable differences in sea levels due to strong tides relevant for seafaring. But as these local zeitgebers are not directly documented we need to be careful when postulating the existence of specific environmental time-markers. No evidence suggests the timing of activities by the equinoxes, the solstices, weeks of varying lengths, or any attempts at constructing a lunisolar year. While this may be a case of absence of evidence rather than evidence of absence given the fragmentary character of the source material, it nonetheless puts the burden of proof on the scholars arguing for their use as zeitgebers.[14]

It can be argued that timing of social activities by equinoxes, solstices, weeks, or lunisolar years is common enough from a comparative perspective to allow for the hypothesis of their use in Viking-age Scandinavia. However, none of them are universal, and their use in past and present societies may be linked to social, political, or ideological needs not necessarily present in Viking-age Scandinavia. To take the week as an example, anthropological studies often connect weeks with the short-term timing of local markets

14 For the summer solstice see also Billington (2008), although her approach to the written sources is lacking in source criticism.

(Maxwell 1972, 62–63; Nilsson 1920, 324–36).[15] But local markets in short-term intervals were not needed to sustain everyday life on Viking-age farms, since they were predominantly self-sufficient, producing all the food, clothes, and most tools needed. Some objects were purchased on markets, for example, finer jewelry, beads, and combs, but these goods would not necessitate regular local markets on a weekly basis. The practical needs of the farms could be served by occasional visits to permanent or seasonal trading sites.[16]

Altogether, this suggests that the Viking-age time-scheme relied on zeitgebers that were observable to the human eye without the use of time-tools. Such tools appear therefore not to have been a necessary requirement, neither in the hands of experts nor disseminated among a wider part of the population, when timing social activities. It is probably no mere coincidence that time-tools hitherto have not been documented for Viking-age Scandinavia.

Regarding the specific social activities timed in accordance with the shift between day and night, the lunar phases, and the seasonal changes, the information in the sources is limited. Many of the activities related to agriculture and animal husbandry are dependent on the seasons of the solar year, so that one might justify drawing on information from later periods and comparative studies. An example could be the year-wheel for the eighteenth-century forest farmer's tasks as presented in Svensson (2008, 41). This approach would, however, eliminate differences across time and space.

As for other social activities, we are left in the dark. The absence of administrative institutions working with written records suggests that political and social authorities in Viking-age Scandinavia had less opportunity for influencing and controlling local social practices than their contemporaries in early medieval Europe.[17] The oral mode of communication in Viking-age Scandinavia must have led to more diverse time-schemes, on both local and regional levels, for social practices that were not directly connected with biological rhythms and larger seasonal changes in the environment. A uniform time-scheme therefore probably never developed in the kingdoms of Scandinavia in the Viking age.

15 Zerubavel (1985, 5–26) treats the history of the seven-day week.
16 The sparse evidence for markets in Viking-age Scandinavia is discussed in Sawyer (1986, 68–74). The regulations for the timing of the medieval Swedish winter fair *Distingen* need not date back to the pre-Christian period.
17 The introduction of written administrations in medieval Scandinavia is discussed by Bagge (2010, 229–92).

4 Back to the Julian Calendar

I began this article at the end of the Viking age when ecclesiastical institutions, and their Julian calendar, were introduced in Scandinavia. I will end with remarks on some of the more important changes in the social time that the new calendar brought about.

The Julian calendar belongs to a category of calendars that Sacha Stern has labeled "fixed calendar," that is, a calendar "determined in advance by a set calculation or following a set scheme" (2012, 3). Thus, the Julian calendar, independently of any outside cues or signals, provides a unique designation, namely month and day-number, to each of the 365 days that make up a Julian calendar year (366 days in leap years). In addition, all days in the calendar (in its medieval form) are grouped into recurrent units of seven days (the seven-day week).[18] A fixed calendar becomes an external pacer providing zeitgebers, namely calendar dates, when social activities are connected to specific points of time defined by the calendar. In this way, the Julian calendar belongs to a group of cognitive artifacts discussed by Kevin Birth that trace time for its users without the users necessarily understanding the underlying logic of the way the artifact traces, or maybe rather constructs, time—in the words of Kevin Birth: "By stating it is April, calendars make it April for their users" (2013, 219–20).

The social importance of the Julian calendar in early medieval Europe has been laid out in a survey by Hans-Werner Goetz (1989, 134–54) of the timing of central political and economic activities. He documents, primarily in France and Germany, that these activities, including fairs and political assemblies, often were temporally organized according to central cues in the medieval Julian calendar, namely the feast-days that constituted the ritual year of the Church (see also Goetz 1991; Starostine 2006, 470–71).

The feast-days of the medieval Church were of two types: fixed and movable.[19] It is characteristic of the former that they each fall on the same calendar day every year, for example Lady Day (Annunciation) on 25 March and All Saints Day on 1 November. The feast-days of the latter type are movable as they change their Julian calendar date from year to year. This is a consequence of their temporal linkage with Easter. Easter is, in principle, temporally fixed according to three parameters: the spring equinox, the seven-day week,

18 The origin of the Julian calendar is presented by Rüpke (2011, 109–21) and Stern (2012, 204–27).

19 The basic structure of the ritual year of the medieval Church is presented by Borgehammar (2005).

and the lunar phases. During late antiquity, the calculation of the right time for the Easter celebration was denaturalized since the spring equinox was set to 21 March and the full moon was determined according to mathematical models of the Moon's orbit around Earth.[20] This made it possible, with the aid of medieval calendar science (*computus*), to calculate the Julian calendar date of any past and future Easter, and thereby also any past and future dates for any of the movable feasts.[21]

It follows that the introduction and gradual implementation of the fixed Julian calendar, from the end of the Viking age onwards, meant a fundamentally new way of timing social activities: from rhythms in nature to units in the Julian calendar organizing social life after the seven-day week, months of 28, 29, 30, or 31 days, and a year of 365 or 366 days. These units provided a closer temporal grid with which to organize social activities, but they also, in a long-term perspective, detached the timing of activities from any observation of nature. This detachment made necessary the use of time-tools, directly or indirectly, telling the time in accordance with the new calendar. In a long-term perspective, the time of the society became mediated by technical devices.

Lennart Lundmark has argued that the use of technological devices has shaped the human experience of time. From the invention of mechanical clocks to the introduction of standard time and summer time (daylight saving time), Lundmark traces the separation of time and nature, concluding that our "concept of time is molded by practical procedures and demands in everyday life" (1996, 103). The Julian calendar is not included in Lundmark's argument, but from the above it can be argued that the introduction of this calendar in Scandinavia was the first step in the separation process described by Lundmark. The change from the Viking-age time-scheme to a time-scheme organized in accordance with the Julian calendar was therefore not just a change in the temporal organization of social life—it was the beginning of a new understanding of time.

20 The debates in late antiquity and early medieval Europe on the correct time to celebrate Easter are presented by Mosshammer (2008) and Warntjes and Cróinín (2010).
21 The medieval *computus* is described in contemporary handbooks by, for example, Byrhtferth and Bede. See Baker and Lapidge (1995) and Jones (1943, 173–291; translated by Wallis 1999).

References

Adam, Barbara. 1990. *Time and Social Theory*. Cambridge: Polity Press.

Ancona, Deborah, and Chee-Leong Chong. 1996. "Entrainment: Pace, Cycle, and Rhythm in Organizational Behavior." *Research in Organizational Behavior* 18: 251–84.

Bagge, Sverre. 2010. *From Viking Stronghold to Christian Kingdom. State Formation in Norway, c. 900–1350*. Copenhagen: Museum Tusculanum Press.

Baker, Peter S., and Michael Lapidge, eds. and trans. 1995. *Byrhtferth's Enchiridion*. Early English text society ss 15. Oxford: Oxford University Press.

Benediktsson, Jacob, ed. 1968. *Íslendingabók*, Íslenzk fornrit 1. Reykjavik: Hið Íslenzka Fornritafélag.

Berend, Nora, ed. 2007. *Christianization and the Rise of Christian Monarchy. Scandinavia, Central Europe and Rus' c. 900–1200*. Cambridge: Cambridge University Press.

Billington, Sandra. 2008. "The Midsummer Solstice as it Was, or Was Not, Observed in Pagan Germany, Scandinavia and Anglo-Saxon England." *Folklore* 119: 41–57.

Birkeland, Harris, trans. 1954. *Nordens historie i middelalderen etter arabiske kilder*. Skrifter utgitt av Det norske Videnskabs-akademi i Oslo, II. Hist. Filos. Klasse 1954/2. Oslo: Jacob Dybwad.

Birth, Kevin. 2013. "Calendars: Representational Homogeneity and Heterogeneous Time." *Time and Society* 22: 216–36.

Bluedorn, Allen C. 2002. *The Human Organization of Time. Temporal Realities and Experience*. Stanford: Stanford University Press.

Bolton, Timothy. 2006. "A Textual Historical Response to Adam of Bremen's Witness to the Activities of the Uppsala-Cult." In *Transformasjoner i Vikingtid og Norrøn Middelalder*, edited by Gro Steinsland. Møteplass Middelalder 1, 61–91. Oslo: Unipub.

Borgehammar, Stephan. 2005. "A Monastic Conception of the Liturgical Year." In *The Liturgy of the Medieval Church*, edited by E. Ann Matter and Thomas J. Heffernan, 13–44. Kalamazoo: Medieval Institute Publications.

Brate, Erik, and Elias Wessén, eds. and trans. 1924–36. *Södermanlands runinskrifter*. Vol. 3 of *Sveriges runinskrifter*. 2 vols. Stockholm: Kungl. Vitterhets Historie och Antikvitets Akademien.

Brink, Stefan. 2003. "Legal Assemblies and Judicial Structure in Early Scandinavia." In *Political Assemblies in the Earlier Middle Ages*, edited by P.S. Barnwell and Marco Mostert. Studies in the Early Middle Ages 7, 61–72. Turnhout: Brepols.

Fidjestøl, Bjarne. 1999. *The Dating of Eddic Poetry. A Historical Survey and Methodological Investigation*. Bibliotheca Arnamagnæana 41. Copenhagen: C.A. Reitzels Forlag.

Frank, Roberta. 2005. "Skaldic Poetry." In *Old-Norse Literature. A Critical Guide*, edited by Carol J. Clover and John Lindow. Medieval Academy Reprints for Teaching 42, 157–96. Toronto: University of Toronto Press.

Ginzel, Friedrich Karl. 1906–14. *Handbuch der mathematischen und technischen Chronologie*. 3 vols. Leipzig: J.C. Hinrichs'sche Buchhandlung.

Glamann, Kristof. 1998. *Time-out. Et essay*. Copenhagen: Gyldendal.

Glennie, Paul, and Nigel Thrift. 2009. *Shaping the Day. A History of Timekeeping in England and Wales 1300–1800*. Oxford: Oxford University Press.

Goetz, Hans-Werner. 1989. „Kirchenfest und weltliches Alltagsleben im früheren Mittelalter." *Mediaevistik* 2: 123–71.

———. 1991. „Der kirchliche Festtag im frühmittelalterlichen Alltag." In *Feste und Feiern im Mittelalter. Paderborner Symposium des Mediävistenverbandes*, edited by Detlef Altenburg, Jörg Jarnut, and Hans-Hugo Steinhoff, 53–62. Sigmaringen: Jan Thorbecke Verlag.

———. 2013. *Die Wahrnehmung anderer Religionen und christlich-abendländisches Selbstverständnis im frühen und hohen Mittelalter (5.–12. Jahrhundert)*. 2 vols. Berlin: Akademie Verlag.

Goody, Jack. 1986. *The Logic of Writing and the Organization of Society*. Studies in Literacy, Family, Culture and the State. Cambridge: Cambridge University Press.

Grønlie, Siân, trans. 2006. *Íslendingabók*, Viking Society for Northern Research, Text Series 18. London: University College London.

Hohn, Hans-Willy. 1984. *Die Zerstörung der Zeit. Wie aus einem göttlichen Gut eine Handelsware wurde*, Fischer Alternativ. Frankfurt am Main: Fischer Taschenbuch Verlag.

Holtzmann, Robert, ed. 1955. *Die Chronik des Bischofs Thietmar von Merseburg und ihre Korveier Überarbeitung*. Monumenta germaniae historica, scriptores rerum germanicarum, nova series 9. Berlin: Weidmannsche Verlagsbuchhandlung.

Hybel, Nils, and Bjørn Poulsen. 2007. *The Danish resources c. 1000–1550. Growth and recession*. The Northern world 34. Leiden: Brill.

Hægstad, Arne. 1964. "Har at-Tartuschi besøgt Hedeby (Slesvig)?" *Aarbøger for nordisk oldkyndighed og historie*: 82–92.

Jacob, Georg, trans. 1896. *Ein arabischer Berichterstatter aus dem 10. Jahrhundert. Artikel aus Qazwînîs Āthâr al-bilâd*. Berlin: Mayer & Müller.

———. 1927. *Arabische Berichte von Gesandten an germanische Fürstenhöfe aus dem 9. und 10. Jahrhundert*. Quellen zur deutschen Volkskunde 1. Berlin & Leipzig.

Janson, Svante. 2011. "The Icelandic Calendar." *Scripta Islandica* 62: 51–104.

Jones, Charles W., ed. 1943. *Bedae opera de temporibus*. Cambridge: The Mediaeval Academy of America.

Jørgensen, Lise Bender. 2002. "Rural Economy: Ecology, Hunting, Pastoralism, Agricultural and Nutritional Aspects." In *The Scandinavians from the Vendel period to the Tenth Century. An Ethnographic Perspective*, edited by Judith Jesch. Studies in Historical Archaeoethnology 5, 129–52. Woodbridge: The Boydell Press.

Källström, Magnus. 2007. *Mästare och minnesmärken. Studier kring vikingatida runristare och skriftmiljöer i Norden*. Acta universitatis Stockholmiensis, Stockholm studies in Scandinavian philology, new series 43. Stockholm: Stockholm University.

Lauer, Robert H. 1981. *Temporal Man. The Meaning and Uses of Social Time*. New York: Praeger.

Laur, Wolfgang, Christian Radtke, Ralf Wiechmann, and Marie Stoklund. 1999. "Haiðaby." In *Reallexikon der germanischen Altertumskunde* vol. 13, edited by Heinrich Beck, Dieter Geuenich, Heiko Steuer, and Dieter Timpe, 361–87. Berlin: Walter de Gruyter.

Lebech, Mogens. 1969. *Fra runestav til almanac*. Copenhagen: Thejls.

Liebgott, Niels-Knud. 1973. *Kalendere. Folkelig tidsregning i Norden*. Copenhagen: The National Museum.

Lind, John. 2012. "Vikinger, vikingetid og vikingeromantik." *Kuml*: 151–70.

Lundmark, Lennart. 1996. "The Separation of Time and Nature." In *Dimensions of Time and Life*, edited by J.T. Fraser and M.P. Soulsby. The Study of Time 8, 97–104. Madison: International Universities Press.

Maxwell, Robert J. 1972. "Anthropological Perspectives." In *The Future of Time*, edited by Henri Yaker, Humphry Osmond, and Frances Cheek, 36–72. London: Hogarth Press.

Mortensen, Lars Boje. 2006. "Sanctified Beginnings and Mythopoietic Moments. The First Wave of Writing on the Past in Norway, Denmark, and Hungary, c. 1000–1230." In *The Making of Christian Myths in the Periphery of Latin Christendom (c. 1000–1300)*, edited by Lars Boje Mortensen, 247–71. Copenhagen: Museum Tusculanum Press.

Mosshammer, Alden A. 2008. *The Easter Computus and the Origins of the Christian Era*. Oxford: Oxford University Press.

Neckel, Gustav, and Hans Kuhn, eds. 1983. *Edda. Die Lieder des Codex Regius nebst verwandten Denkmälern*. Germanische Bibliothek, 4. Reihe, Texte. Heidelberg: Carl Winter Universitätsverlag.

Nilsson, Martin P. 1920. *Primitive Time-Reckoning. A Study in the Origins and First Development of the Art of Counting Time among the Primitive and Early Culture Peoples*. Skrifter utgivna av Humanistiska Vetenskapssamfundet i Lund 1. Lund: C.W.K. Gleerup.

Nordberg, Andreas. 2006. *Jul, disting och förkyrklig tideräkning. Kalendrar och kalendariska riter i det förkristna Norden*, Acta academiae regiae Gustavi Adolphi 91. Uppsala: Kungl. Gustav Adolfs Akademien för svensk folkkultur.

Olsen, Olaf. 1966. *Hørg, hov og kirke. Historiske og arkæologiske vikingetidsstudier*. Copenhagen: G.E.C. Gad.

Price, Neil. 2008. "Dying and the Dead." In *The Viking World*, edited by Stefan Brink and Neil Price, 257–73. London: Routledge.

Rice, Prudence M. 2008. "Time, Power, and the Maya." *Latin American Antiquity* 19: 275–98.

Roesdahl, Else. 1994. "Vikingerne i dansk kultur." *Fortid og nutid* 41: 158–72.

Rotenberg, Robert. 1992. "The Power to Time and the Time to Power." In *The Politics of Time*, edited by Henry J. Rutz. American Ethnological Society Monograph Series 4, 18–36. Arlington: American Anthropological Association.

Rotter, Ekkehart, and Bernd Schneidmüller, eds. and trans. 1981. *Widukind von Corvey: Res gestae Saxonicae. Die Sachsengeschichte*. Stuttgart: Philipp Reclam.

Rüpke, Jörg. 2011. *The Roman Calendar from Numa to Constantine. Time, History, and the Fasti*. Chichester: Wiley-Blackwell.

Rutz, Henry J. 1992. Introduction to *The Politics of Time*, edited by Henry J. Rutz. American Ethnological Society Monograph Series 4, 1–17. Arlington: American Anthropological Association.

Sawyer, Birgit. 2000. *The Viking-Age Rune-Stones. Custom and Commemoration in Early Medieval Scandinavia*. Oxford: Oxford University Press.

Sawyer, Birgit, and Peter Sawyer. 2002. *Die Welt der Wikinger*. Die Deutschen und das europäische Mittelalter. Berlin: Siedler.

Sawyer, Birgit, Peter Sawyer, and Ian Wood, eds. 1987. *The Christianization of Scandinavia*. Alingsås: Viktoria Bokförlag.

Sawyer, Peter. 1986. "Early Fairs and Markets in England and Scandinavia." In *The Market in History*, edited by B.L. Anderson and A.J.H. Latham, 59–77. London: Croom Helm.

Schroeter, Jens Fredrik. 1923–26. *Haandbog i kronologi*. 2 vols. Kristiania/Oslo: Cammermeyers Boghandel.

von See, Klaus. 1999. *Europa und der Norden im Mittelalter*. Heidelberg: Carl Winter.

Simek, Rudolf. 2006. *Lexikon der germanischen Mythologie*. Stuttgart: Alfred Kröner Verlag.

Sonne, Lasse C.A. 2013a. *Thor-kult i vikingetiden. Historiske studier i vikingetidens religion*. Studier fra Sprog- og Oldtidsforskning 349. Copenhagen: Museum Tusculanum Press.

———. 2013b. "Til Thietmar af Merseburgs beskrivelse af Lejre." In *Vikingetid i Danmark*, edited by Henriette Lyngstrøm and Lone G. Thomsen, 123–26. Copenhagen: Saxo-Institute, University of Copenhagen.

———. 2014. "The Origin of the Seven-Day week in Scandinavia (Part 1): the Theophoric Day-Names." *Viking and Medieval Scandinavia* 10: 187–209.

Starostine, Dmitri. 2006. "... in die festivitatis: Gift-Giving, Power and the Calendar in the Carolingian Kingdoms." *Early Medieval Europe* 14: 465–86.

Stern, Sacha. 2012. *Calendars in Antiquity. Empires, States, and Societies*. Oxford: Oxford University Press.

Svanberg, Frederik. 2003. *Decolonizing the Viking age*. 2 vols. Stockholm: Almqvist & Wiksell.

Svensson, Eva. 2008. *The Medieval Household. Daily Life in Castles and Farmsteads. Scandinavian Examples in their European Context*. The Medieval Countryside 2. Turnhout: Brepols.

Thompson, E.P. 1967. "Time, Work-Discipline, and Industrial Capitalism." *Past and Present* 38: 56–97.

Trillmich, Werner, and Rudolf Buchner, eds. and trans. 1961. *Quellen des 9. und 11. Jahrhunderts zur Geschichte der hamburgischen Kirche und des Reiches*. Ausgewählte Quellen zur deutschen Geschichte des Mittelalters, Freiherr vom Stein-Gedächtnisausgabe 11. Darmstadt: Wissenschaftliche Buchgesellschaft.

Tulinius, Torfi H. 2000. "The Matter of the North: Fiction and Uncertain Identities in Thirteenth-Century Iceland." In *Old Icelandic Literature and Society*, edited by Margaret Clunies Ross. Cambridge Studies in Medieval Literature 42, 242–65. Cambridge: Cambridge University Press.

Wallis, Faith, trans. 1999. *Bede: The Reckoning of Time*. Translated Texts for Historians 29. Liverpool: Liverpool University Press.

Warner, David A., trans. 2001. *Ottonian Germany. The Chronicon of Thietmar of Merseburg*. Manchester Medieval Sources Series. Manchester: Manchester University Press.

Warntjes, Immo, and Dáibhí Ó Cróinín, eds. 2010. *Computus and its Cultural Context in the Latin West, AD 300–1200*. Studia traditionis theologiae 5. Turnhout: Brepols.

Whaley, Diana, ed. and trans. 2012. *Poetry from the Kings' Sagas 1: From Mythical Times to c. 1035*. Vol. 1 of *Skaldic Poetry of the Scandinavian Middle Ages*. 2 vols. Turnhout: Brepols.

Whitrow, G.J. 1980. *The Natural Philosophy of Time*. Oxford: Clarendon Press.

Winroth, Anders. 2012. *The Conversion of Scandinavia. Vikings, Merchants, and Missionaries in the Remaking of Northern Europe*. New Haven: Yale University Press.

Zerubavel, Eviatar. 1985. *The Seven Day Circle. The History and Meaning of the Week*. Chicago: University of Chicago Press.

Zoll, Rainer. 1988. "Zeiterfahrung und Gesellschaftsform." In *Zerstörung und Wiederaneignung von Zeit*, edited by Rainer Zoll, Edition Suhrkamp 1411, 72–88. Frankfurt am Main: Suhrkamp.

CHAPTER 7

Time and Memory in the *Odyssey* and *Ulysses*

Stephanie Nelson

Abstract

Although scholarship has seen the *Odyssey* as providing only scaffolding for Joyce's *Ulysses*, Joyce takes over from Homer the important theme of memory, the trace of the past as it affects the present and future. Like Telemachus, Stephen Dedalus, who famously declares that "History [...] is a nightmare from which I am trying to awake" (*U* 2.372) is trapped by his past, while Bloom, like Odysseus, feels cut off from his past and his once happy relation with his wife. *Ulysses*, however reveals him rather to be trapped by the memory of his dead son, Rudy, as Odysseus is trapped in a world of myth. Joyce, like Homer, addresses this issue in two ways, through Bloom's wife, Molly, who, like Penelope, weaves together past, present, and future, and through the figure of the author. Just as Homer's singers bring the poet himself into his poem, Joyce brings his own life into his novel, while creating a new *Odyssey*. Joyce thus uses a past now "fabled by the daughters of Memory" (*U* 2.7) to recreate, and so reappropriate, both his personal and his literary past.

Keywords

Homer – *Odyssey* – Joyce – *Ulysses* – memory – time – entrapment – oral tradition – epic

⋯

> Only through time time is conquered.
> T.S. ELIOT, *Four Quartets*

⋮

1

Despite the extensive work that has been done both on the relation of Joyce's *Ulysses* to the *Odyssey* and on the theme of time and memory in *Ulysses*, no recent work has analyzed how closely these two aspects of Joyce's novel work together.[1] This is largely due to the approach scholars have taken to Joyce's relation to Homer. While scholars have looked closely at the various correspondences of narrative, they have been far less concerned with how the larger overall themes, beyond the narrative of the *Odyssey*, are used by Joyce. Many scholars also see the importance of Homer as negligible. Sam Slote argues in his recent edition of *Ulysses* that Joyce's Homeric references are largely incidental and, as Cynthia Hornbeck has pointed out: "loose adaptations, coupled with the seeming red herring of minor verbal correspondences, have discouraged recent critics from examining individual episodes closely in the light of their Homeric origins."[2] Perhaps even more importantly, scholars who do not dismiss the importance of Homer to *Ulysses* nonetheless tend to see the relation as largely ironic, if not cynical. As Franco Moretti put it as far back as 1997: "Free at last from the interlinear Homer–Joyce homework, it is no longer possible to doubt that Joyce uses myth only to desecrate it, and through it to desecrate contemporary history: to parody Bloom with Ulysses, and Ulysses with Bloom; to create an order which gives greater relief to the absence of order, a nucleus gone haywire with irony and distortions."[3] Such readings, however,

1 For example, Rickard's excellent work on memory in *Ulysses* considers the *Odyssey* as a "palimpsest" (Rickard 1999, 169) but looks at "return" metaphorically rather than at the theme of time or memory in Homer: "Though Bloom and Stephen need somehow to confront the past, to find, and if possible untangle the anxieties and doubts knotted around the traumatic deaths of May Goulding Dedalus and Rudy Bloom, they, like Odysseus, may have difficulty returning the way they came [...]" (46). Similarly, Ferrer's work (2009) on the "secondary" nature of the Homeric references in *Ulysses* follows the recent focus on Joyce's addition of Homeric parallels, rather than any thematic reading of Homer.

2 Hornbeck 2009, 90; Slote 2012 and see Kenner 1987a, 27–29 for some of these often amusing "minor correspondences" which he describes as "largely comic" (1987b, 182). This view extends back to Ezra Pound's declaration that the parallel is just "a scaffold, a means of construction" (1968, 406), also cited in Litz 1964, 21. For other considerations of Joyce and Homer which look primarily to "parallels" rather than themes see Wykes 1968; Ellman 1977, 569; Fuller 1992, 32.

3 Moretti 1997, 192. See also Norris 1988, 48: "[Joyce] appears to offer us the classics and myth [...] but gives us instead mainly the inscription of their absence." Similarly, though writing from the viewpoint of a Classicist, Lillian Doherty: "Joyce's use of the Penelope figure is, in

tend to ignore both the complexity of Homer's epic and the deep similarities of theme shared by the *Odyssey* and *Ulysses*.[4] Extending far beyond its casual references and amusing parallels, *Ulysses* also adopts from the *Odyssey*, and transforms, one of its deepest themes, that of the relationship of time, change, memory, and the problem of identity.

Throughout *Ulysses* characters are obsessed by the problem of identity: since we are constantly changing in time, how can we know who we are? Stephen's wordplay concerning his debt to George Moore (A.E.) points to memory as the chain that binds him to the past:

> Wait. Five months. Molecules all change. I am other I now. Other I got pound.
> Buzz. Buzz.
> But I, entelechy, form of forms, am I by memory because under ever-changing forms.
> I that sinned and prayed and fasted.
> A child Conmee saved from pandies.
> I, I and I. I.
> A.E.I.O.U. (*U* 9.210)[5]

Leopold Bloom raises the same question, but in his eyes the unending flow of time rather carries him always further away from the past:

the first place, ironic. For his is an unfaithful Penelope—a mythical oxymoron" (1990, 343) and Meadowsong 2010, 63: "In *Ulysses*, the Homeric parallels actually authorize the text's self-disruptive practices and support its anarchic dispute with its own mechanics. Myth becomes, in effect, anarchy's silent backer." The sense of discrepancy between the characters of the epic and those of 1904 Dublin originates in Eliot's description of Joyce's "mythical method" in "Ulysses, Order and Myth" in the *Dial*, November 1923 (Eliot 1975, 175–8). See Rickard 1999, 168–9 and Kershner 2004, 183–8 for an overview of scholarship's treatment of Joyce's relation to Homer and ibid., 186–7 for "ironic" and "scaffolding" readings in particular. In the other direction, for an argument that Homeric references in Joyce begin well before *Ulysses*, see Burr, 2012.

4 Although neither specifically treats the use of Homeric themes in *Ulysses*, Hugh Kenner and Fritz Senn see a deep relation between the works. Kenner 1987b, 181 cites a correspondence "between situation and situation" while Senn, who sees the search for Homeric "parallels" as misdirecting Joycean scholarship (1984, 206), points out that "[p]erhaps the most pervasive Homeric features in *Ulysses* are not the one-to-one relationships that Stuart Gilbert began to chart for us, but principles or motive forces—such as the Protean force of transformation in the third chapter" (1984, 127). Also see "Remodeling Homer" in Senn 1995 for other examples.

5 Quotations are taken from the Gabler edition of *Ulysses*, 1986; references are to episode and line number.

I was happier then. Or was that I? Or am I now I? Twentyeight I was. She twentythree. When we left Lombard street west something changed. Could never like it again after Rudy. Can't bring back time. Like holding water in your hand. Would you go back to then? Just beginning then. Would you? Are you not happy in your home you poor little naughty boy? (*U* 8.610)

Ulysses thus presents two negative versions of our relation to the past before suggesting a third, positive, and creative relation. Stephen Dedalus experiences the past, like history, as an entrapment, "a nightmare from which I am trying to awake" (*U* 2.385). Bloom, in contrast, views the past, in particular his past life with Molly, as an ideal to which he can never return. And for both, their relation to the past is the central issue in coming to understand who they are, and who they may come to be.

This theme is also central to Homer's *Odyssey*, which, like *Ulysses*, is a work about shifting identities and the struggle to deal with change over time. Stephen and Bloom recall Telemachus and Odysseus at the opening of the *Odyssey*, the first trapped in his childhood in Ithaca, the second unable to return to the home of his young manhood. Like Stephen, who refers to his father as "the man with my voice and my eyes" (*U* 3.46), Telemachus is growing to resemble his father and yet has no understanding of what that might mean, while the question that surrounds Odysseus is whether he is, or can be, the man he once was. The final "return" of the *Odyssey*, in this way, has as much to do with identity over time as it does with location in space. And as Penelope will prove the critical player in breaking the stalemate of the *Odyssey, Ulysses'* final episode suggests a "return" of Bloom not in time or space, but in the memory of Molly, which brings together past, present, and future.

Ulysses suggests a similar solution on the level beyond the narrative. Joyce's use of Homer, and his reminders of the divine patrons of epic poetry, the Muses, the daughters of Memory (*U* 2.7; 15.4373), reveal a role for the past not only in determining the present, but also as the material from which the future can be formed.[6] In giving the title *Ulysses* to an account of ordinary Dublin life on June 16, 1904, Joyce signaled that his novel had to do with the relation of past and present. And as interest has grown in the way Joyce employs the details of a day in 1904 to explore much later events, such as the Great War for example, or Irish nationalism, the time has come to consider as well how Joyce uses the epic past to reflect upon how the past, brought into the present

[6] See Grethlein 2008 for the role of memory and the past in Homer, particularly as attached to physical objects.

through memory, can be not an obstacle to moving into the future, but rather the very stuff of which the future is made.[7]

2

At first glance the *Odyssey* and *Ulysses* appear to reach opposite conclusions about the possibility of return. Odysseus regains his home, his wife, and his son, while in *Ulysses*' "Ithaca" episode such a return is rejected as "irrational" due to "[a]n unsatisfactory equation between an exodus and return in time through reversible space and an exodus and return in space through irreversible time" (*U* 17.2030). As in the tale of Rip van Winkle, which *Ulysses* uses as a *leitmotif*, or in countless other versions of the story from *The Return of Martin Guerre* to the film *Cast Away*, there is no return. As "Eumaeus" puts it, rejecting the possibility of a "Return of Parnell" (*U* 16.1298):

> Looking back now in a retrospective kind of arrangement all seemed a kind of dream. And then coming back was the worst thing you ever did because it went without saying you would feel out of place as things always moved with the times. (*U* 16.1400)

Unlike the *Odyssey*, it seems, *Ulysses* concludes that you can never return again, since both the place you return to, and the you that returns, are inalterably different.

Such an interpretation, however, undersells the *Odyssey*.[8] While Odysseus succeeds in his return, the epic is also highly aware of the challenge of time. Penelope's first words after acknowledging her husband's return recall the time they have lost forever (23.210–12). The return itself is to lead to another journey and another wandering (11.119ff., 23.248ff.), and even Odysseus' knowledge that his death will come *ex halos*, as foretold by Tiresias (11.134; 23.281),

[7] See Spoo 1986 and Fairhall 1993, 161–213 for Joyce's inclusion of WWI in *Ulysses* and Cheng 1995, 151–248 and Gibson 2002 on Irish nationalism in *Ulysses*.

[8] Hornbeck 2009, 105: "Both the nineteenth-century translators of Homer and Joyce scholars have often operated on the same false assumptions and through the same filters, presupposing that something as culturally sacred as Homer must be without injustice or innuendo, and therefore irrelevant to Joyce's work. But the *Odyssey* is not a simple or edifying poem, and it confronts the complexities of everyday human existence much as *Ulysses* does—without fear." See also Kenner 1987b, 192–3 for Joyce's "Homeric insight," going beyond "Homer's sweaty and quarrelsome Achaeans as unrelaxingly heroic posturers."

is ambiguous, as it could point to a final end that comes either "from out of the sea," or one that comes "far away from the sea" (ibid.). The story of Penelope's weaving and unweaving a shroud for Laertes, told three times in the epic, points to the attempt—and the impossibility—of holding back time. And the more closely we look into the relations of Penelope, Telemachus and Odysseus, the clearer it becomes that, rather than modeling a heroic ideal unapproachable in the modern world, they, like the characters of *Ulysses*, are engaged in an unwinnable contest with time.

It is clear from Joyce's conversations with friends that he thought about the characters of the *Odyssey* in just these very human terms. In his own response to a question about the photograph of a Greek statue of Penelope on his wall in Zurich, Joyce told Frank Budgen and Paul Suter that "she is trying to recollect what Ulysses looks like. You see he has been away many years, and they had no photographs in those days."[9] The extent to which Joyce identified with Odysseus' story appears in his account to Georges Borach of Odysseus' attempt to evade the war by placing his "his little two-year-old son in the furrow" while he was plowing.[10] Traditionally, and more reasonably, it is his infant son that Odysseus places in the furrow. Joyce seems to have transformed the child into a far more mobile two-year-old to match the age of Stephen Dedalus who, like Joyce, was 22 in the year of his "odyssey," not, like Telemachus, 20. Even the well-known letter to Harriet Weaver in which Joyce compares the "initial style" of *Ulysses* to "the rock of Ithaca" explains the ever-changing stylistic shifts of the novel as necessary to capture the *Odyssey*'s expanse of time: "But in the compass of one day to compress all these wanderings and clothe them in the form of this day is for me possible only by such variation which, I beg you to believe, is not capricious" (6 August, 1919).[11]

3

Just as Bloom's relation to time in *Ulysses* resembles that of Odysseus, Stephen's recalls that of Telemachus. Unlike Odysseus, who is attempting a return to the life that he left behind, Telemachus is attempting to break out of the past. The focal point of Telemachus' dilemma is, as it is for Stephen, his mother. The problem is encapsulated in Penelope's reenactment of Odysseus' parting words:

9 Ellmann 1959, 443–4 and see also Budgen 1972, 188.
10 Ellmann 1959, 430.
11 Joyce, *Letters* 1, 1966, 129.

> "I do not know whether the god will spare me, or if I will be taken,
> right there in Troy; here let all things be cared for by you.
> Remember my father and mother in our halls
> as now, or even more, with my being far off.
> But when you see that our son is growing his beard
> marry whomever you wish, forsaking your home."
> That man spoke thus; now all that is being accomplished. (18.265–71)[12]

As long as Telemachus is a child, Penelope is able to hold open a space for Odysseus' return. Once he becomes a man and has taken over the household it will be time for Penelope to marry again. Telemachus will then occupy the space once held by Odysseus, and there will no longer be either a household, or a wife, for Odysseus to return to. For Penelope the problem means that she must keep Telemachus a child. For Telemachus it means that he is trapped in dependency to a father he never knew, by a mother who cannot allow him his independence.

The implicit tension between Telemachus and Penelope appears in Telemachus' need to assert his authority not only to the suitors, but also to his mother. That this attempt at self-assertion is a new element in his relation with his mother, as it is with the suitors (2.310–15), appears in the formulaic phrase that describes both the suitors (1.381, 18.410, 20.268) and Penelope as "astonished" at Telemachus' words (1.360, 22.354).[13] The tension appears even more deeply in Telemachus' insistence that his mother not be told of his voyage. His own, rather unconvincing explanation for this silence: "so that, weeping, she may not harm her fair skin" (2.376) takes on a deeper resonance when we hear Penelope's response to the news that he has left:

> For if I had learned he was planning this journey,
> then either he would have remained, eager though he was for the voyage,
> or he would have left me dead here in the halls. (4.732–4)

12 Greek text taken from W.B. Stanford, ed., 1996. All translations are my own.

13 Similarly, at 17.57 Penelope has no reply to Telemachus' refusal to discuss his journey, but at 17.104–6, after some needling, elicits it ("you could not endure to tell me, / before the proud suitors arrive at our home, / of your father's homecoming, in case you heard of it"). Stanford 1996, 284 comments: "The tone, as Merry observes, may be one of lonely resignation or pettish annoyance, the former being more like a traditional heroine, the latter more human. In any case she extorts what she wants, a statement from Telemachus. The strained relations between a just grown-up son and an anxious mother are well depicted."

As Penelope will tell the disguised Odysseus, Telemachus is eager that she marry. Until she does so, eliminating the possibility of Odysseus' return, he will not be able to take over the household that is rightfully his (19.157–161).

Stephen, like Telemachus, is caught between a father who is absent and a mother who is all too present. In Stephen's case, however, it is his mother's actual death that traps him, along with his recurrent memories of his refusal to kneel and pray for her.[14] The memory, recollected as a dream-image in the first pages of the novel (*U* 1.100), has by "Circe" become a ghost, a *revenant* from a past that he cannot escape.[15] His first response to the scene, remembered as lit by a "ghostcandle" in "ghostly light": "No mother! Let me be and let me live" (*U* 1.270) becomes in Circe his defining, though despairing cry: "*Non serviam*" (*U* 15.4226), "I will not serve." They are the same words (and the same echo of Lucifer's defiance of God) that Stephen used in *Portrait* to declare his independence from his mother and from the service to the Church that she demanded (*P* 117, 239).[16] The echo reveals how little has changed since Stephen Dedalus first attempted to "fly by the nets" of nationality, language, and religion in *Portrait* (*P* 203).

Just as Joyce used the title of *A Portrait of the Artist as a Young Man* to make the autobiographical element of the novel thematic within it, his emphasis on Stephen Dedalus' name in the opening pages of *Ulysses* (*U* 1.11, 13, 34, 36, 80), along with the internal monologue which recalls events from *Portrait*, such as Cranley, Stephen's "Easter service" and above all Stephen's mother (*U* 1.159, 268, 310, *P* 238ff.), calls attention to his importation of Stephen from *Portrait* into *Ulysses*. In this way Joyce is able to have Stephen enter the pages of the new novel laden with the baggage of the past. The Stephen of *Ulysses* thus repeats to the figure representing Ireland, "Old Gummy Granny," and the British soldiers, Privates Carr and Compton, his epigram from *Portrait*: "Do you know what Ireland is? asked Stephen with cold violence. Ireland is the old sow that eats her farrow" (*P* 203, *U* 15.4581). His words to Compton, tapping his brow,

14 For Stephen's relations to his mother see Hill 1993, for a Jungian perspective, Kimball 1991, for a Freudian perspective, Kimball 1980, and for a finally more positive view of Stephen's "haunting," Oded 1985. Interestingly, the event in Joyce's life was a good deal less fraught, as not his mother but Joyce's (not well-respected) uncle demanded that Joyce and his brother kneel while his mother lay in a coma (Ellman 1983, 165).

15 For his mother's death as the origin of Stephen's concern with ghosts see Johnson 1989, 212.

16 References are by page number, to *A Portrait of the Author as a Young Man: Text, Criticism, and Notes*, ed. Chester Anderson, 1968.

"But in here it is I must kill the priest and the king" (*U* 15.4439) indicate that it is history's entrapment of his spirit and imagination that he must escape, and that as yet he has failed to do so.

Between *Portrait* and *Ulysses*, Stephen has attempted his escape in his abortive trip to Paris. Joyce's identification—in the schema he gave to Stuart Gilbert—of Kevin Egan, whom Stephen meets in Paris, with Menelaus indicates a correspondence between Stephen's brief "odyssey" and Telemachus'. However we are to read the results of Telemachus' voyage, in Stephen's case the attempt fails. The Stephen who wrote, on the 26th of April,

> 26 *April*: Mother is putting my new secondhand clothes in order. She prays now, she says, that I may learn in my own life and away from home and friends what the heart is and what it feels. Amen. So be it. Welcome, O life! I go to encounter for the millionth time the reality of experience and to forge in the smithy of my soul the uncreated conscience of my race. (*P* 252)

on June 16 is back in Dublin, summoned for his mother's death, having forged nothing.[17]

Like Telemachus, Stephen sees himself as infantilized. As in his preferred archetype, Hamlet (whose mother/wife is less innocent than Penelope), his mother has foisted upon him a spurious father, the Church, while history itself has indentured him to the British Empire:

– I am a servant of two masters, Stephen said, an English and an Italian.
– Italian? Haines said.
 A crazy queen, old and jealous. Kneel down before me.
– And a third, Stephen said, there is who wants me for odd jobs.
– Italian? Haines said again. What do you mean?
– The imperial British state, Stephen answered, his colour rising, and the holy Roman catholic and apostolic church.
 Haines detached from his underlip some fibres of tobacco before he spoke.

[17] Castle 1993, 311: "At the conclusion of *A Portrait* Stephen exudes confidence; he underestimates history and overestimates the power of art to transcend social and historical realities. What we see in his story as it articulates itself in *Ulysses* is a reconsideration of these estimations which to some degree reveals his own skepticism that any alternative can be found to historical master narratives."

— I can quite understand that, he said calmly. An Irishman must think like that, I daresay. We feel in England that we have treated you rather unfairly. It seems history is to blame. (*U* 1.638)

The association gives Stephen's sense of the bondage of history—"Time has branded them and fettered they are lodged in the room of the infinite possibilities they have ousted" (*U* 2.48)—an intensely personal application.

4

At the opening of the *Odyssey* Telemachus and Odysseus occupy parallel, but opposite situations. Both are trapped on islands, unable to leave for want of a boat. Telemachus, however, is frustrated in his inability to leave Ithaca, while Odysseus is frustrated in his inability to return to it. The contrast between Stephen and Leopold Bloom is similar. While Stephen sees memory as binding him into a past he needs to escape, for Bloom memory taunts him with a past he cannot regain:

> Young life, her lips that gave me pouting. Soft warm sticky gumjelly lips. Flowers her eyes were, take me, willing eyes. Pebbles fell. She lay still. A goat. No-one. High on Ben Howth rhododendrons a nannygoat walking surefooted, dropping currants. Screened under ferns she laughed warmfolded. Wildly I lay on her, kissed her: eyes, her lips, her stretched neck beating, woman's breasts full in her blouse of nun's veiling, fat nipples upright. Hot I tongued her. She kissed me. I was kissed. All yielding she tossed my hair. Kissed, she kissed me.
> Me. And me now.
> Stuck, the flies buzzed. (*U* 8.910)

The moment that Bloom is thinking of here, that he returns to throughout the novel, and that Molly will recall in the novel's last lines, is his proposal on Howth Head and her acceptance. The focus is also an attempted escape from Bloom's continual awareness that one cannot hold back time, as, throughout the day, Bloom attempts to avoid his awareness that at 4:00 pm Molly will meet Blazes Boylan, who is about to become her lover and put an end to the possibility of his return to the happier times of his proposal and early marriage.[18]

18 For Bloom recreating Molly into an Eliadic myth in order to counter the irreversibility of time see Cronin 1982, esp. 442–3.

On the simplest level Bloom and Stephen, like Telemachus and Odysseus, have opposite quandaries, the younger man attempting to escape the past while the older man attempts to return to it. On another level, however, in both the *Odyssey* and *Ulysses*, both son and father are trapped by the past. While Odysseus sees himself as attempting to return to his past life with Penelope, the epic pictures him instead as, like Telemachus, trapped by the past.[19] And while Bloom sees himself as swept away in the flow of time, the novel gradually reveals that he too is trapped by a past event, as implied in Bloom's image of himself and Molly, the two flies, as "stuck." All four characters, Telemachus and Odysseus, Stephen and Bloom, confront a need to escape the past. And for all four the solution appears through memory—specifically, and, paradoxically, through the female characters that represent their entrapment, and through their own recollection of the past that binds them in.[20]

As Homer is deeply aware, the *Odyssey* itself is a trace of time embodied in memory. The poem is set in a historical period, now designated the Mycenaean Age, which occurred about 500 years before Homer. After writing was lost during the Greek Dark Ages, the trace of that time was preserved through an oral tradition of poetry, passed on from one bard to another. The Muses, the "daughters of Memory," as Stephen calls them, serve as the bridge that carries the past forward into the future.

But memory also allows for difference. At the same time that the Muses connect the Mycenaean past with Homer's 8th-century present, the *Odyssey* also, ingeniously, makes use of the discrepancy between the great heroic period of the past, which is the subject of song, and the ordinary reality of the singer's

19 Segal 1983, 46: "Composing, probably, at a time when the heroic ideal is itself undergoing change and redefinition, and when, possibly, epic language is becoming more and more fluid, [Homer] uses traditional elements in new ways and refashions a hero and a style where non-heroic values and fresh social, ethical, and aesthetic currents make themselves felt." Biles 2003, 191 sees the different time-frames rather differently: "Throughout the poem there is a tension between song, which is envisioned even in heroic times as dealing with the past, and the accounts given by the heroes themselves. The latter are more current and a more likely source of information about the living. For both these reasons the heroes' accounts prove to be more valuable than song in confronting the problems at the center of Odysseus' return."

20 In regard to memory Cronin 1982, 437 cites, for example, the potato that Bloom's mother has given him as a charm (the equivalent of the "moly" which Hermes gives Odysseus to ward off Circe's transformative magic): "In the nightmarish 'Circe' chapter, [Bloom] begs Zoe, a whore-mistress, to return it to him: 'There is a memory attached to it. I should like to have it' (555)."

own time.[21] Odysseus, particularly in the course of the magical wanderings he retells, in which he encounters giants, witches, and monsters, is firmly placed in the world of the great heroes of the past. He is part of the old heroic world, the world in which, as is formulaic in the *Iliad*, deeds were accomplished which could not be done by "men as they are now" (1.271–2, 5.303–4, 20. 285–7). This is the world in which Nestor, Menelaus and Helen, all of whom recall Odysseus, are, like the ghosts of the Underworld, trapped.

On Ithaca, however, in the world of Telemachus and Penelope, life is a much more ordinary matter. Here the challenge is not a monstrous Cyclops who can snatch up two men at a time and break their heads against a rock. It is unwanted guests. Odysseus is trapped on the island Ogygia, at the navel of the sea, by a nymph who wishes to make him immortal and unaging. Telemachus is trapped on the island of Ithaca because he does not have a boat. And even when divine assistance appears in the person of Athena, her solution to the problem is somewhat less than magical: she borrows one (2.385).

By employing a split time frame of a mythical, heroic time juxtaposed with the ordinary reality of Ithaca, Homer creates an effect that traps Odysseus not only on Calypso's island, but also, more significantly, in his own mythic past, where there is the possibility of becoming impervious to time. The impossible challenge he faces is to fight his way out of that mythic past back into the mundane present.

As Bloom's history develops over the course of *Ulysses*, a similar challenge appears. Bloom's passing thought, "Could never like it again after Rudy" (*U* 8.610) does not specify whether it is he or Molly who could never like it, and is rather cryptic about what the "it" here is. In accordance with Joyce's usual technique of allowing the reader only gradually to fill in the history of his characters, it is only in the impersonal catalogue of "Ithaca," the novel's penultimate episode, that the reference becomes clear:

> What limitations of activity and inhibitions of conjugal rights were perceived by listener and narrator concerning themselves during the course of this intermittent and increasingly more laconic narration?
>
> By the listener a limitation of fertility inasmuch as marriage had been celebrated 1 calendar month after the 18th anniversary of her birth (8 September 1870), viz. 8 October, and consummated on the same date with female issue born 15 June 1889, having been anticipatorily

21 For the discrepancy between "heroic" and "ordinary" time see Grene 1969 and Whitman 1983.

consummated on the 10 September of the same year and complete carnal intercourse, with ejaculation of semen within the natural female organ, having last taken place 5 weeks previous, viz. 27 November 1893, to the birth on 29 December 1893 of second (and only male) issue, deceased 9 January 1894, aged 11 days, there remained a period of 10 years, 5 months and 18 days during which carnal intercourse had been incomplete, without ejaculation of semen within the natural female organ. (*U* 17.2280)

The two thoughts that have been absorbing Bloom's attention throughout the day, the death of his infant son ten years earlier, and his estrangement from Molly, turn out to be intertwined.

In Bloom's imagination, as in Odysseus', what is needed is a return to the past. In fact, what seems to be needed, before either can fully participate in the present, is an escape from it. What Bloom sees as his consolation, memory, seems rather to be a chain preventing him from moving forward. Joyce, by a little sleight of hand, points us in this direction when he recreates Athena's stalling the rising of the sun on the night that Odysseus and Penelope finally go to bed together. Despite Bloom's obsession, throughout the day, with the constant forward movement of time, when Bloom's watch stops at 4:30 it implies no relief. As Bloom surmises, 4:30 is exactly when Molly and Boylan consummate their relation. The parallel is right. The problem is only that Molly is in bed with the wrong person.

5

But while Odysseus and Bloom, like Telemachus and Stephen, are bound in by the memory of the past, that memory also proves capable of freeing them, specifically through the female characters, Penelope and Molly, both of whom reclaim their own voice only at the end of their respective works. For Odysseus the climax occurs when he explodes at Penelope's suggestion that his bed, which he built around the post of a rooted tree, has been moved. In emotional terms the reunion with Penelope this effects comes about less because he knows the secret of the bed, than because he displays how critical the bed's immovability is to him. Odysseus, after all, is a shape shifter, a master of words, and, throughout the poem, the double of the poet himself. As in his conversation, in disguise, with Penelope, he is as ready in manipulating the memory of the past as he is in manipulating his own appearance (19.204 ff.). The revelation that there is one element of the past where he cannot accept change reveals as well, most importantly to Penelope, his own rootedness in their relation.

The manipulations of the poet, and of Odysseus, show us the memory of the past as fluid and as recreated as it reaches into the future. It is this fluidity that will allow Odysseus, "the man of many turnings" (1.1), to escape from a past in which Nestor, Menelaus and Helen remain mired. Penelope reveals the other side of memory, its rootedness. For her the song of Troy is not, as it is for Telemachus, "the newest song" (1.352) but rather the presence of the past living into, and shaping, the present. As with her account of Odysseus' departure, told to win gifts from the suitors, the past can affect the present. It can also both change and remain fixed. The account of Penelope's weaving and unweaving Laertes' shroud points to this same quality. The creation and uncreation is a dynamic process, but what is created is always the same shroud. In this way Penelope reveals the reason why Odysseus can return to the past that he left behind—exactly because, on this level, he never left it.

That the memory of the past may serve as a portal into the future is also suggested for Bloom at the end of "Circe." After Bloom's musings on Stephen and Rudy in the "Oxen of the Sun" episode, his decision to accompany Stephen through "Circe," and finally Stephen's climactic encounter with the ghost of his mother, Bloom also meets a ghost, the ghost who has been haunting him throughout the day, the ghost of his son Rudy. The difference is that this is now "a fairy boy of eleven" (U 15.4955), the age Rudy would have been had he lived (U 4.420), and the age at which Hamnet Shakespeare, as Stephen argued in "Scylla and Charybdis," died so that *Hamlet* could be born (U 9.172). The vision suggests that the memory of the past can be more than a frozen shell that constrains us. As in the many and creative versions of his own past that Odysseus tells over the course of the *Odyssey*, the memory of the past may itself grow and change over time.

Moreover, just as, in the *Odyssey*, it is Penelope and the persistent image of her weaving that holds the key of joining present and past, in *Ulysses* it is Molly who, in her final monologue, weaves together the past, present and future.[22] On one level she does this simply in her fluid, unpunctuated stream of consciousness. On another she does it by slipping seamlessly from one time frame to another, and by holding together, in a series of undifferentiated "him"s,

[22] See Spoo 1994, 89 and on Molly's anti-historical and anti-teleological narrative, Castle 1993, 323: "Her recollection of the 'dear deaead days beyond recall' (U 762) is the record of a mind remembering and forgetting, creating images and stories in her mind, weaving them with others in a free and unstructured way; but it is also the destruction of the image and story as 'history,' as a realistic (i.e., conventional and authoritative) representation of the past."

Boylan (for whom she might wear a red or white rose), Bloom, and her past lovers while she was a girl in Gibraltar:

> and the castanets and the night we missed the boat at Algeciras the watchman going about serene with his lamp and O that awful deepdown torrent O and the sea the sea crimson sometimes like fire and the glorious sunsets and the figtrees in the Alameda gardens yes and all the queer little streets and the pink and blue and yellow houses and the rosegardens and the jessamine and geraniums and cactuses and Gibraltar as a girl where I was a Flower of the mountain yes when I put the rose in my hair like the Andalusian girls used or shall I wear a red yes and how he kissed me under the Moorish wall and I thought well as well him as another and then I asked him with my eyes to ask again yes and then he asked me would I yes to say yes my mountain flower and first I put my arms around him yes and drew him down to me so he could feel my breasts all perfume yes and his heart was going like mad and yes I said yes I will Yes. (*U* 18.1595)

What Molly's final monologue reveals is her awareness and acceptance of what Stephen and Bloom, in their opposite ways, resist, that the self is Protean and ever-changing in time, and that memory is not a fixed and unalterable record of an unchanging past, but a fluid and dynamic force that creates out of the events of the past a self that is always moving into the future.[23]

6

The same theme that appears in the narrative of *Ulysses* is also evident on a more "meta" level. Joyce's sense that the past lives on into the future, but in a dynamic, rather than static way, appears in a detail as small as the fact that his novel is called not *Odysseus*, but *Ulysses*, the form of Odysseus' name that has come down to us through Rome, through Virgil's reworking of Homer's epic, and through Dante's reworking of Virgil.[24] Joyce, who was not particularly known for his modesty, seems to have had no difficulty in placing himself in the company of Homer, Virgil and Dante, just as Dante, in the *Inferno*,

23 See Ellmann 1983, 603: "In all his books up to *Finnegans Wake* Joyce sought to reveal the coincidence of the present with the past."
24 Meisel 1987, 45 sees this as evidence of the *Odyssey*'s unimportance to *Ulysses*.

pointedly placed himself in the company of the great poets of the past.²⁵ In the "Scylla and Charybdis" episode, which occurs in the National Library, Joyce has the librarian remark that "our national epic has yet to be written" (*U* 9.310). Stephen's thought immediately before, "See this. Remember" (*U* 9.295) makes it clear that while, in 1904, Ireland's national epic had not been written, material was being gathered.²⁶ His words just afterwards:

> As we, or mother Dana, weave and unweave our bodies, Stephen said, from day to day, their molecules shuttled to and fro, so does the artist weave and unweave his image. And as the mole on my right breast is where it was when I was born, though all my body has been woven of new stuff time after time, so through the ghost of the unquiet father the image of the unliving son looks forth. In the intense instant of imagination, when the mind, Shelley says, is a fading coal, that which I was is that which I am and that which in possibility I may come to be. So in the future, the sister of the past, I may see myself as I sit here now but by reflection from that which then I shall be. (*U* 9.380)

put the seal on the possibility. With "that which I was is that which I am and that which in possibility I may come to be" the image of Joyce the father looks out through the ghost of Stephen Dedalus, the unquiet son.²⁷

25 Beplate 2005, 309 sees the constant drive to allusion and inclusion appearing in a negative light in Stephen: "Stephen's musings in this passage point up a crucial conflict that informs his own attitude towards the uses and abuses of language, for the self-affirming drive of his artistic creativeness appears to be compromised by his excessive memory of words. His bookishly overpopulated imagination veers between a fiercely maintained desire for independent authorship and the gravity of a loaded memory. The voices of Aristotle, Dante, Aquinas, and even the twilit world of Celtic mysticism are sheltered in the thought-speech of this self-consciously learned young man whose language echoes with the dead noise of half-remembered historical phrases."

26 Ellmann 1977, 568: "Vico, in his 'Discovery of the True Homer,' argued that Homer was not so much an individual as the entire Greek people, with the *Iliad* and *Odyssey* representing two stages of national development. Joyce aspired to give his own work a stature and significance for the modern period comparable to Homer's in the classical period, as to Dante's in the medieval one." See also Goldman 2004, 91 note 11: "Certainly, this is Joyce boasting that the novel in readers' hands is, in fact, Ireland's national epic, not yet written back in 1904 when the conversation is supposed to take place."

27 Freedman 2009, 84 sees this passage as also reflecting an overall sense of flux in *Ulysses* that reflects Ovid and is in tension with the relation to Homer. See also his earlier comment "But the Ovidian play of *Ulysses* is in tension with its Homeric structure, and pays

In writing *Ulysses* Joyce in fact looked back on the young self who had sat in the National Library arguing about Shakespeare, but through a memory shaped by what had been his future, and was now his past: "in the future, the sister of the past, I may see myself as I sit here now but by reflection from that which then I shall be." The novel thus weaves together the past and future of Stephen Dedalus, the self-proclaimed "artist as a young man," just as Molly weaves together her own past, present, and future with that of all the men and women she has known. In the "Wandering Rocks" episode that follows "Scylla and Charybdis," Buck Mulligan will tell the Englishman Haines that Stephen, the writer who has written nothing, "is going to write something in ten years" (*U* 10.1089). Haynes replies: "Seems a long way off... Still, I shouldn't wonder if he did after all." (10.1090).[28] We, of course, are not surprised that *Ulysses*, subscribed "Trieste—Zurich—Paris / 1914–1921," declares itself as begun ten years after the day on which *Ulysses* occurs.

Although there are any number of reasons why Joyce might wish to indicate through its title that *Ulysses* is essentially an epic, thematically the critical one is that an epic, from Homer's recreation of the oral tradition to Milton's rewriting of both Genesis and Homer, has come to be seen as a recreation of material inherited from the past. For Joyce this worked together with a number of other factors. He had already published a collection of lyric poetry, a play, short stories, and a *bildungsroman*, so epic was the last place left to go. Epic is also a genre that is inherently about memory, as each epic poet recalls those who have gone before. And in Joyce's case, in an epic that he was particularly devoted to, the *Divine Comedy* (Joyce, after all, chose, unusually, to study modern languages, English, French, and Italian, rather than Classics at university), Dante had set an important precedent by including himself as the hero of his own poem.[29]

In *Ulysses*, however, Joyce ties the inclusion of himself even more closely to the theme of time by employing a reference not to his present self, the Joyce who, along with Nora Barnacle, had succeeded in leaving Ireland in October of 1904, but to his past self, the self of the explicitly entitled *A Portrait of the Artist as a Young Man*.[30] In many ways Joyce, during the period he was writing

homage to Homer while undercutting him in a mode remarkably similar to Ovid's own irreverent rewriting of Homer's Ulysses in *Metamorphoses*" (68).

28 For Stephen as author of a work "of a never-to-be-attained future" see Said 1975, 244.

29 For various approaches that consider the importance of Dante to Joyce see Helsinger 1968, Reynolds 1981 and Fraser 2002.

30 See Goldman 2004, 91, who points to Stephen imagining himself as someday writing the episode of *Ulysses* we have just read: "That Stephen of 1904 will become the writer of

Ulysses, had much more in common with Bloom than with Stephen: he was in his thirties, deeply—and complexly—attached to Nora, the father of a son and daughter, fiercely afraid of sexual betrayal, and a wanderer, no longer living in a country which in any sense he could call his own.[31] Even the choice of date—June 16, 1904, the day Joyce first walked out with Nora—points to the break between Joyce, the author of *Ulysses*, and the young man who wonders, while describing Ann Hathaway as a "greyeyed goddess who bends over the boy Adonis, stooping to conquer," "And my turn? When?" (*U* 9.258, 261).[32]

And yet the force of the inclusion, I believe, is not to show us Joyce leaving his past self behind, but rather the continuing existence of his past within his present.[33] After two visits to Ireland in 1909 and, briefly, in 1912, Joyce never returned to Dublin—but he never stopped writing about it either. And just as Dante included in his epic both fictional and historical characters, including Aeneas, the poet Virgil, and Beatrice, the focus of his earlier *La Vita Nuova*, the Dublin of *Ulysses* is peopled by Joyce's past, both imagined and real, not only the shadows of Odysseus, Telemachus and Penelope, but also the actual residents of Dublin, characters from *Portrait* based on actual people, and purely fictional characters created by Joyce himself in *Dubliners*. Even Joyce's childhood essay on Odysseus, "My Favorite Hero," makes an appearance (*U* 17.644).[34] Nor, in this light, is it surprising that the central figure of Joyce's last work, *Finnegans Wake*, is given the initials HCE, which stand for, among many other things "Here Comes Everybody." As Stephen remarks, after Eglinton's claim that "After God, Shakespeare has created most":

> the novel of 1922 and carry out this revenge is again indicated as he leaves the building thinking to himself, 'One day in the national library we had a discussion. Shakes'—a satirical synopsis of 'Scylla and Charybdis' itself (176). This continued doubling of Joyce and Stephen clearly positions Stephen as the author at a stage prior to the writing of the novel." Goldman, however, cautions against reading the text simply as autobiography: "By establishing the author as both a function of writing and the means of decoding it, Joyce enacts a fantasy of a complete and bounded subjectivity uncontaminated by and impermeable to the outside world" (85).

31 In talking to Frank Budgen, Joyce commented that some people, in talking to him about *Portrait*, forget that it is called *A Portrait of the Artist as a Young Man*—emphasizing the last four words (Budgen 1972, 61). For Joyce deliberately playing with parallels between himself and both Bloom and Stephen see King 1999, 300.

32 See Ellmann 1972, xiv, 6–7 on the importance of Joyce's meeting with Nora.

33 In contrast see Latham 2001 and Schloss 1997, 117 for Stephen as "the cast off image of a younger self in whom Joyce was no longer interested."

34 Ellmann 1959, 47. Kenner 2007, 65 points out as well that Homer did not make up the figure of Odysseus, but appropriated and reimagined him.

He found in the world without as actual what was in his world within as possible. Maeterlinck says: *If Socrates leave his house today he will find the sage seated on his doorstep. If Judas go forth tonight it is to Judas his steps will tend.* Every life is many days, day after day. We walk through ourselves, meeting robbers, ghosts, giants, old men, young men, wives, widows, brothers-in-love, but always meeting ourselves. (*U* 9.1040)

Joyce too was the creator of his own world.[35] In the diary entries that end *Portrait* Stephen Dedalus writes "The past is consumed in the present and the present is living only because it brings forth the future" (*P* 251).[36] But what the Joyce of *Ulysses* had realized is that the creator is equally, and necessarily, a creation of his own past, and that memory, rather than being a net that traps us in the past, can be the stuff that the future is made of.

References

Arkins, Brian. 1999. *Greek and Roman Themes in Joyce*. Edwin Mellon Press.
Beplate, Justin. 2005. "Joyce, Bergson, and the Memory of Words." *The Modern Language Review* 100: 298–312.
Biles, Zachary. 2003. "Perils of Song in Homer's 'Odyssey'." *Phoenix* 57: 191–208.
Budgen, Frank. 1972. *James Joyce and the Making of Ulysses and Other Writings*. Oxford: Oxford University Press.
Burr, Jordan. 2012. "'Counterparts,' the *Iliad*, and the Genesis of Joyce's Mythic Method." *James Joyce Quarterly* 49: 493–510.
Castle, Gregory. 1993. "Ousted Possibilities: Critical Histories in James Joyce's *Ulysses*." *Twentieth Century Literature* 39: 306–328.
Cheng, Vincent. 1995. *Joyce, Race and Empire*. Cambridge: Cambridge University Press.
Cronin, Edward J. 1982. "Eliade, Joyce, and the 'Nightmare of History'." *Journal of the American Academy of Religion* 50: 435–448.
Doherty, Lillian. 1990. "Joyce's Penelope and Homer's: Feminist Reconsiderations." *Classical and Modern Literature* 10: 343–349.
Eliot, T.S. 1975. "*Ulysses*, Order and Myth." In *Selected Prose of T.S. Eliot*, edited by Frank Kermode, 175–78. New York: Harcourt Brace Jovanovich.
Ellmann, Richard. 1959. *James Joyce*. Oxford: Oxford University Press.

35 See Goldman 2004, 88–91 and King 1999, 301 particularly on the relevance of Stephen's argument that to understand Shakespeare's works one must know his life.

36 Rickar 1999, 73 points out that Stephen's belief here that he, unlike others, is not "trapped" by the past is an illusion: "Stephen is not as free from the past as he would like to think."

———. 1972. *Ulysses on the Liffey*. Oxford: Oxford University Press.

———. 1977. "Joyce and Homer." *Critical Inquiry* 3: 567–582.

Fairhall, James. 1993. *James Joyce and the Question of History*. Cambridge: Cambridge University Press.

Ferrer, Daniel. 2009. "*Ulysses* de James Joyce: un homérisme secondaire." In *Révolutions homériques. Seminari e convegni 19*, edited by Glenn W. Most, Larry F. Norman, Sophie Rabau, 129–47. Pisa: Edizioni della Normale.

Fraser, Jennifer Margaret. 2002. *Rite of Passage in the Narratives of Dante and Joyce*. Gainesville: University of Florida Press.

Freedman, Ariela. 2009. "The Metamorphoses of *Ulysses*." *Joyce Studies Annual*: 67–88.

Fuller, David. 1992. *James Joyce's Ulysses*. New York: St. Martin's Press.

Gibson, Andrew. 2002. *Joyce's Revenge: History, Politics and Aesthetics in Ulysses*. Oxford: Oxford University Press.

Goldman, Jonathan E. 2004. "Joyce, the Propheteer." *Novel: A Forum on Fiction* 38: 84–102.

Grene, David. 1969. "The *Odyssey*: An Approach." *Midway* 9: 47–68.

Grethlein, Jonas. 2008. "Memory and Material Objects in the *Iliad* and the *Odyssey*." *The Journal of Hellenic Studies* 128: 27–51.

Helsinger, Howard. 1968. "Joyce and Dante." *English Literary History* 35: 591–605.

Hill, Marylu. 1993. "'*Amor Matris*': Mother and Self in the Telemachiad Episode of Ulysses." *Twentieth Century Literature* 39: 329–343.

Homer. 1996. *The Odyssey*, edited by W.B. Stanford. London: Bristol Classical Press.

Hornbeck, Cynthia. 2009. "Greekly Imperfect: The Homeric Origins of Joyce's 'Nausicaa'." *Joyce Studies Annual*: 89–108.

Johnson, Jeri. 1989. "'Beyond the Veil': *Ulysses*, Feminism, and the Figure of Women." In *Joyce, Modernity, and Its Mediation*, edited by Christine van Boheeman, 201–28. Amsterdam: Rodopi.

Joyce, James. 1966. *Letters of James Joyce*. Edited by Stuart Gilbert. New York: Viking Press.

———. 1968. *A Portrait of the Author as a Young Man: Text, Criticism, and Notes*. Edited by Chester Anderson. New York: Viking Press.

———. 1986. *Ulysses*, edited by Hans Walter Gabler. New York: Random House.

Kenner, Hugh. 1987a. *Ulysses*. Baltimore: Johns Hopkins University Press.

———. 1987b. "Homer and Hamlet." In *Dublin's Joyce*, 179–197. New York: Columbia University Press.

———. 2007. *Joyce's Voices*. Rochester: Dalkey Archive Press.

Kershner, R. Brandon. 2004. "Dialogical and Intertextual Joyce." In *Palgrave Advances in James Joyce Studies*, edited by Jean-Michel Rabaté, 183–202. New York: Palgrave Macmillan.

Kimball, Jean. 1980. "Freud, Leonardo, and Joyce: The Dimensions of a Childhood Memory." *James Joyce Quarterly* 17: 165–82.

———. 1991. "Jung's 'Dual Mother' in Joyce's 'Ulysses': An Illustrated Psychoanalytic Intertext." *Journal of Modern Literature* 17: 477–490.

King, John. 1999. "Trapping the Fox You Are(N't) with a Riddle: The Autobiographical Crisis of Stephen Dedalus in *Ulysses*." *Twentieth Century Literature* 45: 299–316.

Latham, Sean. 2001. "A Portrait of the Snob: James Joyce and the Anxieties of Cultural Capital." *Modern Fiction Studies* 47: 774–99.

Litz, A. Walton. 1964. *The Art of James Joyce: Method and Design in Ulysses and Finnegans Wake*. Oxford: Oxford University Press.

Meadowsong, Zena. 2010. "Joyce's Utopian Machine: The Anti-Tyrannical Mechanics of Ulysses." *James Joyce Quarterly* 48: 55–74.

Meisel, Perry. 1987. *The Myth of the Modern: A Study in British Literature and Criticism after 1850*. New Haven: Yale University Press.

Moretti, Franco. 1997. "The Long Goodbye: *Ulysses* and the End of Liberal Capitalism." In *Signs Taken for Wonders*, 182–208. New York: Verso Press.

Norris, Margot. 1988. "Modernism, Myth, and Desire in 'Nausicaa.'" *James Joyce Quarterly* 26: 43–50.

Oded, Brenda. 1985. "The Maternal Ghost in Joyce." *Modern Language Studies* 15: 40–47.

Peradotto, John. 1990. *Man in the Middle Voice, Name and Narration in the Odyssey*. Princeton, N.J.: Princeton University Press.

Pound, Ezra. 1968. *Literary Essays of Ezra Pound*, edited by T.S. Eliot. New York: New Directions.

Reynolds, Mary. 1981. *Joyce and Dante: The Shaping Imagination*. Princeton, N.J.: Princeton University Press.

Rickard, John. 1999. *Joyce's Book of Memory: The Mnemotechnic of Ulysses*. Durham: Duke University Press.

Riquelme, John Paul. 1983. *Teller and Tale in Joyce's Fiction*. Baltimore: Johns Hopkins University Press.

Said, Edward. 1975. *Beginnings*. New York: Basic Books.

Segal, Charles. 1983. "Kleos and its Ironies in the *Odyssey*." *L'Antiquité Classique* 52: 22–47.

Senn, Fritz. 1984. "Book of Many Turns." In *Joyce's Dislocutions: Essays on Reading as Translation*, edited by John Paul Riquelme, 68–83. Baltimore: Johns Hopkins.

———. 1995. "Remodeling Homer." In *Inductive Scrutinies: Focus on Joyce*, edited by Christine O'Neill, 111–132. Dublin: Lilliput.

Shloss, Carol Loeb. 1997. "Joyce's Transgressive Genders: A Feminist Perspective." Review of *Modernism's Body: Sex, Culture, and Joyce* by Christine Froula. *Novel: A Forum on Fiction* 31: 115–18.

Slote, Sam. 2012. *Ulysses*. Richmond, U.K.: Alma Classics.

Spoo, Robert. 1994. *James Joyce and the Language of History: Dedalus' Nightmare*. Oxford: Oxford University Press.

———. 1986. "'Nestor' and the Nightmare: The Presence of the Great War in Ulysses." *Twentieth Century Literature* 32: 137–54.

Whitman, Cedric. 1983. "*The Odyssey* and Change." In *Twentieth Century Interpretations of the Odyssey*, edited by Howard W. Clarke, 72–91. Englewood Cliffs, NJ: Prentice-Hall.

Wykes, David. 1968. "The *Odyssey* in *Ulysses*." *Texas Studies in Literature and Language* 10: 301–316.

CHAPTER 8

Time, Cognition, and Attic Performance: Tracing a New Approach to Theatre History's "Vexing Question"

Erica W. Magnus

Abstract

The seemingly sudden appearance of Western theatre in Attic culture is one of the most controversial subjects in theatre studies, so pertinacious it has been dubbed "the vexing question." Without recorded precedent, the remediation of material from a venerable mythic and bardic tradition into a highly articulated, labor-intensive, and expensive theatrical praxis is certainly enigmatic. It is timely to revisit the "vexing question" in light of several recent hypotheses from the brain sciences—neuroscience, cognitive science, cognitive sociology, and evolutionary psychology—in the hope of viewing the advent of Greek theatrical praxis afresh. In this paper, theatre's historicized constructed nature as a mode of communication takes center stage, and we can make reasonable and sometimes provocative inferences about the period based on present research. My overarching question is this: What function/s might such a medium have fulfilled in the psychic economy of 5th-century Greek society?

Keywords

theatre and consciousness – theatre and individuality – mirror neurons – spectatorship – spectatorship and dopaminergic mind – theatre and cognitive evolution – Greek theatre – theatre and time – performance and perception – theatre and visuality – emergence of theatre – cognition and embodied fiction

1 Introduction

The seemingly sudden appearance of Western theatre in Attic culture in the 6th century BCE is one of the most controversial subjects in theatre studies,[1]

[1] For a review of the debates surrounding the advent of Greek theatre, see the introduction to Csapo and Miller, *The Origins of Theater*.

so compelling and pertinacious that it has been dubbed "the vexing question."[2] In the attempt to understand theatre's emergence in what appears to be a matrix of ritual practices, we must first consider what theatrical praxis may have offered to the cultural moment that was desirable or essential. Fortunately, we possess significant indication of the subject matter the Athenian audience encountered in that over 30 plays by the greatest tragedians have endured. However, we have a paucity of reliable information regarding the modes and methods of the performances. In other words, while we can discern proclivities in the thematic material which made certain issues important ones to engage or foreground at the time, we are unsure of what may have been the experiential array of the productions themselves. For example, we have no theatrical masks or costumes from the period, no examples of the music to which the choral odes were sung, and no definite evidence for the nature of the choral dances. Finally, we are not even sure of the layout of the Theatre of Dionysus at the foot of the Acropolis where evidence suggests the Athenian theatrical festivals began. Indeed, our appraisal of Attic performance has sometimes been colored in traditional pedagogy and popular estimation by what might be termed an "apotheosis syndrome," i.e., the notion that sublime plays constructed by supreme dramatists were produced in a transcendent moment of triumphant individuality and social cohesion. On the other end of the spectrum, studies of 6th- and 5th-century Greek performance have often been distracted by archaeological contestation such as disagreements regarding the true nature of the putative 5th-century post holes in the Theatre of Dionysus or the shape of the 5th-century orchestra there, even though the site is far too corrupted to discern such features responsibly. While there is always hope for future discoveries, we must come to terms with what we have and what we do not. Regarding Attic performance and certainly with regard to theatre's origins, as classicist Sheila Murnaghan acknowledges, "[w]e will never be able to construct a reliable narrative out of our available evidence."[3]

With this situation in mind, I shall revisit the "vexing question" in light of several hypotheses from the brain sciences—neuroscience, cognitive science, cognitive sociology, and evolutionary psychology—in the hope of viewing the advent of Greek theatrical praxis with what Bertolt Brecht described as "astonished eye[s]."[4] While some may regard this methodology as problematic in that we have no direct evidence of neurological functions from this period—sadly, we have no 5th-century Greek brains to examine—we can make reasonable and sometimes provocative inferences about the period based on present

2 Walker, "Invention of Theater," 1–22.
3 Murnaghan, "Women in Groups," 183.
4 Brecht, *Brecht on Theatre*, 193.

research. In this way, I hope to find a sense of the advent of Greek theatre which the apotheosis syndrome obscures and archaeological debates confute by diverting attention from theatre's historicized constructed nature as a mode of communication. My overarching question is this: What did Athenian performative praxis represent in the cognitive economy of Athens of the 6th and 5th centuries BCE?

To contextualize the birth of Attic theatre, I must set the stage, if you will, regarding the cognitive setting into which it was born. It is a critical commonplace to characterize the period from approximately the sixth through the fourth centuries BCE as an era rife with change. Renowned Cambridge classicist G.E.R. Lloyd writes that "[h]owever much scholars differ in their detailed interpretations, they acknowledge that [...] significant changes or developments occurred during the period."[5] Experts in the cognitive sciences such as V.S. Ramachandran and Antonio Damasio agree in identifying the era as one which represents a major cognitive threshold in the evolution of the human mind.[6] Historian Robin Osborne, in critiquing sources which characterize changes in the period as "revolutions," notes that such analysis must not "occlude the fact that what happened in Greece was really new."[7]

Indeed, so much was new. During this period Greece began the general transition from an oral to a written tradition which affects both cognitive techniques and patterns of memory.[8] Contact with foreign cultures, particularly Egypt, relativized prevailing notions about the nature and depth of the past. Also important to this intellectual transition was the transformation of myth into history in the works of Herodotus and Thucydides. In Athens, the chief archon Cleisthenes (570–508 BCE), in order to undermine the monopoly of power held by certain aristocratic houses, initiated a change of political organization from the family and tribe to the locality. It is difficult to overstate the dramatic nature of this adjustment, which has been described as a transformation of the space of Athens from the "closeknit allegiances of the phatries into the artificial geometrical divisions of municipalities."[9] In addition, Cleisthenes' spatial reforms were accompanied by a calendrical reform that historian James

5 Lloyd, *Magic, Reason and Experience*, 5. Quoted in Osborne, "Introduction," Goldhill and Osborne, *Rethinking Revolutions*, 4.
6 For further review, see Damasio, *Self Comes to Mind*, and Ramachandran, *The Tell-Tale Brain*.
7 Osborne, *Rethinking Revolutions*, 6.
8 For further review, see Havelock, *The Literate Revolution in Greece*, Ong, *Interfaces of the Word*, and Shlain, *Art and Physics*.
9 de Kerckhove, "Theory of Greek Tragedy," 23. The phatries were traditional kinship divisions of the Greek tribes.

Davidson asserts represented a "radical and consequential transformation" in the experience of time during the period.[10]

In the midst of what appears to have been a period of significant social upheaval, theatre, a new form of institutionalized representation, emerged. Not only was it new to the Athenian *polis*, it was highly expensive and time-intensive.[11] In a remarkably short amount of time, the City Dionysia became such an essential feature of Athenian society that during the festival, which was held each spring, law courts as well as municipal and governmental businesses were closed while the jails were opened so that prisoners could attend the festival, which included back-to-back theatrical performances from dawn until dusk over the course of four days. What engendered the need for a new type of representation? The complex and problematic situation which characterized the 6th- and 5th-century *polis* and the theatrical paradigm's aptness to answer it can most efficaciously be understood by foregrounding contemporary ideas regarding time.

Although Lloyd cautions that "there is no such thing as *the* Greek view of time,"[12] an examination of temporal notions from the earliest pre-philosophical evidence to the 5th century BCE reveals that certain generalizations can reasonably be advanced concerning dominant tendencies in Greek thought about time. At the beginning of the Archaic period, which most historians place around 750 BCE, the Greeks did not conceive of time as we understand it. As in most pre-literate cultures, meaning was conferred upon the present primarily in its relation to primordial time. This idea of time, based upon recurrent processes and the repetition of ritual gestures, finds its objective correlative in the cycle or, as classical scholar Jean-Pierre Vernant describes it, a "circular model of becoming."[13] In this conception, emphasis was placed upon the succession of human generations as renewed one after another through a process of ceaseless interchange between the dead and the living. In this manner, human time appeared to be integrated into the cyclical organization of the cosmos.[14]

Already in Homer, Hesiod, and lyric poetry, the cyclic temporal model is being tested in relation to what was then a new conception of time. Statements appear regarding the transience of youth and an ineluctable forward temporal

10 James Davidson, "Revolutions," 30.
11 The expense factor of theatre in 5th-century Athens is documented by Roselli, *Theater of the People*, 22, and by Chris Kraus et al., introduction to *Visualizing the Tragic*, 1.
12 Lloyd, "Views on Time," 117. Emphasis Lloyd.
13 Jean-Pierre Vernant, *Myth and Thought*, 89.
14 Vernant, *Myth and Thought*, 89.

movement. In the Classical period, dating from approximately 500 BCE, this very different concept of time proliferated. Classicists Eric Csapo and Margaret Miller emphasize "[t]his time is variously named 'real time,' 'linear time,' or 'rational time.' Emergent expressions of this temporality already appear in Archaic lyric [...]. Above all the late Archaic and classical periods are characterized not by [...] 'an awareness of time,' but by an obsessive problematization of time [...] as two time-centered value-systems clashed head on."[15]

The Greek theatrical canon exhibits a sustained and varied interrogation of both the cyclic and the emergent linear temporal schemas. In both the structure of the plays and in the sensory array of performance as a purveyor of neuro-cognitive activation, theatrical praxis can be seen as broker of affordances for this situation. Through an examination of aspects of tragic performance which, while not unprecedented, were innovative in this period, I will suggest that theatre emerged as an adaptive psychic technology engendered by profound changes which are best understood as matters of time. I will attend to the characteristics of theatrical performance that mark it as an innovative form of representation in Greek culture in three sections: "Demythologization and Fiction," "Enactment and Visuality," and "Selfhood and Death."

2 Demythologization and Fiction

Tragedy appears at the end of the 6th century BCE when evidence suggests that myth ceased to have a definitive hold on the quotidian political realities of the *polis*. Regarding religious observance in daily life, classicist Robert Parker writes that "the ordinary Athenian [...] learnt by daily experience [...] that the sovereignty of the assembly was a reality [...]. To consult an oracle with a view to what the god 'ordered' could perhaps be seen as a surrender of the right of self-determination."[16] The late classicist Simon Price notes that while the divine did have some role to play in this period, "it was needed as an explanation only in default of other explanations."[17]

15 Csapo and Miller, "Towards a Politics of Time and Narrative," in Boedecker and Raaflaub, *Democracy*, 100.
16 Robert Parker, "Greek States and Greek Oracles," 322–323. Quoted in Thomas Harrison, "Religion and the rationality of the Greek city," in Goldhill and Osborne, *Rethinking Revolutions*, 132.
17 Simon Price, *Religions of the Ancient Greeks*, 133. Quoted in Harrison, "Religion and the rationality of the Greek city," in Goldhill and Osborne, *Rethinking Revolutions*, 138.

In this transitional if not somewhat schismatic environment, tragedy offered a new cognitive milieu to Attic culture and this was a venue for fiction. Vernant explains the innovation as "the space of the imaginary, experienced and understood as such [...] as a human production stemming from [...] artifice."[18] The form that these emergent fictions assumed might be said to reflect the schismatic religiopolitical episteme. While neither characters nor their destinies which tragedy co-opted from the material of heroic legends were fictitious to the Greek audiences, the performance was; audiences recognized that the characters in performance were an imitation, a *mimesis* of figures from a bygone era.[19] It was understood that playwrights adapted mythic material according to their needs. Whereas the Hesiodic Prometheus is a relatively minor rebel who indirectly causes all the woes of mankind, the Aeschylean Prometheus, considerably advanced in hereditary position and enlarged in power and breadth of his exploits, emerges as the savior of mankind. *The Odyssey* contains the earliest account of an Oedipus myth and in it Oedipus remains King of Thebes after the revelation of his identity and neither blinds himself nor is exiled as he is in Sophocles' *Oedipus the King*. Regarding received tradition in the 5th century, Medea's deliberate murder of her children appears to be a Euripidean invention. In utilizing characters from myth and legend in adapted and sometimes transformed plots, classical tragedy is a form which evinces its birth in the tensions of transition.

New research suggests that a movement away from stories which are held to have a high level of veracity to those which do not, in terms of subject matter or mode of consumption, implies a different type of cognitive value for consumers. Researchers in the field of evolutionary psychology, Leda Cosmides and John Tooby, while noting that "[i]nvolvement in fictional, imagined worlds appears to be a cross-culturally universal species-typical phenomenon," highlight the lack of attention paid to what the adaptive function of fiction might be.[20] As "natural selection is the only presently accepted explanation for functions that are more highly evident than chance can account for,"[21] there must be some significant adaptive value in the ubiquitous phenomenon of human art behavior, particularly our distinct proclivity for interaction with imagined worlds. Various sources have assessed the value of attending to fictional information in terms of relaxing, or disengaging from quotidian concerns. While

18 Vernant, "The God of Tragic Fiction," in Vernant and Vidal-Naquet, *Myth and Tragedy*, 187.
19 Ibid.
20 Leda Cosmides and John Tooby, "Does Beauty Build?" 7.
21 Ibid., 6. Cosmides and Tooby refer here to G.C. Williams, *Adaptation and Natural Selection*.

the function that fiction likely serves does have to do with the notion of "going offline," its structure is cognitively rigorous.

Cosmides and Tooby posit a notion of what they term "decoupling" to account for the adaptive cognitive value of fiction. Fictive representations are not stored as true information, they are decoupled and "quarantined" from other veridical representations in the mind so that they "do not interact with each other promiscuously—that is without respect to the [...] boundaries within which they are applicable."[22] Decoupling allows human beings to reason subjunctively and evaluate potential outcomes. Cosmides and Tooby observe that the mind

> preserves storehouses of information whose truth is suspended, in decoupled form, ready to be tapped to make inferences or regulate behavior whenever the organism finds itself inside the scope of the conditions where such information applies. Decoupling and recoupling is like letting out or pushing in the clutch, engaging different realities to drive behavior in different settings.[23]

Cosmides and Tooby are not alone in suggesting various and potentially transformative benefits inherent in attending to fictional representations. Theorist Brian Boyd, in his extended bio-cultural study of the persistence of art behavior throughout human history, describes attending to fictional representations "as a kind of cognitive play [that] stimulates our brains more than does routine processing of the environment. It offers what biologists call a supernormal stimulus [... which] can over time fine-tune our minds [...]."[24]

If the emergent decoupled fictional mode of performance represented a cognitive acclimatization to quotidian societal pressures, in what way did this answer cognitive needs at this moment? When tragedy was born in the late Archaic period in Athens it challenged the epic as the dominant genre. The temporal horizons of epic are sprawling while those of tragedy are famously taut and limited, focusing on narrow temporal and causal constraints. Noted French classicist Jacqueline de Romilly connects the appearance of tragedy with the evolution in time consciousness in Greek culture. De Romilly describes the pressing nature of tragic time as a

22 Cosmides and Tooby, "Does Beauty Build?" 20.
23 Ibid.
24 Brian Boyd, *On the Origin*, 94. Boyd refers here to Brian Sutton-Smith, *The Ambiguity of Play*. Cambridge, MA: Harvard University Press, 1997.

continuous and regular progression, where one single problem gets more and more urgent [...]. Such a structure is therefore something quite different from the epic [...] it seems only logical that it should have arisen precisely when the consciousness of time was getting clearer and stronger. Tragedy summons our emotion by following a crisis in its continuous and unavoidable growth.[25]

Viewed in the context of the "obsessive problematization of time" which Csapo and archaeologist Margaret Miller described above, these new time-compact narrative formulations, in the novel decoupled form of fiction, may have had immense cognitive value in accommodating the exigencies of linear time. Cosmides and Tooby argue that such decoupled representations are "attended to, valued, preserved and transmitted because the mind detects that such bundles of representation have a powerfully organizing effect on our neurocognitive adaptations."[26]

When the demands of linear time began to challenge the unity and consolations implicit in the pre-literate temporal schema, theatrical narratives may have offered valuable information regarding how to live a human life in relation to both temporal ideations. This will become more apparent as we turn to a consideration of what can be posited about the sensory array of Attic performance as a purveyor of cognitive information.

3 Enactment and Visuality

The Greek word for a theatre—*theatron*—meant literally a place for seeing. Although Athens had a long-standing bardic tradition in which the Homeric epics were recited, during this period it became very important to see these tales enacted in the flesh. In their introduction to *Visualizing the Tragic*, Chris Kraus, Simon Goldhill, Helene P. Foley and Jaś Elsner explain:

> The 5th century enlightenment, with its complex intellectual debates about vision, perception, and representation, is fueled by the event of theatre [... which] is different from epic and other forms of ancient poetry because of its commitment to embodied enactment before spectators. The modality of the visual is an ineluctable constituent of theatre [...] *theatron*, "the theatre", in Greek means "the place for looking"; a seat

25 Jacqueline de Romilly, *Time in Greek Tragedy*, 9–10.
26 Cosmides and Tooby, "Does Beauty Build?" 21.

in the theatre is called a *thea* [...] the audience is made up of *theatai*, "spectators", "lookers"; [...] its very vocabulary marks theatre as a key institution of the city's visual culture.[27]

Another sight-based term crucial to a discussion of Attic spectatorship is *theoria*. *Theoria* was a venerable cultural practice which, according to classicist Andrea Wilson Nightingale, was "one of the most common [...] in the ancient world, yet it is rarely analyzed in the scholarship on ancient Greek culture."[28] In considerations of Attic spectatorship, its importance seems incontrovertible because the *theoros*, one who undertook a *theoria*, was presumably on a pilgrimage whose goal it was to be altered by the sight of something. Nightingale contends that

> the practice of *theoria* encompassed [...] the detachment from home, the spectating, and the final reentry. But at its center was the act of seeing, generally focused on a sacred object or a spectacle [...] the viewer entered into a "ritualized visuality" in which secular modes of viewing were screened out by religious rites and practices. This sacralized mode of spectating was a central element of traditional *theoria*, and offered a powerful model for the philosophic notion of "seeing" divine truths.[29]

Given that the *theoric* gaze seems to imply an engaged type of spectatorship, what can we posit regarding what might be gained through the visual experience of Attic performance? What was intended by the institutionalized location of a place focused on seeing?

Common sense has it that anyone equipped with healthy eyes can 'see' and what is delivered by this sense is an image of 'how things look' or 'things as they really are.' However, cognitive research during the last three decades regarding the functions of the human brain suggests that this is not the case. Research indicates that an understanding of vision entails more than inquiry into the nature of technical optics in that veridical vision does not exist. As historian Martin Jay observes, we should "wean ourselves from the fiction of a 'true' vision [...]."[30] All that is seen is refashioned through a variety of social and psychological filters before being perceived.[31] There are various models of

27 Chris Kraus et al., *Visualizing the Tragic*, 4, 6.
28 Nightingale, *Spectacles*, 40.
29 Nightingale, *Spectacles*, 3–4.
30 Jay, *Scopic Regimes of Modernity*, 20.
31 Wright, Foreword to *Vision and Visuality*, ed. Foster, vii.

visuality and they are all historically specific. In film studies, Christian Metz has termed these models "scopic regimes"[32] which play a key role in the production of subjectivity. Certainly theatrical praxis is part of the overall scopic regime of any given period, actively asserting or adjusting the tolerances of spectatorship.

The scopic regime of the *theatron* consisted of several novel components. First, a shift was effected from the audio-tactile involvement entailed in ritual epic recitations to a new type of sensory synthesis dominated by the eye. Second, the performance area of the fifth-century Greek theatre offered stable symbolic spatial coordinates in an open yet bounded space. Finally, rather than a meaning-making event in which agential activity is, in great part, "constructed out of words" this is a meaning-making event in which "stories are told by bodies onstage"[33] in the context of a specific, alternative spatio-temporal proposition. We will examine each of these components in order.

It is customary to note the shift from the modes of engagement in epic performance to those of theatrical performances. Although the festival context dedicated to the god Dionysus and the presence of *theoria* in the Athenian audiences ratify theatrical performance's participation in a ritual context, spectatorship at the plays required a revised group of conventions. The unconventional nature of physical non-participation in theatrical praxis of the period is considered by theatre historian Steven F. Walker who emphasizes that "[t]he performance mode of the actor/spectator collaboration in theater ran so counter to all previously familiar verbal performance modes and to general human experience that theater, like the wheel, was devilishly hard to invent [...]. The spectators must also have found it quite difficult to engage in this new type of non-participatory spectatorship."[34]

A recent hypothesis in the realm of evolutionary cognition permits us to consider another group of cognitive adjustments afforded by the separation of spectators from actors and chorus members in the *theatron*. Fred Previc advances a theory focusing on the role of dopamine, a widely studied neurotransmitter in the evolution of modern human behavior. Previc claims that human actions in three-dimensional space "represent perhaps the single-most important factor in shaping the major pathways of the human brain."[35] He goes on to delineate four systems in the brain that coordinate our spatial interactions: the Peripersonal, the Ambient Extrapersonal, the Focal-Extrapersonal

32 This term was first introduced by Metz in *The Imaginary Signifier*.
33 Shaughnessy, *Affective Performance*, 88–89.
34 Walker, "Invention of Theater," 11.
35 Previc, *The Dopaminergic Mind*, 38.

and the Action-Extrapersonal. The first two systems—the Peripersonal, which deals with operations in near-body space, and the Ambient Extrapersonal, which deals with body movement and control—have little involvement with dopamine. However, the conventions of Attic theatrical spectatorship stipulate physical distancing and focus attention to focal-extrapersonal space and action-extrapersonal space, both of which increase dopamine-related transmission in the brain. Previc postulates that when Minoan society, which represented "one of the last [...] relatively egalitarian, peaceful [...] civilizations," was overcome by the Mycenians around 1500 BCE, the Mycenian aggression was emblematic of a contemporary "increase in the *dopaminergic mind*."[36] This type of mind/brain thrives on actions and activities which increase dopamine-related activity in the brain. Previc notes the theories of cognitive theorist Julian Jaynes who famously suggested a shift in consciousness based on an analysis of differences in human agency and interiority between Homer's *Illiad* and *Odyssey* which he attributed to a change to left-hemispheric brain dominance.[37] Previc acknowledges the same historic cognitive shift, but attributes it to the continued rise of the dopaminergic brain/mind.[38] If we accept Previc's historic analysis of the "expansions of the dopaminergic mind," the emergence of theatrical praxis falls within the purview of his idea.

Dopamine is the primary neurotransmitter involved in goal-oriented activities which "mediate our attention to distant space and time."[39] Previc reasons that the functional requirements of goal-directed activities include mapping the spatial location and the goal object in mind while working toward that goal, developing understanding of causal relationships in order to predict rewards, developing a temporal ordering of action, and adjusting behavior in view of feedback.[40] Given that Previc identifies knowledge as the most frequent goal, the functional requirements of these dopaminergic goal-directed actions could describe the process of spectatorship in consuming theatrical narrative. The dopaminergic engagement implicit in theatrical spectatorship is also suggested by the fact that neurons in certain areas of the brain secrete dopamine in reaction to that which is surprising, but not to that which is expected.[41] Finally, goal-directed action which contains elements of surprise

36 Previc, *The Dopaminergic Mind*, 127–128.
37 The reference is to Jaynes, *The Origin of Consciousness*.
38 Previc, *The Dopaminergic Mind*, 128.
39 Previc, *The Dopaminergic Mind*, 46.
40 Previc, *The Dopaminergic Mind*, 46.
41 P.A. Dickinson Waelti and Wolfram Shultz "Dopamine Responses Comply with Basic Assumptions of Formal Learning Theory," in Boyd, *On the Origin*, 184.

is often the challenge for agents in the plays themselves. The conventions of theatre spectatorship offer the possibility of rich dopaminergic activation.

The Theatre of Dionysus was a symbolic space where, as in our churches, synagogues, and mosques today, space becomes "a language to express other non-spatial relations."[42] As noted above, I propose that the Greek theatrical setting at the Theatre of Dionysus, from its earliest incarnation, offered a chronotopic proposition for the examination of the temporal concerns of the *polis*.[43] To explicate this in any comprehensive fashion would require entry into highly contentious scholarship concerning the specifics of the fifth-century Athenian performance space which the limits of this study preclude. To support my notion we will engage only the very basic points which are presently undisputed.

As theatre historian Rush Rehm states, "the early theatre was conceived more as a space than as a building."[44] Although there is some evidence that there were earlier performances of plays in the Agora, none of this is definitive and we can say with authority that whatever shape the Theatre of Dionysus took in the 5th century, it was the primary performance venue of Athenian drama in that period. As classicist Peter Meineck contends, "[i]t is quite possible that almost every play from that period was created specifically for this space."[45] As we are concerned primarily with the emergence of theatrical praxis, we must focus on the scant evidence for the 5th-century playing space. This was probably a somewhat makeshift affair, with wooden seating, a compacted earthen orchestra of some configuration which intersected with or was in close proximity to a temporary wooden *skene* or stage area with some sort of central entrance at the point farthest from the audience.[46] It seems that,

42 Pfister, *Theory and Analysis of Drama*, 257.

43 I have proposed elsewhere that theatre settings throughout Western theatre history evince the shape of historicized understandings of space and time. Please see Magnus "Time on the Stage" and "The Emergence of Theatrical Praxis as a Mediative Technology for Individual Consciousness."

44 Rehm, *Greek Tragic Theatre*, 33.

45 Meineck, "Dionysos, Divine Space," n.p. Interestingly, Meineck utilizes Previc's system to analyze Greek performance space. However, he links Previc's notion of ambient extrapersonal space with spectators' "expansive view of the sky and topography of Southern Attica." (n.p.) Previc stipulates that ambient extrapersonal space "is involved in postural control and locomotion in earth-fixed space and is biased [...] toward the lower field where the ground place predominates." (*The Dopaminergic Mind*, 38–39)

46 Wiles, *Tragedy in Athens*, 52. Wiles' fascinating analysis of many of the arguments regarding 5th-century performance space at the Theatre of Dionysus can be found in chapters 1–3.

unlike Epidaurus, "the early theatre in Athens was not governed by geometric preconditions or architectural refinement."[47]

While we perhaps cannot find the definitive visual dynamics of 5th-century performance set in stone, as it were, we can responsibly advance suggestions regarding significant aspects of staging based upon things we know from the plays themselves. We know that the chorus, however they may have danced, found their defining domain in the orchestra, the dancing place, as a collective, which classicists Renaud Gagné and Marianne Govers Hopman acknowledge "embodies the voice of a group, a collective, in contrast to the emphatically individual voice of the characters."[48] We also know that in contrast to the actors' dialogue, which referred in great measure to the concerns of the specific spatio-temporal coordinates of the action of the play, "[t]here is no deixis of immediate location in the choral ode, the chorus doesn't mention the fictional space of the action [...] it sings of other times and places [...] as if it were no longer contained by any one location."[49] Finally, this temporally bifurcated performative experience took place in a sacred space whose visual panorama was replete with resonances of Athenocentric importance from times past, present, and future set within all that the sacred setting implied of the eternal.

As traditional modes, focused on collectivity and continuity, were tested and amended by a more linear temporal consciousness, the theatre setting of the 5th century offered a comparative venue in which to offer both spatio-temporal modes to the eyes as well as the ears of the Attic spectators. All the plays, while exploring the vitality and possibility of individual lives, also relate those linear narrative propositions to a timeless order. This is achieved primarily through the defining feature of Greek theatre practice: the chorus.

As de Romilly notes, although the Greek plays display an urgency regarding time, it is an urgency which intermittently gives way to meditation on eternal themes:

> [...] this structure, which is special to Greek tragedy, can be said to agree with a notion of time where man's difficulties do not destroy the everlasting harmony of the whole [...] these two opposite tendencies correspond to the particular situation prevailing at the time of its birth. For tragedy arose when the Greeks had become fully conscious of the importance of time and of its problems. Yet, it arose when this consciousness was still

47 Rehm, *Play of Space*, 40.
48 Gagné and Hopman, introduction to *Choral Mediations*, 6.
49 Ibid.

recent, and among people who never allowed time to be [a...] perpetual and all-pervading movement [...]. Greek tragedy describes an acute crisis of a temporal nature belonging to a world which, in many ways, remains nontemporal.[50]

De Romilly associates the non-temporal impulse with the chorus and feels that in the movement from Aeschylus through Sophocles to Euripides, there is a completed evolution regarding drama's association with non-temporal concepts.

In 1982, philosopher Bruce Wilshire wrote that "[t]he bodily and communal fictive variation that is theatre supplies me with the communally constituted missing parts of my own experiencing body."[51] This idea is of fundamental importance to an understanding of theatrical praxis in general and its emergence in Greece in that what was involved consisted of presenting fictively constructed spatio-temporal agents (characters) in living bodies (actors) to the sight of other spatially and temporally coded living bodies (spectators). In light of George Lakoff and Mark Johnson's[52] concept of embodied cognition, which resituates the notion of perception from a process in the mind to an integrated activity in and through the body, theatrical praxis as a mode of thinking with bodies in bounded spatial propositions takes on a new centrality in terms of cognition. Theatre scholar Rhonda Blair emphasizes that "[c]ognition is embodied, i.e. not separable from our physicality. Cognition is embedded, i.e. it depends heavily on [...] taking advantage of affordances or potentials, in the environment [...]."[53] Theatrical praxis is both embodied and embedded in such a way that theatre historian Bruce McConachie, building on the work of Wilshire, explains that spectatorship, "serves a vital social-psychological function: by identifying with actors, spectators become aware of the social construction of their own bodies, experience themselves as an 'other,' and consequently achieve significant individuation [...] [T]heatregoing socializes and individuates through the body."[54]

Hypotheses in the field of neuroscience offer insight into the concept of identification to which McConachie, writing in 1993, refers above. In the mid-1990s Italian researchers discovered a type of neuron in monkeys that fires not

50 De Romilly, *Time in Greek Tragedy*, 26, 31.
51 Wilshire, *Role Playing*, 26.
52 See Lakoff and Johnson, *Metaphors We Live By* and Lakoff, *Women, Fire, and Dangerous Things*.
53 Blair, "Introduction: The Multimodal Practitioner," 139–140.
54 Bruce A. McConachie, "Metaphors We Act By," 28–29.

only when a monkey performs an action, but also when observing that action performed by another individual, be it another conspecific or a human being.[55] These neurons were subsequently identified in the brains of other social animals including dolphins, and elephants, and in 2010 they were confirmed in humans.[56] Named "mirror neurons," these neurons create a neurocognitive situation through which, as neuroscientist Vittorio Gallese contends, "[a]ction observation causes in the observer the automatic activation of the same neural mechanism triggered by action execution."[57]

To date, hundreds of papers have been produced featuring mirror neurons and the putative implications their existence presents for the sciences, social sciences, and the arts. Many claims, particularly those made before mirror neurons were confirmed in humans, were premature and often overstated. In great part due to this, a backlash is currently abroad regarding the authenticity and/or importance of mirror neurons. Overstatements, including claims that the existence of mirror neurons represented the physiological coding for "empathy" in human beings, have upstaged and obscured the value of this discovery. No doubt this will be clarified as new data is collected and the existence of mirroring systems in the brains of human beings is reassessed in a more measured light by scholars such as Paul Armstrong, who recently noted that "[i]nstead of actions being the object of interpretive processes that indirectly construe their meaning, the 'resonance' between observation and action provides an immediate connection between self and other. Not requiring a theory of a simulation, this resonance is bodily, unreflective, and automatic. It is the biological equivalent of primary intersubjectivity."[58]

Through the connection of the fictional agential body with the spectatorial body, mirror neuron activity can also be seen to participate in the formation/adjustment of temporal ideations. To be embodied is to be subject to degenerative implications of linear time. As the spectatorial gaze follows the finite trajectory of seeking, questing, and sometimes failing agents in the tightly bounded narratives of the plays, the ephemeral nature of the individual life project is shared at the level of primary intersubjectivity, not wholly understood, perhaps, but experienced on some level in an embodied sense.

In the midst of the cognitive upheaval that affected Greek society from the late archaic into the Classical periods, the timeless mode of myth no longer

55 Gallese et al., "Action Recognition," 595–596.
56 For more on human mirror neurons, please refer to Keyser, "Social Neuroscience: Mirror Neurons Recorded in Humans."
57 Gallese, "What Do Mirror Neurons Mean?" 48.
58 Armstrong, *How Literature Plays*, 138.

answered the psychic needs of the Athenian public enmeshed in the conflicts inherent in the clash between the traditional temporal ontology and emergent linear time. While evidence suggests that mirror neuronal areas in the brain are multi-modal, i.e., they activate for aural stimulation to an extent as well as for visual, we should recall how Damasio succinctly characterizes brain activation: "more is always better."[59] The multi-modal appeal of theatre performance offered something psychically distinctive and necessary to the *polis* of the period. Theatrical praxis served as an adaptive technology which allowed for the deployment and consumption of the venerable Greek mythic material as "now."

4 Selfhood and Death

The project of historicizing selfhood in archaic and classical Greek culture has met with considerable resistance. I suspect this owes in part to feelings surrounding heroic characters such as Achilles, Hector, and Patrocles which are enshrined in a luster resistant to the suggestion that they do not possess a complete and robust selfhood as we understand it. However, historian Martin Hollis reminds us that "Homeric culture scarcely conceived the self outside social roles" and he recalls the lexical findings of Bruno Snell in noting that ancient Greek "had no single generic word for each and every human being."[60]

Classicist Brooke Holmes confirms that although the idea that the body was not a given may seem strange, it is only in the classical era that the physical body "comes into the visible"; the result, she argues, "is a new kind of ethical subject."[61] Classicist Christopher Gill feels that while our more modern concept of selfhood can be defined as "subjective-individualist," the notion of selfhood in Greek epic, tragedy, and philosophy is better defined as "objective-participant." He points out that Greek thought can be said to "provide a context for the ideas of 'personality' and 'self'" only to a limited extent.[62] Classicist Rainer Friedrich observes that "when the principle of subjectivity and free individuality arose in Socratic thought and Sophistic teaching the *polis* showed itself unable to integrate them."[63]

59 Damasio, *Self Comes to Mind*, 88.
60 Hollis, "Of Masks and Men," 217.
61 Holmes, *Symptom and the Subject*, 2.
62 Gill, *Personality in Greek Epic*, 10, 13.
63 Friedrich, "Drama and Ritual," 189.

Theatre emerged in the midst of the transition to which Friedrich refers, in what Ramachandran identifies as a huge human progress threshold, positing "[t]here is a greater behavioral gap between pre- and post-500 BCE humans than between [...] *Homo erectus* and early *Homo sapiens*."[64] While this seems a strong assessment, echoes of it can be found across the critical spectrum. Oxford classicist Jaś Elsner includes the birth of theatre in this period's "significant and co-ordinated reformulation of subjectivity which has proved of an import [...] that is [...] simply impossible to overestimate."[65]

As the traditional ontology was strained by the socio-political imperatives of the *polis*, the cyclic notions of time remained attached to communal life and linear time attached to the new individuality. This was the type of problem whose urgency rendered it, according to cognitive philosopher Andy Clark, "representationally hungry" and which therefore "demanded feeding with a large amount of representation."[66] It received this representation in the Attic *theatron* in that the type of selfhood which was innovative in tragedy was a problematized selfhood; the individualized characters in tragedies were "the subjects of a debate [...] under examination before the public."[67] This interrogation took place in a setting which capitalized on traditional neurocognitive cues, i.e., a space for the traditional communal dances in relation to a new linear spatial proposition, the *skene*, which was the domain of the individual actors. Media Studies expert Derrick de Kerckhove observes

> [...] the public is being educated to a new sensory response [...] as the single talking actor differentiates himself from the singing, dancing chorus. The actor is projected in isolation from the community [...] as a figure marked by its difference [...]. The chorus is the embodiment of tribal perceptions, whereas the actor introduces the preliminary workings of private perceptions. At the level of noetic content, the differentiation is expressed in terms of the conflict between personal will and mythical collective structure.[68]

The actor presents his being in the mode of not being himself. The act of presenting an individual self as other may have offered an oblique way of enacting

64 Ramachandran, *The Tell-Tale Brain*, 134.
65 Elsner, "Reflections," 68–69.
66 Clark, "Being There," 167–168. Spolsky, "Making 'Quite Anew,'" 93, also refers to this.
67 Vernant, "The Historical Moment of Tragedy in Greece: Some of the Social and Psychological Conditions," in Vernant and Vidal-Naquet, *Myth and Tragedy*, 24–25.
68 De Kerckhove, "Theatre as Information-Processing," 147.

tensions inherent in individual action. Literary theorist Northrop Frye argues that Dionysus has never had anything to do with individual freedom; rather, "his function is to release us from the burden of freedom."[69] Perhaps the Greek theatre's often-debated connection with Dionysus has to do with the disturbing freedom inherent in individuality as it emerged from tribal modes.

The focus on private destiny is just as much or more an effect of the theatrical medium as it is of the thematic operation. The actor in the mode of self-as-other is perceived by spectators whose mirror systems could respond to the motor actions of the other in their own bodies. As the actors changed masks and roles the audience's mirroring capabilities could attach to one fictive agent and then another, each with another point of view, another group of intentions and desires. Theatre praxis offered the experience of multiple perspectives, multiple individual viewpoints, to the Attic audience.

The interrogation of individual action in Attic culture was broad-based and concerted. Questions of proportion, what was right and proper in human activity and what was over-reaching, dominated the artistic, philosophical, and political projects of the period. To understand the intensity of the theatre's focus on the individual, it is helpful to situate it as far as is presently possible in the historicized cognitive framework of selfhood. In *Self Comes to Mind*, Damasio posits a revolutionary account of the evolution of the self. The ground-breaking component of his tripartite structure of consciousness is that it reverses the traditional explanation "by having covert knowledge of life management *precede* the conscious experience of any such knowledge."[70]

While it is impossible in this paper to do justice to Damasio's systematic and reasoned study, certain of his core ideas can be seen to illuminate what classicist Christopher Pelling calls the "slippery figure" of the individual in archaic and classical Greece.[71] Damasio explains that

> subjectivity is not required for mental states to exist, only for them to be privately known [...]. [C]ountless creatures for millions of years have had active minds happening in their *brains*, but only after those *brains* developed a protagonist capable of bearing witness did [modern] consciousness begin [...].[72]

69 Frye, *Fools of Time*, 19.
70 Damasio, *Self Comes to Mind*, 36.
71 Pelling, preface to *Characterization and Individuality*, v.
72 Damasio, *Self Comes to Mind*, 16–17.

Damasio dates this level of a more modern type of consciousness to around the time of the Homeric poems at 800 BCE and names it "autobiographical selfhood." The autobiographical selfhood, according to Damasio, is amended soon after by a modification which he designates the self-reflective self.

> [C]onscious brains eventually capable of flexible self-reflection is the next momentous event [...this] could surface only once the self was complex enough to reveal a fuller picture of the human condition, once living organisms could learn that pain and loss were at stake but so were pleasure and flourishing and folly, once there were questions to be asked about the human past and the human future, once imagination could show how possibly to reduce suffering, minimize loss, and increase the probability of happiness and fancy. [This] self [...] is a recent development, on the order of thousands of years, a mere instant in evolutionary time.[73]

Damasio's "momentous event" speaks to the adaptation to linear time with its concomitant memories of past and imagination directed toward the future. It also reflects what ISST founder J.T. Fraser saw as the ultimate level of temporality in his nested hierarchy of time, noetic time, of which he wrote "selfhood, noetic time and the awareness of death became mutually reinforcing elements in the making of the mind."[74] I suggest that what Damasio identifies as the emergence of the self-reflective self, and a movement into a more modern version of what Fraser identifies as noetic time, were abetted by the neurocognitive activations made available by theatrical praxis in the Attic *theatron*.

As noted above, the fictional narratives of Greek tragedy were quite different from the narratives of epic. They are strictly emplotted and the action presented moves expediently through a beginning, a middle and an end; the form itself replicates the finite career of an individual human being. As H. Porter Abbott contends in his *Cambridge Introduction to Narrative*: "With the growing awareness of time through narrative, the corollary increase in the awareness of death would in turn require fuller cultural mechanisms to accommodate this awareness."[75] Although I am not implying that Greeks before the late archaic period had no knowledge of death, I would like to propose that as the imperatives of linear time became more firmly entrenched in the life of the *polis*, a

73 Damasio, *Self Comes to Mind*, 287–289.
74 Fraser, *Time and Time Again*, 186.
75 Abbott, *Evolutionary Origins*, 251.

hypostatized version of subjectivity, of "I-ness" emerged which brought with it a heightened consciousness of death.

Through the ineluctable forward movement of tragedy, the future is firmly linked to past and present actions; future consequences to past and present decisions. Noted literary scholar Frank Kermode observes that tragedy performs the function "of opening the subject of the hidden death to our reluctant imaginations."[76] Historian Maria Serena Mirto describes the altered sense of death that emerged during the late archaic period as a "trend away from [...] calm acceptance [...] toward the anxieties attending a more individualized vision of death."[77] This growing awareness became "hungry for representation"[78] and, again, theatrical praxis seems appropriate to answer the need. This was, in all probability, a great part of tragedy's value: it performed the mysteries of passage. In the mirroring capabilities of the Athenian spectators it was possible through the rich fictional enactment of performance to play dying or play dead through the agency of the other as self. Through the absent other the subject of the absent self was opened for reflection.

Cognitive evolutionary studies such as this one, which suggest that the arts are grounded in our collective history and physiology, are reorienting because they have as their premise the idea that our fictions and our enacted fictions are ancillary to neither culture nor to individuals. Enacted fictions should have pride of place in considerations of epigenetic change in that they expedite new affordances of space, time, the body, agency and causality. We must begin, as literary theorist Ellen Spolsky explains, "[s]eeing stories [...] as artifacts on par with arrowheads and antibiotics rather than as messengers from a privileged if useless aesthetic realm [...]."[79] and begin to acknowledge that, as literary critic N. Katherine Hayles asserts, we are continually "re-engineered"[80] by our technologies. Whether consuming fictions deployed through the agency of masked actors, pixelated TV personalities, digitized filmic agents, or M.U.D. avatars, our fictions shape and reshape us in fundamental ways that we are only beginning to understand through insights into our cognitive processes. It is both fascinating and cautionary to recall—and we must—the old adage that although the hand shapes the tool, the tool also shapes the hand.

76 Kermode, *The Sense of an Ending*, 161.
77 Mirto, *Death in the Greek World*, 4.
78 Clark, "Being There," 167–8.
79 Spolsky, "Making 'Quite Anew,'" 85.
80 Hayles, "Intermediation," 102.

References

Abbott, H. Porter. "The Evolutionary Origins of the Storied Mind: Modeling the Prehistory of Narrative Consciousness and its Discontents." *Narrative* 8, no. 3 (2000): 247–256.

———. *The Cambridge Introduction to Narrative*. Cambridge: Cambridge University Press, 2008.

Armstrong, Paul B. *How Literature Plays with the Brain: The Neuroscience of Reading and Art*. Baltimore: The Johns Hopkins University Press, 2013.

Bassi, Karen. "Visuality and Temporality: Reading the Tragic Script." In *The Soul of Tragedy: Essays on Athenian Drama*, edited by Steven Oberhelman and Victoria Pedrick, 251–270. Chicago: University of Chicago Press, 2005.

Blair, Rhonda. "Introduction: The Multimodal Practitioner." In *Affective Performance and Cognitive Science: Body, Brain, and Being*, edited by Nicola Shaughnessy, 135–146. Bloomsbury Methuen Drama. London: Bloomsbury, 2013.

Boedeker, Deborah and Kurt A. Raaflaub, eds. *Democracy, Empire, and the Arts in Fifth-Century Athens*. Cambridge, MA: Harvard University Press, 1998.

Bonini, Luca and Pier Francesco Ferrari. "Evolution of Mirror Systems: A Simple Mechanism for Complex Cognitive Functions." *Annals of the New York Academy of Sciences* 1225 (2011): 166–175.

Boyd, Brian. *On the Origin of Stories: Evolution, Cognition and Fiction*. Cambridge: The Belknap Press of Harvard University Press, 2009.

Brecht, Bertolt. *Brecht on Theatre*. Edited by Marc Silberman, Steve Giles and Tom Kuhn. Completely revised and updated third edition. Bloomsbury Methuen Drama. London: Bloomsbury, 2015.

Brüne, Martin. "Theory of Mind: Evolution, Ontogeny, Brain Mechanisms and Psychopathology." *Neuroscience and Behavioral Reviews* 30, no. 4 (2006): 437–455.

Caggiano, Vittorio and Leonardo Fogassi, Giacomo Rizzolatti, Peter Thier, Antonino Casile. "Mirror Neurons Differentially Encode the Peripersonal and Extrapersonal Space of Monkeys." *Science* 324 (2009): 403–406.

Carter, David. "Was Attic Tragedy Democratic?" *Polis: The Journal of the Society for Greek Political Thought* 21, no. 1–2 (2004): 1–25.

Chatterjee, Anjan. *The Aesthetic Brain: How We Evolved to Desire Beauty and Enjoy Art*. New York: Oxford University Press, 2013.

Clark, Andy. *Being There: Putting Brain, Body and World Together Again*. Cambridge, MA: MIT Press, 1997.

Cosmides, Leda and John Tooby. "Does Beauty Build Adapted Minds? Toward an Evolutionary Theory of Aesthetics, Fiction and the Arts." *SubStance* 30, no. 1–2 (2001): 6–27.

Csapo, Eric. *Actors and Icons of the Ancient Theater*. West Sussex: Wiley-Blackwell, 2010.

Csapo, Eric and Margaret C. Miller, "Democracy, Empire, and Art: Towards a Politics of Time and Narrative." In Boedeker and Raaflaub, *Democracy and the Arts*, 87–126.

———, eds. *The Origins of Theater in Ancient Greece and Beyond: From Ritual to Drama*. Cambridge: Cambridge University Press, 2007.

Damasio, Antonio. *Self Comes to Mind: Constructing the Conscious Brain*. New York: Pantheon, 2010.

Davidson, James. "Revolutions in Human Time: Age-class in Athens and the Greekness of Greek Revolutions." In Goldhill and Osborne, *Rethinking Revolutions*, 29–67.

de Kerckhove, Derrick. "A Theory of Greek Tragedy." *SubStance* 29 (1981): 23–36.

———. "Theatre as Information-Processing in Western Cultures." *Modern Drama* 25, no. 1 (1982): 144–153.

de Romilly, Jacqueline. *Time in Greek Tragedy*. Ithaca: Cornell University Press, 1968.

Donald, Merlin. *A Mind So Rare: The Evolution of Human Consciousness*. New York: W.W. Norton, 2001.

———. *Origins of the Modern Mind: Three Stages in the Evolution of Culture and Cognition*. Cambridge: Harvard University Press, 1991.

Duncan, Anne. *Performance and Identity in the Classical World*. Cambridge: Cambridge University Press, 2012.

Elsner, Jaś. "Reflections on the 'Greek Revolution' in Art: From Changes in Viewing to the Transformation of Subjectivity." In Goldhill and Osborne, *Rethinking Revolutions*, 68–95.

———. *Roman Eyes: Visuality and Subjectivity in Art and Text*. Princeton: Princeton University Press, 2007.

Fagan, Garrett G. *The Lure of the Arena: Social Psychology and the Crowd at the Roman Games*. Cambridge: Cambridge University Press, 2011.

Farenga, Vincent. *Citizen and Self in Ancient Greece: Individuals Performing Justice and the Law*. Cambridge: Cambridge University Press, 2006.

Foster, Hal, ed. *Vision and Visuality*. Seattle: Bay, 1988.

Fraser, J.T. *Time and Time Again: Reports from a Boundary of the Universe*. Leiden: Brill, 2007.

Friedrich, Rainer. "Drama and Ritual." *Themes in Drama* 6 (1984): 159–213.

Frye, Northrop. *Fools of Time: Studies in Shakespearean Tragedy*. Toronto: University of Toronto Press, 1967.

Gagné, Renaud and Marianne Govers Hopman, eds. *Choral Mediations in Greek Tragedy*. Cambridge: Cambridge University Press, 2013.

Gallese Vittorio. "Mirror Neurons and Intentional Attunement: A Commentary on David Olds." *Journal of the American Psychoanalytic Association* 54 (2006): 46–57.

———. "What do Mirror Neurons Mean? Intentional Attunement: The Mirror Neuron System and Its Role in Interpersonal Relations." http://www.apsa.org/portals/1/docs/japa/541/gallese--pp.47–57.pdf

Gallese, Vittorio and Luciano Fadiga, Leonardo Fogassi, Giacomo Rizzolatti. "Action Recognition in the Premotor Cortex." *Brain* 119 (1996): 593–609.

Gill, Christopher. *Personality in Greek Epic, Tragedy and Philosophy: The Self in Dialogue.* New York: Oxford University Press, 1998.

Goldhill, Simon and Robin Osborne. *Performance Culture and Athenian Democracy.* Cambridge: Cambridge University Press, 1999.

Goldhill, Simon and Robin Osborne, eds. *Rethinking Revolutions Through Ancient Greece.* Cambridge: Cambridge University Press, 2006.

Harrison, Thomas. "Religion and the Rationality of the Greek City." In Goldhill and Osborne, *Rethinking Revolutions*, 124–140.

Havelock, Eric. *The Literate Revolution in Greece and its Cultural Consequences.* Princeton: Princeton University Press, 1981.

Hayles, N. Katherine. "Intermediation: The Pursuit of a Vision." *New Literary History* 38, no. 1 (2007): 99–125.

Hernadi, Paul. "Literature and Evolution." *Substance* 30, no. 1–2 (2001): 55–71.

Heyes, Cecilia. "Where do Mirror Neurons Come From?" *Neuroscience and Bio Behavioral Reviews* 34 (2010): 575–583.

Hollis, Martin. "Of Masks and Men." In *The Category of the Person: Anthropology, Philosophy, History*, edited by Michael Carrithers, Steven Collins and Steven Lukes, 217–233. New York: Cambridge University Press, 1985.

Holmes, Brooke. *The Symptom and the Subject: The Emergence of the Physical Body in Ancient Greece.* Princeton: Princeton University Press, 2010.

Jay, Martin. "Scopic Regimes of Modernity." In Foster, *Vision and Visuality*, 3–28.

Jaynes, Julian. *The Origin of Consciousness in the Breakdown of the Bicameral Mind.* Boston: Houghton Mifflin, 1976.

Kermode, Frank. *The Sense of an Ending: Studies in the Theory of Fiction.* New York: Oxford University Press, 1967.

Keyser, Christian "Social Neuroscience: Mirror Neurons Recorded in Humans." *Current Biology* 20 (2010): 353–354.

Klein, Stanley B., Keith Rozendal and Leda Cosmides. "A Social-Cognitive Neuroscience Analysis of the Self." *Social Cognition* 20, no. 2 (2002): 105–135.

Kraus, Chris, Simon Goldhill, Helene P. Foley and Jaś Elsner, eds. *Visualizing the Tragic: Drama, Myth, and Ritual in Greek Art and Literature.* New York: Oxford University Press, 2007.

Lakoff, George and Mark Johnson. *Metaphors We Live By.* Chicago: University of Chicago Press, 2003.

———. *Women, Fire, and Dangerous Things: What Categories Reveal About the Mind.* University of Chicago Press, 1987.

Lloyd, G.E.R. *Magic, Reason and Experience.* Cambridge: Cambridge University Press, 1979.

———. "Views on Time in Greek Thought." In *Cultures and Time*, edited by Louis Gardet, P. Erhard, E. Altenmüller, U. Schroeder, H. Boec, A.J. Gurevich, A. Kagame, C. Larre, G.E.R. Lloyd, A. Neher, R. Panikkar, G. Pattaro, P. Ricoeur, 117–148. Paris: Unesco, 1976.

Magnus, Erica. "Theatrical Praxis as a Mediative Technology for Individual Consciousness." *KronoScope* 13:1 (2013): 127–140.

———. "Time on the Stage," *KronoScope* 4:1 (2004): 95–126.

McConachie, Bruce A. *Engaging Audiences*. New York: Palgrave Macmillan, 2008.

———. "Metaphors We Act By: Kinesthetics, Cognitive Psychology, and Historical Structures." *Journal of Dramatic Theory and Criticism* 7, no. 2 (1993): 25–45.

McConachie, Bruce A. and F. Elizabeth Hart. *Performance and Cognition: Theatre Studies and the Cognitive Turn*. New York: Routledge, 2007.

Meineck, Peter. "Dionysos, Divine Space and Dopamine: A Cognitive Approach to the Greek Theatre," http://www.academia.edu/5933752/Dionysos_Divine_Space_and_Dopamine_-_DRAFT_Center_for_Hellenic_Studies_Research_Seminar.

———. "The Neuroscience of the Tragic Mask." *Arion* 19, no. 1 (2011): 113–158.

Metz, Christian. *The Imaginary Signifier: Psychoanalysis and the Cinema*. Bloomington: Indiana University Press, 1982.

Mirto, Maria Serena. *Death in the Greek World: From Homer to the Classical Age*. Trans. A.M. Osborne. Norman: University of Oklahoma Press, 2012.

Murnaghan, Sheila. "Women in Groups: Aeschylus' *Suppliants* and the Female Choruses of Greek Tragedy." In *The Soul of Tragedy: Essays on Athenian Drama*, edited by Victoria Pedrick and Steven M. Oberhelman, 183–200. Chicago: University of Chicago Press, 2005.

Nightingale, Andrea Wilson. *Spectacles of Truth in Classical Greek Philosophy: Theoria in its Cultural Context*. Cambridge: Cambridge University Press, 2004.

Ong, Walter J. *Interfaces of the Word: Studies in the Evolution of Consciousness and Culture*. Ithaca: Cornell University Press, 1977.

Olson, David R. *The World on Paper: The Conceptual and Cognitive Implications of Writing and Reading*. Cambridge: Cambridge University Press, 1994.

Osborne, R.G. "Death Revisited: Death Revised. The Death of the Artist in Archaic and Classical Greece." *Art History* 11, no. 1 (1988): 1–16.

Pache, Corinne Odine. *Baby and Child Heroes in Ancient Greece*. Chicago: University of Illinois Press, 2004.

Parker, Robert. "Greek States and Greek Oracles." In *Crux: Essays Presented to Geoffrey de Ste Croix*, edited by P.A. Cartledge and F.D. Harvey, 289–326. Exeter: Exeter University Press, 1985.

Pedrick, Victoria and Steven M. Oberhelman, eds. *The Soul of Tragedy: Essays on Athenian Drama*. Chicago: University of Chicago Press, 2006.

Pelling, Christopher, ed. *Characterization and Individuality in Greek Literature*. Oxford: Oxford University Press, 1990.
Pfister, Manfred. *Theory and Analysis of Drama*. Translated by John Halliday. Cambridge: Cambridge University Press, 1988.
Pineda, Jaime A., ed. *Mirror Neuron Systems: The Role of Mirroring Processes in Social Cognition*. New York: Humana Press, 2009.
Previc, Fred H. *The Dopaminergic Mind in Human Evolution and History*. Cambridge: Cambridge University Press, 2012.
Price, Simon. *Religions of the Ancient Greeks*. Cambridge: Cambridge University Press, 1999.
Purves, Alex C. *Space and Time in Ancient Greek Narrative*. Cambridge: Cambridge University Press, 2010.
Ramachandran, V.S. "Mirror Neurons and Imitation Learning as the Driving Force Behind the 'Great Leap Forward' in Human Evolution." *Third Culture* (2000): http://www.edge.org/3rd_culture.
———. *The Tell-Tale Brain: A Neuroscientist's Quest for What Makes us Human*. New York: W.W. Norton, 2011.
Rehm, Rush. *Greek Tragic Theatre*. London: Routledge, 1992.
———. *Play of Space: The Spatial Transformation of Greek Tragedy*. Princeton: Princeton University Press, 2002.
———. *Radical Theatre: Greek Tragedy in the Modern World*. New York: Bloomsbury Academic, 2014.
Roselli, David Kawalko. *Theater of the People: Spectators and Society in Ancient Athens*. Austin: University of Texas Press, 2011.
Shaughnessy, Nicola, ed. *Affective Performance and Cognitive Science: Body, Brain, and Being*. Bloomsbury Methuen Drama. London: Bloomsbury, 2013.
Shlain, Leonard. *Art and Physics: Parallel Visions in Space, Time and Light*. New York: Morrow, 1991.
Shimamura, Arthur P. and Stephen E. Palmer, eds. *Aesthetic Science: Connecting Minds, Brains, and Experience*. New York: Oxford University Press, 2012.
Spolsky, Ellen. "Making 'Quite Anew': Brain Modularity and Creativity." In *Introduction to Cognitive Cultural Studies*, edited by Lisa Zunshine, 84–102. Baltimore: Johns Hopkins University Press, 2010.
Starr, G. Gabrielle. *Feeling Beauty: The Neuroscience of Aesthetic Experience*. Cambridge: The MIT Press, 2013.
Taplin, Oliver. "Spreading the Word Through Performance." In *Performance Culture and Athenian Democracy*, edited by Simon Goldhill and Robin Osborne, 33–57. Cambridge: Cambridge University Press, 1999.
Vernant, Jean-Pierre. "The God of Tragic Fiction." In Vernant and Vidal-Naquet, *Myth and Tragedy in Ancient Greece*, 181–188.

———. "The Historical Moment of Tragedy in Greece: Some of the Social and Psychological Conditions." In *Myth and Tragedy in Ancient Greece*, 23–28.

———. *Myth and Thought Among the Greeks*. London: Routledge, 1983.

———. "The Tragic Subject: Historicity and Transhistoricity." In Vernant and Vidal-Naquet, *Myth and Tragedy in Ancient Greece*, 237–247.

Vernant, Jean-Pierre and Pierre Vidal-Naquet. *Myth and Tragedy in Ancient Greece*. Translated by Janet Lloyd. New York: Zone Books, 1990.

Waelti, P.A. Dickinson and Wolfram Shultz. "Dopamine Responses Comply with Basic Assumptions of Formal Learning Theory." In Boyd, *On the Origin*, 184.

Walker, Steven F. "The Invention of Theater: Recontextualizing the Vexing Question." *Comparative Literature* 56, no. 1 (2004): 1–22.

Wiles, David. "Seeing is Believing: The Historian's Use of Images." In *Representing the Past: Essays in Performance Historiography*, edited by Thomas Postlewait and Charlotte M. Canning, 215–239. Iowa City: University of Iowa Press, 2010.

———. *Theatre and Citizenship: The History of Practice*. Cambridge: Cambridge University Press, 2011.

———. *Tragedy in Athens*. Cambridge: Cambridge University Press, 1997.

Williams, G.C. *Adaptation and Natural Selection: A Critique of Some Current Evolutionary Thought*. Princeton: Princeton University Press, 1996.

Wilshire, Bruce. *Role Playing and Identity: The Limits of Theatre as Metaphor*. Bloomington: Indiana University Press, 1982.

Wright, Charles, foreword to *Vision and Visuality*, ed. Hal Foster, vii–viii. Seattle: Bay, 1988.

Young, Kay and Jeffrey L. Saver. "The Neurology of Narrative." *SubStance* 30, no. 1–2 (2001): 72–84.

PART 3

Thought Traces: Philosophy, Memory, and the Human Mind

∴

CHAPTER 9

A.N. Prior's Ideas on Keeping Track of Branching Time

Peter Øhrstrøm and Thomas Ploug

Abstract

This paper offers a presentation and a discussion of one of the most interesting ideas suggested by A.N. Prior (1914–69). According to this idea the Now can be said to keep track of the totality of time in a very precise and formal manner. The claim is that Now conceptually not only includes everything which holds about the past and the future. In fact, it reflects everything in the entire branching time system, in the sense that even true counterfactuals are formally entailed by the Now. Prior's formalization of this very rich idea of the Now may be seen as a conceptual foundation for his presentist view. Various aspects and problems related to this idea are discussed in the paper with references to the current discussions of the issues.

Keywords

philosophy of time – tense-logic – branching time – temporal logic – Arthur N. Prior – Saul Kripke – presentism

1 Introduction

A.N. Prior (1914–69) was the founder of modern temporal logic, which may also be termed "the logic of time." Prior himself often used the term "tense-logic," although "temporal logic" has now become the most common designation of the discipline. The field has become very important within philosophical logic as well as within theoretical computer science.

Prior was born in New Zealand in 1914. He graduated in philosophy in 1937 and worked for a number of years at Canterbury University, Christchurch, from 1952 as professor. In 1959 he was appointed professor of philosophy at Manchester University, and in 1965 he became a reader in Oxford and a fellow of Balliol College. Until the mid-1950s Prior was a very active member

of the Presbyterian Church. However, over the years he found himself to be more and more in doubt and even in opposition to the Presbyterian ideas of predestination. Ultimately he left the Presbyterian Church for good. In fact, to a large extent his philosophy and logic of time may be seen as a reaction to Presbyterian thought, although his interests and studies in theology certainly also inspired him greatly in his development of a logic of time. In this work he kept on referring to his theological library, and he remained very interested in metaphysical topics such as the relation between time and existence. Actually, much of his work with temporal logic seems to have been inspired by the classical tension between the Christian doctrines of divine foreknowledge and human freedom. In order to analyze problems of this kind he developed a formal language in terms of which the relevant concepts and arguments can be treated in a precise manner.

Actually, Prior presented some of his ideas on time at the very first conference organized by The International Society for the Study of Time (ISST) which was held in Oberwolfach (Germany) in 1969, just a few months before he died. At this conference Prior gave a paper on presentism, i.e., the view that only the present exists, and that the real can in fact be identified with the present. He stated his position in his paper "The Notion of the Present," claiming that "[...] the present simply is the real considered in relation to two particular species of unreality, namely the past and the future" (Prior 1972, 320). However, this formulation appears to be a bit odd. How can something real stand in a relation to something unreal? It seems that a claim of this kind would lead to a contradiction if it is assumed that whatever relates to something real is itself real.

It is obvious that Prior was aware of the problem. As documented in David Jakobsen (2011), Prior was evidently trying to find an alternative formulation in order to explain in what sense we can compare the real with what has been real or what will be real. When Prior gave his lecture at the ISST conference he did in fact try to explain it in terms of some examples referring to the past lecture by Whitrow and the future lecture by Scott (Prior 1972, 321). He pointed out that although we cannot directly compare a past lecture with a present lecture, we can compare the proposition "it has been the case that Whitrow is lecturing" with the proposition "Prior is lecturing." In his lecture Prior claimed that both propositions are true. However, there is obviously a formal difference between the two propositions. The former clearly contains a tense-logical prefix ("it has been the case that...") whereas the latter does not contain a prefix. So if we consider the set of all propositions which *are* true, the present can simply be defined as the subset of all propositions without a prefix. The conjunction of all such propositions will be a complete description of what *exists*. It is important that the tense of the italicized verbs in the

previous sentence be taken into serious account. On this background, Prior claims that the reality of the present simply consists in "the absence of a qualifying prefix" (Prior 1972, 321). What Prior was trying to explain here should be seen in light of his general philosophy and logic of time. The point seems to be that the present is just a subset of the set of all propositions which are true now. In Prior's general approach to time the latter set may in fact be identified with the Now, i.e., the conjunction of all propositions (with and without prefix) that *are* true. Conceived in this way the Now becomes a much richer concept than the Present. The Now implies the Present, but not vice versa.

According to Prior, logic is the key to a proper understanding of time. Clearly, it cannot be logic in the classical restricted and atemporal sense. It has to be logic in a broader sense. What we need in order to provide a relevant understanding of time is a logic which takes the dynamical aspects of reality into serious consideration. In order to explain what these dynamical aspects are, it should be pointed out that there are two fundamentally different ways of dealing with the temporal aspects of reality. One can consider the dynamics of the world from the outside trying to apply a God's-eye perspective, i.e., seeing the history of the world as a whole. In this case time will be described in terms of the relations "before," "after," and "simultaneous with." Alternatively, one may consider the dynamics of the world from the inside accepting that we are ourselves parts of this dynamical process. In this case the temporal aspect can be described in terms of the tense-logical prefixes corresponding to past and future. The latter approach refers to what McTaggart had called the A-series, whereas the former refers to McTaggart's so-called B-series (Prior 1967, 1–9). Prior insisted on the primacy of what we might call the A-view, i.e., the A-series is conceptually fundamental. This does not mean that the alternative B-view should be entirely rejected. It should, however, be conceived as a useful abstraction, i.e., a practical but secondary way of dealing with the dynamic aspects of the world. According to Prior tense-logic is the primary key to a rational discussion of reality. In his own words: "I believe that what we see as a progress of events *is* a progress of events, a *coming to pass* of one thing after another, and not just a timeless tapestry with everything stuck there for good and all [...]" (undated note by Prior, published in Copeland 1996, 47; emphasis original).

Prior introduced the idea of grades of tense-logical involvement (Prior 2003, 117ff.). The first grade is the B-view, i.e., the claim that the temporal aspect of reality may be conceived as a timeless tapestry. According to the second grade, the A- and B-language should be seen on a par—neither of them being more conceptually fundamental than the other. Prior definitively rejected these two lower grades and focused on what he called the third and the fourth grades of tense-logical involvement, according to which the A-language should

be seen as the background for a proper understanding of time, and according to which any statement formulated in the B-language can in fact be reduced to a statement formulated in terms of A-concepts alone. (The third and the fourth grades will be presented in more detail below.)

2 Tense-Logic Giving Cash Value to Assertions about Time

According to Prior the idea of time is basically a convenient construction for talking about the dynamics of reality in an abstract manner. In his own words:

> Time is not an object, but whatever is real exists and acts in time [...] But this earlier-later calculus is only a convenient but indirect way of expressing truths that are not really about 'events' but about things [...]. (Undated note by Prior, published in Copeland 1996, 45)

Prior held that the abstract concept of time should be discussed rationally in terms of tense-logic, which makes it is possible to reflect rationally on what is, what has been and what will be. In principle, any question about time has to be dealt with in this way. According to Prior, we may understand tense-logic as the proper way of "giving cash value to assertions about time" (Prior 1967, 74). This approach is clearly inspired by William James who gave the cash-value metaphor a very prominent role in his writings on pragmatism. According to James the cash-value of a concept is its experiential worth, i.e., its worth in terms of particular experience (see Cotkin 1985). Similarly, Prior held that time should be explained in terms of tensed experiences (past, present, future).

Tense-logic may be seen as an extension of classical logic. Given that propositional constants $p, q, r \ldots$ describe how things are right now, we may form new propositions dealing with what has been the case and what is going to be the case using the tense-operators (i.e., tense-logical prefixes) P and F, corresponding to "it has been the case that..." and "it is going to be the case that...," respectively. Using the negation operator \sim, we may in fact define two more propositional operators, G and H, corresponding to $\sim F\sim$ and $\sim P\sim$ respectively. In this way, four different propositions can be formed from a given proposition, p:

Pp : "it has been that p"
Fp : "it is going to be that p"
Hp : "it has always been that p"
Gp : "it is always going to be that p"

In addition, we make take advantage of the fact that durations can in principle be measured. This means that we may also formulate tense-logical statements like:

$P(x)p$: "x time units ago it was the case that p"
$F(x)p$: "in x time units it is going to be the case that p"

According to Prior, it will be possible to reformulate statements regarding the properties of time as such in a precise manner in terms of this tense-logical formalism. For instance, to state that time has an end, would mean that for any p it is the case that

$$Gp \vee FGp$$

The idea is that at the end of time Gp, i.e. "p will always be the case" will be true for any p. So the above formula is based on the fact that if time has an end, then it is either in the present moment or at some future moment. Another example of tense-logic giving cash-value to an assertion about time is that the claim of circular time implies that for any p it is the case that

$$Pp \supset Fp$$

The point is here that if time is circular, then any past truth will occur some time in the future as well.

In the 1950s and 1960s Prior laid out the foundation of tense-logic and showed that this important discipline was intimately connected with modal logic (i.e. extension of propositional logic with possibility as a propositional operator, M). He showed how temporal logic can be used in order to keep track of the past and of the future possibilities in a way which makes it possible to reason systematically about temporal matters.

3 The Idea of Branching Time

Prior published his first book on temporal logic, *Time and Modality*, in 1957. In this book he suggested some logical properties of the future operator assuming that the suggested logical system would correspond to the idea of linear time. However, when Saul Kripke had read the book he sent a letter to Prior, dated Sept. 3, 1958, pointing out that the tense-logical system suggested by Prior for the future operator corresponded to a more general idea of time than

linear time. In his letter, Kripke, who was at that time only 17 years old, proposed for the very first time the notion of branching time and argued that this idea corresponds to the logical system that Prior had discussed in the book. (The logical system considered by Prior and Kripke is the so-called S4 system for the operator "now or in the future." The critical axiom in this system is $FFp \supset Fp$.)

In the branching time model first suggested by Kripke, time is supposed to flow 'downwards' in the sense that the future is placed 'below' the past in the diagram. In most later branching time diagrams the past-future-direction is represented horizontally, from left to right. Kripke's original model was illustrated in the following manner:

FIGURE 1 Saul Kripke's model of branching time, Sept. 3, 1958. (After Ploug & Øhrstrøm 2012).

In the correspondence following this famous letter, Prior and Kripke discussed the idea of branching time further. After some hesitation, Prior embraced the idea, and in the following years he labored hard to explore some of the formalities to which it may give rise. Among other things he showed how branching time models can be used to keep track, not only of the past and the future, but also of counterfactual possibilities (i.e., what could have become the case). This means that the discussion involves a notion of possibility, which can be represented in terms of a modal operator, M, as well as a notion of necessity,

represented in terms of the operator, N, and defined as ~M~. Given this formalism Prior was able to demonstrate that there is a close connection between the Now and the branching time structure. In fact, as we shall see, Prior argued that the entire branching time structure follows logically from the formal properties of the Now.

4 Prior's Ideas on Branching Time

In his papers and letters, Prior discussed the idea of branching time, demonstrating that it can be used to analyse the notion of time itself as well as fundamental existential problems, such as the problem of determinism versus freedom of choice. One of his main interests was the proper understanding of the proposition $F(n)p$, which may be read: "In n time units it is going to be the case that p." The meaning of this proposition may be discussed in terms of the following diagram:

FIGURE 2
Prior's branchingtime model constructed in order to discuss the meaning of $F(n)p$. (After Prior 1967, 127).

Let us assume that p is true at the instant z in the diagram (and nowhere else). In order to evaluate $F(n)p$ at x according to Prior's so-called Ockhamistic model, we have to know which of the branches in the diagram will represent the true course of events. If this is supposed to be x-y-z, then $F(n)p$ is true at x, whereas if the true course of events will be x-y-t, then $F(n)p$ is false at x. In Prior's early versions of the Ockhamistic model, he suggested that one of the possible courses of events is in fact "picked out" as the true course of events. In an unpublished paper he wrote:

> In each model there is a single designated point, representing the actual present moment; and in an Occamist model there is a single designated line (taking one only of the possible forward routes at each fork), which might be picked out in red, representing the actual course of events. (Quoted from Øhrstrøm and Hasle 2011, note 3)

This early version of the model seems to be conceptually very close to the classical view defended by William of Ockham (c. 1287–1347) and many other medieval writers. Ockham presented his view in the book *Predestination, God's Foreknowledge, and Future Contingents* (1969). According to this view statements about the future can be true now without being necessary, since it is assumed that God has specific and complete knowledge regarding the future course of events. In terms of the modern branching time model this means that there is a future chronicle with a special status because it corresponds to the divine foreknowledge, i.e., as Prior states it, "a single designated line" in the branching time system. This idea of a so-called "thin red line" and related ideas have often been discussed in philosophical logic (see Belnap et al. 1994 and 2001). In fact, it turns out that the idea can be further developed based on a view that can be traced back to Luis de Molina, 1535–1600 (see Øhrstrøm 2014).

In his later book, *Past, Present and Future* (1967), Prior suggested a version of the Ockhamistic model according to which the notion of a truth-value of $F(n)p$ at x is dropped in the absolute sense and only accepted relative to various possible branches in the diagram (corresponding to the various possible courses of events). Obviously, this "Ockhamistic" view differs from the classical view, which we may call the *classical Ockhamistic model*, mentioned above, although it turns out that the two "Ockhamistic" approaches actually do agree on which expressions should be accepted as theorems. Eventually, Prior rejected the Ockhamistic approach totally, and embraced the so-called Peircean model defined and defended by the American philosopher C.S. Peirce (1839–1914) in the following way:

> [The future] is not Actual, since it does not act except through the idea of it, that is as a law acts; but is either Necessary or Possible [...]. (CP 5.459)

> A certain event either will happen or will not. There is nothing now in existence to constitute the truth of its being about to happen, or of its being not about to happen, unless it be certain circumstances to which only a law or uniformity can lend efficacy. But that law or uniformity, the nominalists say, has no real being, it is only a mental representation. If so, neither the being about to happen nor the being about not to happen has any reality at present [...] If, however, we admit that the law has a real

being, and of the mode of being an individual, but even more real, then the future necessary consequent of a present state of things is as real and true as the present state of things itself. (CP 6.368)

According to the model corresponding to this view, $F(n)p$ is false at x, since we cannot be sure at x that it is true, given the indeterministic setting represented in the branching time system. In fact, according to the Peircean model not only $F(n)p$, but also $F(n){\sim}p$ will have to be counted as false.

Prior demonstrated that the Peircean model can be formally conceived as a fragment of the Ockhamistic model, since it turns out that the Peircean $F(n)$ is simply the Ockhamistic $NF(n)$. This means that what the Peircean sees as true regarding the future is simply what the Ockhamist will call necessary future. The Peircean statements will correspond to the Ockhamist statements in which any $F(n)$ occur together with an N as in $NF(n)$. This means that the Ockhamist idea of the simple (and not necessary) future, $F(n)$, will not even be statable in the language accepted according to the Peircean model, which only allows truth about the future in case we are speaking about the necessary future. Prior argued that this view was precisely what Peirce had defended in his writings.

In the following we shall focus on classical Ockhamistic tense-logic and its further elaborations. In terms of this logical model, the claim that time is branching can be presented as the assertion that at least at some instants, the following holds:

(BT) For some p and some n, it may be true that $MF(n)p \land MF(n){\sim}p$

This means that there are some possibilities which both may and may not be the case in the future. In order to show that (BT) is a good description of branching time, one may discuss whether the negation of (BT) could be valid in general (i.e., whether the negation is a logical theorem):

(~BT) For all p and all n, it is true that ${\sim}MF(n)p \lor {\sim}MF(n){\sim}p$

This claim can be reformulated as the general validity of the following implication:

$MF(n)p \supset {\sim}MF(n){\sim}p$

Within classical Ockhamistic tense-logic this turns out to be equivalent with

$MF(n)p \supset NF(n)p$

Clearly, (~BT) means that if something *can* happen in the future, then it is bound to happen. If this is a logical theorem, then there will be no branching, and time will just be a linear order of events. For this reason, it seems obvious that (BT) is an adequate formalization of the idea of branching of time.

What is at stake in (BT) is so-called *forward branching*. Prior considered the following diagram in order to illustrate the idea:

FIGURE 3 *Prior rejects a branching time model like this one, since it allows for the possibility that at some future time there will be alternative histories.*

One interesting question for Prior was whether branches as indicated in Figure 3 may eventually unite again in the future, after having branched. Prior pointed out that some Christians as well as some Marxists seem to think so. However, if such models are accepted, we would have to acknowledge not only forward branching, but also backwards branching, i.e., the idea that at some moments of time there could be alternative pasts. Prior wrote:

> [I]f there is really only one possibility after the fork, then what that future is, which includes *what will have been the case* in the future, can depend only on 'possible pasts'—one would have to say that once we are past the fork there is no actual past but only two possible pasts. (Prior 1967, 28)

Prior was not ready to accept a view like that. In his opinion, this view would lead to an assumption of backwards branching in time, and in his view, such an idea should be rejected. In other words, there exist no *n* and no *p* for which the conjunction

$MP(n)p \land MP(n)\sim p$

could be true (note that this is a mirror image of (BT), but with *P* replacing the *F* operator). Prior maintained that in this sense there is an important asymmetry between the past and the future. It is evident that a crucial element in Prior's argumentation was that any future instant (as all other instants) in

principle includes information about what has been the case. Yesterday at noon it was true to say, either "Joe is at home" or "Joe is not at home"—but not both (given that "Joe" and "at home" are well-defined terms). In this way, the Now may be said to keep track of all past moments of time.

Therefore, according to Prior's view of time, the Now implies that there is a unique past. However, Prior's notion of an instant is even richer. An instant includes in principle (i.e., ontologically) everything which is true at that instant. In Prior's view, there is in a certain sense no distinction between "being true at a certain instant" and the instant itself. The present instant, the Now, implies everything which is currently true. This includes statements describing a snapshot of the current situation, and also all true statement about the past, the future, and the counterfactual states. In this way, the Now may formally be said to keep track of all other moments of time. In fact, the Now implies every aspect and every element of the entire branching time structure. If we assume the classical Ockhamistic model the Now even keeps track of the contingent future in the sense that any truth about the contingent future follows from the Now.

Prior's view on time means that the Now contains a number of statements formulated in terms of modal- and tense-operators (P, F, and M), i.e., statements with various prefixes, where F now stands for future possibility and M stands for universal possibility. However, the Now also includes statements without prefixes. The conjunction of these statements (without modal- or tense-logical prefixes) may be called "the present." Clearly, the Now also contains sets of statements which correspond to the past and the future, respectively. As Prior maintained in his definition of presentism, the present is the real, i.e., the set of statements without prefixes implied by the Now. Explained in this way, it is evident that Prior's definition of presentism does not give rise to any contradiction.

Prior's notion of instants as a very special kind of propositions is the crucial idea in his development of what is called hybrid logic. The instant propositions are assumed to be possible, i.e., Mi, for any instant proposition, i. In addition, it is a theorem that there is an instant proposition which *is* (currently) true, i.e. $\exists i: i$. In particular, the instant proposition which *is* currently true is the Now. Finally, the instant propositions are total in the sense that for any instant proposition, i, and any arbitrary other proposition, p, i will either necessarily imply p or necessarily imply $\sim p$. This means that Prior's three axioms for instant propositions, i, can be presented in the following manner:

Mi
$\exists i: i$
$N(i \supset p) \vee N(i \supset \sim p)$.

Understood in this way Prior's hybrid logic becomes a response to questions regarding the relation between McTaggart's A- and B-languages by demonstrating how the B-language can be constructed from the A-language. The before-after relation, <, between instant propositions, a and b, may be defined as

$a < b$ iff $N(b \supset Pa)$

or as

$a < b$ iff $N(a \supset Fb)$

It turns out that the two definitions are in fact equivalent given a few basic tense-logical assumptions (axioms and inference rules), in which it can also be shown that the before-after relation possesses all the basic properties which a B-theorist would expect it to have.

In fact, one might want to start with the set of instant propositions fulfilling the conditions just mentioned, and with the above definition of the before-after relation. From this relation one may define another and more general relation, namely the relation of connectedness. Two instant propositions are connected if the second can be reached from the first using a finite number of steps going backwards or forwards relative to the before-after relation in the branching time model. Prior introduced this idea in a formal manner using the following iterative definition (see Prior 2003, 131):

$M_0 p = p$
$M_{n+1} p = P M_n p \lor F M_n p$
$M'p = \exists n: M_n p$

In short, the operator M' is any operator which can be defined in terms of disjunctions and the operators P and F alone. $M'p$ is true at the actual instant if, by going backwards or forwards a number of times in the branching time model, a moment can be reached at which p is the case. One interesting question in this context is: Could there be un-connected instant propositions, i.e., world-states which cannot be tracked even in this extended sense? This question turns out to be equivalent with the question of the uniqueness of the time-series. Could reality be made up of two or more independent branching time trees? Formally, the question is whether

$Mp \supset M'p$

is a theorem. The question is whether possibility transcends what can be defined in terms of *P*, *F*, and disjunction. Is possibility more than what at some past time could have been the case in what was seen as future at that time? If possibility is in fact more, in the sense that *Mp* is true now without *M'p* for some *p*, and *M* is still assumed to refer to a possible moment, then that moment cannot be connected with the actual moment. It will have to be a moment not belonging to the same tree-structure as the actual moment.

If we stick to a classical Ockhamistic tense-logic with a primitive possibility-operator without any restrictions, then the world-view of un-connected trees cannot be ruled out, and we cannot be sure that the above implication holds in general. If, on the other hand, possibility (and necessity) is defined in terms of the actual tree in the branching time model, then the above implication must hold in general, and thus be a theorem.

The difference between Prior's third and the fourth grade of tense-logical involvement has to do with the notion of necessity, *N* (and possibility, *M*). According to the fourth grade the *N*-operator can in fact be defined in terms of the tense-logical operators (*P*, *F*, along with negation and disjunction) in an iterative manner. According to the third grade, on the contrary, the *N*-operator should be conceived as primitive, i.e., not definable in terms of the tense-operators.

Clearly, the understanding of the modal operators is closely related to the question of connectedness. Given that we have the axiom, *Mi*, which means that any instant proposition is possible, it would obviously follow from the fourth grade of tense-logical involvement that any instant proposition, *i*, is connected with the Now. If on the other hand, we want to stick to the third grade of tense-logical involvement, then no such conclusion follows.

But should we go to the fourth grade of tense-logical involvement or choose to stick to the third grade? In Prior's opinion, this is a question

> [...] of quite a different order from the questions as to whether time is endless or ending, discrete or dense or continuous, circular or non-circular, branching or non-branching, etc. For to raise it as a genuine question is not merely to invite us to consider a non-standard tense-logic, but to suggest that there are truths about time which are not tense-logically expressible. It is not, indeed, to deny outright the existence of an A series, or the possibility and worth of a tense-logic, but it is to deny its primacy, and to relativize it to a B series, a sequence of ordered 'positions' which is tenselessly 'there' (and which may well be only one of a number of such series). (Prior 1967, 199)

It seems obvious that Prior is right when it comes to our time, i.e., the time which is relevant in relation to the life or existence to which we have some sort of cognitive access. On the other hand, it is hard to imagine very strong *a-priori* reasons for ruling out in principle that there could be a broader field of possibility and time, out of our human reach, although the claim of the existence of such a field would be highly metaphysical.

5 The Idea of the Now as Including Time as a Whole

According to Prior, the present instant, the Now, is constituted by the set of propositions about the current state of affairs, as well as all true propositions about the past, the future, and all true propositions about counterfactual states. In any model of time in which there are truths about the past, future, and about counterfactual states of affairs, this notion of instants thus implies that the Now (as well as any other instant proposition) formally keeps track of or contains traces of all other moments of time. In slightly other words, the Now may in this particular sense be said to encompass time as a whole.

It is remarkable that idea of the Now as reflecting the entire system of all moments in time can be found in early Eastern thought as well. As pointed out by Raji Steineck, the medieval Zen Master Dōgen (1200–1253) held that the passing of time is a passing in which entities pass from one stage to another, and where each stage is an effect of past stages and entities, but also itself a cause of future stages and entities (Steineck 2007, 40). Thus, if all stages and entities are linked in a web of causal relations then—assuming a common-sense view of causation in which a cause brings about an effect—what happens to be the case now also encompasses or is linked or connected to what has been the case and what will be the case. In this way, Dōgen's view of time also implies that the Now keeps track of or contains traces of all other moments in time.

We are certainly not claiming that Prior found inspiration in Eastern ideas like Dōgen's when he formulated his thoughts on the instant proposition as including information about the entire branching time system. We have no evidence of that kind. On the contrary, it seems clear that Prior came up with his conceptual constructions regarding instants without any such inspiration. It is, however, very interesting that the idea of the instant as including a reflection of the structure of the entire temporal system has been brought up in these very different contexts. On the other hand, it should also be emphasized that there is an important difference between Dōgen's teachings on time and Prior's notion of the Now. In Prior's understanding the relation between the Now and other moments in time is logical and not causal. If all truths about

the future were established on the grounds of causal relations, then there seems to be little room for the claim that there are truths about what will happen in the future as a result of free choice. It should also be noted that Prior's notion of the Now is compatible with models of time according to which there are truths about the contingent future.

Clearly, there are some metaphysical aspects of Prior's idea of the Now as logically including (or implying) the entire branching time system. However, the claim is in fact mainly conceptual. Prior's idea shows how the inner logical structure of the Now (or any other instant proposition) can in fact give cash value to assertions regarding the properties of the entire branching time system. Prior's idea also offers a clear and formal account of the relation between the A- and the B-view of time. Finally, it shows how we can hold Presentism without having to accept that something real (the present) stands in relation to something unreal (the past and the future). According to Prior's presentism the Present simply corresponds to the subset of all propositions implied by the Now which do not include a tense-logical prefix (or operator). In this way, Prior's idea of instant propositions turns out to be crucial for his understanding of time, including his account of how the Now can keep track of the entire branching time system.

Acknowledgment

The authors wish to thank Professor Raji Steineck for useful suggestions regarding Dōgen's ideas on time. We also thank Dr. Ulrik Sandborg-Petersen for useful comments and ideas.

References

Belnap, N. and M. Green. 1994. "Indeterminism and the Thin Red Line." *Philosophical Perspectives*, 8: 365–88.

———, M. Perloff and M. Xu. 2001. *Facing the Future. Agents and Choices in Our Indeterminist World*. Oxford: Oxford University Press.

Copeland, Jack (ed.). 1996. *Logic and Reality. Essays on the Legacy of Arthur Prior*. Oxford: Clarendon Press.

Cotkin, George. 1985. "William James and the Cash-value Metaphor." *Et cetera*, Spring: 37–46.

Jakobsen, D. 2011. "A.N. Prior's Notion of the Present." In *Time and Time Perception*. LNAI 6789, edited by Argiro Vatakis et al., 36–45. Berlin & Heidelberg: Springer.

Øhrstrøm, Peter and Per Hasle. 2011. "Future Contingents." *The Stanford Encyclopedia of Philosophy* (Summer 2011 Edition); http://plato.stanford.edu/entries/future-contingents/.

Øhrstrøm, Peter. 2014. "What William of Ockham and Luis de Molina Would have said to Nuel Belnap: A Discussion of Some Arguments Against 'The Thin Red Line.'" In T. Müller (ed.), *Nuel Belnap on Indeterminism and Free Action*, Outstanding Contributions to Logic 2, Springer eBooks, 175–90.

Peirce, Charles Sanders. 1931–1958. Collected Papers of Charles Sanders Peirce, Vol. I–VIII, edited by C. Hartshorne, P. Weiss, A. Burke. Harvard University Press (CP).

Ploug, T. and P. Øhrstrøm. 2012. "Branching Time, Indeterminism and Tense Logic—Unveiling the Prior–Kripke letters." *Synthese* 188: 367–79.

Prior, Arthur N. 1957. *Time and Modality*. Oxford: Clarendon Press.

———. 1967. *Past, Present and Future*. Oxford: Clarendon Press.

———. 1972. "The Notion of the Present." In *The Study of Time*, edited by J.T. Fraser, F.C. Haber and C.H. Müller. 320–23. Berlin & Heidelberg: Springer.

———. 2003. *Papers on Time and Tense*. (Second revised and extended edition edited by P. Hasle, P. Øhrstrøm, J. Copeland, and T. Braüner) Oxford University Press.

Steineck, Raji. 2007. "Time is not fleeting: Thoughts of a Medieval Zen Buddhist." *KronoScope*, 7, no. 1: 33–47

William of Ockham. 1969. *Predestination, God's Foreknowledge, and Future Contingents*, translated by Marilyn McCord Adams and Norman Kretzmann, New York: Appleton-Century-Crofts.

CHAPTER 10

Psychoanalysis and the Temporal Trace

John S. Kafka

Abstract

Deepening one's self-knowledge in psychoanalysis involves reviving one's memory traces and exploring one's distorting or forgetting of them. These processes involve one's experience of time and one's conscious and unconscious manipulation of time. This essay provides an overview of the relevance of time-related concepts in classical psychoanalysis while also extending to—and casting a new light on—some concepts based on the treatment of psychotic patients.

Keywords

déjà vu – Ketamine – memory – Nachtraeglichkeit – object formation – perception – psychoanalysis – screen memories – Sigmund Freud – Sernyl – timelessness of the unconscious

1 Introduction

Time is a central theme in psychoanalysis as a theory of the *sequences* in human development and as a historical perspective that concerns itself with unconscious temporality, the unconscious motivations of the individual and of societies. As a specific psychotherapeutic method, psychoanalysis takes time, and it is not limited to a brief encounter because its aims are not limited to symptomatic change. The aims of psychoanalysis include change through self-knowledge, resulting from new and more inclusive perceptions of self and others that in turn lead to freedom from compulsive repetitions of self-damaging thoughts, actions, and destructive relationship patterns. *Transference*, emotionally charged repetitions between analyst and analysand of earlier relationship patterns in the analysand's life, is a key element in the psychoanalytic method. Transference thus involves memory and time, as well as distortions of memory and of time.

Time is also of essence in the very arrangement of psychoanalytic treatment. Sessions begin and end at a fixed time, but within that time period, the analysand is encouraged to "free associate," to suspend judgment about the *correct* sequential connectedness between different thoughts that come to his mind. The analysand is asked to function in a tight conscious and a loose unconscious mode. This temporal polarity and the movements between these poles, given the obstacles to and limitations of these movements, is at the core of the psychoanalytic process, which strives to modify them. I will explore various aspects of time from this psychoanalytic perspective. I also will examine connections between earlier and recent psychoanalytic and wider recent philosophical and scientific views on time. In addition to the more familiar "classic" psychoanalytic perspective, I will also introduce ideas that are based on my psychoanalytically-informed work with psychotic, especially schizophrenic, patients. Their pathology challenges us to focus on temporal disorientation and the connection between time experience and the sense of reality and unreality.

The earliest and most widely known connection between psychoanalysis and the topic of time is Freud's notion of *timelessness of the unconscious*. Freud believed that the unconscious knows no time and that whatever has been repressed leaves permanent traces in the unconscious (Freud 1923–25, 225ff.). Late in his life, Freud wrote that he had not solved the paradox of this unchanging state that can be modified when the analysand retrieves it from the unconscious. Freud thought that "the solution to this puzzle would have to wait for further scientific and philosophic development" (Freud 1932–36, 74). Some such recent developments may contribute to the solution of this puzzle.

From a historical perspective, Freud's most explicit reference to the concept of a temporal *trace* is his paper on the "Mystic Writing Pad" [*Wunderblock*, literally, the "Miraculous Pad"], a forerunner of Etch-A-Sketch (Freud 1923–25, 225ff.). On a Mystic Writing Pad, one writes on a covering surface, leaving a *temporary* trace on that cover. This trace disappears when the cover is lifted from the underlying surface; however, the writing has also left a permanent trace below. Freud used the Mystic Writing Pad as a concrete representation of his early views on the functioning of the perceptual apparatus of the mind. The Mystic Writing Pad illustrated how permanent *traces* are laid down while a perceptual conscious system is ready to receive new stimuli (perceptions) on what seems to be a blank page. The *trace* on one layer of the pad seemed at that time to solve the problem of combining the functions of a permanent and a temporary memory. One limitation of the Mystic Writing Pad model is, however, that experienced memories are not exact reproductions of the past. Thus, even if we could conceive of a psychological method that would correspond

to lifting the Mystic Writing Pad's covering sheet and exposing the original impression, such a feat would not lead us to a replication of living memory in which some traces are subject to repression and alterations.

What does the temporal trace contribute to the formation of the living memory, to its plasticity and its modifiability? After a general discussion of time and memory, I will focus on and re-examine some specific psychoanalytic concepts that address this question, the concepts of *Nachtraeglichkeit* or *après coup* and of *screen memory*.

2 Studying Memory and the Temporal Trace is Studying Time

All study of memory is a study of time.[1] Meaning depends on the traces of short-term memory. Usually, when psychoanalysts discuss memory, they think of relatively long-term memory. However, without short-term memory, there is no meaning, and without meaning, psychic life does not exist. All meaning, all thinking, all psychological functions are time-linked, as the following illustration of the loss of meaning that accompanies loss of short-term memory confirms.

1 My work with schizophrenic patients and my recent treatment of some dying patients have reinforced my interest in Kurt Eissler's ideas about archaic time, the aging analyst, and the dying patient. Eissler, a prominent New York psychoanalyst émigré from Vienna, was considered an eminently "classical" analyst, a staunch defender of Freud's theories, their inclusiveness, and their relevance to a wide range of topics. It is remarkable, therefore, that he regarded Freud's ideas about time as needing considerable re-examination and elaboration. Eissler's preoccupation with time was apparent not only in his interest in the work of the aging analyst (Eissler 1993, 316ff.) and his work with dying patients. In Eissler's book *The Psychiatrist and the Dying Patient* (1955) he writes: "Time is constantly in us and around us; nevertheless, we cannot grasp it. Probably there is a fundamental resistance in us to understanding it, a resistance which goes far deeper and is far more basic than that which is encountered in the ego when it fights off a content in the repressed part of the personality. It is conceivable that this ego would be seized by fright when facing the true issue of what time really is. And again one can well understand when Augustine breaks out in the essentially blasphemous words: 'O, my Lord, shall not here, too, Thy truth mock at man?' The primary experience of time, I would think, is entirely bound to the course of inner processes and occurs much earlier than perception of time. Perception of time is a function of a relatively high organization and is a later product, gradually formed out of an archaic time experience. The latter seems to be indelibly attached to the psyche; even if the individual has never experienced an external perception there still would be an experience of time." (Eissler 1955, 266)

Sernyl[2] is a drug that interferes with short-term memory. It was once used as an anesthetic for animals and children, but research on the drug continued after its clinical use was stopped. In an experiment that I conducted (which was probably the last authorized research project on humans involving the drug), Sernyl was given by injection to Kenneth Gaarder, a psychiatrist and psychoanalyst who participated in this research and who served as a voluntary subject (Kafka 1989b, 62ff.). Dr. Gaarder was well acquainted with the literature about Sernyl, but had not seen the drug in use. Here is a transcript of the taped record of Dr. Gaarder's words 10 minutes after the injection:

> [S]omething is going on here and uh-uh-I'm alive-and uh-I'm doing something for some reason, and I don't know what it is I'm doing and uh—what's happening to me now—and words are things like that what is happening? What is to say what is happening? is a word- and people talk-and what is talking? and uh-I don't know what's going on [...] I'm experiencing something and I don't know what's going on, and I don't know what saying what's going on is saying.... (Kafka 1989b, 65)

From this illustration of the loss of meaning linked to the experience of *timelessness* induced by the short-time memory loss, let us return to Freud's most well-known psychoanalytic hypothesis relating to time. It is the notion of the so-called *timelessness* of the *unconscious*, and the ensuing paradox of the existence of change, a puzzle that Freud could not solve (as he admits

[2] Sernyl is chemically related to Ketamine and the experiment described here is especially relevant to the currently much-publicized experimentation with Ketamines as an antidepressant. In the September 10, 2013 issue of *Psychiatric News*, for instance, the lead article, "Ketamine Shows Rapid Action in Treatment-Resistant Depression," describes a recent large multi-site study that demonstrated a significant, but very short-lived, antidepressant effect (Watts 2013, 1, 23). In the description of this study, short-term memory loss is not even mentioned. It is considered an insignificant side effect. There is good reason, however, to consider it *the* antidepressant effect. To put it simply, you may briefly be less depressed if you do not know what you were depressed about, and that amounts to a loss of consciousness. The use of Sernyl as an anesthetic was based on its extreme effect of short-term memory loss. In a drug-focused psychiatric environment, the finding of a fast-acting antidepressant agent has energized a major research field that ignores the effect of the temporary fading of a memory trace. I believe that the brevity of the antidepressant effect is the result of the short-lived short-term memory loss, and that hopes of having discovered an entirely new class of antidepressant medications are not justified. In my own work with schizophrenic patients, I have observed that there are periods when some patients become inaccessible. I think of such periods as a possible loss of short-time memory and attendant loss of meaning.

in the quote above). An important recent development in psychoanalytic theory that is relevant here is the work of psychoanalyst and mathematician Matte-Blanco, in particular his understanding of this so-called timelessness (Matte-Blanco 1988). Matte-Blanco distinguishes symmetrical and asymmetrical mental processes. "John is the brother of Peter" is symmetrical because Peter is also the brother of John. "Peter is the brother of Mary" is asymmetrical because Mary is not the brother of Peter (Matte-Blanco 1959, 2). "Yesterday is before today" is asymmetrical because today is not before yesterday. The unconscious, according to Matte-Blanco, does not distinguish between the symmetrical and the asymmetrical, and is, in this way, timeless (Matte-Blanco 1988, 43ff.). Of particular relevance to psychoanalysis and the psychoanalytic interpretation of dreams is that, in dreams, there is no directionality of time, no consistent before and after.

It will be helpful at this point to step back from psychoanalytic theory and practice and turn to physics and time studies more broadly conceived. Freud knew about relativity theory, about the uncertainty principle, and about quantum physics, but he did not consider these scientific advances relevant to psychoanalysis and warned against facile use of these concepts. But a complex, non-reductive theory of time (including its evolution and conflicts) such as J.T. Fraser's can assist us in working through the vexed problem of time Freud leaves us with. For example, Matte-Blanco's psychoanalytic view of the unconscious is congruent with Fraser's *eotemporal umwelt*, the shaft of an arrow representing events that are countable and orderable without a preferred direction (Fraser 1981).* Fraser writes:

* Eds. Note: J.T. Fraser developed what he called a hierarchical theory of time's conflicts according to which time assumes (at least) five canonical forms. The model is evolutionary as well as hierarchical in that each higher level emerges as the result of the incompleteness evident in the conflicts generated in the level beneath it, but without cancelling out any lower level. In the work cited here, Fraser (1981) identifies the five forms (and illustrates each with regard to the image of the arrow of time) as, in order of decreasing complexity: the *nootemporal*, the level of the mature human mind with its symbol-generating capacity (the full arrow with head and tail clearly drawn); the *biotemporal*, or world of living organisms (just the arrow's head, representing consciousness of the immediate present and past but without long-term anticipation or memory); the *eotemporal*, the abiding present of directionless time (only the shaft of the arrow); the *prototemporal*, the fragmented time of elementary objects (the arrow disintegrated into slivers of wood); and the *atemporal*, the world of electromagnetic radiation in which time blends with space (a blank sheet of paper on which the image of an arrow could be drawn). Fraser later began to develop the concept of the *sociotemporal* as a response to the conflicts of *nootemporality*.

> [W]hen psychoanalysts deal with time in the psychoanalytic situation, they assume the existence of an objective temporal matrix in which psychic processes take place and to which the subjective time of the patient is gradually attuned. A desirable result of therapy is an identification of the subjective time of the patient with the assumed, objective physical time. Psychoanalytic theory may, therefore, be seen as endorsing that view of time which was proposed by Issac Newton in 1687. He wrote that "absolute, true and mathematical time, of itself, and from its own nature, flows equably without relation to anything external, [that is, anything other than itself] and by another name is called duration..." But this understanding of time must be rejected, though not at all for reasons that come from post-Newtonian physics but rather because of reasons that stem from evolutionary biology and from psychoanalytic insight. (Fraser 1981, 3)[3]

The relationship between the hierarchical levels of time and psychoanalytic approaches to time is the central subject of Fraser's 1981 paper "Temporal Levels and Reality Testing." Fraser's work can be considered the new philosophical and scientific development that provides an answer to Freud's puzzle. One hierarchical level involves an unchanging state and another accommodates modifiability. In Fraser's system, no previous or "lower" level of organization is lost. They are constantly recapitulated and co-exist although they may be in conflict with each other. This is congruent with Freud's view that permanent traces of the past in the unconscious are constantly recapitulated. But, as mentioned, change in the unconscious that knows no time remains a puzzle for Freud while Fraser's system accommodates co-existence despite conflict.

3 Fraser explains in a note to this passage: "Relativity theory is silent on the origins of time. It only gives instructions on how to measure time and remain consistent with motional and positional variations of clocks, whose nature also remains unanalyzed. Newtonian (absolute) and Einsteinian (relativistic) time are identical in that they are both independent of the quality and complexity of the observer. This fact is never noted in physics texts because of the temperament of physical science, a projection of the unresolved conflicts of the physicist. If the interpretation of time in physics, as given by physicists, is uncritically accepted and the vocabulary of relativity theory is carried over to psychoanalytic theory, confusion results. Even such a meticulous scholar as Abraham mistakes the relativistic metaphor of the variability of the time metric for a qualitative, rather than quantitative, statement about time."

Another scientific and philosophical development that postdates Freud and is relevant here is Gödel's conclusion that time is not a "physical reality."[4] Gödel theorized that the maximum curvature in Einstein's space-time leads to our return to the same point in space-time in conceptual time travel (Gödel 1931, 173ff.). If we find ourselves at the same point in space-time, he reasoned, time does not exist as a "physical" reality. This notion suggests that all time-related psychological activity (and there is no time-independent psychic activity) is constructed by us. In Fraser's theory, we construct all hierarchical levels of time in the course of evolution.

The human construction of time is the construction of mind, the construction of meaning. The Sernyl experiment described previously illustrated the loss of meaning that accompanies the loss of short-term memory. Even the word "now" lost its meaning. A "now" without short-term memory is meaningless. It has no psychological existence; it is mind-less.

3 Psychic Reality

The psychological moment, the existence of a psychic reality, needs short-term memory to exist. The psychic reality of the moment is a building block of later memories. Therefore, our study of the memory trace is inescapably linked to the study of the building of psychic reality. Psychoanalysts are careful to avoid "reification" of their concepts, but nevertheless the psychoanalytic term "object" has some connotations of solidity, of a separate, tangible existence.

In this connection, I will summarize here some ideas that I have developed in much more detail elsewhere (Kafka 1989a). In general psychology, the concept of object permanence, or object constancy, refers to observations of the kind that a table is perceived as the same table when viewed from different angles despite the fact that the retinal projections of the table are different when the viewing angles change. In the context of our study of memory and the recognition that memories are not reproductions either of a scene or of an object, it is essential to note that time is involved in the movement from one position to another in viewing the table that figures as a (permanent) object. This notion is not absent from the psychoanalytic understanding of object constancy, but psychoanalysts focus on affect and meaning when considering that object constancy has been achieved, for example, when the nourishing and the withholding mother is recognized as the same person. But

4 For a most thorough discussion of Gödel's work and its philosophical implications, see Palle Yourgrau (2005).

here, too, the term "mother" refers to a physical presence that, seen from different angles and in different physical positions, also has different retinal projections. I emphasize that even object constancy has both a hermeneutic and a physically real, tangible component, a theme to which we will return when discussing *Nachtraeglichkeit*.

This discussion of object constancy leads to the conclusion that our psychological "object world" consists of subjective equivalences of different objects. *Different* time intervals may also be subjectively equivalent. As is well known, an identical "linear" time interval may be experienced as shorter or longer, and different time intervals may be experienced as similar or identical, depending on many different factors, including time-linked affective factors such as expectations, hopes, and fears. From this perspective, psychic reality consists of processes of forming networks of spatial and temporal subjective equivalences. "Object" loses some of its "solidity." (Note that I speak about processes of forming subjective equivalences that, I believe, recapitulate ontogenic development.)

Freud thought that past traces in the unconscious are permanent and are always available for repetition and recapitulation. In Fraser's system, as stated above, levels of organization are not lost but recapitulated, co-existing even if they are in conflict with each other. Reports of—and by—drowning individuals (after they were saved) that they experienced their whole life "in a flash" may serve as an illustration of my hypothesis that every perceptual process is a recapitulation of the onto-genesis of perception. This conscious experience may correspond to the unconscious micro- or nano-second recapitulation of the development of the individual's perceptual processes. What is being recapitulated? In Fraser's theory, as already mentioned, all hierarchical levels co-exist or are available for recapitulation. My clinical work with *schizophrenic* patients has led me to focus on a developmental sequence of the discrimination between outside and inside, the discrimination of the animate from the inanimate, the synesthetic from the sensory-specific, and the priority of temporal or of spatial ways of organizing sensory data. A patient described how the distance between two buildings had shrunk. I noticed that she walked faster. Such observations made me realize to what extent we usually give priority to spatial, over temporal, organization (Kafka 1989a, 14). These developmental stages are recapitulated in "object formation" (Kafka 1989a, 26–50). Furthermore, there is a congruity between, on the one hand, animate, inside, temporal, and synesthetic, and, on the other hand, inanimate, outside, spatial, and sensory-specific objects. Tachistoscopic experiments, the study of perception of stimuli that one is exposed to for extremely short periods, permit a kind of temporal dissection of the recapitulative process. Extremely short exposure

led adults to have responses that have characteristics in common with those of very young children; longer exposures correspond to responses of older children (Westerlundh and Smith 1983, 597ff.; Kafka 1989a, 41ff.).

Returning to "subjective equivalence" in object formation, if the psychic objects are not real, tangible objects, but represent subjective equivalences of different perceptions, then each perceptual act represents a travelogue—and therefore a micro-memory trail—through different object formations. If the recapitulation of developmental processes is complete in each perception, the subjective equivalences form objects that are recognizable by and can be shared by others. If the recapitulations of some perceptions are incomplete, as they may be in psychotic thought disorder, subjective equivalences between completed and partially completed perceptions form "bizarre" objects or what we may call atmospheric rather than sensory-specific objects. Here is a clinical example of the latter. During an acute psychotic phase, a patient insisted on calling a nurse "Heidi" although that was not her name. After this acute phase, the patient explained to me that people were not the same for her from day to day. This nurse, however, was blond and had a foreign accent. The patient had loved the Swiss book *Heidi* since her childhood and a combination of characteristics, a kind of "Heidiness," permitted her to hold on to something—and incidentally something pleasant—during a time of distress, disorientation, and loss of her sense of self. Atmospheric objects are more synesthetic than sensory-specific. It was only in retrospect (*nachtraeglich, après coup*) that the patient understood the source and reasons for her misnaming the nurse.

4 Nachtraeglichkeit

The concept of *Nachtraeglichkeit*, Freud's term for the retroactive modification of memory traces, has long been neglected in the English-speaking psychoanalytic world because the term had been poorly (or at least very incompletely) translated as "deferred action." An attempt has been made to clarify the concept by speaking of "retroactive attribution of meaning." M. Kettner, who has studied Freud's use of the concept, finds that Freud sometimes gave it a hermeneutic meaning, referring to changes of interpretation of memories, and sometimes a "causal" meaning. The latter can be thought of in terms of aftereffects, like a chain of effects on a series of billiard balls. Kettner finds that psychoanalysis operates in the *Spielraum* (latitude, literally "space for play") between these two meanings (Kettner 1999). This *Spielraum* is also the area of confluence of unidirectional linear time linked to traditional causality and of bidirectional temporal processes. Bidirectional processes escape the narrow structure

of a mechanical billiard-ball chain of causality and involve the alterations of meaning produced by seeing old material in the light of new information and vice versa, in the *Spielraum* between the concrete and the hermeneutic.

Another aspect of *Nachtraeglichkeit* is a relatively neglected one, the *nachtraeglich* modification of the sense of duration.[5] Different senses of duration leave behind traces. Shifts during psychoanalysis in what is understood as meaningful, be it in one analytic session or in a perspective on life developed during a course of psychoanalysis, have profound consequences for our experience of time, because the judgment of the duration of intervals in which "meaningful" things happen differs from the judgment of duration of intervals of "accidental" events. The following experiment demonstrates the retroactive effects of new information on judgment of past duration: Subjects in one experimental group memorized a series of apparently random numbers and then were asked how long it took them to memorize the series. Subjects in another group memorized the same series and then were given a code that transformed what was apparently a random series into an ordered one before being asked to estimate how long it had taken them to memorize the series. The actual memorization period of each group was the same, but the subjects who were given the code estimated its duration as shorter than did the codeless group: the new information about the code permitted them to reorganize—recode—their experience retrospectively. It is well established that ordered numbers are learned more rapidly than random ones. Subjects given the code that transformed the apparently random series into an ordered one after memorizing them estimated their period of memorization as though they had known the ordering code when they committed the series to memory. New information has had a retroactive effect on judgment of past duration (Kafka 1989c, 18).

The sense of duration is influenced by cognitive information, but it is more profoundly influenced by affective elements. During a German-speaking conference on time, I was asked what I thought was the opposite of *Muße*, a hard-to-translate term referring to the experience of peaceful, utterly relaxed free time. I was surprised that what came to my mind was *boredom*. In effect, boredom is a problem for the military in certain situations when troops are not active. In a cease-fire situation (not after a peace accord) when opposing troop encampments remain facing each other, soldiers have to be on the

5 Rémy Lestienne has described how focused attention interferes with our sense of duration (Lestienne 2013, 228ff.).

alert for any sign of a possible violation. At the same time, they must make sure not to do anything that the enemy could interpret as a threat. This is the perfect situation of inhibited aggression which, I believe, is the deep source of boredom, the utterly *not*-relaxed free time. In psychoanalytic treatment, attention to the quality of experienced duration can contribute much to the understanding of emotional conflicts. This was the case in the psychoanalytic treatment of a man who was trying to decide whether to stay with his wife or to marry his mistress. It gradually emerged that a conflict between a situation in which he experienced *Muße* (with his mistress) and one of inhibited aggression (with his wife) best described his situation. This clarification permitted the patient to contextualize his current conflict, to recollect, re-examine and re-evaluate it *nachtraeglich* in the light of current understanding of some past situations.

5 Screen Memories

The concept of "screen memories" deals more explicitly than *Nachtraeglichkeit* with the polarity of overall actual temporal traces and living memory. In addition, however, screen memory also deals explicitly with false memories. In his article on screen memories (Freud 1893–1899, 299ff.), Freud often refers to similarities between other memories and memories that he designates as screen memories. I think this is a device to highlight certain characteristics that may be present in all memories, but are more prominent in some. They include sensory intensity and the *delay* in developing the screen memories. Freud himself reports a screen memory that refers to events which occurred when he was three years old, and one that was formed when he was 17. Freud also emphasizes that the wish he encounters in this screen memory is the wish to change the past rather than a wish for the future. He emphasizes that he returns to a past nostalgia. (My own favorite graffito is "Nostalgia ain't what it used to be.") Nevertheless, Freud's technique of analyzing his screen memory is not fundamentally different from the technique he employs in analyzing other memories. He emphasizes that the concept of screen memory owes its value as a memory not to its own content but to the relation existing between that content and some other that has been repressed. While this may be particularly salient in the analysis of screen memories, it is indeed part of all psychoanalytic study of memories.

Freud locates the source of his screen memory at age three when the financial collapse of the family's business leads to a quite sudden and unexpected

move to Vienna (Freud 1893–1899, 309).⁶ For analysands, a screen memory is—or, I would say, was once—accepted by the subject as a "real" memory, but Freud and other students of screen memories emphasize to what extent the sensory intensity (the yellow flowers in his screen memory) appears particularly fresh and current and, as it were, factually verifiable.⁷ The narrative of the screen memory is, however, particularly unlikely. The manifest story is false although, as already mentioned, analyzing the story as one would analyze a dream may make it understandable. While all memories are constructions, the more evident falseness of the screen memory makes it a confabulation. Psychiatrically, confabulation is considered a replacement of a gap in memory by a falsification that the subject accepts as correct.

6 The disguised autobiographical instance of the partly confabulated memory runs as follows:
 "I see a rectangular, rather steeply sloping piece of meadow-land, green and thickly grown; in the green there are a great number of yellow flowers—evidently common dandelions. At the top end of the meadow there is a cottage and in front of the cottage door two women are standing chatting busily, a peasant woman with a handkerchief on her head and a children's nurse. Three children are playing in the grass. One of them is myself (between the ages of two and three); the two others are my boy cousin, who is a year older than me, and his sister, who is almost exactly the same age as I am. We are picking up the yellow flowers and each of us is holding a bunch of flowers we have already picked. The little girl has the best bunch; and, as though by mutual agreement, we—the two boys—fall on her and snatch away her flowers. She runs up the meadow in tears and as a consolation the peasant woman gives her a big piece of black bread. Hardly have we seen this when we throw the flowers away, hurry to the cottage and ask to be given some bread too. And we are in fact given some; the peasant woman cuts the loaf with a long knife. In my memory the bread tastes quite delicious—and at that point the scene breaks off." (Freud 1893–1899, 311).
 According to David L. Smith (2000), Freud's fundamental claims are "1. Retrogressive screen memories are produced when a *contemporary* thought is repressed and finds some associative contact with an earlier memory. The screen memory portrays the contemporary concern. 2. Screen memories take the form of scenes, involving visual representation. 3. Retrogressive screen memories can be interpreted only in light of the life-context during which they are recalled. 4. The fact that a memory assumes a screening function does not mean that it is a complete fabrication, although this process may modify the content of the memory in some respects.
 "In the final analysis, Freud wonders whether *all* of our childhood memories are not screen memories. 'It may indeed be questioned whether we have any memories from our childhood; memories *relating* to our childhood may be all that we possess. Our childhood memories show us our earliest years not as they were but as they appeared at the later periods when the memories are aroused'" (Smith 2000, 11–12, citing Freud 1893–1899, 322).
7 "Freud emphasises that the yellow of the dandelions and the delicious taste of the bread seemed disproportionately prominent" (Smith 2000, 9–10).

I think that Freud's choice of the trauma of a particularly abrupt interruption as the source of his emblematic screen memory is not accidental. "Implicit" memories permit us to perform daily tasks without conscious focused attention. Implicit knowledge involves the unconscious memory of the correct timing in which these tasks have to be performed in a specific setting. Sudden changes of setting disrupt our expectations, force us to pay conscious attention where it was not needed previously, and disrupt the continuity in our sense of duration. This leads to pronounced gaps in narrative memory coexisting with particularly clear and vivid memory of sensory impressions, the hallmarks of screen memories. In discussing *Nachtraeglichkeit* in memory formation, we have referred to both the billiard-ball-like mechanical aftereffect of events and to hermeneutics, meanings, and changes of meaning. Intermixed, all of these play a role in memory formation and our search to reconstruct the past. This is relevant to the analyst's listening during a psychoanalytic session. The psychoanalyst's suspended way of listening differs from the focused attention of ordinary listening. The analyst may even suspend the distinction between the recital of a dream and the description of real events. She may listen to everything as though it were a dream or a screen memory. In such a listening mode, the analyst's attention may shift back and forth to a focus on the description of the sensory experience and away from the analysand's story line that may be confabulated.

6 Déjà Vu

The individual experiencing and describing a screen memory locates it, the confabulated story, in a specific point in time. This is one feature that distinguishes it from the *déjà vu* experience, another elaboration of a memory trace. There is, however, also a close connection between the concept of screen memory and the *déjà vu* phenomenon. It is the emphasis on sensory experience. In the *déjà vu* experience, the individual is convinced that the same sensory features were present in the past and are present now—the same location, the same colors, the same landscape. Yet, as we shall see, in a sense, *déjà vu* is the opposite of the screen memory. My hypothesis is that the apparent sameness of a past and current situation is based on the resemblance of formal patterns, precisely *not* the same sensory experience.[8]

8 In Freud's paper "Fausse Reconnaissance (*'Déjà Raconté'*) in Psycho-Analytic Treatment" (Freud 1913–14, 199ff.), he reviews some of the earlier literature on the *déjà vu* subject, including an "anatomical" one put forward by Wigan in 1860 (Freud 1913–14, 202). I will return

I have emphasized the uncanny nature of *déjà vu* experiences (Kafka 1966; Kafka 1989a, 46–47) and related it to simultaneous contradictory convictions such as "I am sure I have seen this, or I have been there" and "I am sure I have never been there." My hypothesis, which is supported by neurobiological findings: *Contradictory convictions are the result of the repetition of the same pattern of stimulation, but in different sensory compartments.* Synesthesia is the blending of different sensory compartments. The *pattern* of a synesthetic perception may be the same as a pattern of a compartmentalized perception. Think of an oscilloscope that has the same wave pattern whether it represents an auditory, a visual, or a synesthetic stimulus pattern. Neuroscientific support for this hypothesis derives from the importance of temporal-lobe functions in the integration and differentiation of sensory "compartments" and the fact that individuals with temporal-lobe abnormalities are often inundated by ongoing *déjà vu* experiences. In this connection, the "anatomical" hypothesis put forward by Wigan in 1860, the hypothesis that Freud cites, is quite remarkable: Wigan thought that *déjà vu* phenomena resulted from an absence of simultaneity in the functioning of the two cerebral hemispheres.

7 A Clinical Example of *Déjà Vu* and Fugue States

A middle-aged woman without any previously observed psychiatric pathology rather suddenly was frequently absent from home, sometimes for several days. She could not give any explanations for this and apparently had no memory of her activities during these days. When I saw her for an evaluation, she described frequent and somewhat disorienting *déjà vu* experiences. Her family had traced her absences and found that she, very active in women's clubs, had given several well-received lectures at women's clubs in other cities. As mentioned, she was amnesic of these trips and activities. Temporal-lobe abnormalities have been linked with fugue states (altered states of consciousness in which a person may move about purposely and even speak but is not

to this "anatomical" idea later because of its relevance to a modern biological hypothesis. Primarily, however, Freud speaks of an unconscious earlier experience that explains the present feeling of *déjà vu*, the sense of familiarity. Freud makes an especially interesting link between *déjà raconté* and screen memory when he explains that a patient's false certainty that he had already told him of a memory turned out to be correct in the sense that he had told of the remembered event in the form of a screen memory. Jacob Arlow has described how a *déjà vu* experience can be analyzed with the usual techniques of dream analysis (Arlow, 1959, 611ff.).

fully aware of having done so) and great frequency and intensity of *déjà vu* phenomena. I referred her for a neurological evaluation that revealed a very large tumor involving the temporal lobes.

My work with schizophrenic patients has led me to believe that ongoing, steady immersion in *déjà vu* experiences may play a role in the profound temporal disorientation. Also, in connection with the study of schizophrenic thought disorder, I have already described the hypothesis that each perceptual act represents an unconscious recapitulation of the ontogeny of perception, and that, developmentally, synesthetic perceptions antedate sense-specific (visual, auditory, etc.) perceptions. Interruptions, however, of some microtemporal recapitulations lead to the subjective equivalence of completely and of incompletely recapitulated perceptions and therefore to the formation of bizarre psychotic uncanny "objects."

8 Conclusion

We cannot talk about memories, about memory traces, without talking about time. Some modern conceptions of time are relevant to psychoanalysis, particularly to the notion of the timelessness of the unconscious. In any case, memories are not copies of the past. Episodic memories are constructions. In that sense, all memories are false. We have examined different ways in which they are false and how episodic memories unroll what has been temporally condensed. (Freud says that when the patient says "I have known this all along," the end of the analysis is near [Freud 1913–14, 207].) The concept of *Nachtraeglichkeit* has received special attention. Clinical psychoanalysis and memory formation function in the *Spielraum* (space—or time—for play) between the concreteness of mechanical aftereffects on the one hand, and hermeneutics, i.e., meaning and change of meaning resulting from new information, on the other. And it is here, somewhat surprisingly, that the psychoanalytical concept of *Nachtraeglichkeit* and neurobiology may encounter one another.

The simple naming of specific areas of the brain as centers of a specific affective or cognitive function may strike us as only a kind of internal phrenology and thus of limited interest. The situation is different when a shift in cerebral activation and the timing of the shift correspond to interesting psychological developments. Tori Nielsen and Philippe Stenstrom have observed that a different brain area is activated when an individual recounts a dream he had yesterday and when he talks about the same dream one week later: "[T]he dependence of newly acquired memories on the hippocampus decreases over

time whereas their dependence on neocortical structures, such as the medial prefrontal cortex, increases in a complementary fashion. Memories are [...] relocated over time from the hippocampus to the neocortex [...]." The authors describe corresponding qualitative changes, in essence from "day residue" to cognitive elaboration, to emotionally relevant episodic memories (Nielsen and Stenstrom 2005, 1286ff.). Here is a neurobiological finding connected to the construction of meaning and to the hermeneutic pole of *Nachtraeglichkeit*. The finding that chronobiological factors at several levels influence the selection of memory sources corresponds to "aftereffect," the "billiard-ball" external, mechanical, and concrete pole of *Nachtraeglichkeit*. The timing and the rhythms of cerebral functions in general correspond to linear clock time, that is, the linear clock time in which billiard balls have their aftereffects. These "external" rhythms are gatekeepers that provide or deny access, at any one moment, to a multitude of cerebral activities. The brain itself functions within the polarity of aftereffect and hermeneutic transformations, a polarity that can be conceptualized as existing in Fraser's hierarchical levels. This polarity of brain functioning is also congruent with our psychoanalytic work. The fixed clock-time of the beginning and ending of the psychoanalytic session forms the frame in which the hermeneutic search of the unconscious unfolds, an unfolding necessary for the construction of personal psychological time, an unraveling of what is initially condensed and timeless into the thread with which we then proceed to weave our memory traces and our lives.

References

Arlow, Jacob. 1959. "The Structure of the *Déjà Vu* Experience." *Journal of the American Psychoanalytic Association* 7: 611–31.

Eissler, Kurt R. 1955. *The Psychiatrist and the Dying Patient*. New York: International Universities Press, Inc.

———. 1993. "On the Possible Effects of Aging on the Practice of Psychoanalysis." *Psychoanalytic Inquiry* 13: 316–332.

Fraser, J.T. 1981. "Temporal Levels and Reality Testing." *The International Journal of Psychoanalysis* 62: 3–26.

Freud, Sigmund. 1893–1899. "Screen Memories." In Freud 1953–1974, vol. III: *Early Psycho-Analytic Publications (1893–1899)*, 299–322.

———. 1909. "Analysis of a Phobia in a Five-Year-Old Boy." In Freud 1953–1974, vol. X: *Two Case Histories ("Little Hans" and the "Rat Man") (1909)*, 1–150.

———. 1913–1914. "Fausse Reconnaissance ('*Déjà Raconteé*') in Psycho-Analytic Treatment." In Freud 1953–1974, vol. XIII: *Totem and Taboo and Other Works (1913–1914)*, 199–207.

———. 1923–1925. "A Note Upon the 'Mystic Writing Pad.'" In Freud 1953–1974, vol. XIX: *The Ego and the Id and Other Works (1923–1925)*, 225–232.

———. 1932–1936. "New Introductory Lectures on Psycho-Analysis." In Freud 1953–1974, vol. XXII: *New Introductory Lectures on Psycho-Analysis and Other Works (1932–1936)*, 7–182.

———. 1953–1974. *The Standard Edition of the Complete Psychological Works of Sigmund Freud*. Translated from the German under the general editorship of James Strachey, in collaboration with Anna Freud, assisted by Alix Strachey and Alan Tyson. 24 vols. London: Hogarth Press and the Institute of Psycho-Analysis.

———. 1971. "Screen Memories." In *Abstracts of the Standard Edition of the Complete Psychological Works of Sigmund Freud*, edited by Carrie Lee Rothgeb. 28. Rockville, Md., National Institute of Mental Health (Philadelphia, PA: Scientific Literature Corporation, Philadelphia).

———. 1985. *The Complete Letters of Sigmund Freud to Wilhelm Fliess 1887–1904*, edited by J.M. Masson. Cambridge, Mass. and London: Harvard University Press.

Gödel, K. 1931. "Über formal unentscheidbare Sätze der Principia Mathematica und verwandter Systeme: I." *Monatshefte für Mathematik und Physik* 38: 173–98.

Kafka, John. 1966. "Déjà Vu Phenomena—Observations and a Theory." Paper presented at the annual meeting of the American Psychoanalytic Association.

———. 1989a. *Multiple Realities in Clinical Practice.* New York: Yale University Press.

———. 1989b. "Déjà Vu, Drugs, Synesthesia." In Kafka 1989a, 51–78.

———. 1989c. "Time, Timing, and Temporal Perspective." In Kafka 1989a, 18–25.

Kettner, M. 1999. "Das Konzept der Nachträglichkeit in Freuds Erinnerungstheorie." *Psyche* 4: 309–342.

Lestienne, Rémy. 2013. "On the Limits of Time in the Brain." *KronoScope* 13, no. 2: 228–239.

Matte-Blanco, Ignacio. 1959. "Expression in Symbolic Logic of the Characteristics of the System Ucs or the Logic of the System Ucs." *The International Journal of Psychoanalysis* 40: 1–5.

———. 1988. *Thinking, Feeling, and Being: Clinical Reflections on the Fundamental Autonomy of Human Beings and World.* New Library of Psychoanalysis 5. London and New York: Tavistock/Routledge.

Murrough, James W.; Iosifescu, Dan V.; Chang, Lee C.; Al Jurdi, Rayan K.; Green, Charles E.; Perez, Andrew M.; Iqbal, Syed; Pillemer, Sarah; Foulkes, Alexandra; Shah, Asim; Charney, Dennis S.; Mathew, Sanjay J. 2013. "Antidepressant Efficacy of Ketamine in Treatment-Resistant Major Depression: A Two-Site Randomized Controlled Trial." *American Journal of Psychiatry* 170: 1134–1142.

Nielsen, Tore A. and Philippe Stenstrom. 2005. "What Are the Memory Sources of Dreaming?" *Nature* 437 (27 October): 1286–1289.

Smith, David L. 2000. "The Mirror Image of the Present: Freud's Theory of Retrogressive Screen Memories." *Psychoanalytische Perspectieven* 39: 7–29.

Watts, Vabren. 2013. "Ketamine Shows Rapid Action in Treatment-Resistant Depression." *Psychiatric News* September 10: 1, 23.

Westerlundh, B., and G. Smith. 1983. "Percept-genesis and the psychodynamics of perception." *Psychoanalysis and Contemporary Thought* 6: 597–640.

Yourgrau, Palle. 2005. *A World Without Time. The Forgotten Legacy of Gödel and Einstein.* New York: Basic Books.

CHAPTER 11

Memory: Epistemic and Phenomenal Traces

Carlos Montemayor

Abstract

This paper argues that memory traces are integrated according to tradeoffs concerning accuracy and autobiographical narrative. It concludes that conscious autobiographical memory cannot be reduced to epistemic memory traces, and that autobiographical memory should be associated with a different category of memory traces: phenomenal traces.

Keywords

episodic memory – autobiographical memory – self-narrative – intrusive memories – memory traces

1 Introduction

Our memories must reliably encode information about past events in order for them to serve as guides for our behavior. While it is true that memories are never infallible, they need to be reliable enough to play this role. As more memories are encoded, the memory register that they constitute becomes a fundamental source of information for a vast number of cognitive tasks. For this memory register to provide knowledge about the past, the memories it contains need to accurately represent causal relations, temporal information, and semantic content. At storage and retrieval, memories about a specific event must be unified and archived as memories about the same episode. Analogously to the binding problem in perception, memory traces must encode information about different aspects of an event as belonging to the same event. These causally constrained traces can contain a lot of information about a single event. They also comply with requirements for knowledge about

the past, in the sense that they allow us to have safe, non-accidental, and justified true beliefs about the past. I shall call these memories *epistemic traces*.[1]

Memory, however, is not just a register. Conscious memory for the standard human being is autobiographically structured and provides more than access to information about past events. The experiences associated with remembering episodes of our lives are valuable not only because they help reproduce information, but fundamentally, because they also evoke meaningful and emotional responses in us. The emotional and personal value that a specific set of memories has cannot be captured or reduced to their informational accuracy. Because of the role these memories play in producing the phenomenally conscious experience of reliving and personally understanding the past, I shall call them *phenomenal traces*. The main thesis of this paper is that the distinction between epistemic and phenomenal traces is crucial for explaining why memory is not merely a register; memory also affords an evocative way of making sense of our pasts.

The epistemic aspects of memory have received much more attention in the psychological and philosophical literature than its phenomenal aspects. I shall argue that the informational tradeoffs for epistemic and phenomenal traces are quite different and that these tradeoffs present a significant challenge with respect to our current understanding of autobiographical memory in particular. Since the evocative and emotional aspects of phenomenal traces very likely interact with their epistemic features during storage, consolidation, and retrieval, the different tradeoffs discussed in this paper will help us discern and understand the contrast between autobiographical long-term memory and other types of memory.

Epistemic traces must comply with at least two constraints in order to be reliable (that is, be highly accurate on average): *metric* and *causal* constraints. Metric constraints are those imposed by the simultaneity and temporal-order relations that depend on the structure of the environment. These relations are necessary to integrate different features into a single event. Causal constraints are those that depend on knowing the origin of information, including internal and external sources of information. With respect to both conscious (explicit) and unconscious (implicit) processing, the metric and causal constraints can be satisfied without conscious awareness, as the navigational systems of insects and other animals confirm. For instance, most forms of procedural memory for motor control, navigation, and automatic performance

1 Throughout the text, by "trace" I mean a memory that is encoded for cognitive and behavioral use, as this term is used in psychology (see Moscovitch and Nadel 1999; Nadel et al. 2000; Agren et al. 2012).

must accurately represent duration and causality, but these cognitive processes are all unconscious (see Montemayor 2013 for a review of the relevant findings). Autobiographical memory, by contrast, seems to be necessarily conscious and, as an explicitly represented personal narrative, depends on the interaction between epistemic and phenomenal traces.

If the main function of autobiographical memories is to produce a self-conscious narrative, the kind of tradeoff that exists between autobiographical memories and other memories cannot be thought of exclusively in terms of accuracy.[2] One can illustrate this point with Nelson Goodman's (1981, 110–111) example of the difference between a report or exposition and a narrative. According to Goodman, reorganizing a set of events (for our purpose a set of memories) in the interest of careful description may alter a narrative to such a critical point that it becomes an exposition or report. Interestingly, the difference between an exposition or report and a narrative, while involving a tradeoff between describing a set of events chronologically and telling a story, does not depend on the accuracy or inaccuracy of information. A false narrative can give way to a false report and vice versa, and the same holds for an accurate one. What matters for producing a cohesive story is the significance a set of memories has. Narrative is much more than a chronometrically organized set of events, and autobiographical memory, by analogy, is much more than a chronometrically organized set of memories.[3] I shall argue that while narratives may be turned into expositions by being chronologically reorganized, autobiographical memory can never be turned into strictly chronological exposition because that would defeat its main purpose: to provide a meaningful personal story.

In what follows, I first discuss the tradeoffs for accurate epistemic trace-integration and then explain why phenomenal traces render problematic several features of epistemic storage and retrieval.

2 It is important to clarify, before discussing the epistemic tradeoffs, the sense of "narrative" that is at stake in autobiographical memory. The diverse meanings of "narrative" are studied across the spectrum of disciplines in the humanities. In a broad sense, narrative is "a means by which human beings represent and structure the world" (Mitchell 1981, viii). A study of narrative in this general sense is far beyond the scope of this text. In this broad sense, narratives are important for understanding social developments, history, art, and one's own relation to society. I focus here on a much narrower sense of "narrative," understood in terms of memory and self-awareness, based on empirical findings in psychology. Thus, I employ "narrative" to identify the sense-making components of memory and self-awareness, which constitute a conscious personal story.

3 On the relation between narrative and a deeper understanding of temporality that relies on this distinction, see Ricoeur (1981).

2 Epistemic Traces

Epistemic traces represent events from the past in compliance with the metric and causal constraints mentioned above. These mnemonic representations need not be fully detailed vignettes of past events. Rather, they only need to be detailed *enough* to satisfy the contextually specific epistemic purposes for which they are retrieved. Epistemic memory traces may be episodic (informative of the time of an event) or semantic (informative of the conceptual identity of an object or event). Epistemic traces, semantic or episodic, are used to satisfy immediate goals, such as reminding oneself of the location and time of a recurrent feeding event. The interaction between semantic and episodic memory produces a rich variety of sources of information that guide subjects in their daily activities. For example, recalling someone's last name (a semantic memory) and recalling when one last saw this person (an episodic memory) generally occur in unison.

Epistemic traces require the asymmetry of time and causality, because the main function of the memory system is to represent the past as accurately as possible. Without such an asymmetry, all information would be atemporal (timelessly in the present, as it were) and exclusively concern the identity of objects. According to John Campbell (1994), causality gives us a conception of the past, in the sense that the origin of information is represented asymmetrically from our present temporal perspective, as fixed and determined. But how is the causal origin of mnemonic traces epistemically secured? Marcia Johnson (1991) proposed an epistemic routine that is in charge of implicitly verifying the causal origin of traces, which she called "reality monitoring." Reality monitoring distinguishes informational sources according to their causal origin (e.g., perceptual or emotional). With respect to memory, reality monitoring seeks to confirm that memory traces are causally linked to events that one perceived, rather than those that one merely thought or dreamed (Johnson, 1991). The main function of reality monitoring, therefore, is to distinguish perception from memories, dreams, and introspective thoughts not just in terms of vivacity (as Hume would have distinguished them), but rather in terms of causal origin.

2.1 *Storage Tradeoffs*
Traces need to satisfy other epistemic requirements besides the causal and metric constraints for accurate duration judgments. Because of the importance of reality monitoring, these requirements include the reliable *storage* and *formatting* of traces, which depend upon a significant amount of cognitive integration. Additionally, *retrieval* must also be reliable. But the view that

mnemonic traces are literally "stored," as if they were deposited in neatly designated file cabinets somewhere in our brain, is implausible for several reasons, many of which are known since the work of Rumelhart, et al. (1986).

For instance, adequate storage does not seem to require amounts of "space" for itemized traces, understood literally as spatial regions of the brain that store information. Instead, memory traces can be organized and stored in networks of activation that are not neatly identified with specific regions of the brain. Ideally, the storage of traces must include information about the relation between specific facts or events, stored in different traces. A holistic and distributed format for memory storage is more realistic than itemized storage because the anatomy and functional dynamics of the brain strongly suggest that information is encoded in networks that activate different regions of the brain. Thus, isolated and itemized memories are not kept in specific regions and rigidly stored for discrete inspection. This "network perspective" proposes that the storage, interaction, and integration of memories depend on networks of neural activation and their organization, rather than on the specific characteristics of brain regions.[4] According to this holistic proposal, traces dispose subjects to retrieve information in specific ways, determined by the *role* the trace plays in the informational network (Rumelhart, et al. 1986).

This kind of flexibility, however, comes at a price: the integration of stored information with contextual information in terms of roles in a cognitive network makes the location of particular memories problematic. More specifically, too much mixture of information may lead to problems concerning the identification of the causal origins of traces, so reality monitoring also becomes problematic. A possible solution is to propose the central monitoring of the causal origin of each memory trace, but then the flexibility, context sensitivity, and general appeal of the approach are jeopardized. Thus, an epistemic tradeoff concerning storage is the balance between itemized storage and a fully holistic regeneration of traces.

Another informational tradeoff is the degree to which context modifies the content of traces. Emotional and social aspects of a trace may modify how the trace is stored and interpreted, thereby changing or even eliminating causal and metric (or duration-related) features of the trace. The tradeoff is that storage and re-storage must not modify the trace to a degree that it loses its epistemic characteristics, but it also must not preserve it in a rigid way such that it cannot be reconsolidated in different ways. Notice that this tradeoff

4 See Pessoa (2013) for a defense of the network perspective as an account of the integration of cognitive and emotional signals in the brain, which is applicable to the integration of memories.

concerns the influence of emotional and social factors, rather than the atomistic or holistic format of traces.

Finally, there is an epistemic tradeoff concerning the temporal range of a trace. It would be ideal to have immediate access to as much reliable information as possible, based on limitless storage, both with respect to detail and time range. It is true that for the standard human being this would produce an unbearable cognitive overload, but ideally speaking, a perfect memory would bring with it many benefits. For ordinary purposes, however, it suffices to have access only to the most useful and reliable information one may need for concrete tasks, such that one is generally in a position to specify the causal origin of traces. It would be useless to store information about every single event that occurs during the day. Humans do not store every detail about an event for long periods of time. There are cases of people with remarkable memory storage, but they are exceptions to the rule.

The opposite extreme of quickly forgetting everything defeats the purpose of memory. One need not keep useless information for long periods, but at the same time one must not lose traces after a few hours or days. It would be bad if no information could be kept for relatively long periods. In this case, autobiographical narratives, based on epistemically constrained memories, could not be formed, because autobiographical memories require at the very least some range of working memory capable of allowing "time-traveling" into the past. These three tradeoffs concerning format, context, and temporal range must be calibrated in order to achieve ideal epistemic performance. Our memory system does a very good job finding a balance for these tradeoffs (e.g., one rarely if ever remembers memories in isolation from other information, or recalls memories that are jumbled together without contextual and chronological framing). Retrieval, however, has epistemic constraints of its own.

2.2 Retrieval Tradeoffs

Memory retrieval affords epistemic access to events about the past because memory traces are evidence that justifies beliefs about past events. Traces can be evidence for the justification of beliefs about the past only if they comply with the causal and metric constraints. Epistemically constrained memory for time corresponds to the memory system that Endel Tulving (2002) called "episodic memory" which allows subjects to register and retrieve information about particular events according to their time of occurrence. But the relationship between this system and the autobiographical memory system is more problematic than is generally assumed.

A central consideration regarding epistemic retrieval is the quality of the access to information. The tradeoff is: remembering in excruciating detail

impedes the formation of abstract and contextual patterns between memories while remembering in the most abstract and ambiguous way does not reproduce information with enough specificity.[5] The access we normally have to memories we voluntarily retrieve almost never includes details about the specific color, location and identity of, for instance, a set of objects we encountered three years ago, or even a week ago. But we do remember enough details to think about something that we did three years ago, roughly speaking, or what objects we probably encountered a week ago.

Another important equilibrium that must be achieved is between *suppression* and *intrusion* (involving the recurrence of memories and our capacity to retrieve them at will). Suppression impedes access to a memory that one is voluntarily trying to remember. Intrusion, by contrast, is involuntary access to a memory that one is trying to forget. Although suppression and intrusion include thoughts, unwanted recurrent memories are produced by specific mechanisms and have unique cognitive characteristics. Memories that come to mind spontaneously may be useful, like when one needs to do something that one keeps forgetting. But in many cases, such memories irrupt into our conscious awareness in strange and troubling ways: too much intrusion is extremely disruptive. On the other hand, if there is too much suppression, memories could not be generated spontaneously and one would have trouble linking memories with contexts, thereby reducing the informational richness of traces.

The mechanisms for intrusion and suppression operate in intriguing ways. Research has shown that conscious effort to suppress a thought intentionally (for instance, by following the command "don't think of a white bear") exacerbates the intrusion of such thought, generating the opposite effect (Wegner, 1994). Wegner proposed the *ironic processing* theory in order to explain this phenomenon. His main idea is that resources for suppression ironically highlight the suppressed thought for targeted recurrent-attention processes, producing intrusion.

Subjects may eliminate involuntary suppression by focusing on the right external cues for the trace to become epistemically accessible, as when one remembers a painful memory by visiting the place where the unpleasant event occurred. If this were the case with most traces, however, we would be epistemically handicapped and fully dependent on the contingencies of the environment for successful retrieval. The positive aspect of suppression is that it

5 See Quiroga (2012) and references therein for evidence concerning neurons that ignore detail in order to create abstract patterns of thought. Thus, our minds are also good at striking a balance between details and patterns at retrieval.

prevents rumination and the constant reevaluation of what one could have done in the past. Thus, adequate suppression helps prevent obsessive routines and behaviors.

The importance of the balance between intrusion and suppression is evident in cases in which one of them dominates, with deeply damaging consequences for the subject. Recurrent thoughts and memories can be quite disruptive and tormenting. Intrusion in post-traumatic stress disorder (PTSD) is a paradigmatic case of epistemically inadequate retrieval with powerful emotional effects. Intentionally and non-intentionally re-experienced trauma memories are intensely vivid, and researchers argue that they should not be called intrusive thoughts because they affect autobiographical narratives much more strongly than intrusive thoughts (Ehlers, Hackmann and Michael 2004 and references therein). Patients describe these memories as overwhelming experiences that affect their temporal perspective:

> The intrusive re-experiencing symptoms in PTSD appear to lack one of the defining features of episodic memories, the awareness that the content of the memory is *something from the past.* In a dissociative flashback the individual loses all awareness of present surroundings, and literally appears to relive the experience. The sensory impressions are re-experienced as if they were features of something happening right now, rather than being aspects of memories from the past. Also, the emotions (including physical reactions and motor responses) accompanying them are the same as those experienced at the time. (Ehlers, Hackmann and Michael 2004, 404)

The intrusive trauma memory is so powerful and evocative that it overwhelms the reality monitoring system. Notice that the information is not entirely false. On the contrary, most of it is painfully true. The information that is absent concerns temporal indexing: the emotional reactions are not registered as information that occurred in the past. Less dramatic cases involve cues that trigger emotions and reactions that are associated with the traumatic event without any recollection of the event (Ehlers, Hackmann and Michael, 2004, 405). In one case the trauma memory is relived without any temporal perspective, while in the other case it evokes reactions without being explicitly recalled.

Intrusion and suppression may be altered, conditioned or enhanced by interacting with subjects who have very high-quality access to memories of events that one experienced with them. A friend from childhood, for instance, may correct us about the source of a memory, e.g., who was at a party. This collaborative interaction between storage, intrusion, and suppression across

subjects could be categorized as transactive memory, a term introduced by Wegner (1986). The collective memory of groups and organizations, of families and close friends, is characterized by this transactive way of cueing one another for specific memory retrieval and for the reshaping and preservation of narratives. It also plays an important epistemic role, as a kind of collective reality monitoring. Thus, the mechanisms for maintaining a balance between the epistemic tradeoffs include self-generated monitoring and social sources of information. But narratives constructed from autobiographical memories require a further level of integration, uniformity, and cohesion than can be achieved through accurate information alone.

3 Phenomenal Traces

At this point the difference between what I will in the following call *neutralism* and *phenomenalism* becomes significant.[6] One could argue that all memories are epistemic. The assumption would be that "remember" is a success term: subjects who cannot accurately recall episodic or semantic information cannot *remember* this information, and they are either confabulating or misremembering. This is *neutralism*, the view according to which the most important function of the memory system is to provide accurate information about the past. The choice of the term "neutralism" is based on the notion that mood or emotion should not alter accurate memories. Memories are thereby "neutral" with respect to emotion and narrative. Storage and retrieval must be accurate and reliable with respect to information concerning the causal origin and the duration of events. Neutralism, then, takes "remembering" to be a success term and assumes that such a balance is somehow achieved. According to neutralism, access to our past is strictly an epistemic achievement.

An alternative view, which I call *phenomenalism*, denies that accuracy suffices to characterize memory, and proposes that no amount of accurate information is sufficient to capture what memories can evoke. According to phenomenalism, the set of all episodic and semantic memories of a subject at any given time, epistemically understood, is insufficient to produce phenomenally conscious autobiographical memories. This is because while the tradeoffs of accuracy (described above) which characterize neutralism are crucial to navigate the world and therefore *necessary* for the successful behavior of

6 I introduce and define these terms to elucidate two types of cognitive integration in memory. Their application is restricted to my discussion of memory and it is independent of other definitions in debates concerning consciousness.

a conscious creature, they are *insufficient* to explain how autobiographical memory works.

While neutralism conceives of memory as a truth-seeking device, phenomenalism conceives of memory as a constructive and evocatively integrative process. Research has shown that memory is indeed malleable and susceptible of manipulation (Loftus, 2005). This does not entail that we should become skeptics about the past or that memory is generally unreliable. On the contrary, we could not perform many basic tasks without having accurate memories, as the neutralist claims. In particular, our daily successes in recalling information by remembering events from our past, as well as basic common sense, show that the majority of our memories cannot be groundless confabulations. However, the malleability of traces presents the challenge that memory does not have as its exclusive function to give accurate information about the past; an equally important function is to *make sense of the past*. According to phenomenalism, what is most intriguing about memory is what it *evokes*, rather than the accuracy of the information it contains. Obviously, it is important to retrieve accurate memories, but what is distinctive about how we consciously remember the past is that it makes us understand, feel, and relive past experiences with powerful effects on imagery and the imagination (as in the case of persons affected by PTSD).

Dreams provide an example of how phenomenalism helps us understand memory traces. For the phenomenalist, although all memories of dreams are false because they are about unreal events, they are as distinctively narrative as normal wakeful memories, and should be studied *as memories*. The way we remember our dreams is unique, and it helps illustrate key differences between epistemic and phenomenal traces. Compared to our wakeful memories, everything about how we remember dreams seems different. In spite of the vivacity of dreams, there is active suppression during the storage and retrieval of dreams—a constant form of reality monitoring in the sense that these memories are systematically treated as confabulations because their causal origin is not from external sources. Yet dream memories seem to be made, as it were, of the same material as wakeful ones.

Dreams may be related to learning and creativity, but their most important characteristics are not epistemic. Descartes (1996 [1641]) famously pointed this out using the powerfully convincing experiences we have in dreams to raise epistemic problems. In particular, one cannot eliminate the possibility that what one is experiencing right now may be a dream. Because knowledge requires eliminating possibilities that are incompatible with knowing, such as dreaming or confabulating, some philosophers think that Descartes's

skeptical argument based on dreams is irrefutable. But in spite of the epistemic problems that dream awareness generates, it is clear that dreams are experiences and that they can be remembered, with marked effects on our emotions and cognition.

I assume a positive characterization of the unique qualities of dream awareness in what follows, with an emphasis on the commonalities between dreams and other phenomenal mnemonic traces—commonalities that justify the view that dreams are introspectively indistinguishable from veridical experiences. Dream traces demonstrate that although phenomenal traces may be epistemically constrained by reality monitoring, they need not be.

Epistemic traces are schematic. They contain a few entries about the location and time of the event, and most importantly, the verification that the information was perceived rather than daydreamed or dreamed. The vivacity, emotional intensity, and the perspective-dependent features of the memory obey principles of phenomenal integration which are not subject to metric or causal constraints. The relevance of these criteria is that epistemic information is insufficient to account for phenomenal traces and the narrative that they create. Crucially, autobiographical memory integrates a subjective perspective—an experienced self-narrative. The same schematic information contained in an epistemic trace can be experienced with different levels of absorption, empathy, and vividness. Thus the same epistemic trace with invariantly accurate information can have different emotional and narrative effects, that is, one can remember an event either from the perspective of "the observer" or from a selfless perspective that includes the environment as a whole, such as a room or a dance hall (Rice and Rubin, 2009). The same event can be remembered accurately but with different narrative effects.

To give a concrete example, suppose one remembers being in a serious car accident. The epistemic trace includes information about duration, location, and the conceptual identity of objects and events. The phenomenal trace, however, includes perspective, emotional responses, and narrative components. One could remember the event from "the inside." People report that in car accidents time slows down and that very specific details, like the way the windshield shatters, seem to be incredibly vivid from one's own perspective. Alternatively, one could remember the event from "the side of the road." One would then remember the windshield shattering, "observing" the accident, oneself and other passengers from an outside vantage point, as in "out of body" experiences. But how can phenomenal traces produce these narrative effects at storage and retrieval? What are the ways in which phenomenal traces enrich a personal narrative with such a variety of perspectives?

3.1 *Involuntary Immersion*

There are conscious effects concerning involuntary retrieval that are characteristic of phenomenal traces. When these traces are triggered, what is fundamental about them is their vivacity and the significance of what they evoke in the subject. They can be accurate, occurring in tandem with epistemic information, but the set of recollections that are evoked saturate the schematic epistemic trace with vivid narrative features, opening up a spectrum of phenomenal variation. Metaphorically speaking, triggering these traces is like opening a door, rather than neatly retrieving specific information about the past from a file cabinet. They are surprising and have profound emotional and aesthetic effects. This involuntary process of recollection could be described as a form of immersion in the past.

For instance, smells and sounds are powerful cues for phenomenal trace retrieval. It has been empirically confirmed that odors are powerful cues for autobiographical memories that are particularly evocative and vivid.[7] These cues trigger information automatically in the sense that their retrieval needs no control or conscious guidance. Music seems to have a similar effect on the spontaneous retrieval of phenomenal traces—the experience is one of immersion. One feels as if the memories of a whole period of one's past suddenly rushed in when one listens to a favorite song, as introspection of such experiences reveals.

This type of retrieval process makes our conscious lives interesting and surprising, as well as meaningfully continuous with our past. It is not just that it creates a cohesive narrative concerning who we are and what happened to us in the past, but, fundamentally, that it does so in a compelling way. Traces here are not retrieved as discrete items in a chronologically organized register. Rather, the traces constitute a form of *revelation* in which many memories are evoked, creating a single contextual whole. What is revealed by these memories is the emotional significance of some event, which may help the subject understand her current experiences. This opening of recollections also seems to be fundamental for the retrieval of dreams, because a single trace may trigger a dream narrative with much more complexity than one expected. For instance, remembering that in the dream one was at a friend's house may be the key to remembering who was there and what was their mood. This process

[7] See Chu and Downes (2000) and references therein. Their experimental data specifically shows that odors are more effective cues for autobiographical memories than cues from the other senses. Marcel Proust (1922) provides an impressive literary examination of such experiences although with an emphasis on taste.

occurs without conscious inferential reasoning or a step-by-step chronological reconstruction.

It must be emphasized that the traces evoked need not be chronologically ordered to be suggestively powerful. On the contrary, that is why the experience is one of immersion in the past. Several "snapshots" of phenomenal traces rush into consciousness simultaneously like "flashes" in one's mind. Moreover, as mentioned above, the traces need not be entirely accurate to produce reliable autobiographical information. In fact, as long as they are not fully confabulated, their not being entirely accurate seems irrelevant, because what is distinctive about these traces is significance for self-narration. The evocative power of a set of memories is not simply a matter of epistemological organization—their accuracy, temporal order, or causal origin, what Goodman (1981) describes as a report or exposition of a set of events. For these chronologically organized memories to evoke the meaning and significance of certain events for a subject in a particular context, the epistemic information concerning time, order, and causal origin must be infused with autobiographical narrative.

Involuntary immersion differs from abnormal memories, such as PTSD memories. While immersion resembles trauma memory because it is involuntarily cued, immersion does not produce the disturbing effect of losing one's own temporal perspective. More importantly, the effect of involuntary immersion is edifying and constitutive of one's own personal narrative. Although too much evocative power may lead to epistemic problems, such as confabulation, the contexts in which this would be really problematic seem to be limited to those that demand more accuracy than is normally expected, such as testifying before a court of law.

Additionally, involuntary immersion cannot be understood simply as the transition from unconscious to conscious memory, because this distinction also characterizes epistemic traces and does not explain the phenomenon of immersion. Immersion does not obey the rules of chronological linearity, and the epistemic tradeoffs mentioned above do not suffice to capture the narrative components of immersion. Finally, retrieving memories by immersion also affects how such memories are re-stored without much voluntary effort.[8]

3.2 Narrative Density

Another type of phenomenal trace-effect concerns voluntary retrieval and storage and a unique kind of non-epistemic tradeoff. Involuntary immersion is effortless, but there are forms of remembering that require conscious effort.

8 For empirical support concerning this kind of change in memory reconsolidation see Nadel et al. (2000).

The difficulty in these cases concerns how autobiographical phenomenological traces are structured in light of the density and richness of self-narration. The voluntary and effortful reconstruction of autobiographical narratives depends not only on constructing causally and chronologically organized sequences of events, but also on the way in which conscious experiences associated with them are integrated in a stretch of self-conscious awareness. There is a structural tradeoff between the linearity of epistemic traces and the complexity of a stream of conscious awareness. The tradeoff is that the more one stays within a linear structure, the less accurate is the description of the stream of consciousness as experienced by the subject, and the more one departs from a linear narrative the higher the risks of confabulation.

Goodman's (1981) distinction between an exposition or report and a story helps explicate this tradeoff. One may keep a meticulous daily record of events without considering this document in any way a personal journal. While from an external perspective such a record is accurate and chronologically structured, from an internal perspective it may not have any personal significance. If the goal of recording events is simply to establish their linearly determined chronological order, then one approximates the external (or third-person) perspective. If the goal, on the other hand, is to seek a narrative that has personal significance, then one must depart from such linear exposition, thereby increasing the risks of expository inaccuracy.

In contrast to involuntary immersion, voluntarily enriching one's narrative is, therefore, subject to active interpretation. Narrating a stretch of conscious awareness may involve different perspectives, starting points, and end points, thereby creating a dense mesh of possible narratives (or narrative density). One is not in command of the reconstructive task in immersion, but in voluntary conscious retrieval, one is actively describing a stretch of conscious awareness (including the recollection of dreams).

For example, in describing what one did yesterday or what one dreamed last night, as in any conscious effort to narrate autobiographical memories, one may take a first-person or a scenario-field perspective. A first-person perspective, in this sense, is one in which one is at the spatio-temporal center of the frame of reference of events, while a scenario perspective is one in which such a center is not one's own spatio-temporal perspective, as in the example above of the car accident. But it also applies to self-originated thoughts centered on the subject and to events that are occurring in the environment the subject is in. One could remember a single episode or event in different ways, for example, attending a professional meeting. One could recall the conversations in detail, the facial expressions of the attendees, what they said or did not say. Or one could recall the event very vaguely and focus instead on what one was

thinking at the time. One may focus on a monotonous conversation and the thoughts one had about the conversation. Alternatively, one could focus on what one was daydreaming. There is no simple and unique way of capturing everything.

There are also specific aspects of conscious experiences that create problems of density: their vivacity, relation to other experiences, complex temporal structure, and the possible perspectives and forms of arranging sequences of experiences. The tradeoff concerning narrative is that the more accurate (or linear-causal) the description of one's own conscious perspective is, the more one ignores other perspectives. Unlike the epistemic tradeoffs, however, there seems to be no clear resolution in which everything that needs to be captured *is* captured.

Just as one can change narrative perspective from subject-centered to scenario-field, one can switch from a causally constrained linear temporal progression to a backward-looking narrative or even a timeless narrative, in order to be more insightful about how one experienced a stretch of conscious self-awareness. Examples of how the most meaningful narrative of a set of possible narratives moves from the present into the past abound in literature. Similarly, "timeless" perspectives are useful to convey the intricacy of an experience that is fraught with meaning. This meaningful association of phenomenal traces is much more important for autobiographical memory than the causal-linear structure or strict epistemic accuracy of a sequence of events. Dream traces are more problematic because the epistemic constraints cannot be satisfied, but they still seem to comply with involuntary immersion and narrative density.

4 Conclusion

The distinction between phenomenal and epistemic traces has important implications for the theoretical and empirical study of memory. The main difficulty in this study is that the epistemic constraints required to characterize "remember" as a success term do not suffice to explain how autobiographical narratives are constructed. This difficulty is manifest in the different ways in which storage and retrieval operate in epistemically constrained conscious and unconscious forms of memory, which differ from conscious autobiographical memory storage and retrieval. Resolving this difficulty, therefore, does not depend on further analyses of the epistemic constraints concerning causal origin and duration. Rather, it depends on paying close attention to how autobiographical memory challenges causal-linear narratives and metrically constrained information about duration because of *involuntary immersion*

and *narrative density*. A promising source of future insights on this problem is the research on memory and dreams, because autobiographical memory seems to be actively operating in dreams. Since dream memories seem to challenge causal and linear narratives, they may help us understand how autobiographical memory is enhanced and enriched independently of the epistemic tradeoffs.

References

Agren, Thomas; Engman, Jonas; Frick, Andreas; Björkstrand, Johannes; Larsson, Elna-Marie; Furmark, Tomas and Fredrikson, Mats. 2012. "Disruption of Reconsolidation Erases a Fear Memory Trace in the Human Amygdala." *Science* vol. 337, no. 6101 (21 September): 1550–1552.

Campbell, John. 1994. *Past, Space, and Self*. Cambridge, MA: MIT Press.

Chu, Simon and Downes, John J. 2000. "Odour-evoked Autobiographical Memories: Psychological Investigations of Proustian Phenomena." *Chemical Senses* 25: 111–116.

Descartes, René. 1996. *Meditations on First Philosophy*. Edited by J. Cottingham. Cambridge: Cambridge University Press. [1641]

———. 1904. *Œuvres de Descartes*. Edited by C. Adam and P. Tannery. Paris: J. Vrin.

Ehlers, Anke; Hackmann, Ann and Michael, Tanja. 2004. "Intrusive re-experiencing in post-traumatic stress disorder: Phenomenology, theory and therapy." *Memory* 12, no. 4: 403–415.

Goodman, Nelson. 1981 "Twisted Tales; or, Story, Study, and Symphony." In *On Narrative*, edited by W.J.T. Mitchell, 99–115. University of Chicago Press: Chicago.

Johnson, Marcia, K. 1991. "Reality monitoring: Evidence from confabulation in organic brain disease patients." In *Awareness of deficit after brain injury: Clinical and theoretical issues*, edited by George P. Prigatano and Daniel L. Schacter, 176–197. New York: Oxford University Press.

Loftus, Elizabeth. 2005. "Planting Misinformation in the Human Mind: a 30-year investigation of the malleability of memory." *Learning and Memory* 12: 361–366.

Mitchell, W.J.T. 1981. "Foreword." In *On Narrative*, edited by W.J.T. Mitchell, vii–x. University of Chicago Press: Chicago.

Montemayor, Carlos. 2013. *Minding Time: A Philosophical and Theoretical Approach to the Psychology of Time*. Leiden: Brill.

Moscovitch, Morris and Nadel, Lynn. 1999. "Multiple-trace theory and semantic dementia: Response to K.S. Graham (1999)." *Trends in Cognitive Sciences* 3: 87–89.

Nadel, Lynn; Samsonovich, Alexei V.; Ryan, Lee and Moscovitch, Morris. 2000. "Multiple trace theory of human memory: Computational, neuroimaging, and neuropsychological results." *Hippocampus* 10, no. 4: 352–368.

Pessoa, Luiz. 2013. *The Cognitive-Emotional Brain: From Interactions to Integration*. Cambridge, MA: MIT Press.

Proust, Marcel. 1922. *Remembrance of Things Past, Part One. Swann's Way*. Translated by C.K. Scott Moncrieff. New York: Henry Holt and Company.

Quiroga, Rodrigo Quian. 2012. *Borges and Memory: Encounters with the human brain*. Translated by J.P. Fernandez. Cambridge, MA: MIT Press.

Rice, Heather J. and Rubin, David C. 2009. "I Can See It Both Ways: first-and third-person visual perspectives at retrieval." *Consciousness and Cognition* 18. no. 4: 877–890.

Ricoeur, Paul. "Narrative Time." 1981. In *On Narrative*, edited by W.J.T. Mitchell, 165–186. University of Chicago Press: Chicago.

Rumelhart, David E.; Smolensky, Paul; McClelland, James L. and Hinton, Geoffrey E. 1986. "Schemata and Sequential Thought Processes in PDP Models." In *Parallel Distributed Processing, Vol. 2*, edited by James L. McClelland and David E. Rumelhart, 7–57. Cambridge, MA: MIT Press.

Schwitzgebel, Eric. 2011. *Perplexities of Consciousness*. Cambridge, MA: MIT Press.

Smallwood, Jonathan; Ruby, Florence J. and Singer, Tania. 2013. "Letting Go of the Present: Mind-Wandering is Associated with Reduced Delay Discounting." *Consciousness and Cognition*, 22 , no. 1: 1–7.

Sosa, Ernest. 2007. *A Virtue Epistemology: Apt Belief and Reflective Knowledge*. New York: Oxford University Press.

Tulving, Endel. 2002. "Episodic Memory." *Annual Review of Psychology* 53: 1–25.

Wegner, Daniel M. 1986. "Transactive Memory: a contemporary analysis of the group mind." In *Theories of Group Behavior*, edited by Brian Mullen and George R. Goethals, 105–208. New York: Springer-Verlag.

———. 1994. "Ironic Processes of Mental Control." *Psychological Review* 101: 34–52.

PART 4

Leaving Traces: Society and Ethics

CHAPTER 12

Heredity in the Epigenetic Era: Are We Facing a Politics of Reproductive Obligations?

Michael Crawford

Abstract

Recent research in the emerging field of epigenetics has implications with the potential to re-ignite acrimony in the discourse of reproductive rights, medical ethics, and the role of the state in our homes and in our lives. For scientists, epigenetics has profoundly realigned our understanding of heredity: epigenetics provides a mechanism through which the environmental challenges met in one generation can be inscribed and transmitted to future offspring. Although both genetic parents have the potential to transmit heritable epigenetic changes to their offspring, mothers have a particularly potent effect because nutrition in the uterine environment can exert a supplemental effect upon the epigenetic imprint of her offspring, and potentially, upon subsequent generations. Moreover, parental care post partum may have generational consequences that are more than just social. Unless discussants have a nuanced understanding of basic epigenetics, women could suffer a disproportionate burden of the obligation to promote fetal, neonatal, and trans-generational health. Drawing upon past patterns of discourse, ethics, and legislation in reproductive rights, I list some of the challenges and temptations that we will be facing at the individual, familial, social, and legislative levels.

Keywords

heredity – epigenetics – law – social justice – environmental justice – diet – health costs – ethics – reproductive politics

∴

> The amazing thing about mammalian development is not that it sometimes goes wrong, but that it ever succeeds.
> VAN HEYNINGEN 2000

∴

1 Introduction

"The apple does not fall far from the tree," goes the famous adage. The legacy of our ancestors is transmitted to us in the form of genes, cultural/social memes, the built and the altered "natural" environments. We, in turn, modify and then transmit these traces of our existence to our descendants. Until recently, debate has centered on the extent to which our behavior, health, etc., are the product of our genes or the social and physical environment that we inhabit. Intelligent observers would intuit that a combination of the two—nature and nurture—is what helps us to develop into such amazingly complex, creative, and resilient organisms. The surprise is that there is now a mechanism linking the two: epigenetics is an emerging field of study that is requiring biologists to reassess their fundamental understanding of inheritance. It is a field that clarifies how the environment and our experiences biochemically alter the way in which our genes behave without altering the sequence of the genes themselves. Epigenetics inscribes an imprint that is both malleable and heritable—in a real sense, it can record critical experiences of our environment and pass them on to the next generation. Lamarck would have been pleased!

Epigenetic imprinting is altered by diet, toxins, drugs, even emotional and social experiences, to name but a few factors. It affects us at the genetic, cellular, and organismal levels; however, not all imprints are universally applied throughout a body. Some remain cell-type specific, and it is likely that only a few are applied to the sex cells for transmission to prospective offspring. For example, there are even imprints that are gender-specific—differentially imparted by parents—that play a role in regulating fetal size, among other things (Moore and Haig 1991; Wilkins and Haig 2003). This varied and sometimes patchy expression of epigenetic imprints makes the phenomenon difficult to study: it is not likely that a blood test will tell you how all other cells in the body are imprinted since the cells that are imprinted may not be circulating. It also makes it hard to predict which imprints are liable to transmit across generations, although some clearly do.

Nevertheless, an emerging picture indicates that how our ancestors lived and how we conduct our own lives has the potential to give us concern for longer-term effects. Imprinting manifests in a subtle way insofar as individuals are concerned, but in aggregate, at the demographic level, the full implications become clear. Without doubt or exaggeration, epigenetics is poised to challenge us in a profound way with respect to medical, ethical, legal, and social values. My agenda will be to define epigenetics, to show how it affects us, and then to suggest how this emerging field could, if not carefully examined, level an unfair burden upon women. The reasons for my concern relate to the way

that reproductive ethics and debate have roiled in many jurisdictions since *Roe versus Wade*. Because human epigenetics studies have predominantly examined the effects of maternally transmitted changes, there is a danger that elements of the biology will be selectively deployed to force an agenda. This representational bias in the literature fails to acknowledge compelling studies that reveal paternal effects, as well as the studies in rodents that are more gender-balanced.

2 The Mechanics of Epigenetic Imprinting

So what is epigenetic imprinting? Chromosomes comprise more than just the DNA sequences that spell out our genes: many structural proteins and RNA molecules contribute to give chromosomes their structure. When we look at magnified pictures of chromosomes, their banded appearance reflects different densities of packing. Alternative constellations of proteins and RNA molecules can be recruited to implement these packaging differences, and these differences in turn regulate accessibility of genes to factors that turn them on or off. Typically, one of the hallmarks of an imprint modification begins with changes to how DNA is decorated with small molecules called methyl groups. The pattern of methylation modulates the activity of nearby proteins, so that histones (proteins around which DNA is coiled) are chemically modified. In combination, the methyl groups and modified histones serve as a scaffold to recruit packaging proteins that either suppress or permit the activation of genes. Imprints can specifically target individual genes, or they can alter the activity of suites of genes that occupy a chromosomal neighborhood.

A good example of an imprinting effect is found in a mouse strain called *Agouti*. Strains of these mice have been isolated and in-bred to the point that siblings are essentially genetically identical. So it comes as a surprise that when you look at a litter of pups, they can look quite different. Some have an exotic coat of dark fur fringed with yellow at the tips. Other pups are much larger and yellow. The yellow pups will develop a predisposition to obesity, diabetes, and cancer, yet at the genetic level, they are identical to their smaller dark siblings (Bultman, Michaud, and Woychik 1992; Michaud et al. 1994; Morgan et al. 1999; Wolff et al. 1998). The difference lies in how the gene responsible for *Agouti* is decorated with methyl groups. This difference alters how the gene is packaged, and as a consequence, when and where it is active in the body. The predisposition to cancer, obesity, diabetes and a yellow coat can be altered to some extent by diet (Waterland et al. 2006). The traits are also affected by environmental contaminants, a topic to which we will return later.

3 Prenatal Epigenetic Imprinting Changes Can Return to Haunt Individuals Late in Life

So if imprinting affects mice, can it affect humans too? In a nutshell, yes. In a comprehensive study of a cohort born immediately following the Dutch Famine of 1944 (the *Hongerwinter*), interesting health patterns emerged. In the winter of 1944, occupying German forces imposed supply cuts in retaliation for a rail workers' strike. Citizens of the region suffered a precipitous decline in their daily caloric intake, but when food supplies were restored, nutritional status rebounded to near-normal conditions almost immediately. Studies of children who were gestating during this period are revealing. Only those who were nutritionally challenged during their third trimester showed a lowered birth weight. With the restoration of food supplies they, as well as the younger first- and second-trimester infants, grew to adulthood normally. As adults, however, it soon became clear that they were all predisposed to a constellation of conditions such as obesity, coronary heart disease, hypertension, elevated cholesterol, altered glucose tolerance, obstructive airways disease, and other ailments including schizophrenia and depression (Ravelli et al. 2005; Ravelli et al. 1999; Stein et al. 2007; Stein et al. 2006; Lumey et al. 2009; Lumey et al. 2007; Painter, Roseboom, and Bleker 2005; Heijmans et al. 2008). Sometimes these effects were gender-specific. For example, when the imprinting state of genetic regions associated with cardiovascular health, appetite, and obesity was assessed, both males and females demonstrated altered imprinting of the cardiovascular genes (Tobi et al., 2009). However, only males showed changes in the behavior of a gene associated with appetite and glucose metabolism. Other factors that can inhibit parental nutrition, such as Crohn's and coeliac disease, *in extremis* might lead to additional defects of embryonic development such as cleft lip and palate (Arakeri, Arali, and Brennan 2010).

The link to diet is not peculiar to starvation: tropical rainy season cycles affect food supplies, and the seasonality of conception alters resistance to disease by the time adulthood is reached (Waterland et al. 2010). Moreover, maternal obesity imparts quantifiable risks to infants (Bouchard et al. 2010). It is now known that these risks are associated with alterations to the packaging and behavior of genes. Genes such as *Insulin-Like Growth Factor* (*IGF2*, which affects fetal growth, adiposity, and adult glucose tolerance), *H19* (a control region adjacent to *IGF2*), and *leptin* (related to appetite, obesity, and diabetes) are all affected by imprinting, and as with the *Agouti* mice, changes in methyl-group decoration of these chromosomal regions have been confirmed (Hoyo et al. 2012; Perkins et al. 2012; Guo et al. 2008; Tobi et al. 2011; Bouchard et al. 2010).

Diet is not the only factor that affects gestating humans in this way. Severe maternal depression during pregnancy can affect the imprint of a gene in the fetus (Liu et al. 2012). This latter study suggested that sensitivity to depression-induced effects might be race-specific, since African American mothers were more likely to transmit changes to their offspring than others in the cohort. While subtle genetic effects could indeed be playing a role, racial differences were not separated from cultural and dietary practices, and at the very least, we might consider that these are important confounding factors. Addictive substances also affect imprinting as monitored by methylation changes in both humans and rodents (D'Addario et al. 2013; Heberlein et al. 2013; Launay et al. 2009; Levine et al. 2011; Nieratschker et al. 2012; Ponomarev et al. 2012; Renthal et al. 2008; Schwarz, Hutchinson, and Bilbo 2011; Zhou et al. 2011, Murphy et al. 2012).

Contaminants in the environment can change imprinting, and the list of substances that do this ranges from endocrine disruptors leached from fungicides, insecticides, and plastics to heavy metals (Anway et al. 2005; Anway, Leathers, and Skinner 2006; Anway and Skinner 2006; Skinner and Anway 2005; Anderson et al. 2012; Dolinoy, Huang, and Jirtle 2007; Smith and Taylor 2007; Arita and Costa 2009; Cheng, Choudhuri, and Muldoon-Jacobs 2012). The significance of this is that epigenetics appears to offer a mechanism for these compounds to alter fertility, behavior, cognition, and cancer rates. Indeed, altered imprinting is a major new subject in the study of cancer progression and treatment (Blancafort, Jin, and Frye 2013; Suva, Riggi, and Bernstein 2013; Wang and Shang 2013).

4 Postnatal Experiences Can Install Persistent Epigenetic Changes

In rodents, patterns of inferior maternal behavior, such as the negligent grooming of pups, affect the imprint of a gene that encodes a stress hormone receptor in the offspring. This has the effect of altering their stress response into adulthood, as well as of modifying the parental diligence and behavior that they themselves will exhibit when they become parents (Weaver et al. 2004; Weaver et al. 2005; Sapolsky 2004). The imprint status of the stress hormone receptor in offspring is transmissible to subsequent generations, but this particular imprint appears to be reversible through early fostering by good parents. Moreover, administration to the infants of a drug that alters epigenetic imprints by non-specifically erasing them reverses poor parenting behavior (Weaver et al. 2005). Unfortunately, the generalized properties of the drug (trichostatin A) probably preclude routine use since it alters the imprint of

other chromosomal regions indiscriminately and could activate genes better left dormant.

Humans also exhibit imprint modifications that are associated with behavioral change. In an economically challenged Montreal district, patterns of aggressive behavior among kindergarten children were linked to heritable epigenetic changes (Provencal et al. 2013). Brain-associated imprints can have even more catastrophic consequences: brain-derived neurotrophic factor (BDNF) is involved in learning, memory, and intellect, and it was discovered to be abnormally imprinted in brain samples derived from adult suicide victims (Ernst et al. 2009). Abusive experiences during childhood can leave detectable imprinting changes (McGowan et al. 2009; Labonte et al. 2012), and this has been confirmed in behavioral tests of rats as well (Roth et al. 2009). Finally, mice that have been exposed to adversity in association with a particular smell transmit an aversion to this smell to their pups and grandpups, even if those offspring are fostered by untraumatized parents (Dias and Ressler 2014). With regard to epigenetic modification, we must infer that we are not merely passive recipients of environmental cues: we can be affected also by our behavioral interactions with it, our neighbors, and our family.

5 Imprinting can be Transmitted across Generations

Epidemiological and rodent studies have demonstrated that imprinting effects caused by diet can extend across multiple generations in humans as well. Överkalix is a northern Swedish municipality that was prone to periods of feast and famine in the late 1800s to the early 1900s. A retrospective analysis reveals that grandchildren were predisposed to specific suites of diseases that were gender-specific in their heritability: grandmothers could transmit disease predispositions to their granddaughters but not to their grandsons, and grandfathers could transmit to their grandsons, but not to their granddaughters (Kaati et al. 2007; Bygren, Kaati, and Edvinsson 2001; Kaati, Bygren, and Edvinsson 2002; Pembrey 2010; Pembrey et al. 2006). Trans-generational effects have since been confirmed in the Dutch famine studies (Lumey and Stein 2009), and it is a picture mirrored in rodents (Jimenez-Chillaron et al. 2009; Ng et al. 2010; Burdge et al. 2011). Imagine the legacy that starvation will impose upon the generations that emerge from the great famines of China (1958–61), Bangladesh (1974), Ethiopia (1983–5, 2011–13), and North Korea (1994–98)!

Similarly, imprinting alterations caused by endocrine disruptors can persist for generations (Skinner et al. 2012; Guerrero-Bosagna et al. 2013). Bisphenol A, the leachate associated with low-grade beverage containers, is an endocrine

disruptor. In studies of mice (including our former example of the *Agouti* strain), methylation states and hence imprint status were changed by low concentrations of this contaminant (Anderson et al. 2012; Dolinoy, Huang, and Jirtle 2007). One might well imagine the paroxysm of legal activity that transgenerational effects might elicit: if the products that companies sell damage customers or bystanders slowly, perhaps even over the course of generations, how will litigation deal with the statute of limitations? This vexing question has been addressed in a provocative article where the authors examine the specific example of DES, a purported fertility drug, that had adverse trans-generational effects (Rothstein, Cai, and Marchant 2009b). If there is a little light to be had at the end of the tunnel, it is that at least some of these effects, caused either by endocrine disruptors or by nutritional challenges, are potentially reversible through changes to diet or the provision of nutritional supplements (Dolinoy, Huang, and Jirtle 2007; Dolinoy et al. 2006; Burdge et al. 2011).

6 The Social and Ethical Challenges

Surprisingly few people have written concerning the ethical and social ramifications of epigenetic imprinting. A notable exception to this is Rothstein, Cai, and Marchant (2009a, b), who have provided an impressively comprehensive overview of the potential ethical and legal challenges to come. Briefly, they argue that the field of epigenetics raises questions regarding environmental justice, poverty, privacy, and health. They argue persuasively that the poor are liable to suffer a disproportionate share of challenges by virtue of their constrained access to the best foods and healthcare, as well as their relegation to jurisdictions where environmental contamination, poor labor practices, and psychological stress will exert a pronounced effect upon them, and upon ensuing generations (Rothstein, Cai, and Marchant 2009b, a; Ziech et al. 2010). The social and racial challenges of epigenetics on a geographical scale have also been highlighted elsewhere (Guthman and Mansfield 2012; Mansfield 2012).

Somewhat more attention has been paid to risks that imprinting might pose for Assisted Reproductive Technologies (ART), otherwise known as In Vitro Fertilization (IVF). Concerns have been articulated that because imprinting changes are a normal part of egg versus sperm development, damage could be incurred during manipulation of the gametes (Johnson 2005; Kaariainen, Evers-Kiebooms, and Coviello 2005). For example, some studies suggest that the use of the (potentially immature) sperm derived for fertilization by intracellular sperm injection might predispose embryos to a suite of imprinting-related problems such as Beckwith-Weidemann, Angelman's, or Prader-Willi

syndromes (Feng et al. 2011; Li et al. 2011). Despite anecdotal accounts of the aforementioned effects, preliminary studies have failed to reveal imprinting effects upon the small suite of genes analyzed (Zheng et al. 2011). However, others have argued that even a brief exposure of egg and sperm to the artificial environment of a Petri dish in a lab incubator engenders subtle risks that will only become apparent when a comprehensive analysis of the entire "epigenome" is attempted (Johnson 2005). The use of these technologies *per se* need not present secular ethical concerns for either reproductively challenged heterosexual couples or homosexual couples potentially desiring to generate offspring from same-sex gametes, as long as the risks are known and reasonable (Testa and Harris 2004).

The major practical and ethical concern is to assure practitioners and patients alike that not only are the contributed germinal genomes undamaged, but that they are packaged to behave correctly too. As we have seen recently in world markets, pragmatism and ethics do not necessarily go hand in hand if enterprises are profit-oriented. Since assisted reproduction is provided on a for-profit basis in many countries, there are substantial impediments to assessing its procedural safety. Procedures and innovations are subject to proprietary secrecy, and can vary from one medical practice to another. How then, does one access, compare, and evaluate medical outcomes, especially when the elements that are epigenetically controlled might take many years to be revealed and the medical providers meanwhile might have sold their practice or retired? It is still early days to make such a risk assessment—the first human to be born using this technology is only 30 years old.

Assisted reproductive technologies aside, the implications of epigenetics/imprinting are vast, and they are liable to reach into reproductive politics, ethics, and law in ways that we cannot presently foresee. My agenda here will be to focus upon mothers. Mothers are assumed, by virtue of the intimacy of contact with the fetus and the breastfeeding baby, to play the most significant role in nourishing and programming a child. This assumption carries risks. For example, one can imagine how over-simplification of epigenetics in popular media could deliver an understanding that was lacking in the nuances necessary for a balanced understanding of the phenomena. This in turn could impinge upon the flavor of maternal/medical consultation, as well as upon social mores, policy, and law. Mothers could be told that their pre-conception and gestational nutritional status, habits, and exercise regimen will not only affect the health of their baby at birth and for the duration of their offspring's life, but extend to subsequent generations.

Smolensky argued that parents might expose themselves to liability if they were to intentionally alter pre-implantation embryos to deliver a desired trait

(the example she cites is deafness) (Smolensky 2008). Although in this latter instance the manipulation envisaged was genetic, a similar argument has been advanced to suggest that liability might apply for parents who indulge in behavior that causes pre-conception epigenetic harms (Weiner 2010). As the custodian of a fetus, a woman is uniquely placed to be held accountable for what transpires during development: her feeding, behavior, and metabolic activity supports growth. Case law regarding maternal obligation has met with mixed results. In *Ferguson v. City of Charleston* (532 U.S. 67, 2001), pregnant women who were arrested after testing positive for the presence of drugs in their system escaped penalty since the blood tests were done without their knowledge and therefore constituted a violation of their right to freedom from arbitrary search and seizure. When the justices of the Supreme Court U.S. were considering the case, the issue of "special needs" arose. "Special needs" in this context is a category of narrowly defined circumstances where managers and employees have a duty of care to individuals or the collective: a drug-free workplace is critical to their mission. For example railway, customs, and sports managers may require blood testing of their employees. Although the final court decision had three justices dissenting regarding the use of blood tests, "special needs," in this case the care of a fetus, were not deemed applicable by any of the adjudicators. By contrast, in *Whitner v South Carolina* (492 S.E.2d 777 S.C., 1997), a mother failed to overturn her conviction for abusing her "viable fetus" following cocaine abuse while pregnant. In essence, personhood was extended to the fetus because the damage was inflicted during the third trimester and a baby was delivered. While most cases in this realm have had to do with physical or drug-induced harm to a fetus, it is not a stretch to wonder what the courts will make of epigenetic harms. For example, what if a mother develops an eating disorder, or decides to smoke packs of cigarettes per day? Given present ambiguities regarding the concept of a "viable fetus" in some jurisdictions, there is a danger that a degree of fetal "personhood" will emerge and compete with freedoms of the mother, *Roe versus Wade* to the contrary. There is legitimate concern that regulations and legal precedents that develop to deal with epigenetic issues will erode the rights of the mother, potentially even prior to conception (Smith, Maccani, and Knopik 2013). Moreover, post-partum deficits of attention or negligent maternal behavior could be construed to have implications that will last for generations. Will this too fall into the category of abuse?

There is a risk that the relative paucity of studies concerning paternal input into the equation could bias perceptions and drive discussions in a way that unfairly burdens pre-conception women, as well as mothers. While it is true that maternal imprinting and the intimacy of gestational connection mean

that mothers have the capacity to affect the imprint of their progeny, it is equally clear that fathers can also transmit imprints. Recent studies indicate that, depending upon the challenge or exposure, epigenetic factors are differentially packaged and delivered to the egg by human sperm (Fullston et al. 2013; Meunier et al. 2012; Rodgers et al. 2013). Moreover, post-partum care and influences need not exclusively be a mother's purview, and adverse socialization can be caused by fathers as well as by mothers. For example, reading between the lines, a factor in the Montreal study of aggressive kindergarten boys was the aggressive behavior of their fathers and the consequent stress of their mothers (Hall 2014).

7 Proscriptive Solutions?

The Fourth World Conference on Women declared:

> The human rights of women include their right to have control over and decide freely and responsibly on matters related to their sexuality, including sexual and reproductive health, *free of coercion, discrimination* and violence. (Conferences 1995; my italics)

Nevertheless, it is hard to forecast where the balance will tip with regard to state versus individual interests. With a new recognition of the role of epigenetics in reproduction, development, and aging, states will have additional incentive and interest to regulate or intervene in order to ensure generational health. One extreme possibility might be for a state to impose tax, housing, or health insurance programs that make it financially or socially difficult for a woman to do anything other than stay at home following delivery despite her desires or what her career path might optimally require. Another suggestion, already voiced, would be to level a tax on childbirth against the eventuality of epigenetic damage and consequent healthcare costs (Weiner 2010).

If mothering skills are deemed sub-par, will states find it easier to lower the threshold for removing a mother's children to foster care? Who decides the threshold for acceptable care? Previously, states have enacted controversial policies to move children out of their homes in the interest of either health or education: a 2002 case in the Court of Appeals in Texas upheld a decision to remove a child from her mother's care on the basis that she was failing to adequately deal with her young son's obesity (*In re* G.C., 66 S.W.3d 517, 524. Tex. App. Fort Worth 2002). However, the forced removal of aboriginal

children to "modern" residential schools in Canada and Australia delivered catastrophic and persistent consequences for all concerned (Australia, Human Rights and Equal Opportunity Commission, and Wilkie 1997; National Inquiry into the Separation of Aboriginal and Torres Strait Islander Children from Their Families [Australia], Wilson, and Australia, Human Rights and Equal Opportunity Commission. 1997; Elias et al. 2012).

Exclusionary reproductive policies are not without precedent in recent memory. *In extremis*, states have demonstrated a willingness to indulge in eugenics before—might there not be a temptation for totalitarian regimes to make it difficult for diabetics, former addicts, the morbidly obese, or even formerly abused citizens to have children of their own? It is not too long ago that homosexual couples were forbidden to adopt or act as custodians of children, even in states with a socialist agenda.

8 Neutral or Disinterested Solutions

A more contrarian perspective might be to do nothing and to assert that just as genetic variation confers resilience on our species, so too might epigenetic variation. In the pre-medical era, people who carried a single recessive mutation for the CFTR gene, or who were carriers of sickle-cell anemia, might have enjoyed resistance to cystic fibrosis or malaria respectively. By extension, perhaps epigenetic variants offer contingent protection against some future assault. Perhaps we should not work to improve the imprinting status of out compatriots. Imagine for a moment that the 1962 Cuban Missile Crisis had escalated out of hand, and World War III had descended upon Europe. The same Dutch adults who had experienced prenatal starvation might have been well served: they would metabolize their food slightly differently, and they might possess a more generous store of fat. The result? There would be a larger portion of the general population endowed to cope with periodic deprivation. Looked at as a beneficial mechanism to contend with very real and experienced environmental conditions, epigenetics prepares the organism to cope with more of the same. That similar challenges do not necessarily repeat means that the body might be metabolically misaligned and clumsy in responding to more favorable conditions.

The difference between "subliminal" gene mutations and epigenetics is that epigenetics can respond to a challenge inside a generation and in multiple individuals. No selective breeding and proliferation of a trait is required for it to enter a population at large. But when peace or adequate nutrition become

the norm, what are the benefits? Life for most of us is unlikely to be "nasty, brutish, and short," so there is little reason to value epigenetic variation: it seems unethical to advocate for systemic and widespread social injustice on the presumption that it might husband biological variations that could prove *contingently* useful. On the contrary, it seems equally plausible that if governments strive to improve access to good health for their citizens, then they will be more likely both to capitalize upon opportunities and to weather calamities. Invariably, there will always be individuals who chart their own course, and irrespective of what facilities a society provides for its citizens, epigenetics, like genetics, will have an ample slate of variation from which to draw when the going gets tough.

9 Facilitative Solutions

At the other end of the spectrum, states might find it socially responsible, not to mention fiscally prudent, in the interest of generational health and cumulative system costs, to provide free early medical advice, nutritional supplements, etc., to pre-pubescent children, to pregnant women, and to post-partum parents. Since behavioral and environmental contexts appear to influence imprinting in the young, perhaps more states will find it expedient to provide universally accessible paid parental leave, parental education, childcare facilities, enriched early-childhood education programs, as well as school- and daycare-based feeding programs. Many jurisdictions have already found it practical, just, or merely expedient to support families in this way, and there was no need to invoke epigenetics to do so. What the evidence from epigenetics provides is an additional incentive to regard social, environmental, and educational support in an intrinsically holistic way, rather than as an assembly of relatively disassociated but beneficial policies.

Briefly, there are two concrete examples of this philosophical disposition in modern societies. First, in Finland, the baby box program rewards prenatal medical visits with a package of baby clothing and other goodies designed to make post-partum life easier. The program, begun in 1938 to address high mortality rates among the poor, was universalized in 1949 and persists to this day. Finland now has one of the lowest rates of infant mortality in the world. Second, in Hawaii, U.S. Centers for Disease Control-funded research provided the fodder to support a successful lawsuit that ultimately required expansion of specific health-care programs. The programs in question were directed toward mitigating problems arising from pregnancy, addiction, and

an impoverished lifestyle/diet among a cohort of aboriginal teens. Neither program was designed to deal with epigenetic considerations; however, both go a long way toward mitigating demographically significant costs, and it is easy to see how epigenetics could add weight to similar social agendas.

Finally, one wonders to what extent we will be permitted to remain private custodians of our histories. Will prospective spouses, organs of church and state, allied medical professionals, and insurers begin to demand that we disclose elements of our past that might end up costing society, if not in this generation, then the next? To what extent do individuals have to be held accountable for the choices of their ancestors, accidents of history, their medical disposition, or perhaps their errant youth? Maria Hedlund (2012) asserts that it is unfair to saddle individuals with a retrospective responsibility for their own future health or for that of their possible descendants. A similar dichotomy of responsibility and agency has been identified within the context of environmental bioethics (Dupras, Ravitsky, and Williams-Jones 2012). These authors argue that a major challenge with regard to epigenetics will be to balance individual needs and rights with communitarian dictates. Some of the factors involved are clearly linked to historical social, economic, and environmental injustices over which individuals have little or no control. A subtle case in point: historically, obesity has been ascribed to over-indulgence. We now know that not only are there genetic components to the problem, but epigenetically inherited ones as well (Delport and Pollard 2010).

10 Conclusion

In essence, what epigenetics provides is concrete evidence that confirms what we likely already know at a deeper level: factors such as good parenting, good nutrition, and a supportive culture are important. That the evidence might provide polemicists with ammunition to further a cause is beside the point. Good information is power, and in this case, it provides tools for transformative thinking and pro-active policy making. Perhaps uniquely, epigenetics highlights the necessity for individuals to take responsibility for themselves while also requiring that governments and societies help their citizens to help themselves.

The message can be summarized:

1. Individuals owe it to themselves, to society at large, and to their prospective progeny to treat their bodies with respect.

2. Governments and societies owe it to future generations to treat their citizens with respect. Even pre-conception ages are susceptible to imprinting damage or improvement, and the long-term advantages and costs need to be considered.
3. The preliminary evidence suggests that imprinting is, in some cases, reversible. We are not entirely prisoners of our heritage, and we have a duty to make lifestyle improvements, if only for the sake of our descendants.
4. Even those members of society who are not reproductive have the potential and therefore the obligation to change the nutritional, educational, social, and physical environments for the better—if not for the generations to come, then for their own collective self-interest and the containment of the health and social costs that they must share.
5. Epigenetics is subtle and exerts a pervasive influence. Education about its role is key, and polemical extremes will be managed best when the stakeholders are well informed.
6. By virtue of the intimate biological connection of women with their fetuses, and because many of the studies focus upon maternal effects, there is a danger that women will be disadvantaged in the re-balancing of duties and obligations that could ensue.
7. The scientific evidence is clear that even the pre-conception nutrition and behavior of prospective fathers can exert trans-generational effects upon imprinting—the obligations that attend reproductive health and child rearing are not one-sided.
8. The pervasive influence of imprinting demands integrative thinking and policies.

Forward-looking and pro-active political decisions can help to mitigate structural, economic, and social inequities. An ethics that places facilitative rather than proscriptive tools in the hands of institutions and people empowered to wield them can help to mitigate past damage and to build for a healthier future. Even if the short-term cycles of democratic politics mitigate against expensive social policies in the short term, it seems likely that conversations about epigenetic features of our society will provide ample reason to be proactive on ethical as well as upon long-term economic grounds. This "healthier future" connotes a place where fewer resources would have to be expended addressing at least some of the complex health, behavioral, and social problems that afflict our times. By the same token, as individuals, we owe it to our own comfort and vitality in older age, as well as to our offspring, to exercise discipline and sense in the care of ourselves. Responsibility for epigenetic health is a two-way street—it is a collective and personal obligation.

Acknowledgements

MJC was supported by a grant for the Natural Sciences and Engineering Research Council of Canada.

References

Anderson, O.S., M.S. Nahar, C. Faulk, T.R. Jones, C. Liao, K. Kannan, C. Weinhouse, L.S. Rozek, and D.C. Dolinoy. 2012. "Epigenetic Responses Following Maternal Dietary Exposure to Physiologically Relevant Levels of Bisphenol A." *Environ Mol Mutagen* 53 (5): 334–42.

Anway, M.D., A.S. Cupp, M. Uzumcu, and M.K. Skinner. 2005. "Epigenetic Transgenerational Actions of Endocrine Disruptors and Male Fertility." *Science* 308 (5727): 1466–9.

Anway, M.D., C. Leathers, and M.K. Skinner. 2006. "Endocrine Disruptor Vinclozolin Induced Epigenetic Transgenerational Adult-Onset Disease." *Endocrinology* 147 (12): 5515–23.

Anway, M.D., and M.K. Skinner. 2006. "Epigenetic Transgenerational Actions of Endocrine Disruptors." *Endocrinology* 147 (6 Suppl): S43–9.

Arakeri, G., V. Arali, and P.A. Brennan. 2010. "Cleft Lip and Palate: An Adverse Pregnancy Outcome Due to Undiagnosed Maternal and Paternal Coeliac Disease." *Med Hypotheses* 75 (1): 93–8.

Arita, A., and M. Costa. 2009. "Epigenetics in Metal Carcinogenesis: Nickel, Arsenic, Chromium and Cadmium." *Metallomics* 1 (3): 222–8.

Australia, Human Rights and Equal Opportunity Commission, and Meredith Wilkie. 1997. *Bringing Them Home: Report of the National Inquiry into the Separation of Aboriginal And Torres Strait Islander Children from Their Families, Parliamentary Paper*. Sydney: Human Rights and Equal Opportunity Commission.

Blancafort, P., J. Jin, and S. Frye. 2013. "Writing and Rewriting the Epigenetic Code of Cancer Cells: From Engineered Proteins to Small Molecules." *Mol Pharmacol* 83 (3): 563–76.

Bouchard, L., S. Thibault, S.P. Guay, M. Santure, A. Monpetit, J. St-Pierre, P. Perron, and D. Brisson. 2010. "Leptin Gene Epigenetic Adaptation to Impaired Glucose Metabolism During Pregnancy." *Diabetes Care* 33 (11): 2436–41.

Bultman, S.J., E.J. Michaud, and R.P. Woychik. 1992. "Molecular Characterization of the Mouse *Agouti* Locus." *Cell* 71: 1195–1204.

Burdge, G.C., S.P. Hoile, T. Uller, N.A. Thomas, P.D. Gluckman, M.A. Hanson, and K.A. Lillycrop. 2011. "Progressive, Transgenerational Changes in Offspring Phenotype and Epigenotype Following Nutritional Transition." *PLoS One* 6 (11): e28282.

Bygren, L.O., G. Kaati, and S. Edvinsson. 2001. "Longevity Determined by Paternal Ancestors' Nutrition During Their Slow Growth Period." *Acta Biotheor* 49 (1): 53–9.

Cheng, T.F., S. Choudhuri, and K. Muldoon-Jacobs. 2012. "Epigenetic Targets of Some Toxicologically Relevant Metals: A Review of the Literature." *J Appl Toxicol* 32 (9): 643–53.

Conferences, United Nations Specialised. 1995. Beijing Declaration and Platform for Action, adopted at the Fourth World Conference on Women, edited by United Nations.

D'Addario, C., F.F. Caputi, T.J. Ekstrom, M. Di Benedetto, M. Maccarrone, P. Romualdi, and S. Candeletti. 2013. "Ethanol Induces Epigenetic Modulation of Prodynorphin and Pronociceptin Gene Expression in the Rat Amygdala Complex." *J Mol Neurosci* 49 (2): 312–9.

Delport, Tiffany, and Irina Pollard. 2010. "Changing Perspective on Obesity: Genetic and Environmental Health Consequences in the Offspring." *Eubios Journal of Asian and International Bioethics* 20 (6): 170–173.

Dias, B.G., and K.J. Ressler. 2014. "Parental Olfactory Experience Influences Behavior and Neural Structure in Subsequent Generations." *Nat Neurosci* 17: 86–96.

Dolinoy, D.C., D. Huang, and R.L. Jirtle. 2007. "Maternal Nutrient Supplementation Counteracts Bisphenol A-Induced DNA Hypomethylation in Early Development." *Proc Natl Acad Sci USA* 104 (32): 13056–61.

Dolinoy, D.C., J.R. Weidman, R.A. Waterland, and R.L. Jirtle. 2006. "Maternal Genistein Alters Coat Color and Protects Avy Mouse Offspring from Obesity by Modifying the Fetal Epigenome." *Environ Health Perspect* 114 (4): 567–72.

Dupras, C., V. Ravitsky, and B. Williams-Jones. 2012. "Epigenetics and the Environment in Bioethics." *Bioethics*. Sept. 28(7): 327–34.

Elias, B., J. Mignone, M. Hall, S.P. Hong, L. Hart, and J. Sareen. 2012. "Trauma and Suicide Behaviour Histories among a Canadian Indigenous Population: An Empirical Exploration of the Potential Role of Canada's Residential School System." *Soc Sci Med* 74 (10): 1560–9.

Ernst, C., V. Deleva, X. Deng, A. Sequeira, A. Pomarenski, T. Klempan, N. Ernst, R. Quirion, A. Gratton, M. Szyf, and G. Turecki. 2009. "Alternative Splicing, Methylation State, and Expression Profile of Tropomyosin-Related Kinase B in the Frontal Cortex of Suicide Completers." *Arch Gen Psychiatry* 66 (1): 22–32.

Feng, C., S. Tian, Y. Zhang, J. He, X.M. Zhu, D. Zhang, J.Z. Sheng, and H.F. Huang. 2011. "General Imprinting Status is Stable in Assisted Reproduction-Conceived Offspring." *Fertil Steril* 96 (6): 1417–1423 e9.

Fullston, T., E.M. Ohlsson Teague, N.O. Palmer, M.J. DeBlasio, M. Mitchell, M. Corbett, C.G. Print, J.A. Owens, and M. Lane. 2013. "Paternal Obesity Initiates Metabolic Disturbances in Two Generations of Mice with Incomplete Penetrance to the F2 Generation and Alters the Transcriptional Profile of Testis and Sperm Microrna Content." *FASEB J* 27 (10): 4226–43.

Guerrero-Bosagna, C., M. Savenkova, M.M. Haque, E. Nilsson, and M.K. Skinner. 2013. "Environmentally Induced Epigenetic Transgenerational Inheritance of Altered

Sertoli Cell Transcriptome and Epigenome: Molecular Etiology of Male Infertility." *PLoS One* 8 (3): e59922.

Guo, L., S. Choufani, J. Ferreira, A. Smith, D. Chitayat, C. Shuman, R. Uxa, S. Keating, J. Kingdom, and R. Weksberg. 2008. "Altered Gene Expression and Methylation of the Human Chromosome 11 Imprinted Region in Small for Gestational Age (SGA) Placentae." *Dev Biol* 320 (1): 79–91.

Guthman, Julie, and Becky Mansfield. 2012. "The Implications of Environmental Epigenetics: A New Direction for Geographic Inquiry on Health, Space, and Nature-Society Relations." *Progress in Human Geography* 37 (4): 486–504.

Hall, S.S. 2014. "Behaviour and Biology: The Accidental Epigeneticist." *Nature* 505 (7481): 14–17.

Heberlein, A., M. Muschler, H. Frieling, M. Behr, C. Eberlein, J. Wilhelm, M. Groschl, J. Kornhuber, S. Bleich, and T. Hillemacher. 2013. "Epigenetic Down Regulation of Nerve Growth Factor During Alcohol Withdrawal." *Addict Biol* 18 (3): 508–10.

Hedlund, Maria. 2012. "Epigenetic Responsibility." *Medicine Studies* 3: 171–183.

Heijmans, B.T., E.W. Tobi, A.D. Stein, H. Putter, G.J. Blauw, E.S. Susser, P.E. Slagboom, and L.H. Lumey. 2008. "Persistent Epigenetic Differences Associated with Prenatal Exposure to Famine in Humans." *Proc Natl Acad Sci USA* 105 (44): 17046–9.

Hoyo, C., K. Fortner, A.P. Murtha, J.M. Schildkraut, A. Soubry, W. Demark-Wahnefried, R.L. Jirtle, J. Kurtzberg, M.R. Forman, F. Overcash, Z. Huang, and S.K. Murphy. 2012. "Association of Cord Blood Methylation Fractions at Imprinted Insulin-Like Growth Factor 2 (IGF2), Plasma IGF2, and Birth Weight." *Cancer Causes Control* 23 (4): 635–45.

Jimenez-Chillaron, J.C., E. Isganaitis, M. Charalambous, S. Gesta, T. Pentinat-Pelegrin, R.R. Faucette, J.P. Otis, A. Chow, R. Diaz, A. Ferguson-Smith, and M.E. Patti. 2009. "Intergenerational Transmission of Glucose Intolerance and Obesity by In Utero Undernutrition in Mice." *Diabetes* 58 (2): 460–8.

Johnson, M.H. 2005. "The Problematic In-Vitro Embryo in the Age of Epigenetics." *Reprod Biomed Online* 10 (Suppl 1): 88–96.

Kaariainen, H., G. Evers-Kiebooms, and D. Coviello. 2005. "Medically Assisted Reproduction and Ethical Challenges." *Toxicol Appl Pharmacol* 207 (2 Suppl): 684–8.

Kaati, G., L.O. Bygren, and S. Edvinsson. 2002. "Cardiovascular and Diabetes Mortality Determined by Nutrition During Parents' and Grandparents' Slow Growth Period." *Eur J Hum Genet* 10 (11): 682–8.

Kaati, G., L.O. Bygren, M. Pembrey, and M. Sjostrom. 2007. "Transgenerational Response to Nutrition, Early Life Circumstances and Longevity." *Eur J Hum Genet* 15 (7): 784–90.

Labonte, B., M. Suderman, G. Maussion, L. Navaro, V. Yerko, I. Mahar, A. Bureau, N. Mechawar, M. Szyf, M.J. Meaney, and G. Turecki. 2012. "Genome-Wide Epigenetic Regulation by Early-Life Trauma." *Arch Gen Psychiatry* 69 (7): 722–31.

Launay, J.M., M. Del Pino, G. Chironi, J. Callebert, K. Peoc'h, J.L. Megnien, J. Mallet, A. Simon, and F. Rendu. 2009. "Smoking Induces Long-Lasting Effects through a Monoamine-Oxidase Epigenetic Regulation." *PLoS One* 4 (11): e7959.

Levine, A., Y. Huang, B. Drisaldi, E.A. Griffin, Jr., D.D. Pollak, S. Xu, D. Yin, C. Schaffran, D.B. Kandel, and E.R. Kandel. 2011. "Molecular Mechanism for a Gateway Drug: Epigenetic Changes Initiated by Nicotine Prime Gene Expression by Cocaine." *Sci Transl Med* 3 (107): 107ra109: 1–10.

Li, L., L. Wang, X. Xu, H. Lou, F. Le, J. Sheng, H. Huang, and F. Jin. 2011. "Genome-Wide DNA Methylation Patterns in IVF-Conceived Mice and Their Progeny: A Putative Model for ART-Conceived Humans." *Reprod Toxicol* 32 (1): 98–105.

Liu, Y., S.K. Murphy, A.P. Murtha, B.F. Fuemmeler, J. Schildkraut, Z. Huang, F. Overcash, J. Kurtzberg, R. Jirtle, E.S. Iversen, M.R. Forman, and C. Hoyo. 2012. "Depression in pregnancy, infant birth weight and DNA methylation of imprint regulatory elements." *Epigenetics* 7 (7): 735–46.

Lumey, L.H., and A.D. Stein. 2009. "Transgenerational Effects of Prenatal Exposure to the Dutch Famine." *BJOG* 116 (6): 868; author reply 868.

Lumey, L.H., A.D. Stein, H.S. Kahn, and J.A. Romijn. 2009. "Lipid Profiles in Middle-Aged Men and Women After Famine Exposure During Gestation: The Dutch Hunger Winter Families Study." *Am J Clin Nutr* 89 (6): 1737–43.

Lumey, L.H., A.D. Stein, H.S. Kahn, K.M. van der Pal-de Bruin, G.J. Blauw, P.A. Zybert, and E.S. Susser. 2007. "Cohort Profile: The Dutch Hunger Winter Families Study." *Int J Epidemiol* 36 (6): 1196–204.

Mansfield, Becky. 2012. "Race and the New Epigenetic Biopolitics of Environmental Health." *Biosocieties* 7 (4): 353–72.

McGowan, P.O., A. Sasaki, A.C. D'Alessio, S. Dymov, B. Labonte, M. Szyf, G. Turecki, and M.J. Meaney. 2009. "Epigenetic Regulation of the Glucocorticoid Receptor in Human Brain Associates with Childhood Abuse." *Nat Neurosci* 12 (3): 342–8.

Meunier, L., B. Siddeek, A. Vega, N. Lakhdari, L. Inoubli, R.P. Bellon, G. Lemaire, C. Mauduit, and M. Benahmed. 2012. "Perinatal Programming of Adult Rat Germ Cell Death after Exposure to Xenoestrogens: Role of Microrna Mir-29 Family in the Down-Regulation of DNA Methyltransferases and Mcl-1." *Endocrinology* 153 (4): 1936–47.

Michaud, E.J., M.J. van Vugt, S.J. Bultman, H.O. Sweet, M.T. Davisson, and R.P. Woychik. 1994. "Differential Expression of a New Dominant Agouti Allele (Aiapy) is Correlated with Methylation State and is Influenced by Parental Lineage." *Genes Dev* 8 (12): 1463–72.

Moore, T., and D. Haig. 1991. "Genomic Imprinting in Mammalian Development: A Parental Tug-of-War." *Trends Genet* 7 (2): 45–9.

Morgan, H.D., H.G. Sutherland, D.I. Martin, and E. Whitelaw. 1999. "Epigenetic Inheritance at the Agouti Locus in the Mouse." *Nat Genet* 23 (3): 314–8.

Murphy, S.K., A. Adigun, Z. Huang, F. Overcash, F. Wang, R.L. Jirtle, J.M. Schildkraut, A.P. Murtha, E.S. Iversen, and C. Hoyo. 2012. "Gender-Specific Methylation Differences in Relation to Prenatal Exposure to Cigarette Smoke." *Gene.* 494(1): 36–43.

National Inquiry into the Separation of Aboriginal and Torres Strait Islander Children from Their Families (Australia), Ronald Wilson, and Australia, Human Rights and Equal Opportunity Commission. 1997. *Bringing Them Home: A Guide to the Findings and Recommendations of the National Inquiry into the Separation of Aboriginal and Torres Strait Islander Children from Their Families.* Sydney: Human Rights and Equal Opportunity Commission.

Ng, S.F., R.C. Lin, D.R. Laybutt, R. Barres, J.A. Owens, and M.J. Morris. 2010. "Chronic High-Fat Diet in Fathers Programs Beta-Cell Dysfunction in Female Rat Offspring." *Nature* 467 (7318): 963–6.

Nieratschker, V., M. Grosshans, J. Frank, J. Strohmaier, C. von der Goltz, O. El-Maarri, S.H. Witt, S. Cichon, M.M. Nothen, F. Kiefer, and M. Rietschel. 2012. "Epigenetic Alteration of the Dopamine Transporter Gene in Alcohol-Dependent Patients is Associated with Age." *Addict Biol.* 19(2): 305–11.

Painter, R.C., T.J. Roseboom, and O.P. Bleker. 2005. "Prenatal Exposure to the Dutch Famine and Disease in Later Life: An Overview." *Reprod Toxicol* 20 (3): 345–52.

Pembrey, M.E. 2010. "Male-Line Transgenerational Responses in Humans." *Hum Fertil (Camb)* 13 (4): 268–71.

Pembrey, M.E., L.O. Bygren, G. Kaati, S. Edvinsson, K. Northstone, M. Sjostrom, and J. Golding. 2006. "Sex-Specific, Male-Line Transgenerational Responses in Humans." *Eur J Hum Genet* 14 (2): 159–66.

Perkins, E., S.K. Murphy, A.P. Murtha, J. Schildkraut, R.L. Jirtle, W. Demark-Wahnefried, M.R. Forman, J. Kurtzberg, F. Overcash, Z. Huang, and C. Hoyo. 2012. "Insulin-Like Growth Factor 2/H19 Methylation at Birth and Risk of Overweight and Obesity in Children." *J Pediatr* 161 (1): 31–9.

Ponomarev, I., S. Wang, L. Zhang, R.A. Harris, and R.D. Mayfield. 2012. "Gene Coexpression Networks in Human Brain Identify Epigenetic Modifications in Alcohol Dependence." *J Neurosci* 32 (5): 1884–97.

Provencal, N., M.J. Suderman, D. Caramaschi, D. Wang, M. Hallett, F. Vitaro, R.E. Tremblay, and M. Szyf. 2013. "Differential DNA Methylation Regions in Cytokine and Transcription Factor Genomic Loci Associate with Childhood Physical Aggression." *PLoS One* 8 (8): e71691.

Ravelli, A.C., O.P. Bleker, T.J. Roseboom, G.A. van Montfrans, C. Osmond, and D.J. Barker. 2005. "Cardiovascular Disease in Survivors of the Dutch Famine." *Nestle Nutr Workshop Ser Pediatr Program* 55: 183–91; discussion 191–5.

Ravelli, A.C., J.H. van Der Meulen, C. Osmond, D.J. Barker, and O.P. Bleker. 1999. "Obesity at the Age of 50 y in Men and Women Exposed to Famine Prenatally." *Am J Clin Nutr* 70 (5): 811–6.

Renthal, W., T.L. Carle, I. Maze, H.E. Covington, 3rd, H.T. Truong, I. Alibhai, A. Kumar, R.L. Montgomery, E.N. Olson, and E.J. Nestler. 2008. "Delta Fosb Mediates Epigenetic Desensitization of the C-Fos Gene after Chronic Amphetamine Exposure." *J Neurosci* 28 (29): 7344–9.

Rodgers, A.B., C.P. Morgan, S.L. Bronson, S. Revello, and T.L. Bale. 2013. "Paternal Stress Exposure Alters Sperm Microrna Content and Reprograms Offspring HPA Stress Axis Regulation." *J Neurosci* 33 (21): 9003–12.

Roth, T.L., F.D. Lubin, A.J. Funk, and J.D. Sweatt. 2009. "Lasting Epigenetic Influence of Early-Life Adversity on the BDNF Gene." *Biol Psychiatry* 65 (9): 760–9.

Rothstein, M.A., Y. Cai, and G.E. Marchant. 2009a. "Ethical Implications of Epigenetics Research." *Nat Rev Genet* 10 (4): 224.

———. 2009b. "The Ghost in Our Genes: Legal and Ethical Implications of Epigenetics." *Health Matrix Clevel* 19 (1): 1–62.

Sapolsky, R.M. 2004. "Mothering Style and Methylation." *Nat Neurosci* 7 (8): 791–2.

Schwarz, J.M., M.R. Hutchinson, and S.D. Bilbo. 2011. "Early-Life Experience Decreases Drug-Induced Reinstatement of Morphine CPP in Adulthood via Microglial-Specific Epigenetic Programming of Anti-Inflammatory IL-10 Expression." *J Neurosci* 31 (49): 17835–47.

Skinner, M.K., and M.D. Anway. 2005. "Seminiferous Cord Formation and Germ-Cell Programming: Epigenetic Transgenerational Actions of Endocrine Disruptors." *Ann N Y Acad Sci* 1061: 18–32.

Skinner, M.K., M. Mohan, M.M. Haque, B. Zhang, and M.I. Savenkova. 2012. "Epigenetic Transgenerational Inheritance of Somatic Transcriptomes and Epigenetic Control Regions." *Genome Biol* 13 (10): R91.

Smith, C.C., and H.S. Taylor. 2007. "Xenoestrogen Exposure Imprints Expression of Genes (Hoxa10) Required for Normal Uterine Development." *FASEB J* 21 (1): 239–46.

Smith, T.F., M.A. Maccani, and V.S. Knopik. 2013. "Maternal Smoking During Pregnancy and Offspring Health Outcomes: The Role of Epigenetic Research in Informing Legal Policy and Practice." *Hastings Law Journal* 64 (6): 1619–1648.

Smolensky, K.R. 2008. "Creating Children with Disabilities: Parental Tort Liability for Preimplantation Genetic Interventions." *Hastings Law Journal* 60 (2): 299–345.

Stein, A.D., H.S. Kahn, A. Rundle, P.A. Zybert, K. van der Pal-de Bruin, and L.H. Lumey. 2007. "Anthropometric Measures in Middle Age after Exposure to Famine During Gestation: Evidence from the Dutch Famine." *Am J Clin Nutr* 85 (3): 869–76.

Stein, A.D., P.A. Zybert, K. van der Pal-de Bruin, and L.H. Lumey. 2006. "Exposure to Famine During Gestation, Size at Birth, and Blood Pressure at Age 59 Y: Evidence from the Dutch Famine." *Eur J Epidemiol* 21 (10): 759–65.

Suva, M.L., N. Riggi, and B.E. Bernstein. 2013. "Epigenetic Reprogramming in Cancer." *Science* 339 (6127): 1567–70.

Testa, G., and J. Harris. 2004. "Genetics. Ethical Aspects of ES Cell-Derived Gametes." *Science* 305 (5691): 1719.

Tobi, E.W., B.T. Heijmans, D. Kremer, H. Putter, H.A. Delemarre-van de Waal, M.J. Finken, J.M. Wit, and P.E. Slagboom. 2011. "DNA Methylation of IGF2, GNASAS, INSIGF and LEP and being Born Small for Gestational Age." *Epigenetics* 6 (2): 171–6.

Van Heyningen, Veronica. 2000. "Gene Games of the Future." *Nature* 408 (6814): 769–771.

Wang, Y., and Y. Shang. 2013. "Epigenetic Control of Epithelial-to-Mesenchymal Transition and Cancer Metastasis." *Exp Cell Res* 319 (2): 160–9.

Waterland, R.A., D.C. Dolinoy, J.R. Lin, C.A. Smith, X. Shi, and K.G. Tahiliani. 2006. "Maternal Methyl Supplements Increase Offspring DNA Methylation at Axin Fused." *Genesis* 44 (9): 401–6.

Waterland, R.A., R. Kellermayer, E. Laritsky, P. Rayco-Solon, R.A. Harris, M. Travisano, W. Zhang, M.S. Torskaya, J. Zhang, L. Shen, M.J. Manary, and A.M. Prentice. 2010. "Season of Conception in Rural Gambia Affects DNA Methylation at Putative Human Metastable Epialleles." *PLoS Genet* 6 (12): e1001252.

Weaver, I.C., N. Cervoni, F.A. Champagne, A.C. D'Alessio, S. Sharma, J.R. Seckl, S. Dymov, M. Szyf, and M.J. Meaney. 2004. "Epigenetic Programming by Maternal Behavior." *Nat Neurosci* 7 (8): 847–54.

Weaver, I.C., F.A. Champagne, S.E. Brown, S. Dymov, S. Sharma, M.J. Meaney, and M. Szyf. 2005. "Reversal of Maternal Programming of Stress Responses in Adult Offspring through Methyl Supplementation: Altering Epigenetic Marking Later in Life." *J Neurosci* 25 (47): 11045–54.

Weiner, Christopher J. 2010. "Transgenerational Tort Liability for Epigenetic Disease." *DePaul J. Health Care L.* 13: 319–338.

Wilkins, J.F., and D. Haig. 2003. "What Good is Genomic Imprinting: The Function of Parent-Specific Gene Expression." *Nat Rev Genet* 4 (5): 359–68.

Wolff, G.L., R.L. Kodell, S.R. Moore, and C.A. Cooney. 1998. "Maternal Epigenetics and Methyl Supplements Affect Agouti Gene Expression in Avy/A Mice." *FASEB J* 12 (11): 949–57.

Zheng, H.Y., X.Y. Shi, L.L. Wang, Y.Q. Wu, S.L. Chen, and L. Zhang. 2011. "Study of DNA Methylation Patterns of Imprinted Genes in Children Born after Assisted Reproductive Technologies Reveals No Imprinting Errors: A Pilot Study." *Exp Ther Med* 2 (4): 751–755.

Zhou, Z., Q. Yuan, D.C. Mash, and D. Goldman. 2011. "Substance-Specific and Shared Transcription and Epigenetic Changes in the Human Hippocampus Chronically Exposed to Cocaine and Alcohol." *Proc Natl Acad Sci USA* 108 (16): 6626–31.

Ziech, D., R. Franco, A. Pappa, V. Malamou-Mitsi, S. Georgakila, A.G. Georgakilas, and M.I. Panayiotidis. 2010. "The Role of Epigenetics in Environmental and Occupational Carcinogenesis." *Chem Biol Interact* 188 (2): 340–9.

CHAPTER 13

The Trace of Time in Judicial Reasoning: A Case of Conflicting Argument in the High Court of Australia (Al-Kateb v. Godwin, 2004)

Rosemary Huisman

Abstract

In 2004, Ahmed Al-Kateb, a stateless person who could not be deported, appealed to the High Court of Australia against "indefinite detention." The appeal was lost in part because the different judgments gave various weight to the temporal aspects of the Migration Act. This paper examines and compares the "trace of time" in that legal reasoning, and the different interpretive strategies employed. Its account of interpretation uses a model of language as social semiotic, as theorised in systemic functional linguistics.

Keywords

High Court of Australia – Migration Act – indefinite detention – judicial reasoning – time – temporality – interpretation and construction of law – systemic functional linguistics

1 "Indefinite Detention"

In 2004, the case of *Al-Kateb v. Godwin* was decided in the High Court of Australia, the highest court of appeal.[1] The *Migration Act* of 1958 (as amended in 1992) decreed that "an unlawful non-citizen" must be kept in immigration detention until s/he could be "removed or deported" from Australia or granted a visa. Al-Kateb had been refused a visa, and so was an "unlawful non-citizen" who had no permission to remain in Australia, but he could not be removed as

[1] *Ahmed Ali Al-Kateb v. Philippa Godwin* (2004) 219 Commonwealth Law Reports 562. I am indebted to Tony Blackshield for suggesting materials which could be relevant to this paper. For *Al-Kateb*, see Blackshield and Williams, *Australian Constitutional Law*, 655–66, 874–78.

he was a stateless person: his parents were Palestinian, so though he was born and had lived in Kuwait, he was not entitled to a Kuwaiti passport. Despite approaches to various middle eastern states, no other country would accept him. Caught in this legal limbo, Al-Kateb was appealing against indefinite detention.

Al-Kateb lost his appeal. The case was heard by the full court of 7 judges and narrowly decided, with 4 judges in the majority and 3 dissenting.[2] This is a close decision; in support of their reasoning, six of the seven judges wrote detailed "reasons for judgment"[3] (hereafter "judgment" for short, referred to in the United States as an "opinion"). The phrase "indefinite detention," central to this appeal, foregrounds the trace of time in justice—to be erased or confronted?[4]—and in what follows I discuss the different judicial responses.

2 The Australian Migration Act

Each judgment is an interpretation of the relevant provisions of the Migration Act, a parliamentary statute, in its application to the agreed facts of the case. For the purposes of these judgments in *Al-Kateb v. Godwin*, the "critical provisions" (Gleeson para [5]) of the Australian *Migration Act* are sections 189, 196 and 198.[5] Sections 189 and 196 deal with "detention of unlawful non-citizens" and section 198 deals with "removal of unlawful non-citizens":

> **Section 189(1)**
> If an officer knows or reasonably suspects that a person in the migration zone (other than an excised offshore place) is an unlawful non-citizen, the officer must detain the person.

2 MAJORITY: Michael McHugh; Kenneth Hayne; Ian Callinan; John Dyson Heydon.
 DISSENTS: Murray Gleeson; William Gummow; Michael Kirby.
3 Conventionally, High Court "reasons for judgment" are printed in continuously numbered paragraphs ("para"). The judgment of Gleeson, as Chief Justice, appears first (paras 1–30), then, in order of appointment, McHugh (31–75), Gummow (76–143), Kirby (144–194), Hayne (195–270), Callinan (271–302), Heydon (303–304).
4 The word "trace," for me, comes trailing its post-structuralist use by Jacques Derrida, along with his phrase "under erasure." It evokes for me the image of the cloud-chamber, in the physics experiment, where the water-vapour path of ionization tells you where the particle has passed, though its actual presence escapes you. See many references to "trace" and "erasure" in the index to Kamuf, *A Derrida Reader*.
5 In written judgments referring to sections of the Act, "section" is usually abbreviated to s (as in "s 198"), but in those quoted in this paper I have expanded the abbreviation.

Section 196
(1) An unlawful non-citizen detained under section 189 must be kept in immigration detention until he or she is:
 (a) removed from Australia under section 198 or 199; or
 (b) deported under section 200; or
 (c) granted a visa.
(2) To avoid doubt, subsection (1) does not prevent the release from immigration detention of a citizen or a lawful non-citizen.
(3) To avoid doubt, subsection (1) prevents the release, even by a court, of an unlawful non-citizen from detention (otherwise than for removal or deportation) unless the non-citizen has been granted a visa.

Section 198
(1) An officer must remove as soon as reasonably practicable an unlawful non-citizen who asks the Minister, in writing, to be so removed […]
(6) An officer must remove as soon as reasonably practicable an unlawful non-citizen if:
 (a) the non-citizen is a detainee; and
 (b) the non-citizen made a valid application for a substantive visa that can be granted when the applicant is in the migration zone; and
 (c) […]
 (i) the grant of the visa has been refused and the application has been finally determined;
 […] and
 (d) the non-citizen has not made another valid application […]

The four judges in the majority, who dismissed the appeal—Justices Hayne, McHugh, Callinan and Heydon—saw no difficulty in applying these provisions. The three judges in dissent did. Patently, there is a difference in interpretation of the relevance of the Act to the facts of the case.

3 The "Trace of Time" in Majority Judgments: Justice Hayne

The four judges in the majority saw no vagueness or ambiguity[6] in the Migration Act in relation to the facts of the case. In accord with section 189 Al-Kateb was

[6] "Vagueness and ambiguity" in legal interpretation are briefly discussed below in section 5, "The Relativity of Doubt in Judicial Interpretation."

in the migration zone and had no visa, so he was lawfully detained. In accord with section 196, Al-Kateb could not yet be removed, so he must remain in detention. And in accord with section 198, Al-Kateb had written to the Minister asking to be removed from Australia "as soon as reasonably practicable." The reason why Al-Kateb had not been removed, to satisfy either section 196 or section 198, was that no state had yet agreed to receive him.

Three of the four majority judges wrote detailed judgments, with different focus. Justice Hayne wrote the leading judgment for the majority, that is the judgment to read first in making sense of the majority arguments. Despite the majority's opinion that the Act can be unambiguously applied, Hayne perhaps felt a potential tension (between a legal and a moral decision?); certainly his reasons for the legal decision are given at great length, the longest of all six. Here I focus on his "construction," his construal of what he considers to be the proper interpretation of the wording of the Migration Act.

Hayne claims the provisions make no reference to their purpose.[7] For comparison, he quotes (para [224]) what had been said by another judge (Justice Dixon) in a similar case:[8]

> [The provisions] mean that a deportee may be held in custody *for the purpose* of fulfilling the obligation to deport him until he is placed on board the vessel [and that] unless within a reasonable time [the person to be deported] is placed on board a vessel he would be entitled to his discharge on habeas. [Emphasis added]

However, Hayne contrasts Dixon's use of "within a reasonable time" with the use in the Migration Act, section 198, of "as soon as reasonably practicable." The force of reasonableness is now shifted from an adjective modifying the noun "time" to an adverb modifying the adjective "practicable." In Hayne's construction of the Act, it is now *practice* which has to be *reasonable*, rather than *time*. The temporal meaning has moved from realization in the noun "time" to the conjunction "as soon as";[9] the latter means "a point in time," like "when." The Act's "as soon as [it is] reasonably practicable" could be paraphrased colloquially as, "when you're reasonably able to do it"; contextually, this is a vaguely realized point in time.

7 See Appendix 2 on "purpose" and statutory interpretation.
8 *Koon Wing Lau v. Calwell* (1949) 80 Commonwealth Law Reports 533, at 581.
9 Halliday and Matthiessen, *Introduction*, 3rd ed. (2004), 411, 4th ed. (2014), 477, identify the expression "as soon as" as a principal marker for hypotactic enhancement at a particular point in time, comparable to "when."

It becomes clear that the delimiting role of time is "under erasure," not fully present in Hayne's construction, in that it is too vague to identify when detention can end (para [226]). He writes, "That compound temporal expression [as soon as] recognises that the time by which the event is to occur is affected by considerations of what is '[c]apable of being put into practice, carried out in action, effected, accomplished, or done.'" (Hayne takes this paraphrase from the *Oxford English Dictionary*.)[10] He continues, "[i]n particular, the expression recognises that the co-operation of persons, other than the non-citizen and the officer, will often (indeed usually) be necessary before the removal can occur. The duty to remove must be performed within *that* time." So Hayne concludes, "[a]nd so long as the time for performance of that duty has not expired, section 196 in terms provides that the non-citizen must be detained."

Rather than a singular limiting concept of "time," Hayne's account invokes a multiplicity of temporalities. First there is a period of indeterminate time, an unpredictable period (rather comparable to J.T. Fraser's "prototemporality" in his evolutionary model of time)[11]—when removal is not possible, though constantly anticipated; then, when removal is possible, the chronological time of human bodily experience (Fraser's biotemporality) is reactivated and re-enters the situation.

Hayne reiterates his construction (para [227]), linking it to what he regards as the purpose of this Act. "*Removal* is the purpose of the provisions, not repatriation or removal *to* a place [...] [T]he duty imposed by section 198 requires an officer to seek to remove the non-citizen to any place that will receive the non-citizen. And the time for performance of the duty does not pass until it is reasonably practicable to remove the non-citizen in question." We can see that, in Hayne's reasoning, there are two points of time: now and the time of removal. The time between these two times is effectively timeless, or at least unmeasurable:

> (para [230]) The most that can be decided with any degree of certainty is whether removal can be effected *now* or can be effected in the future pursuant to arrangements that *now* exist [...]
>
> (para [231]) [U]nless it has been practicable to remove the non-citizen it cannot be said that the time for performance of the duty imposed by section 198 has arrived. All this being so, it cannot be said that the purpose of detention (the purpose of removal) is shown to be spent by showing that efforts made to achieve removal have not so far been successful.

10 *Oxford English Dictionary*, 2nd ed. (1989), vol. 12, p. 269, under "practicable."
11 Fraser, *Time and Time Again*, 46–47.

Hayne's argument is based on a construction of formal meaning, that is, it is one of construing meanings as the meaning of wording, of dictionary vocabulary and grammatical syntax. In linguistic terms, it shows a formalist focus on semantics and lexicogrammar (see Appendix 1).

Another example confirms the consistency of Hayne's approach. In paragraph [230], Hayne had commented, "[o]f course, it must be accepted in the present appeal that, as the primary judge [that is, the judge in a lower court] found, 'there is no real likelihood or prospect of [the appellant's] removal in the reasonably foreseeable future', but that does not mean it will *never* occur." In using the phrase, "the reasonably foreseeable future," the primary judge had echoed a judgment in a previous case similar to *Al-Kateb*, that of Mohammad Al Masri.[12] However, in *Al Masri* the phrase was used as an argument *against* indefinite detention (as Hayne quotes at para [234]). So, just as he had objected to Dixon's phrase "within a reasonable time," Hayne also objects to the phrase "in the reasonably foreseeable future" (para [237]):

> [T]he limitation on the operation of sections 189 and 196 identified in *Al Masri* is a limitation which depends upon taking the temporal element of the legislative command in section 198 (to remove as soon as reasonably practicable) and converting that into a different temporal limitation on the operation of section 196 and, by inference, on the operation of section 189. The limitation imposed is not simply *transferred* from one section to the others (a process which can readily be justified by the need to read the provisions together). It is *transformed* from "as soon as reasonably practicable" to "soon" or "for so long as it appears likely to be possible of proximate performance".

Again, Hayne's argument is focused on the levels of semantics and lexicogrammar, on construing meaning from wording. Among the dissenting judges, it is Justice Gummow, in particular, who contests these formal constructions of Justice Hayne.

4 The "Trace of Time" in Minority Judgments

4.1 *Justice Gummow*

The three dissenting judgments are by Chief Justice Gleeson and Justices Gummow and Kirby; though their conclusions converge, their reasons for

12 *Minister for Immigration and Multicultural and Indigenous Affairs v. Al Masri* (2002) 192 Australian Law Reports 609, (2003) 197 Australian Law Reports 241.

judgment differ in significant ways. Gummow writes the leading judgment in dissent (the judgment to read first for a factual summary of the case).

First, compare Gummow's comments on "purpose" with those of Hayne. For Gummow, time is not effaced; time is present in the purpose (para [117]): "In considering these provisions, it is important to eschew, if a construction doing so is reasonably open, a reading of the legislation which recognises a power to keep a detainee in custody for an unlimited time [...]"[13] Rather, temporal limits are linked to the purposive nature of the detention requirement in the legislation."

Gummow then offers a detailed reading of time in the relevant provisions of the Act, linking "reasonably" to the temporal trace in the purpose of the Act (para [121]):

> There are several temporal elements in the provisions under consideration. There is the requirement in section 196(1) to keep the appellant in detention "*until* he or she is ... *removed* from Australia *under* section 198" (emphasis added). There is also an element of process or outcome which is attainable or achieved *under* section 198. What then is the significance for a removal under section 198 of a failure to do so "*as soon as* reasonably practicable"? (Emphasis added) Here, too, there is a temporal element, supplied by the phrase "as soon as". The term "practicable" identifies that which is able to be put into practice and which can be effected or accomplished. The qualification "reasonably" introduces an assessment or judgment of a period which is appropriate or suitable to the purpose of the legislative scheme. The term "purpose" identifies "the object for the advancement or attainment of which [the] law was enacted". This involves the detention of the appellant to facilitate his availability to removal from Australia but not with such delay that his detention has the appearance of being for an unlimited time.

Whereas Hayne pointed to two discrete points of legal time, the present now and the time of removal, Gummow projects an experienced (biotemporal) time continuing into the future. So he can argue that, the fully present temporal elements being an integral part of the purpose of the legislation, the

13 Gummow comments, "[t]hat reluctance is evident in the construction given the legislation in *Calwell*." (*Koon Wing Lau v. Calwell*, cited earlier, in the construction "within a reasonable time.")

continued operation of the legislation is undermined if the temporal elements are not fulfilled. In Gummow's words (para [122]):

> If the stage has been reached that the appellant cannot be removed from Australia and as a matter of reasonable practicability is unlikely to be removed, there is a significant constraint for the continued operation of section 198. In such a case section 198 no longer retains a present purpose of facilitating removal from Australia which is reasonably in prospect and to that extent the operation of section 198 is spent.

Gummow can now conclude:

> If that be the situation respecting section 198, then the temporal imperative imposed by the word "until" in section 196(1) loses a necessary assumption for its continued operation. That assumption is that section 198 still operates to provide for removal *under* that section.

For Gummow, it is the continued presence of time in the purpose of the legislation that must be attended to. This leads him to a conclusion diametrically opposed to that of Hayne. For Hayne, it was irrelevant that an earlier court had found that "there was no real likelihood or prospect of removal of the appellant in the reasonably foreseeable future" (para [230]). In contrast, given his recognition of time in the legislative purpose, Gummow argues the necessary relevance of that finding and that, therefore, the earlier court "should have gone on to hold that, on their proper construction, sections 198 and 196 no longer mandated the continuing detention of the appellant" (para [123]).

Hayne appears to have focused principally on a static construction of the words of the Act, while Gummow took a more dynamic perspective, taking account of the wider potential context of interpretation. In this context, Gummow recognizes the differing viewpoints of those involved in the case. As he points out, with some rhetorical flourish (para [125]):

> The point of present importance for the appellant is that the continued detention of this stateless person is not mandated by the hope of the Minister, triumphing over present experience, that at some future time some other State may be prepared to receive the appellant.

Yet, despite the different interpretive strategies of Hayne and Gummow in their construction of the Act, they have in common their attempts to construct

a meaning from its wording which supports their different "reasons for judgment." In contrast, Chief Justice Gleeson pursues a different path.

4.2 Chief Justice Gleeson

Gleeson's reasons focus on the intrinsic problem of this case: that the facts of the case include a particular context of situation not considered in the potential contexts of the original drafting. In effect, this case presented the judiciary with a problem of legislative origin. In passing the Act, the legislature had not envisaged a context of situation in which its force applied to a stateless person. In the course of debating earlier amendments to the Migration Act, in 1992, the then Minister for Immigration, Gerard Hand, had made the following comment: "The Government has no wish to keep people in custody indefinitely and I could not expect the Parliament to support such a suggestion."[14] However, in *Al-Kateb*, some twelve years later, the Migration Act as it stands has been constructed by the majority to allow just such "indefinite detention." Unlike Gummow, Gleeson will not dispute this construction of meaning from the wording of the text. Rather he expands the legal context in which the case can be judged beyond the wording of the Act itself.

It is in the very clarity of the provisions (his construction of the meaning of its wording) that Gleeson identifies its inadequacy, that is, its "legislative silence" relevant to the temporal circumstances of this case (para [18]). His reasons are worth quoting at length:

> [I]n the case of the appellant, a time may come where his removal, by reason of a change in international circumstances, is reasonably practicable. It cannot be said that it will never be reasonably practicable to remove him. The primary purpose of his detention is in suspense, but it has not been made permanently unattainable. The Act makes no express provision for suspension, and possible revival, of the obligation imposed by section 196, according to the practicability of effecting removal under section 198. Similarly, it makes no express provision for indefinite, or permanent, detention in a case where the assumption underlying section 198 (the reasonable practicability of removal) is false. In resolving

14 Commonwealth of Australia, *Hansard*, House of Representatives, 5 May 1992, p. 2372. Hand was speaking here on the second reading of the Migration Amendment Bill 1992. Six months later, on 4 November 1992, he introduced the Migration Reform Bill 1992, which inserted into the Migration Act the provision at issue in *Al-Kateb*—initially section 54ZD, later renumbered as section 196.

questions raised by the legislative silence, resort can, and should, be had to a fundamental principle of interpretation.

For Gleeson, this principle arises from the inter-relationship of powers conferred by the Australian Constitution: on the legislature, that is the Australian Parliament; on the executive government, here represented by the Minister for Immigration; and on the judiciary, here the High Court. Gleeson continues (para [19]):

> Where what is involved is the interpretation of legislation said to confer upon the Executive a power of administrative detention that is indefinite in duration, and that may be permanent, there comes into play a principle of legality, which governs both Parliament and the courts. In exercising their judicial function, courts seek to give effect to the will of Parliament by declaring the meaning of what Parliament has enacted. Courts do not impute to the legislature an intention to abrogate or curtail certain human rights or freedoms (of which personal liberty is the most basic) unless such an intention is clearly manifested by unambiguous language, which indicates that the legislature has directed its attention to the rights or freedoms in question, and has consciously decided upon abrogation or curtailment.

Australia does not have a Bill of Rights. A standard Australian textbook on "statutory interpretation" notes that the courts "approach the interpretation of legislation with a number of basic assumptions or presumptions in mind," and suggests that "the various assumptions can be viewed as the courts' efforts to provide, in effect, a common law Bill of Rights—a protection for the civil liberties of the individual against invasion by the state [...] In more recent times," the authors write (citing *Al-Kateb* as the first reference), "the courts have taken to designating this approach as the 'principle of legality'."[15] But Gleeson is at pains to describe the principle of legality as long established within the potential legal context of statutory interpretation (para [19] continues):

> That principle has been re-affirmed by this Court in recent cases. It is not new. In 1908, in this Court, O'Connor J referred to a passage from the fourth edition of *Maxwell on Statutes*[16] which stated that "[i]t is in the last degree improbable that the legislature would overthrow fundamental

15 Pearce and Geddes, *Statutory Interpretation*, 168.
16 4th ed. (1905), 121–2.

principles, infringe rights, or depart from the general system of law, without expressing its intention with irresistible clearness".

In fact it has been pointed out by Robert French (Gleeson's successor as Chief Justice)[17] that the passage in *Maxwell on Statutes* was in turn derived from an opinion written by the United States Chief Justice John Marshall in 1805![18]

4.3 Justice Kirby

The third judge in dissent, Justice Kirby, dealt with the interpretive problem of the case by expanding the relevant context of interpretation: Kirby reaches outside the Australian legal system altogether, making use of the wider cultural context of international and comparative law.

Among Kirby's international comparisons was the United States Supreme Court decision in *Zadvydas v. Davis*;[19] in that case the relevant statutory provision first provided that an alien whose removal had been ordered could initially be detained for a maximum period of ninety days, but then went on to authorize further detention if the Government failed to remove the alien during those 90 days. The crucial words were "may be detained beyond the removal period." The Opinion of the Court (delivered by Justice Breyer), in summary, was that a statute permitting indefinite detention of an alien would raise a serious constitutional problem (690), that in such a situation the Court would "first ascertain whether a construction of the statute is fairly possible by which the question may be avoided" (689) (that is to say, the Court will try to find another meaning for the wording), and that the Court would therefore "read an implicit limitation into the statute before us. In our view, the statute, read in light of the Constitution's demands, limits an alien's post-removal-period detention to a period reasonably necessary to bring about that alien's removal from the United States. It does not permit indefinite detention." (689) Citing more than one previous case, Justice Breyer continues: "Despite this constitutional problem, if 'Congress has made its intent' in the statute 'clear, "we must give effect to that intent".'" (696)

17 French, "What Were They Thinking?" 20.
18 *United States v. Fisher*, 6 United States Reports (2 Cranch) 358, at 390 (1805).
19 (2001) 533 United States Reports 678. For a United Kingdom comparison by Kirby, see the Privy Council decision in *Tan Te Lam v. Superintendent of Tai A Chau Detention Centre* [1997] Appeal Cases 97 (on appeal from Hong Kong).

This (matryoshka-like) opinion is comparable to that of Gleeson in *Al-Kateb*. Gleeson had found the particular statute lacked clarity of intent, but here the Supreme Court turned to extrinsic materials to find a wider legal context of such silence. This is a temporal context of legal history—in terms of Fraser's model of time, the sociotemporal context[20] of the American legal system:

> We have found nothing in the history of these statutes that clearly demonstrates a congressional intent to authorize indefinite, perhaps permanent, detention. Consequently, interpreting the statute to avoid a serious constitutional threat, we conclude that, once removal is no longer reasonably foreseeable, continued detention is no longer authorized by statute. (699)

I have omitted from this paper the considerable discussion of Australian constitutional powers in all six judgments in *Al-Kateb*, but here is Justice Gummow (para [137]) citing Justice Antonin Scalia in the United States Supreme Court: "The very core of liberty secured by our Anglo-Saxon system of separated powers has been freedom from indefinite imprisonment at the will of the Executive."[21]

5 The Relativity of Doubt in Judicial Interpretation

In their study of legal reasoning, in the (whimsically titled) section: "The unhappy interpreter and the relativity of doubt," Twining and Miers describe different types of interpreters.[22] An interpreter may respond to his/her interpretation as happy or unhappy, and—if unhappy—may let the matter rest, or may not. Their comments cast some light on the different responses of the justices in *Al-Kateb*: Justices Hayne and Gummow placed particular emphasis on the temporal purpose of the Migration Act yet reached different constructions of its meaning, Chief Justice Gleeson asserted the need for the "meaning of the text" to be construed from an expanded legal context. Justice Kirby, in turn, widened the potential for Australian legal interpretation to include an international context.

20 Fraser, *Time and Time Again*, 158.
21 *Hamdi v. Rumsfeld*, 542 United States Reports 507, at 554–55 (2004).
22 Twining and Miers, *How To Do Things With Rules*, 1st ed. (1976), 96–8. Compare the revised treatment in their 3rd ed. (1991), 190–92.

It is important to emphasize, write Twining and Miers, that "doubt is a relative matter. It is not uncommon in both legal and non-legal contexts for some participants to express doubts about the interpretation or application of a rule, while others maintain that it is clear."[23] The nature of human communication—that language is not a simple communication of ideas from one mind to another[24]—and the complexity of construal[25] make different interpretations unsurprising.

For Twining and Miers's unhappy interpreter however, "although the scope of the rule may be clear, at least on the surface, it is an obstacle to his securing the result he desires."[26] Two responses are possible. The first response, in a nineteenth-century case, is nicely formalistic:

> If the precise words used are plain and unambiguous, in our judgment we are bound to construe them in their ordinary sense, even though it do lead, in our view of the case, to an absurdity or manifest injustice [...] [W]e assume the functions of legislators when we depart from the ordinary meaning of the precise words used, merely because we see, or fancy we see, an absurdity or manifest injustice from an adherence to their literal meaning.[27]

In *Al-Kateb*, Justice Hayne writes a similar comment (it would be impertinent of me to assume he is "happy" or "unhappy"). Initially he acknowledges the possible relevance of a wider legal context (para [241]):

> There is a relevant general principle to which effect must be given in construing the provisions now in question: legislation is not to be construed as interfering with fundamental rights and freedoms unless the intention to do so is unmistakably clear. General words will not suffice.

23 Twining and Miers, 1st ed. (1976), 97.
24 As memorably illustrated by Michael Reddy's use of "the toolmakers paradigm": Reddy, "The Conduit Metaphor," 292–97.
25 See Appendix 1: in SFL terms, from the same wording, interpreters have construed a different meaning and context of situation, with a different understanding of its instantiation of the potential legal and social context.
26 Twining and Miers, 1st ed. (1976), 97.
27 Chief Justice Jervis in *Abley v. Dale* (1851) 11 Common Bench Reports 378 at 391, 138 English Reports 519 at 525—quoted in part by Twining and Miers, 1st ed. (1976), 70, 3rd ed. (1991), 167.

However, after "reading the three sections together" Hayne concludes "what is clear" is that "the time limit imposed by the Act cannot be transformed by resort to the general principle identified. The words are, as I have said, intractable."[28]

In contrast, Chief Justice Gleeson also invokes "a relevant general principle" from the legal context, but comes to the opposite conclusion, admitting the principle into his legal reasoning. Gleeson's judgment could be included as an example of one type of the "second response," now discussed.

As Twining and Miers emphasized, "doubt is a relative matter." So the second response of the unhappy interpreter may be to encourage doubt: "the unhappy interpreter may be able to pave the way for a less obvious interpretation, by creating or establishing a doubt that then needs to be resolved." (97) The unhappy interpreter can do this in one of two ways. S/he can, like Gleeson, and also Kirby, not dispute the construal of meaning and context of situation from the wording of the text, but insist that the legal context of interpretation must be wider than that of the Act. Or s/he can dispute the construal of meaning and context of situation from the wording of the Act; in the case of *Al-Kateb*, that will be disputing the interpretation of temporal limits. This is the response of Justice Gummow.

These observations support the need for a functional model of language, as outlined in Appendix 1, to study "vagueness" in legal interpretation. Such a model can accommodate the "relativity of doubt" described by Twining and Miers, relating not only to differences of interpretation by different readers but also to the deliberate fostering of doubt by "unhappy interpreters". Those who assume a formalist theory of language[29]—one in which the upper level of linguistics is semantics, consigning study of social context to another discipline, pragmatics—can see "semantic conventions" and "pragmatic social purpose" as oppositional.[30] Theoretical approaches that maintain this distinction cannot explain, as a functional model can, how the "unhappy interpreter," through recontextualizing the text, can *introduce* doubt into the meaning (the semantics) of the text. In short, vagueness—even in an Act using the quintessentially vague word "indefinite"—is not an intrinsic attribute of the wording of the text.

28 One is reminded of the 2003 article by the British Lord Steyn, "The Intractable Problem of the Interpretation of Legal Texts."

29 See Halliday, "Language as Code and Language as Behaviour," 4–11; Halliday, "A Recent View of 'Missteps,'" 235–36.

30 For example, see Poscher, "Ambiguity and Vagueness," 135.

6 And Then... An Inconclusive Conclusion

Al-Kateb's personal story had a happy ending. Soon after the High Court dismissed his appeal, the new Immigration Minister Amanda Vanstone granted Al-Kateb a bridging visa so that he could be released from detention. On 11 October 2007 he was granted permanent residence; on 7 February 2009 he became an Australian citizen. The legal story, however, at the time of writing, continues.

In 2012,[31] it was argued that the *Al-Kateb* decision should be overruled. For four judges it was "neither necessary nor appropriate" to deal with the *Al-Kateb* issue, as they disposed of the case on a different ground. Three judges did find it "necessary" and "appropriate" to deal with the issue, but of those, two (Gummow and Bell) thought that *Al-Kateb* should be overruled and one (Heydon) thought it should not be. Both Gummow and Bell made the point, in Gummow's words (para [119]), that "two members of the majority in *Al-Kateb*, McHugh J and Callinan J, did not refer to what was then and has remained the doctrine of the Court which provides strongest guidance in resolving [such an] issue of construction"—namely, the "principle of legality" relied on by Chief Justice Gleeson. Their silence on this fundamental presumption weakened the authority of *Al-Kateb* as a precedent because, to that extent, the decision "appears to have erred in a significant respect in the applicable principles of statutory construction" (para [120]).

More recently, the High Court majority again refrained from reconsidering the issue. However, in giving reasons for judgment, Justices Kiefel and Keane joined Justice Hayne in affirming that *Al-Kateb* "should now be regarded as having decisively quelled the controversy [...] which arose in that case," and accordingly "should not be re-opened."[32]

∴

Appendix 1: Language, Text, and Context

Of the five dimensions of language described in systemic functional linguistics (SFL), two are particularly relevant here: stratification and instantiation.[33] "Stratification" refers to the modelling of levels of language: the extra-linguistic

31 *Plaintiff M47/2012 v. Director General of Security* (2012) 251 Commonwealth Law Reports 1.
32 *Plaintiff M76/2013 v. Minister for Immigration, Multicultural Affairs and Citizenship* (2013) 251 Commonwealth Law Reports 322, at 383, para [199].
33 Halliday and Matthiessen, *Introduction*. 3rd ed. (2004), 24–29; 4th ed. (2014), 24–30.

level of context; the semantic level of meaning (the "discourse semantics" of text); the formal level of the lexicogrammar (vocabulary and the grammar of the sentence); the expression level of phonology (for speech) and graphology (for written language, as in the expression of statutes). Each level realizes that above it, and is realized by that below it. In M.A.K. Halliday's words (emphasis in original):

> Realization is [...] the relationship of "meaning-&-meant" which, in semiotic systems, replaces the "cause-&-effect" relation of classical physical systems. Unlike cause, realization is not a relationship in real time. It is a two-way relationship that we can only gloss by using more than one word to describe it: to say that wordings (lexicogrammatical formations) *realize* meanings (semantic formations) means both that wordings *express* meanings and that wordings *construct* meanings.[34]

"Instantiation" refers to a cline of language, from maximum potential to specific instance, with intermediate positions. It operates at all levels of stratification, as shown in Table 1, with examples relevant to the case discussed in this chapter.

TABLE 1 *Levels of stratification (vertical axis) and instantiation (horizontal axis)*

Potential	Intermediate Potential		Instance
context of culture	context of Australian legal culture	situation type: High Court case; sub-situation type: genre of judgment	context of situation:[35] Al-Kateb v. Godwin sub-situation: specific judgment
semantic system	legal discourse	judgment register	meaningful text
lexicogrammatical system	legal wording	judgment wording	wording of specific text
graphic system of expression	legal graphology	judgment graphology	graphology of specific text

34 Halliday, "Systemic Grammar and 'Science of Language,'" 210. In general, Halliday prefers *construe* to *construct*: "*construed*—that is, constructed in the semiotic sense."

35 "Context of situation" is constituted by three parameters: field of social action, including subject-matter; tenor of discourse, the relations and attitudes of those in the situation;

Different theories (explicit or implicit) of statutory interpretation can be plotted on the grid of the two SFL dimensions. For more formalist theories, the upper level of stratification is that of semantics, construed from the wording of the text. To a greater or lesser degree, such theories may permit movement on the cline of instantiation in their interpretation of a legal text, that is, they may allow the inclusion of a more general potential of legal meanings at the semantic level. However, they do not include movement into the level of context. For those theories that do allow the upper SFL level of context, the meaning of the text can only be fully construed in an understanding of its context of situation. Legal interpretation is often referred to as "construction." The more the potential legal and wider social context is admitted to the construction, the wider the range of extrinsic materials[36] that may be included in interpretation.

Appendix 2: The Australian Acts Interpretation Act

In 1981 a new section 15AA was added to the *Acts Interpretation Act* 1901 (Cth) by the *Statute Law Revision Act* 1981. Originally the new section provided the following:

> In the interpretation of a provision of an Act, a construction that would promote the purpose or object underlying the Act (whether that purpose or object is expressly stated in the Act or not) shall be preferred to a construction that would not promote that purpose or object.

As further amended in 2011, it now provides:

> In interpreting a provision of an Act, the interpretation that would best achieve the purpose or object of the Act (whether or not that purpose or object is expressly stated in the Act) is to be preferred to each other interpretation.

mode, the organization of the message as coherent with its environment. See Halliday, "Text as Semantic Choice," 54–58. For detailed use of the SFL model in the study of *Al-Kateb*, focused particularly on tenor, see Huisman and Blackshield, "Tenor in Judicial Reasoning."

36 See Smyth, "Extrinsic Materials." See also the contrast in Pearce and Geddes, *Statutory Interpretation*, between "3: Extrinsic Aids to Interpretation," and "4: Intrinsic or Grammatical Aids to Interpretation."

The original 1981 version had included an additional subsection, warning that the new "regard to purpose or object" did not authorize any additional recourse to extrinsic materials. But a further amendment in 1984 repealed that restriction, and instead inserted a new section 15AB, making elaborately regulated provision for resort to extrinsic materials "if any material not forming part of the Act is capable of assisting in the ascertainment of the meaning of the provision." These materials might include, for example, committee reports, speeches in Parliament, and Explanatory Memoranda. In particular, resort to such materials is permitted (section 15AB (1)(b)(ii)) if "the ordinary meaning conveyed by the text of the provision taking into account its context in the Act and the purpose or object underlying the Act leads to a result that is manifestly absurd or is unreasonable."

Suzanne Corcoran ("Theories of Statutory Interpretation," 25) has summarized these provisions, along with similar legislative provisions in all Australian States, as establishing in Australia "what might be called an 'official' approach to statutory interpretation that is stipulated by legislation," inasmuch as they "provide for a purposive approach to the interpretation of statutes."

In *Al-Kateb*, Justices Hayne and Gummow place particular emphasis on the purpose of the Migration Act in their differing constructions of its meaning. The word "underlying", in the original version of section 15AA, rather begged the question: it is an interpretation to be understood from an interpretation. It was deleted from section 15AA but has reappeared in section 15AB!

Cases Cited

Abley v. Dale (1851) 11 Common Bench Reports 378, 138 English Reports 519.
Al-Kateb v. Godwin (2004) 219 Commonwealth Law Reports 562.
Hamdi v. Rumsfeld, 542 United States Reports 507 (2004).
Koon Wing Lau v. Calwell (1949) 80 Commonwealth Law Reports 533.
Minister for Immigration and Multicultural and Indigenous Affairs v. Al Masri (2002) 192 Australian Law Reports 609, (2003) 197 Australian Law Reports 241.
Plaintiff M47/2012 v. Director General of Security (2012) 251 Commonwealth Law Reports 1.
Plaintiff M76/2013 v. Minister for Immigration, Multicultural Affairs and Citizenship (2013) 251 Commonwealth Law Reports 322.
Tan Te Lam v. Superintendent of Tai A Chau Detention Centre [1997] Appeal Cases 97.
United States v. Fisher, 6 United States Reports (2 Cranch) 358 (1805).
Zadvydas v. Davis, 533 United States Reports 678 (2001).

Australian Statutes Cited

Acts Interpretation Act 1901 (Cth)
Migration Act 1958 (Cth)
Migration Reform Act 1992 (Cth)
Statute Law Revision Act 1981 (Cth)

References Cited

Blackshield, Tony and George Williams. *Australian Constitutional Law and Theory*, 5th ed. Sydney: Federation Press, 2010.
Corcoran, Suzanne, "Theories of Statutory Interpretation." In *Interpreting Statutes*, edited by Suzanne Corcoran and Stephen Bottomley, 8–30. Sydney: Federation Press, 2005.
Fraser, Julius T., *Time and Time Again*. Leiden/Boston: Brill, 2007.
French, Robert S. "What Were They Thinking? Statutory Interpretation and Parliamentary Intention." Address given at The University of New England, Armidale, New South Wales: The Sir Frank Kitto Memorial Lecture 2011, Friday, 23 September 2011. Accessed 1 August 2014. http://www.hcourt.gov.au/assets/publications/speeches/current-justices/frenchcj/frenchcj23sep11.pdf.
Halliday, Michael A.K. "Language as Code and Language as Behaviour: A Systemic-Functional Interpretation of the Nature and Ontogenesis of Dialogue." In *The Semiotics of Culture and Language*, edited by Robin P. Fawcett, M.A.K. Halliday, Sydney M. Lamb and Adam Makkai, 3–35. London: Frances Pinter, 1984.
———. "A Recent View of 'Missteps' in Linguistic Theory." In *On Language and Linguistics*, vol. 3 of *Collected Works of M.A.K. Halliday*, edited by Jonathan J. Webster, 232–47. London/New York: Continuum, 2003. Originally published in *Functions of Language* 2 (1995) 249–67.
———. "Systemic Grammar and the Concept of a 'Science of Language.'" In *On Language and Linguistics*, vol. 3 of *Collected Works of M.A.K. Halliday*, edited by Jonathan J. Webster, 199–212. London/New York: Continuum, 2003. Originally published in *Language Studies and Textual Analysis: Proceedings of the Second National Seminar in Systemic-Functional Linguistics, Suzhou (China), 15–18 July 1991*, edited by Zhu Yongsheng. Reprinted in *Waiguoyu (Journal of Foreign Languages)*, General Series 78, no. 2 (1992): 1–9.
———. "Text as Semantic Choice in Social Contexts." In *Linguistic Studies of Text and Discourse*, vol. 2 of *Collected Works of M.A.K. Halliday*, edited by Jonathan J. Webster, 23–81. London/New York: Continuum, 2002. Originally published in *Grammars*

and Descriptions, edited by Teun A. van Dijk and János S. Petöfi. Berlin: Walter de Gruyter (1977): 176–226.

Halliday, Michael A.K. and Christian M.I.M. Matthiessen. *An Introduction to Functional Grammar*. 3rd ed. London: Arnold, 2004. 4th ed. London/New York: Routledge, 2014.

Huisman, Rosemary and Tony Blackshield. "Tenor in Judicial Reasoning: Modality in Majority and Dissenting Judgments in the High Court of Australia (*Al-Kateb v. Godwin*)." *Linguistics and the Human Sciences* 9 (2014): 229–48.

Kamuf, Peggy, ed. *A Derrida Reader: Between the Blinds*. New York: Harvester Wheatsheaf, 1991.

Maxwell, Peter B. *On the Interpretation of Statutes*. 1st ed. London: Maxwell & Co. 1875. 4th ed. by J. Anwyl Theobald. London: Sweet & Maxwell, 1905. 12th ed. by Peter St John Langan. London: Sweet & Maxwell, 1969.

Pearce, Dennis C. and Robert S. Geddes, *Statutory Interpretation in Australia*, 7th ed. Sydney: Lexis Nexis Butterworths, 2011.

Poscher, Ralf. "Ambiguity and Vagueness in Legal Interpretation." In *The Oxford Handbook of Language and Law*, edited by Peter M. Tiersma and Lawrence M. Solan, 128–44. New York: Oxford University Press, 2012.

Reddy, Michael. "The Conduit Metaphor—A Case of Frame Conflict in Our Language about Language." In *Metaphor and Thought*, edited by Andrew Ortony, 284–310. Cambridge: Cambridge University Press, 1979.

Smyth, Russell. "Extrinsic Materials." In *The Oxford Companion to the High Court of Australia*, edited by Tony Blackshield, Michael Coper and George Williams, 265–67. Melbourne: Oxford University Press, 2001.

Steyn, Johan. "The Intractable Problem of the Interpretation of Legal Texts." *Sydney Law Review* 25 (2003): 5–19.

Twining, William and David Miers. *How To Do Things With Rules*. 1st ed. London: Weidenfeld and Nicolson, 1976. 3rd ed. London: Weidenfeld and Nicolson, 1991.

CHAPTER 14

Time, Waste, and Enlightenment, or: On Leaving No Trace

Raji C. Steineck

Abstract

Time may be the ultimate excuse for an economy built on waste: if everything is taken away by the stream of time, why, then, worry about what we leave behind? If time instead came to be seen in its aspect of sustaining and bringing forth what has been there before, would that prompt us to think in a different way about how to produce, how to consume, and what to do about the results? This is the hypothesis explored in the present essay. It turns to the argument made by medieval Zen Master Dōgen against seeing time as "just flying away," and explores how it connects to notions of karma and the ideal of "leaving no trace." It then presents secular versions of both the idea of karma and the ideal of "leaving no trace." Taking account of the limitations of the latter, a complementary model is proposed from which to envision the future development of human society.

Keywords

time imagery – impermanence – nuclear waste – environmentalism – karma – Dōgen

1 Time's River and the Fate of Waste

There is a trace we leave on the planet that we usually attempt to ignore: the trace of waste. This essay deals with its most persistent part, with forms of durable waste that refuse to be washed away by the river of time. It ponders the connection between the production of such waste and the image of time as a river-like force that carries everything away. Its argument is driven by the belief that our actions are intricately linked to the ideas we hold about time. By way of a detour through Japanese Buddhist literature, I offer a complementary way of imagining time in the hope of supporting a change towards a global human society that leaves traces of increased fertility, complexity, and beauty

on this planet, instead of destroying the very foundations of the life of our and many other species, as we currently busy ourselves in doing. I take it that such change is as urgent as it is feasible, although I do not assume it will be easy. But I believe that human minds and human societies—who invented and created things as complex and grand as the science and technology of nuclear fission or genetic engineering—can achieve this difficult goal if they perceive it to be not only necessary (as many have started to suspect), but also urgently desirable. And an appropriate image of time, or so I hope, may help to bring about the needed change of mind, if it translates into concomitant methods of organizing human production and consumption.

The importance of our images of time was powerfully suggested by J.T. Fraser in his last "Founder's Lecture." Fraser recounts his experience, as a young man in war-torn Pannonia, of standing between two vast armies, each driven by a specific idea of history and a sense of mission derived from it. This experience clearly fueled his systematic exploration of time felt and time understood, which led to the eventual formulation of the hierarchical theory of time.[1] According to this theory, there are five canonical forms of time, ordered in a nested hierarchy along a scale of increasing complexity. Each form represents the temporal *umwelt* of a certain class of objects. The human notion of time, or *nootemporality,* is described via the image of the full-fledged "arrow of time," i.e., an arrow with a tip (the present) and an end (the initial singularity/origin of time), moving within a Cartesian grid that allows us to coordinate all moments *in* time as so many moments *of* time.[2] This is a comprehensive image which allows for various accentuations, and it even serves as the prototype from which Fraser models, by way of reduction, the lower, or more pristine, levels of temporality. By the very same token, Fraser was less concerned with the typology of the manifold human ways to picture time.

On the other side of the globe, Japanese sociologist Y. Maki developed a theory of human time *imageries*, i.e., sets of interrelated images, evaluations, and programs for individual and social action.[3] Perceiving lacunae in the dominant modern image of time, Maki looked for alternatives in the anthropological literature and in Japanese cultural history, eventually presenting a system of four fundamental types of human time imagery: oscillating time (time as a simple alternation between two distinct temporal spheres, such as night and day, hot and cold season, life and death), circular time (time as periodical reiteration of a cyclical pattern, such as the four seasons), segmented linear

[1] Fraser, "The Origin of the Integrated Study of Time."
[2] Fraser, *Time, Conflict, and Human Values*, 26–43, esp. 36.
[3] Maki, *Jikan no hikaku shakaigaku*.

time (time as an extended totality, modeled after the pattern of action, with a beginning, a mediating term, and an eventual final state) and infinite linear time (time as a limitless, unidirectional linear projection).[4] His theory may be seen as complementary to Fraser's, with an exclusive focus on the sphere of nootemporality, and his observations allow us to cast into stronger relief the problem that is the starting point of this paper.

Maki begins his analysis of the dominant modern view of time with a seminal quote from Pascal's *Pensées*: "For it is not to be doubted that the duration of this life is but a moment; that the state of death is eternal, whatever may be its quality."[5] He goes on to observe: "This is not only Pascal's fear, but, as we shall see, a fear that undergirds much of modernity's thinking, or probably even modern rationality itself."[6] Modern thought, Maki believes, is based on three axioms, all related to the dominant pattern of imagining time as an unlimited, unidirectional flow. These axioms seem self-evident to the mind-set in question, but lose their aspect of necessity upon closer scrutiny. They are: 1) "Time annihilates all things;"[7] 2) "Human life is short and ephemeral;"[8] 3) "Limited existence (human life) is futile/inane."[9] Belief in these axioms leads to both the fear of death and a longing for eternal existence, which in turn produce illusory remedies in three dimensions: that of technology (from mummies preserving the body in eternity to the search for medication against death), of imagination (belief in an immortal soul; religion), and of logic (denial of time).[10]

While Maki thus focuses on human attempts to neutralize annihilation through time, I am more interested here in the reverse side of this image of time. In this, I am inspired in part by M. Yuasa's mapping of Maki's time imageries onto the problem of nuclear power in Japan in the previous volume of the *Study of Time*.[11] To put it simply, I would concur with Maki that powerful

4 Ibid., 158–164. See also Yuasa, "The Future of August 6, 1945," 243–244 for a brief summary in English.
5 Pascal, *Pascal's Pensées*, No. 195. Cf. Maki, *Jikan no hikaku shakaigaku*, 2. Maki quotes Pascal in Japanese, with a reference to the following French edition: Brunschvicg, *Blaise Pascal, Opuscules et Pensées*, 4. The French text is as follows: "Car il est indubitable que le temps de cette vie n'est qu'un instant, que l'état de la mort est éternel, de quelque nature qu'il puisse être, [...]." Pensées B 195, L 428, S 682; Pascal et al., *Pensées*, 477.
6 Maki, *Jikan no hikaku shakaigaku*, 2. My translation from the Japanese original (same below).
7 Ibid., 4.
8 Ibid., 7.
9 Ibid., 9.
10 Ibid., 12.
11 Yuasa, "The Future of August 6th 1945."

modern world-views, from the religious conservative to the socialist progressive, converge in taking axiom 1 for granted. I would however add that this translates into a way of life built on producing, and discharging, waste, and leaving it to time to take care of things. It also seems to me that this view, and the waste-accumulating practices that go with it, are time-honored human ways of dealing with life—ways that, however, have acquired a new scale of impact with the invention, industrial production, and mass distribution of durables such as plastics or radioactive materials, both of which share in the unhappy disproportion between a short period of usefulness and a very long life as waste.

To adduce an example: it is common knowledge that the notion of "impermanence" informed Japanese elite culture ever since the introduction of Buddhism in the 6th century; and it was very often articulated in the water imagery of time, carrying notions of loss and futility. This is exemplified by the following masterful poem from the first imperial collection of Japanese court poetry:

> Speaking of yesterday, today is spent: the Morrow-River has flown past—oh, they become quick months and years![12]

It is less well known that this view was not without its companion, a relentless exploitation of resources and pollution of densely populated areas, leading to the depletion of natural resources in the region of the capital as early as the 8th century.[13]

To elaborate on the connection between this time imagery and the practice of excessive pollution, to say that time is a river is to use a powerful metaphor, but an incomplete one. It manages to capture two opposing experiences of time—that of the flow that carries what is present into the past (with the observer standing unmoved, as on a bridge or river bank) and that of the flow that carries *us* from the present to the future (with the present remaining behind, as on a river bank or bridge). What the image can hardly present to the mind is the fact that the past is never completely gone (the river of time is exceptional in that it carries the past with us *and* washes it away), and that the future is in important ways dependent on our present and past acts (the course of the river of time is changed by our present and past swimming).

12 My translation of the Japanese: といひ、と暮らして、あすか川流れてはやき月日なりけり。 Poem by Harumichi no Tsuraki 晴通列樹 (d. 920). Ki no Tsurayuki et al., *Kokin waka shū* vol. 6, no. 341, p. 147.

13 Totman, *A History of Japan*, 84–85.

The result of the reductions inherent in the metaphor can be easily illustrated in regard to our subject of waste: if time were a stream that simply carried what is present to the ever more distant past, we could indeed safely throw everything into its waters and let time take care of it, just as humans have done for ages on. If, conversely, we perceive time as a stream that carried *us* from the past to the present to an unknown future, we may become more hesitant to pollute the spot we're swimming in, so to speak. But that is not how the image usually operates, because in our imagination, it is only us who are carried away, while we leave behind what is significant in the present situation. Either way, as Maki illustrated by way of quoting Pascal, we are prompted to have more pressing problems on our mind while in the grasp of the river image of time: how can we hold on to what is dear to us? How can we, as mortal beings, avoid complete obliteration through time? How can we make a mark and leave a trace in this world?

While the argument above may sound speculative, there is some evidence that practice with regard to the production and disposition of durable waste is indeed supported by the water imagery of time. Or this is how I read Jacob Hamblin's description of the outlook of oceanographers who, in the early 1950s, formulated threshold values for the practice of dumping barrels of radioactive waste into the sea:

> It was no stretch to assume that, like fish stocks, the ocean could rejuvenate itself *through dilution* [emphasis mine], and that it had a definable annual capacity to do so for radioactive waste.[14]

Although Hamblin criticizes the practice, he doesn't seem too troubled by the fundamental flaw in the line of thought he presents—and which seems to stand behind much of current practice in regard to waste disposal. In the case of fish, there is a biological process of reproduction that renders the idea of "rejuvenation" plausible. To speak of rejuvenation through dilution in a given, limited entity (even if it is as vast as the world's oceans), however, can only mean to trust in time's power to further and further carry the load away from those who left it—and to believe that it will never come back. The ubiquitous water imagery of time may have facilitated the semantic shift from the literal ocean to the oceans of time where everything gets lost in the end. That in fact it does not is vividly exposed by another landmark trace of humanity's current practice of production and distribution of durable waste.

The "Great Pacific Garbage Patch", according to one media report, is a stretch of ocean approximately the size of Texas in the North Pacific Subtropical

14 Hamblin, *Poison in the Well*, 11.

Convergence Zone.[15] It is only one of several large areas in the world's oceans where plastic debris—mostly in the form of microdebris—continues to accumulate to a massive extent, and with unknown consequences for the maritime environment.[16] The exact sources of the contamination and the traveling routes of the debris have yet to be established, but there appears to be a strong connection to the increased production and use of synthetic fibers.[17] In coastal areas, a large portion of the microplastic found in ocean water and sediment seems to stem from sewage water and, ultimately, household washing machines.[18] Plastic beverage containers appear to be another relevant source.[19] The increasing abundance of plastic in the world's oceans bears witness to the simple truth that the durables we dispose of to be washed away, in the hope that they shall vanish with time, in fact accumulate. They may well become a physical representation of what can be called the *repository function* of time that is captured, as Maki's study demonstrates, in different ways in many older traditions.[20] It is also an important element of the Buddhist notion of *karma* that I want to explore in the next section.

As mentioned above, there seems to have been as much concern with the transience of time and as little awareness of problems of environmental pollution in Japan as in Europe prior to the modern age. But the view of impermanence as annihilation did not go unchallenged, and the critiques directed at it provide us with useful ideas and alternatives for re-thinking our imagery of time. In the following, I shall briefly sketch one such alternative view (which I have described in more detail elsewhere)[21] and ponder its potential.

2 Impermanence and the Persistence of the Past

The Japanese Buddhist monk Dōgen (1200–1253) was certainly not one to criticize the notion of impermanence. Quite to the contrary, in *Gakudō yōjin shū*, a collection of essential instructions to his monastic disciples, he adduces an

15 Johnston, "Study." Other reports give larger estimates of the size of the area, e.g., "twice the size of Texas" (Kaiser, "The Dirt on Ocean Garbage Patches").
16 Kaiser, "The Dirt on Ocean Garbage Patches." Goldstein, Rosenberg and Cheng, "Increased Oceanic Microplastic Debris."
17 Thompson et al., "Lost at Sea."
18 Browne et al., "Accumulation of Microplastic on Shorelines Woldwide."
19 Rochman et al., "Polystyrene Plastic."
20 Maki, *Jikan no hikaku shakaigaku*, 15–27.
21 Steineck, "Time is not fleeting: Thoughts of a Medieval Zen Buddhist."

unidentified quote from the grand patriarch Nāgārjuna to the extent that meditation on impermanence is the primary gate to Buddhist insight:

> To single-mindedly contemplate the instability of origination and annihilation in the human world is called the thought pregnant with enlightenment.[22]

However, in his more esoteric instructions preserved in the now-canonical, widely accessible and oft-translated *kana-Shōbōgenzō* collection, he takes much trouble to refine this idea, and to save it from the misleading identification with the notion that time is like a stream or wind that simply passes by. Even time's passage, he insists, cannot be grasped in that way:

> If you reckon time to be something that solely passes by in one direction, you haven't understood it as something that has not yet arrived. [...] You can't stop at studying its passage through stations according to the simile of wind and rain passing from East to West.[23]

Apart from its incompleteness, the major problem with the time imagery associated with the unidirectional flow is that it implies a persistent object that retains its essence or identity apart from that flow. Already in *Genjōkōan*, one of his earliest writings directed at a lay follower, Dōgen addresses this problem in terms of the relationship of firewood and ash:

> Once firewood turns to ash, the ash cannot turn to being firewood. Still, one should not take the view that it is ashes afterward and firewood before. One should realize that although firewood abides in the dharma-rank[24] of firewood, and that this is possessed of before and after,

22 My translation of the logographic Japanese: 唯觀世間生滅無常心亦名菩提心。cf. Dōgen, *Dōgen Zenji zenshū*, vol. 2, p. 253.

23 My translation of the Japanese: 時は一向にすぐるとのみ計功して、未到と解會せず。[...] 經歷といふは、風雨の東西するがごとく學しきたるべからず。See *Shōbō genzō Uji*, Dōgen, *Dōgen Zenji zenshū*, vol. 1, p. 192. On the translation of *kyōryaku* 經歷 as "passage through stations", see Elberfeld, *Phänomenologie der Zeit im Buddhismus*, 267–269.

24 Jap. *hō* 法, skt. *dharma* can refer in the Buddhist literature both to the authoritative teaching of the Buddha and to the constituents of reality whose nature is explained in that teaching. Dōgen's phrase *hōi ni jūsu* 法位に住す "abide in the dharma-rank" is a quote from the chapter on "Expedient means" in Lotus Sutra: "All things abide in their dharma rank, [hence] the world abides forever" (Translation adapted after Kato,

before and after are cut off. Ashes dwell in the dharma-rank of ashes, and possess before and after. Just as firewood does not revert to firewood once it has turned to ashes, man does not return to life after his death. This is why we speak of non-birth. To say that death does not become life is the Buddha's wheel-turning that defines the Dharma. This is why we speak of non-annihilation. To use a simile, it is like winter and spring. We don't think that winter becomes spring, and we don't say that spring becomes summer.[25]

In my reading of this passage,[26] Dōgen attempts to complement the notion of impermanence or transience with the notion that all transient states such

The Threefold Lotus Sutra, 70). In a recent contribution that also reviews a substantial part of the literature on Dōgen's notion of time, Rein Raud has suggested the term "dharma configuration" as a translation for Dōgen's use of *hōʻi* 法位. He explains: "[…] we can understand *jūhōʻi* 住法位 ["dwelling in the dharma-stage/configuration"] […] as the relation in which the constituent particles of reality are to each other: in one specific mode of organization they are perceived as 'firewood,' in another as 'ashes'; the notion of 'firewood' abides in a particular configuration of dharmas just as the notion of 'offside' abides in a particular configuration of players on a football field." ("The Existential Moment," 156–157) I find both the term and the simile illuminating but for the reified use of "notion"—in Dōgen's text, it is the firewood and the ashes that abide in their specific dharma configurations and not their notions. In addition, one might say that Raud's translation abstracts from the specifically Buddhist connotations and especially from the link to the term's source, the Lotus Sutra. See also Steineck, "Übersetzung und theoretische Rekonstruktion," 135–142.

25 My translation of the Japanese original: たき木、はひとなる、さらにかへりてたき木となるべきにあらず。しかあるを、灰はのち、薪はさきと見取すべからず。しるべし、薪は薪の法位に住して、さきありのちあり。前後ありといへども、前後際断せり。灰は灰の法位にありて、のちありさきあり。かのたき木、はひとなりぬるのち、さらに薪とならざるがごとく、人のしぬるのち、さらに生とならず。しかあるを、生の死になるといはざるは、佛法のさだまれるならひなり。このゆゑに不生といふ。死の生にならざる、法輪のさだまれる佛轉なり。このゆゑに不滅といふ。生も一時のくらゐなり、死も一時のくらゐなり。たとへば、冬と春のごとし。冬の春となるとおもはず、春の夏となるといはぬなり。Dōgen, *Dōgen Zenji Zenshū*, vol. 1, p. 8.

26 Alternative readings exist. Much hinges on the seminal expression *zengo saidan seri* 前後際断せり, translated here literally as "before and after are cut off." Waddell and Abe ("Shōbō genzō Genjōkōan", 176) for example translate it as "firewood is beyond before and after" and thus suggest that the temporal sequence is external to firewood and ashes. For more extensive discussion of the various extant translations and their hermeneutical implications and for a defence of my reading see Steineck, "Übersetzung und theoretische Rekonstruktion"; Steineck, "Time is not Fleeting." Waddell and Abe's reading connects to

as firewood or ash are invariably connected to ("possess") anterior and posterior states. Thus, while each state of necessity will give way to another one, and there is no possibility of persistence beyond time or reversing the order of transition (as the order of so many states or configurations of reality), what once happened does not simply go away without leaving a trace. It is preserved in its state (i.e., its position in the order of time), and it continues to *inform* the ensuing present states. In light of this view, the issue is not to make a mark and leave a trace in this world. Quite to the contrary, Dōgen perceives as a hallmark of enlightenment the feature that it may lead to a cessation of traces. Before elaborating on this, I want to present some further quotes that reveal how Dōgen elucidates the complementary aspects of time by a powerful, if sometimes taxing, play with time imagery.

The *locus classicus* is his famous talk on "The Time-being", where he comments on the following poem by an old master, who lists various states on the road of transmigration through the realms of existence:

有時高高峰頂立、	At one time-being, standing on the top of the high, high mountain
有時深深海底行。	At one time-being, wandering the grounds of the deep, deep sea.
有時三頭八臂、	At one time-being, three heads and eight arms [a Guardian Deity],
有時丈六八尺。	At one time-being, six yards and eight ells [a transcendent Buddha].
有時手杖拂子、	At one time-being, the staff and whisk [a Zen abbot with his insignia],
有時露柱燈籠。	At one time-being, an exposed lamp-pillar.
有時張三李四、	At one time-being, the third son of Jones or the fourth of Miller,
有時大地虛空。	At one time-being, the great earth and empty sky.[27]

the position that Dōgen presents a theory of momentariness, which has recently been taken up by Rein Raud in his article quoted above ("The Existential Moment").

27 Dōgen, *Dōgen Zenji Zenshū*, vol. 1, p. 189; English translation mine. Cf. Waddell, "Being Time: Dōgen's Shōbōgenzō Uji," 116 for a different English translation, and the German translation and discussion of this paragraph in Elberfeld, *Phänomenologie der Zeit im Buddhismus*, 224–229.

Having first posited his view of the strict correlation between time and being, Dōgen goes on to critique the notion that things pass through the flow of time. Through a re-arrangement of the images in the poem he arrives at a more complete view:

> The view of common people who are not used to the Buddha-Dharma is like this: When they hear about time-being, they think that at one time someone became a being with three heads and eight arms [= a guardian deity], and then at some time he became a golden body of six yards [= a Buddha], as if for example I were crossing a river and a mountain: while the river and mountain may still exist, I have now passed them by and I, at the present time, reside in the vermilion tower of a fine palace. In this view, the mountain and river and I are as far distant as heaven from earth. While that may be the case, the measure of the way is not found in this yardstick alone. When, as we said, I was crossing the river and climbing the mountain, I was there in time, and the time has to be in me. Since I am already there, the time cannot pass away. If time is thus not the form of arriving and passing, then the time of climbing the mountain is the "also now" of time-being. And if time preserves and gives itself to the form of arriving and passing, I have the "also now" of time-being, and that is time-being. Now, does the time of climbing the mountain and crossing the river not gulp down and spit out that of the vermilion palace? The three heads and eight arms are yesterday's time, and the six yards and eight ells are today's time. While that is so, the measure of the way with respect to this past and now is simply the period of entering directly into the mountains and surveying the thousand and ten thousand peaks. The three heads and eight arms make their complete passage in our time-being, and while they appear to be over there, they are "also now." The six yards and eight ells make their complete passage in our time-being, and while they appear to be in a distant place, they are "also now."[28]

28 My translation from the Japanese: しかあるを、佛法をならはざる凡夫の時節にあらゆる見解は、有時のことばをきくにおもはく、あるときは三頭八臂となれりき、あるときは丈六金身となれりき。たとへば、河をすぎ、山をすぎしがごとくなりと。いまはその山河、たとひあるらめども、われすぎきたりて、いまは玉殿朱樓に處せり、山河とわれと、天と地となりとおもふ。しかあれども、道理この一條のみにあらず。いはゆる山をのぼり河をわたりし時にわれありき、われに時あるべし。われすでにあり、時さるべからず。時もし去來の相にあらずは、上山の時は有時の而今なり。時もし去來の相を保任せば、われに有時の而今ある、これ有時なり。かの上山渡河の時、この玉殿朱樓の時を呑却せざらんや、吐却せざらんや。三頭八

It should be noted first that Dōgen does not simply reject the common notion of time's passage. He only insists that it needs to be complemented by further reflections on what Kantians would call the conditions of possibility of precisely that experience of time that we address as time's passage. Secondly, in the ensuing sentences he encourages us to adopt two seemingly contradictory views—namely that time is not identical with the form of arriving and passing, and that it preserves precisely that form. Both are connected via the nominalized phrase *shikin* (also: *nikon*) 而今, which in standard use would be a conjunctive phrase meaning "and now as well (like then, or in the future)" or "but now (as opposed to some anterior or posterior state)." Many extant translations and interpretations reduce the aspect of juxtaposition with some other, non-present instance implied in the first character *shi/ni* 而, and take the phrase to point to the "immediate present."[29] In my reading of the passage in question, however, the context strongly supports a translation that takes note of this aspect. Dōgen's words imply that the present moment is "beyond itself," so to speak, in that it carries its past and is pregnant with a future, without denying their distance from itself.

In abstract terms, what Dōgen seems to emphasize is that all temporal instances build a continual sequence with "our" time, and there is thus no isolated state of being. Time in this image has a spatial aspect in that it can be surveyed at every moment. Present time thus contains a co-presence of the past (and the future) while retaining the notion of temporal directionality and distance. While each state of existence is transient, it does not simply vanish into the past, but is pregnant with a future in which it will be present as that future-become-present's past. Dōgen also insists that when impermanence is only exposed under the aspect of time's passing, we miss out on the aspect

臂はきのふの時なり、丈六八尺はけふの時なり。しかあれども、その昨今の道理、ただこれ山のなかに直入して、千峰萬峰をみわたす時節なり、すぎぬる にあらず。三頭八臂もすなはちわが有時にて一經す、彼方にあるににたれども而今なり。丈六八尺も、すなはちわが有時にて一經す、彼處にあるににたれども而今なり。Dōgen, *Dōgen zenji zenshū.*, vol. 1, p. 190. Compare Waddell ("Being Time: Dōgen's Shōbōgenzō Uji," 119) and Raud ("The Existential Moment," 162) for alternative interpretations. Tanahashi (*Enlightenment Unfolds,* 70–71) is somewhat closer to the translation given here. See Steineck, "Time is not Fleeting," 38–42 for a defence of my interpretation.

29 E.g. Raud, "The Existential Moment", 162. Unfortunately, this is even true for the Japanese standard reference work *Zengaku daijiten* (cf., 977). In contrast, Rolf Elberfeld in his extensive study of Dōgen's philosophy of time uses a similar translation (*das gegenwärtige Jetzt* / "the present now"), but in his commentary argues much along the lines presented here. Elberfeld, *Phänomenologie der Zeit im Buddhismus,* 260–261.

that time is also the coming of what had been the future into the present (the "spitting out" of the vermilion palace, so to speak). What is important here is that the future is not understood as something entirely new—an idea that would be the logical complement to the notion that the passing of time annihilates the present—but that it is the future of a past (and present), a future conditioned, according to Buddhist convictions, by the Karmic effects of preceding actions. Every action thus leaves, however inadvertently, a trace that will lead to future events and conditions. If read in this way, the rather esoteric passage quoted above is consistent with a more exoteric informal talk recorded in the *Shōbōgenzō* on "Karma in the Three Times" (*Sanjigō* 三時業). Here, Dōgen quotes Buddhist lore to illustrate how meritorious deeds produce beneficial effects in the same or another existence, relating edifying stories like the following:

> An example of doing good in this life and—with retribution being received in the immediate present—getting a good reward:
> "Once upon a time, King Kaniṣka of the county of Gandhāra retained an androgyne who always supervised internal court affairs. On a temporary excursion beyond the city [walls], he saw a herd of bulls, fully five hundred in number, being led into the city. He asked the herder, "What kind of bulls are these?" [The herder] replied, "These bulls are going to be castrated." At this, the androgyne immediately thought to himself, "I, through long-held karma, have received an emasculate body. Now I shall use my wealth to rescue these bulls from [that] hardship." Eventually he paid their price and had them all set free. Through the force of good karma, this androgyne was caused at once to recover a male body. He profoundly rejoiced."[30]

Many modern readers who want to stage Dōgen as a superior kind of *philosopher* prefer to disregard such adduction of lore as inconsequential.[31]

30 Nishijima and Cross, *Master Dogen's Shobogenzo* vol. 4, pp. 118–119; Japanese original: この生に善をつくりて、順現報受に善報をえたる例。昔健駄羅國迦膩色迦王、有一黄門、恆監内事。曾出城外、見有群牛、數盈五百、來入城内。問駈牛者、此是何牛。答言、此牛將去其種於是黄門即自思惟、我宿惡業受不男身、今應以財救此牛難。遂償其債悉令得脱。善業力故、令此黄門即復男身。深生慶祝、[…]. Cf. Dōgen, *Dōgen Zenji Zenshū* vol. 1, p. 684.

31 See Heine, "The Dōgen Canon" for a review of the reception of Dōgen in the 20th century and the respective hierarchizations of Dōgen's texts. I agree with Heine that there is no sufficient reason to assume major doctrinal shifts between the various stages in his career once he had established himself as a Zen master and prefer to work from the traditional

It is, however, not uncharacteristic for his writing, and it is completely in line with the reading of *Uji* presented above, and with other passages in his work. In yet another fascicle, and on a less picturesque note, for example, Dōgen assures his disciples that due to the causal link between actions and effects, the as-yet-unenlightened practitioner may have confidence in his or her eventually becoming a Buddha.[32]

With this, we are back at the ultimate goal he posits, which is to arrive at a state where the Karmic traces—even those of enlightenment itself—are put to rest. Thus he says in *Genjōkōan*: "There is the serene cessation of the trace of enlightenment, and the trace of enlightenment that is serene cessation is grandly put to effect."[33]

Leaving no trace is thus put forth as the ultimate goal, but it is understood in a particular way: It does not signify a quietistic ideal, and it thus does not point towards the aim of ceasing to have an effect on the world. What it does signify is, first of all, dissolving the Karmic traces, the conditioning of the future that, according to Buddhist thinking, necessarily goes with unenlightened behaviour. Secondly, it refers to a state where the effects of action are no longer *mechanical imprints* left in a blind, automatic, and involuntary fashion, but are subject to the knowledge and conscious design of the Bodhisattva or Buddha, who, according to tradition, possesses an omniscient knowledge of the karmic effects of each action.

It should be clear at this point that Dōgen shares in all the grand notions of Mahāyāna Buddhism concerning the mysterious and miraculous powers of the Buddha and the metaphysical workings of the world. And this leads to the problem I want to treat in the next section, that is, the question of what his ideas have to offer to those among us who have either a less elated and more prosaic view of the world and what we can reasonably aspire to know and do about it, or a different set of religious beliefs. In other words, I want to propose in what follows an ontologically and epistemologically deflated version of Dōgen's view of karma, and consequently, of time, one that may be deprived of much of its soteriological lustre, but that may lend itself better to integration into a wider spectrum of worldviews.

hypothesis of consistency in his oeuvre. In a forthcoming article ("A Zen philosopher?"), I argue *in extenso* that reading Dōgen as a philosopher leads to a distortion of his views.

32 Dōgen, *Dōgen Zenji Zenshū* vol. 1, p. 222.
33 My translation of the Japanese original: 悟迹の休歇なるあり、休歇なる悟迹を長長出ならしむ。 Ibid., vol. 1, p. 8.

3 Karma without Metaphysics

Starting on an abstract note, I want to argue that Dōgen's technique of turning around pre-extant images of time has a profound lesson to teach on how to, and how not to, imagine time. What Dōgen shows is that any concrete image of time can only grasp a part of the complex structure of nootemporality, or time as human beings have learned to understand it upon sustained reflection on their various experiences. The full-fledged notion of time is one of a complex structure, comprising dynamic and static elements and a two-tiered superstructure of relations between them, and the relations of these relations. Any image of time thus has to be inverted and subverted, and the various contrasting and conflicting images have to be held against each other in order to prevent us from reducing time to one of its aspects, e.g., that of unidirectional flow. It is furthermore remarkable that Dōgen manages to demonstrate this with a very limited number of concise abstract statements. Instead, he methodically nudges his readers along on a way of subsequent contemplations in which they are led to new *intuitions* about time. This, I believe, is important because only few of our everyday decisions and actions are induced by systemic analytical planning, which requires time, an extensive knowledge of conditions, and a certain remoteness from strong needs or incentives.[34] We therefore need to translate our rational, conceptual understanding of time into time imageries that may serve as intuitive guides if we want to actually divert human behavior from the currently dominant pattern leading to the over-abundance of persistent waste towards a rational and sustainable path of production, distribution, consumption, and re-production.

With this in mind, we can summarize the gist of what in Dōgen's contemplation of time speaks to us, independently of whether we accept his Buddhist views or not, in the following way:

34 While this is a philosophical statement based on abstract reasoning, it is backed up by an increasing empirical literature on "naturalistic" or "intuitive decision making." As already Klein, "Naturalistic Decision Making" summed up, "under operational conditions, decision makers rarely use analytical methods and nonanalytical methods can be identified that are flexible, efficient, and effective" (17). The idea has been applied to the analysis of fields of human action as diverse as management, street crime, medical services, or the training of armed forces; see, e.g., Khatri and Ng, "The Role of Intuition in Strategic Decision Making"; Jacobs, "Serendipity in Robbery Target Selection"; Hall, "Reviewing Intuitive Decision-Making and Uncertainty"; Spaulding, "Intuitive Decision Making." As this thematic selection suggests, intuitions play the most prominent role in situations of uncertainty. They may thus become even more important in the increasingly complex social environment of late modernity.

1. Human beings have to reckon with the irreversible directionality of time's flow. There is no returning to, or undoing of, events once they have happened in the present.
2. There are, furthermore, two sides to time's passage: time not only passes away, but it also arrives.
3. The time that arrives will bring events that are never completely independent of the past. In other words, nothing simply vanishes in the past, and past events continue to condition the present and future.
4. While we cannot hope for the traces of past events and actions to become fully extinct, there is a possibility of *shaping the traces*, and thus, to work on consciously conditioning the future in a beneficial way. This requires
5. that we be aware of the imprints of our actions as fully as we can, and that we avoid the trap of regarding intended consequences as necessary and unintended consequences as accidental—implying that they are insubstantial and will take care of themselves.[35]

This brings me to a secular reformulation of the notion of *karma*. Let me first be clear about the fact that, while mechanical causality is a well-attested phenomenon, I do not posit an intersubjective basis to ascertain the reality of karmic causality as Dōgen describes it: it remains, as Dōgen and other Buddhist sources are quick to admit, a prerogative of the transcendent powers of enlightened beings to discern karmic causes and effects—provided such beings exist.

In this light, I want to propose the following secular reading of the notion of karma: Let karma indicate, firstly, the fact that we cannot escape the very fact of our own actions, once they have been committed. The minimum karmic trace that every action leaves is the simple fact that it has occurred. Its meaning and evaluation may all be up for interpretative shifts, and the fact of it may be denied, but it cannot be undone. From this follows, secondly, that we have to live with the fact of our actions. In doing so, they will trigger both subsequent actions from ourselves and re-actions from others affected by them. This is what I propose to call the karmic trace of our actions. Consider a person telling a lie, however insignificant in the first instance: she will have to hope that the lie will go unchallenged, undiscovered, or else she will be exposed as a liar; consequently, she may feel the need to either cover up the lie with further lies, or to somehow distance herself from it, or to make up for it and attempt to restore trust. I assume that the most inescapable and sometimes also most

[35] This latter point has been emphasized, independently from the Buddhist context, by techno-ethicist Günter Ropohl in his seminal *Ethik und Technikbewertung*, 214–222.

salient effect is that each action reflects back on our self-image and thus on our personal integrity.

On the larger level of societal and political events, and returning to the subject of this paper: in deciding to dump durable or noxious waste in the sea one may hope that time will take care of the matter, or that the dumping goes unnoticed, or that, in the absence of policing powers, it will remain unpunished. Options two and three obviously carry the risk of discovery and retaliation and necessitate action to cover up the deed or to protect oneself from punitive consequences—as in the case of the dumping of waste near the coast of Somalia, a failed state, which turned fishermen who ran out of fish to catch into pirates, calling for military action that increased violence and hatred in the region.[36]

But even in the absence of conscious wrongdoing, the fact remains that the action that has occurred will have further effects, all traceable to the initial action, whether it is a lie or the disposal of waste in the sea. The Great Pacific Garbage Patch and parallel phenomena in other oceans are a material illustration of this point. Karma in this reading simply reminds us that we cannot live on the shallow hope that, some initial caution provided, time will take care of things. Or, in an affirmative mode: We had better act in awareness of the fact that the action, once committed, will continue to produce effects in the future—and there is no force in the world, not even time's passing, that will relieve us of this fact.

4 On Leaving No Trace

To apply this thought to the topic of waste, or—to put it in more general terms—to the topic of our production, use, and disposal of material objects, can be a frustrating experience. As was demonstrated above with relation to the accumulation of plastics in the world's oceans, in contemporary society, seemingly innocent acts such as washing clothes or drinking a bottle of water leave traces that we can hardly keep track of, and even less control. This becomes most saliently visible when we leave urbanized civilization and enter areas with no infrastructure to cover up and partially remove what we, during life in our habitual technospheres, regularly dispose of. This salience has led, in the wildlife preservation movement, to the motto of "leaving no trace": an attempt to regulate human behavior in such a way that it leaves no imprint

[36] On this subject, see the chilling documentary "Analysis: Somalia Piracy Began in Response."

on the immediate environment. A similar kind of mind-set seems to inform much of environmentalist thinking: in light of the devastating traces left by the cycle of production and consumption in industrial societies, it seems only natural to want to minimize the impact of human activities. Consequently much, if not most, environmentalist and green attention has been dedicated to issues of curbing pollution, lowering energy consumption, and so on. And does not this maxim resonate well with the Buddhist ideal, described above, of not producing karmic traces? It is certainly not by chance that many Western Buddhist (especially Zen-Buddhist) neophytes also support an environmentalist agenda,[37] or that environmentalist proposals for consuming and polluting less sometimes carry a distinct Buddhist, mostly Zen-Buddhist garb[38]—a link that was already noticed in 1967 by historian Lynn White.[39]

Should we then consider this ideal, and the temporal orientation it engenders, as the essence of ecological thinking? Is "leaving no trace" the proper antidote against the unimpeded proliferation of desires for consumption that undergirds contemporary economic wisdom and the mass-production of durable waste it engenders? Should we no longer heed the moral of Mandeville's 1714 poem on the *Fable of the Bees*, illustrating the common sense of modern economists that "Bare Virtue can't make Nations live/In Splendor; they, that would revive/A Golden Age, must be as free,/For Acorns, as for Honesty"?[40] Do we have to replace it with stern injunctions for virtuous frugality and settle for a simple life that minimizes the consumption of resources?

There is little doubt that the environmentalist idea of "leaving no trace" was nurtured by honorable motives, and that it is beneficial in directing attention, for once, to the fact that the consumptive use of the most inconspicuous and ordinary material objects can leave traces that seriously alter the quality of the environment. When facing technologies that lead to the massive release of toxic or otherwise harmful substances, it certainly makes sense to work towards "eco-efficiency," spelled out as the optimized ratio between productive output and pollution or other detrimental impact.[41]

[37] See the pertinent volume edited by Tucker, *Buddhism and Ecology*, or James, *Zen Buddhism and Environmental Ethics*, esp. 76–79.

[38] James, *Zen Buddhism and Environmemtal Ethics* (76) mentions that deep ecologists Arne Naess, Bill Devall, George Sessions and Warwick Fox all refer to Zen Buddhism, sometimes explicitly to Dōgen, in the affirmative.

[39] White, "The Historical Roots of Our Ecologic Crisis," 1203–1207.

[40] Mandeville, *Fable of the Bees*, 37.

[41] See the succinct description in McDonough and Braungart, "The Next Industrial Revolution."

However, the imperative to "leave no trace" comes with problems of its own. First of all, as may be learned from the secularized reading of Dōgen's view of time presented above, there is simply no option to truly leave no trace. In the absence of metaphysical powers leading to the serene cessation of karmic consequences, each action of necessity comes with a trace connecting it to future events and actions. Consequently—and as also suggested by Dōgen's idea of putting "serene cessation grandly into effect"—while minimizing detrimental effects remains an issue in large areas of material production and consumption, the main issue is to systematically anticipate the sum total of results, and to creatively think about ways that produce an all-in-all positive outcome. If the environmentalists among us stick to the notion of minimizing impact, chances are that we will not manage to replace current, disastrous technologies of production, distribution, and consumption by beneficial ones for the simple reason that the alternatives remain too small in size and number. What we need is not growing numbers of environmentally concerned individuals eking out an almost invisible life in the woods. Neither would we want the kind of eco-austerity world-government that Frederick Turner imagined so vividly in his epic *Genesis*—a government that led humanity into silent withdrawal from the world. Instead, what we want and what we actually need is that the world's cities from Abu Dhabi, Beijing and Chicago down to Yokohama and Zurich be converted into factories and conveyors of clean air, edible food, and high biodiversity—and all of this without depleting fertile soil in Africa or South America or displacing waste to environmental no-go-areas, from Calabria to Somalia and Tibet. Formulating the objective in this way also points to another problem of traditional environmentalist thinking and environmentalist-inspired policy-making—namely that it focuses on curbing noxious ways of waste disposal without addressing the core problem of why, in the mode of capitalist production, an abundance of durable, noxious materials is created in the first place.[42]

In part, the suggestion to seek for new modes of production instead of attempting to "leave no trace" is inspired by and in consonance with the principle of "cradle to cradle" design proposed by architect William McDonough and chemist Michael Braungart, which they introduced through the simile of a cherry tree:

> Consider the cherry tree. It makes thousands of blossoms just so that another tree might germinate, take root, and grow. Who would notice piles of cherry blossoms littering the ground in the spring and think,

42 Schandl, "Dimensionen des Mülls"; Foster, "Capitalism and Ecology."

"How inefficient and wasteful"? The tree's abundance is useful and safe. After falling to the ground, the blossoms return to the soil and become nutrients for the surrounding environment. Every last particle contributes in some way to the health of a thriving ecosystem. "Waste equals food"—the first principle of the Next Industrial Revolution. [...] Our concept of eco-effectiveness leads to human industry that is regenerative rather than depletive. It involves the design of things that celebrate interdependence with other living systems. From an industrial-design perspective, it means products that work within cradle-to-cradle life cycles rather than cradle-to-grave ones.[43]

McDonough and Braungart, who successfully worked with several companies to realize material products as diverse as roofs for industrial architecture, airplane seat covers, carpeting, or re-usable plastic cups and bottles,[44] went on to propose three fundamental principles of industrial design in concord with this general idea:

1. "Waste is food": designing materials for secondary use in the same *or a different* cycle of production and consumption, ideally materials that are *upgraded* through primary production and use.
2. Use solar energy; they propose, for example, to imagine "a building as a kind of tree. It would purify air, accrue solar income, produce more energy than it consumes, create shade and habitat, enrich soil, and change with the seasons."
3. "Respect diversity"—in the sense of paying attention to specific local conditions on ecological, societal, and cultural levels.[45]

While McDonough and Braungart's principles go beyond the classical environmentalist paradigm and address the essential issue of finding a mode of production that would enrich rather than impoverish the global ecosphere, there is one point where I would take exception with their view. Their rhetoric of unrestricted growth and abundance matches all too well with the imperative of capitalist production to not only meet extant needs, but to create ever-growing needs among property holders in order to secure the continued re-production of capital, while at the same time disregarding even the most

43 McDonough and Braungart, "The Next Industrial Revolution." Similar ideas are introduced by Hawken et. al. in their book *Natural Capitalism*.
44 McDonough and Braungart, *Cradle to Cradle: Remaking the Way we Make Things*.
45 Ibid.

basic needs of those without property. Their point about the cherry tree's blossoms fertilizing the ground is well taken. Still, it is no more than an ecological metaphor, and even concerning its original domain, we know that ecosystems can suffer from the excessive growth of one species. Since technosystems do not have natural enemies curbing their growth, I venture that the virtues of temperance and moderation should have their place in our vision of the "next industrial revolution," which would, by the same token, be a revolution leading us out of the world of capitalist production.[46] In the absence of the metaphysical capacity to foresee the totality of effects of a given action—in the absence of real-world Buddhas, so to speak—I believe it is imperative to restrict the scale of human action in a manner that leaves room for maneuvering with respect to unforeseen consequences. To champion yet another unpopular or oft-abused virtue: I believe that we would do well to re-instate a place in our thoughts and social practices for some decent form of humility, of remembering our limitations as human beings—not vis-à-vis some transcendent power and its representatives among us, but precisely with the notion that there is, after all, no final guarantee that what we think is true and right is *really*, all things considered, true and right. Time will have to tell.

5 Time Imagery and Human Action

To sum up this journey from contemporary practices of waste disposal to medieval Zen Buddhist thoughts on time and back to new design strategies for a future-conscious human society, I think it is essential that we avail ourselves of an array of time imageries that represent not only the temporal aspect of transience, but also the repository and accumulative functions of time. The secularized notion of karma, which engenders a holistic vision of past causes, present conditions, and future consequences, may help—or so I hope—to achieve a more balanced evaluation of the actions and social structures we want to implement. Many of the conveniences offered to us by the current economy, which massively discounts the future (and the past) in favor of the present, will seem much less attractive in the light of karma. Precisely because

46 Sandler in his 1994 article "Grow or Die" argued to the contrary and identified an emerging regime of strict ecological regulations as a growth factor for the capitalist economy. However, as experiences with "bio-fuels" and similar developments of the past decades have shown, eco-capitalist growth exacerbates rather than resolves the "rift in the universal metabolism of nature," as the title of Foster's 2013 article puts it.

we will never be able to fully control the present conditions and the future consequences of our actions, we are in urgent need of a rich and functional set of intuitions that help us to choose a beneficial course of action—if possible, one in which what we leave behind becomes the fertile ground for future life on this earth. To recollect, systematize, and further develop the social, technical, and cultural resources that make such a way of life a realistic option for all is arguably the most urgent challenge humanity faces right now.

References

"Analysis: Somalia Piracy Began in Response to Illegal Fishing and Toxic Dumping by Western Ships off Somali Coast." *Democracy Now!*. Online. Internet. Available: http://www.democracynow.org/2009/4/14/analysis_somalia_piracy_began_in_response.

Browne, Mark Anthony, Phillip Crump, Stewart J. Niven, Emma Teuten, Andrew Tonkin, Tamara Galloway, and Richard Thompson. "Accumulation of Microplastic on Shorelines Worldwide: Sources and Sinks." *Environmental Science & Technology* 45, no. 21 (November 1, 2011): 9175–79. doi: 10.1021/es201811s.

Dōgen 道元. *Dōgen Zenji Zenshū* 道元禅師全集. Ed. Ōkubo Dōshū 大久保道舟. 2 vols. Kyōto: Rinsen Shoten, 1989.

Elberfeld, Rolf: *Phänomenologie der Zeit im Buddhismus. Methoden interkulturellen Philosophierens*. Stuttgart-Bad Cannstatt: Frommann-Holzboog, 2004.

Fraser, J.T. "Founder's lecture: The Origin of the Integrated Study of Time." In *Origins and Futures: Time Inflected and Reflected*, edited by Raji C. Steineck and Claudia Clausius, 15–24. The Study of Time vol. 14. Leiden; Boston: Brill, 2013.

———. *Time, Conflict, and Human values*. Urbana: University of Illinois Press, 1999.

Foster, John Bellamy. "Capitalism and Ecology: the Nature of the Contradiction." *Monthly Review* 54/4 (2002), 6–16.

———. "Marx and the Rift in the Universal Metabolism of Nature. *Monthly Review* 65, no. 7 (2013), 1–19.

Goldstein, Miriam C., Marci Rosenberg, and Lanna Cheng. "Increased Oceanic Microplastic Debris Enhances Oviposition in an Endemic Pelagic Insect." *Biology Letters* 8, no. 5 (2012): 817–20. doi: 10.1098/rsbl.2012.0298.

Hall, Katherine H. "Reviewing Intuitive Decision-Making and Uncertainty: The Implications for Medical Education." *Medical Education* 36, no. 3 (March 1, 2002): 216–24. doi: 10.1046/j.1365-2923.2002.01140.x.

Hamblin, Jacob Darwin. *Poison in the Well: Radioactive Waste in the Oceans at the Dawn of the Nuclear Age*. New Brunswick, NJ: Rutgers University Press, 2008.

Hawken, Paul, Amory B. Lovins, and L. Hunter Lovins: *Natural Capitalism: The Next Industrial Revolution*. London: Routledge, 2013.

Heine, Steven. "The Dōgen Canon. Dōgen's Pre-Shōbōgenzō Writings and the Question of Change in His Later Works." *Japanese Journal of Religious Studies* 24, no. 1–2 (1997): 39–85.

Jacobs, Bruce A. "Serendipity in Robbery Target Selection." *British Journal of Criminology* 50, no. 3 (May 1, 2010): 514–29. doi: 10.1093/bjc/azq002.

James, Simon P. *Zen Buddhism and Environmental Ethics*. London: Ashgate, 2004.

Johnston, Ian. "Study: Plastic in 'Great Pacific Garbage Patch' increases 100-fold." NBC News. http://worldnews.nbcnews.com/_news/2012/05/09/11612593-study-plastic-in-great-pacific-garbage-patch-increases-100-fold.

Kato, Bunno et al., ed. and trans.: *The Threefold Lotus Sutra*. Tokyo: Kosei, 1975.

Kaiser, Jocelyn. "The Dirt on Ocean Garbage Patches." *Science* 328, no. 5985 (June 18, 2010): 1506–1506. doi:10.1126/science.328.5985.1506.

Khatri, Naresh, and H. Alvin Ng. "The Role of Intuition in Strategic Decision Making." *Human Relations* 53, no. 1 (January 1, 2000): 57–86. doi:10.1177/0018726700531004.

Ki no Tsurayuki 紀貫之 (ed.), Ozawa Masao 小沢正夫 (ed.), Matsuda Shigeho 松田成穂 (ed.). *Kokin wakashū* 古今和歌集. [Shinpen Nihon koten bungaku zenshū 11.] Tōkyō: Shōgakkan, 1994.

Klein, Gary. "Naturalistic Decision Making." *Human Factors: The Journal of the Human Factors and Ergonomics Society* 50, no. 3 (2008): 456–60.

Maki Yūsuke 真木悠介. *Jikan no hikaku shakaigaku* 時間の比較社会学. Tōkyō: Iwanami, 2003.

Mandeville, Bernard. *The Fable of the Bees or Private Vices, Publick Benefits*, 2 vols. With a Commentary Critical, Historical, and Explanatory by F.B. Kaye. Indianapolis: Liberty Fund, 1988. Text of the second, enlarged edition (1732).

McDonough, William, and Michael Braungart. *Cradle to Cradle: Remaking the Way we Make Things*. New York: North Point Press, 2002.

———. "The Next Industrial Revolution." *The Atlantic Monthly* 282, no. 4 (1998): 82–92. Quoted from the online text available at http://www.theatlantic.com/magazine/archive/1998/10/the-next-industrial-revolution/304695/3/ (last accessed April 10, 2015).

Nishijima, Gudō, and Chodo Cross. *Master Dogen's Shobogenzo*. London: Windbell Publications, 1994.

Pascal, Blaise, Gérard Ferreyrolles, and Philippe Sellier. *Pensées*. Paris: LGF, 2000.

Pascal, Blaise. *Opuscules et Pensées: publiés avec une introduction, des notices et des notes*. Edited by Léon Brunschvicg. Paris: Hachette, 1897.

———. *Pascal's Pensées*. Tribeca, 2013 (electronic edition).

Raud, Rein. "The Existential Moment: Rereading Dōgen's Theory of Time." *Philosophy East and West* 62, no. 2 (2012): 153–73.

Rochman, Chelsea M., Carlos Manzano, Brian T. Hentschel, Staci L. Massey Simonich, and Eunha Hoh. "Polystyrene Plastic: A Source and Sink for Polycyclic Aromatic

Hydrocarbons in the Marine Environment." *Environmental Science & Technology* 47, no. 24 (Dezember 2013): 13976–84. doi: 10.1021/es403605f.

Ropohl, Günter. *Ethik und Technikbewertung*. Frankfurt am Main: Suhrkamp, 1996.

Sandler, Blair. "Grow or Die: Marxist Theories of Capitalism and the Environment." *Rethinking Marxism* 7, no. 2 (1994), 38–57.

Schandl, Franz. "Dimensionen des Mülls." *Krisis* 18 (1996).

Spaulding, Dave. "Intuitive Decision Making." *Police: The Law Enforcement Magazine* 29, no. 3 (2005): 62–64.

Steineck, Christian. "Time Is Not Fleeting: Thoughts of a Medieval Zen Buddhist." *KronoScope* 7, no. 1 (2007): 33–47.

———. "Übersetzung und theoretische Rekonstruktion am Beispiel von Dōgen: Genjōkōan." *Horin* 9 (2002): 117–44.

Tanahashi, Kazuaki. *Enlightenment Unfolds: The Essential Teachings of Zen Master Dogen*. Boston, London: Shambhala, 1999.

Thompson, Richard C., Ylva Olsen, Richard P. Mitchell, Anthony Davis, Steven J. Rowland, Anthony W.G. John, Daniel McGonigle, und Andrea E. Russell. "Lost at Sea: Where Is All the Plastic?" *Science* 304, Nr. 5672 (May 7, 2004): 838. doi: 10.1126/science.1094559.

Totman, Conrad. *A History of Japan*. Malden, Mass: Blackwell, 2000.

Tucker, Mary Evelyn. *Buddhism and Ecology: The Interconnection of Dharma and Deeds*. Cambridge, Mass.: Harvard University Press, 1997.

Turner, Frederick. *Genesis: An Epic Poem*. Dallas; New York, N.Y.: Saybrook; distributed by W.W. Norton, 1988.

Waddell, Norman. "Being Time: Dōgen's Shōbōgenzō Uji." *Eastern Buddhist (New Series)* 12, no. 1 (1979): 114–29.

Waddell, Norman and Masao Abe. "Shōbōgenzō Genjōkōan. Translated with an Introduction by Norman Waddell and Masao Abe." *Eastern Buddhist (New Series)* 5, no. 2 (1972): 129–140.

White Jr, Lynn. "The Historical Roots of Our Ecologic Crisis". *Science* 155, no. 3767 (1967): 1203–1207.

Yuasa, Masae. "The Future of August 6th 1945: A Case of the 'Peaceful Utilization' of Nuclear Energy in Japan." In *Origins and Futures: Time Inflected and Reflected*, edited by Raji C. Steineck and Claudia Clausius, 235–258. The Study of Time vol. 14. Leiden, Boston: Brill, 2013.

Zengaku daijiten 禅學大辞典. Ed. Komazawa daigakunai Zengaku daijiten hensanjo 駒沢大学内禅學大辞典編纂所. New Edition, Tokyo: Daishūkan, 1985.

Index

Note: entries for a given term can be taken to include its morphological derivations without explicit mention (e.g., "psychology" will also include "psychological", "addiction" includes "addictive" and "addict", etc.)

abuse 145, 243, 295
aggression 162, 207, 253
Acts Interpretation Act 1901 272
Adam, Barbara 42, 57
addiction 246
Adorno, Theodor W. 87
Aeneas 16, 147
Aeschylos 157, 165, 175
Against the Day (see Pynchon, Thomas)
Al Masri, Mohammad 261
Alighieri, Dante 14, 41, 144ff
Al-Kateb v. Godwin 256f, 261, 264f, 267ff
Al-Kateb, Ahmed 256ff, 270
al-Qazwini, Zakarija ibn Muhammad ibn Mahmud 118
al-Udri, Ahmed ibn Omer 118
Alvíssmál (poem) 117
ambiguity 5, 26, 49, 66, 71, 76ff, 134, 158, 220, 243, 258f
 spatio-temporal ambiguity 80
 temporal ambiguity 66f, 77
anachrony 4
Angelman's syndrome 241
Ansgar 116
Apaches, The 63
après coup 199, 205
Arcadia (see Stoppard, Tom)
Archaic period (Greece) 155, 158, 171
Arlow, Jacob 210
Art Nouveau 62
Arts of Impoverishment (see Bersani and Dutoit)
A-series of time (see time)
Assisted Reproductive Technologies (ART) 241f
Athens 14, 154, 158ff
at-Tartuschi, Ibrahim ibn Ahmad 118f
Attic theatre/theater 154
 performance 153, 159f
 culture 152, 157, 169
 audience 169

Augustine 199
autumn 113, 115f
avant-garde 13, 63
Avernus 17

backward branching (see branching time)
Ballets Russes 61f
Bantu 8f
Barnes, Susan 90
Barthes, Roland 26, 52
Beckwith-Weidemann syndrome 241
Belnap, Nuel 188
Bersani, Leo and Ulysse Dutoit 84, 91ff
 Arts of Impoverishment 91
bioethics 242
biotemporality (see under Fraser, J.T.)
Birka, Swede 116
Birkeland, Harris 118
birth weight 238
Birth, Kevin 123
Blackshield, Tony 256
blaze 6, 8ff, 11, 13, 17
Bleeding Edge (see Pynchon, Thomas)
Bloom Leopold (see Joyce, James)
Bloom, Molly (see Joyce, James)
body 79, 145, 162, 165ff, 171, 225, 236f, 245, 278, 285, 287
Bohr, Niels 12
boredom 206f
Bottom (see Shakespeare, William)
bough, golden 16
boundary 9, 11
bourn 11
brain 79f, 152f, 158ff, 211f, 219, 240
branching time 185ff
 backward branching time 190, 192
 forward branching time 190, 192
 thin red line 188
Braungart, Michael 293f
Brecht, Bertolt 153
Breyer, Judge (Stephen G.) 266

Bruhn, Siglind 85f, 91, 105
B-series of time (see time)
Buddhism 279, 288
Budgen, Frank 135, 147
Byron, Lord (George Gordon) 23, 26f, 30ff

cabalistic proofs 24, 29f
calendar 112, 113f, 124, 141
 calendrical reform 111
 definition 114
 fetishism 111
 fixed 123
 Julian 111, 114, 120, 123f
Campbell, John 218
cancer 237, 239
canon (in Greek theatre) 156
cardiovascular disease 238
causality 52, 57, 171, 205f, 217f, 290
cerebral function 212
 rhythms of 212
chaos 5, 22f, 27f, 32
 chaos theory 5, 22, 28f, 35
 deterministic ch. 27, 29
Chatman, Seymour 24
chijikijilu 9f, 12ff
chorus (in Greek theatre) 161, 164f, 168
Christmas 10, 119
chromosomes 237
Cicero (Marcus Tullius Cicero) 85
circle 11ff, 16
 of knowledge 36
 hermeneutic circle 10
Classical period (Greece) 145, 165, 166
Cleisthenes 154
clock, mechanical 124
clock time 6, 40, 42, 49, 52, 77, 89, 212f
clue 12, 43ff, 113
coeliac disease 238
cognition 152–171, 225, 239
 embodied 165
cognitive evolution 171
confabulation 208, 224, 227f
Conrad, Joseph
 Heart of Darkness 13
consciousness 41, 45, 143, 158f, 162, 164, 169ff, 210, 220, 223, 227f
constraints 56, 220, 229
 causal constraints 158, 216, 218, 225
 metrical constraints 216

construction of legislation (see statutory interpretation)
contaminant 237, 239, 241
context of situation 264, 269, 271
Cook, Nicholas 88, 106
Corcoran, Suzanne A. 273
Cosmides, Leda and John Tooby 157ff
Cowart, David 48
cradle to cradle design 293
Crohn's disease 238
cross-cultural 8, 157
Crying of Lot 49, The (see Pynchon, Thomas)
Csapo, Eric and Margaret C. Miller 156, 159
Cubism 62

Damasio, Antonio 154, 167ff
Dante (see Alighieri, Dante)
Davis, Mike 48
day residue 212
De Kerckhove, Derrick 168
death 11, 35f, 47, 134ff, 156, 167ff, 277f, 283
 heat-death 26ff
Debussy, Claude 62, 87
 La Mer 62, 87
Dedalus, Stephen (see Joyce, James)
déjà vu 209ff
Delage, Maurice 63
 Four Hindu Songs 68
demythologization 156
deportation 258
Derrida, Jacques 4, 10f, 257
DES (diethylstilbestrol) 241
Descartes, René 224
detention 270
 indefinite detention 256ff, 265ff
 removal from 266
diabetes 237f
Diaghilev, Serge 61
diet 237ff
differentiation, loss of 93, 96f, 99
Dionysus 153, 161f, 169
discourse 4–6, 42, 271
Distingen 122
DNA 237
Dōgen 194ff, 281ff, 296ff
Dohoney, Ryan 105
Dopamine 161ff
dopaminergic mind (see also: Previc) 162
doubt, relativity of 258, 267f

INDEX 301

dream 11, 14, 31, 49f, 134, 137, 201, 208ff, 218, 224ff
Drucker, Johanna 47
drugs 236, 243
Dryden, John 16
duration, sense of 206, 209
Dutch Famine (see also: *Hongerwinter*) 238ff
dynamical systems theory 22

Easter 123f, 137
ecology 292
egg 34, 113, 241ff
Einarr skálaglamm 15
Einstein, Albert 203
Eisen, Keisai 62, 69
Eissler, Kurt 199
 The Psychiatrist and the Dying Patient 199
ekphrasis 84ff
 musical ekphrasis 84ff, 106f
elfland (see also: fairyland) 15
Eliot, Thomas Stearns 132
Ellman, Richard 145
Elsner, Jaś 159, 168
emplotment 33, 35
enargeia 85
endocrine disruptor 239ff
Enkidu 15f
epic 14, 16, 24, 132ff, 144, 165ff, 293
epigenetics 236ff
 defined 236f
 effects 242
 imprinting 236
 influences 247f
Epiphany 210
equinox 113, 121ff
ethics 233ff, 242, 248
etymology 8
Euripides 157, 165
Eurydice 16
evidence 26, 30ff, 41ff, 56, 119ff, 153, 167, 220, 246ff
evolution 10, 29, 31, 56, 153–171, 201ff, 260
Executive, the 265, 267

Fable of the Bees, The (see Mandeville, Ernest de)
fairyland (see also: elfland) 14ff
 queen of 14
Feldman, Morton 83ff

Ferguson v. City of Charleston 243
Festival of Lanterns (see Hokusai)
fiction 35, 41ff, 147, 156ff
 detective fiction 43
 enacted fiction 171
 gothic fiction 56
 noir fiction 48
Fine, David 48
Finland 246
Finnegans Wake (see Joyce, James)
fixed point attractor 29
forensics 42, 44, 48
formalist theory of language 269
forward branching (see branching time)
Four Hindu Songs (see Delage, Maurice)
fractals 28
Frankenstein (see Shelley, Mary)
Franklin, Benjamin 49
Fraser, J.T. 6, 36, 47f, 170, 201ff, 267, 277f
 and temporal levels 202
 atemporality 183, 201, 218
 biotemporality 201, 260, 262
 eotemporality 201
 nootemporality 201, 277f, 289
 dynamic and static elements 289
 prototemporality 201, 260
 sociotemporality 48, 201, 267
 canonical forms of time 277
 hierarchical theory of time 201, 277
French, Robert S. 266
Freud, Sigmund 137, 198ff, 209ff
Frye, Northrop 169
fugue state 210
Funayama, Takashi 62
fungicides 239
future
 contingent future 191, 195
 necessary future 189

Gaarder, Kenneth 200
game 12, 23, 31, 56
Gauguin, Paul 62
genes 236ff
genetics 6, 246
gestation 242f
Giddens, Anthony 57
Gilbert, Stuart 132, 138
Gilbert, W.S. and Arthur Sullivan 62
 The Mikado 62
Gilgamesh, Epic of 15f

Ginzburg, Carlo 3, 46
Glamann, Kristof 111
Gleeson, A. Murray 257, 261, 264ff
Gleick, James 22, 28
Gödel, Kurt 11, 203
Goehr, Lydia 84ff, 106
Goodman, Nelson 217, 227f
Great Pacific Garbage Patch 280, 291
Great Wave (see Hokusai)
Greek theatre/theater (see also: Attic theatre/er) 6, 154, 161, 164, 169
Gummow, William M.C. 261ff

habeas corpus 259
Halliday, Michael A.K. 259, 269ff
Hamblin, Jacob 280
Hamlet (see Shakespeare, William)
Hand, Gerard L. 264
Harald Finehair 119
Haraldskvæði (poem) 119
Hawaii 246
Hayashi, Tadamasa 62
Hayne, Kenneth M. 258ff
Heart of Darkness (see Conrad, Joseph) 13
heaven 12ff, 285
heavy metals 239
Hedeby (Denmark) 118ff
Heffernan, James 85f, 91
Heidegger, Martin 4
Heidiness 205
hell 12, 15f
Henry the Fowler 119f
hermeneutic (see also: circle, hermeneutic) 3, 10, 204ff, 209, 211ff, 283
Herodotus 154
High Court of Australia 256ff
history 34ff, 64, 80, 112ff, 131f, 154ff, 171, 267, 277
 and narrative 143, 217
Hofstadter, Douglas 23
Hokusai, Katsushika 62, 68ff, 80f
 Great Wave 62, 69
 Festival of Lanterns 69f
home 11, 43, 68, 113ff, 160, 191, 244
Homer 84, 131ff, 155, 159, 167f
 The Odyssey 130–151
 Odysseus 130–151
 Penelope 133ff
 Telemachus 133ff

Hongerwinter (see also: Dutch Famine) 238
Houdini, Harry 55
hunter 3
Husserl, Edmund 4
hybrid logic 191f

Iceland spar 53f
Ickstadt, Heinz 54
identity 84, 97, 132f, 157, 218, 221, 225, 282
imagination 12, 77, 138, 145, 170f, 224, 278ff
 Forensic imagination 41ff, 57
 Luddite imagination 42, 56
implied movement 79
imprinting (see also: epigenetic imprinting) 236ff
in vitro fertilization (IVF) 241
Indian Ink (see Stoppard, Tom)
individuality 93, 97, 105f, 153, 167ff
Indo-European 8f
industrial revolution 51
 next (McDonough & Braungart) 292, 294
Inherent Vice (see Pynchon, Thomas)
inheritance 10, 236
inherited 146, 247
initial conditions 28, 30ff
insecticides 239
instability 69f, 79ff, 282
instant 52, 95, 145, 170, 187ff, 278
 propositions 191ff
instantiation 270ff
intermedial 5
International Expositions, Paris (1867, 1878, 1889, 1900) 62
international law 266
International Society for the Study of Time (ISST) 1, 182
interpretation of legislation (see statutory interpretation)
intersubjectivity 166
Invention of Love, The (see Stoppard, Tom)
involuntary immersion 226ff
Ireland 137, 145ff
Irish nationalism 133f
IVF (see in vitro fertilization)

James, William 184
Japon Artistique, Le 62
Japonisme, Le 61

INDEX

Jay, Martin 160
Johnson, Marcia, K. 218
Johnson, Mark 165
Johnson, Philip 90
Johnson, Steven 89, 96ff, 101
Joyce, James 6, 41, 130–151
 Finnegans Wake 147
 A Portrait of the Artist as a Young Man 137f, 146ff
 Dedalus, Stephen 130–151
 Ulysses 130–151
 Bloom, Leopold 130ff, 135, 139ff, 147
 Bloom, Molly 130, 133, 139ff
judgment, reasons for 257, 264, 270
justice 48, 169, 257
 environmental justice 241
 generational justice 235, 244

Kamens, Edward 66f
karma 281, 287ff
 secularized notion of 295
Kenner, Hugh 132, 134, 147
Kermode, Frank 171
ketamine 200
Kettner, Matthias 205
Ki no Tsurayuki 279
Kirby, Michael D. 257, 261, 266ff
Kirk, Paul Leland 45
Kirschenbaum, Matthew G. 41f, 51
known (see also: unknown, circle of knowledge) 4, 9f, 13, 16
Kokin Wakashu 64
Kramer, Jonathan 89, 93ff, 98, 104
Krämer, Sibylle 2
Kripke, Saul 185f

labyrinth 13
Lakoff, George 165
language 9ff, 28, 47, 86, 137, 182ff, 192, 268ff
legal precedents 243, 270
legality, principle of 265, 270
legislation, purpose of 262f
legislative intent 265f
Lejre (Denmark) 120f
Lestienne, Rémy 206
Levinas, Emmanuel 1, 3ff
limit 9ff, 30, 40f, 117, 120f, 163, 261f, 269
linguistics 261, 269f
listening, multitextual 86

Locard, Edmund 42, 45
Logical operators, definition 193
 Fp 184ff
 Gp 184f
 Hp 184
 Pp 184f
Loti, Pierre 62
Luddism (see also: imagination, Luddite) 57
Luis de Molina 188
lunar phases 117ff, 121ff
Lundmark, Lennart 124
lunisolar year 121

Madame Butterfly (see Puccini, Giacomo)
Maeterlinck, Maurice 148
Magic Flute, The (see Mozart, Wolfgang Amadeus)
Maki, Yūsuke 277ff
Man'yōshū 64ff, 76
Mandeville, Ernest de 292
 The Fable of the Bees 292
Manet, Edouard 62
Manga 62, 80
Marey, Étienne-Jules 52f
mark 3, 9, 45, 280, 284
marriage 139ff
Marshall, John 266
Masazumi, Miyamoto 54, 73, 75f, 81
material object 291f
materiality 2, 42, 44, 47
Matte-Blanco, Ignacio 201
Matthiessen, Christian M.I.M. 259
Maxwell on Statutes 265f
McDonough, William 293f
McTaggart, John Ellis 56, 183, 192
Medea 157
Meiji Restoration 62
Meineck, Peter 163
Méliès, Georges 55
Melville, Herman 41, 50
memory 6, 47, 49, 131ff, 137ff, 142ff, 146, 148, 154
 autobiographical memory 215ff, 229
 episodic memory 218, 220
 intrusive memory 221
 retrieval 220, 223
 screen memory 199, 207ff
 semantic memory 218
 storage 219f, 229

memory (cont.)
 suppression 221f
 short-term memory 119f, 203
 traces 205, 211f, 215ff, 197
 epistemic traces 218
 phenomenal traces 216
Mendelson, Edward 51
Menil, John and Dominique de 90
metaphor 8ff, 13f, 106, 184, 202, 268, 279f, 295
metaphysics 289
Metz, Christian 161
Mexican paradise tree 10
Midsummer Night's Dream, A (see Shakespeare, William)
Miers, David R. 267ff
Migration Act 1958 256, 274
Mikado, The (see Gilbert, W.S. and Arthur Sullivan)
Milton, John 146
Minister for Immigration (Australia) 264f
Minkowski, Hermann 56
Minotaur 13
mirror neurons 166
modal logic 185
Monet, Claude 62
mono no aware 65
moon 117f, 124
Morelli, Giovanni 46
Moretti, Frank 131
mother-son relation 136ff
Mount Fuji 68f
Mozart, Wolfgang Amadeus 15
 Magic Flute, The 15
 Papageno 15
Mudyi tree 10
multimedia, musical 88
multi-modal 167
Muße 206f
Mussorgsky, Modest 88
Muybridge, Eadweard James 52
Mycenean Age 140, 162
mystic writing pad 198f
myth (see also: demythologization) 16, 48, 131, 141, 154, 157, 166ff

Nachtraeglichkeit 199, 204ff
Nadel, Lynn 216, 227

Narihira 65
narrative 23f, 27, 33ff, 41ff, 56, 64, 120, 131ff, 153, 159, 162ff, 208, 217, 220ff
 density 227ff
 encyclopedic narrative 51
 vs. exposition or report 217, 228
Ndembu 9f
neurological effects 61
neuron 162, 165f
neuroscience 79, 153, 165f
neurotransmitter 161f
neutralism 223f
Newton, Isaac 29, 52, 202
Nielsen, Tori 211
nikon (see *shikin*) 286
Nōin 64f
nootemporality (see under Fraser, J.T.)
Nordberg, Andreas 118, 121
Now (see also: present) 183, 187, 191ff

O'Connor, Richard E. 265
O'Malley, Michael 52
obesity 237f, 244
object constancy 203f
object formation 204f
object permanence 203
obligations, maternal 243, 248
obligations, paternal 248
obligations, pre-conception 242ff
Ockhamistic model (classical) 187ff
Odinkar the Older 120
Odysseus (see Homer)
Odyssey (see Homer) 130ff, 157, 162
Oedipus 157
Ong, Walter 154
ontology 167f
opacity 8
opinion, judicial (see judgment, reasons for)
orality 118, 122, 140, 146, 154
Orpheus 16
Orthodox Academy of Crete vii, 1
Överkalix 240

pacer 114ff
 external pacer 115
 internal pacer 115
Papageno (see Mozart)
parenting 239, 247

Pascal, Blaise 278, 280, 297
past 8ff, 22ff, 41ff, 64f, 106, 113f, 121ff, 132ff, 182ff, 194ff, 215ff, 279ff
 possible pasts 202
Pearce, Dennis C. 273
Peirce, Charles Sanders 188f
Peircean model 188f
Penelope (see Homer)
Penn, William 49
perception (see also: time, perception of) 47, 51, 80, 94, 159, 165, 168, 197ff, 243
 ontogeny of 211
 stimuli for 80, 198, 204
performance 77, 88f, 105, 153ff, 217, 220, 260f
perspective 47, 51, 62, 67ff, 114, 1221, 183, 198, 218ff, 227ff, 263
Peter Quince (see Shakespeare, William)
phenomenalism 223f
photography 50ff
 spirit photography 55
play 10, 14, 21ff, 36, 146, 153ff, 163ff, 205, 211
poem 10, 16, 61ff, 71ff, 94, 112, 115ff, 140, 169, 279, 284, 292
poet 11f, 16, 31, 34, 61ff, 142ff
poetry 10, 26, 61ff, 85, 115ff, 133ff, 146, 155, 159, 279
pollution 279, 292
Portrait of the Artist as a Young Man, A (see Joyce, James)
post-traumatic stress dissorder 222, 230
Pound, Ezra 131, 150
Prader-Willi syndrome 241
pragmatics 269
praxis, theatrical/performative 152ff
precedent, legal (see legal precedent)
pre-conception 242ff
Presbyterian Church 182
 and predestination 182
present
 specious present 13
 vs. Now 191f
presentism 191, 195
Previc, Fred 161ff
Prigogine, Ilya 23, 38
Prior, A.N. 181–196
privacy 241
program music 105
Progymnasmata 84f

Prometheus 157
prototemporality (see temporality)
Proust, Marcel 227
provable (see also: unprovable) 11ff
Psychiatric News (journal) 200
Psychiatrist and the Dying Patient, The (see Eissler, Kurt)
psychic reality (see reality, psychic)
psychoanalysis 209ff
psychoanalytic theory 201f
Puccini, Giacomo 62
 Madame Butterfly 62
purpose of legislation (see legislation, purpose of)
Pynchon, Thomas 40–60
 Against the Day 40f, 51ff
 Bleeding Edge 41
 The Crying of Lot 49 44f, 48f
 Inherent Vice 41, 44ff

Quintilian (Marcus Fabius Quintilianus) 85
Quiroga, Rodrigo Q. 221

Ramachandran, V.S. 154, 167
Ravel, Maurice 63, 68
 Three Mallarmé Poems 68
reality monitoring 218ff
reality, psychic 203f
realization 259, 271
reasonable, reasonably 10, 152f., 259ff.
Reddy, Michael J. 268
reification 203
relativity theory 201
representation 31, 47, 51, 85, 93, 154ff, 168ff, 188, 198, 208, 217, 236, 281
 musical representation 86, 94, 106
resistance 8, 41, 50, 56f, 167, 199, 238, 245
retrieval 215ff
tradeoffs 216ff
return 105, 133ff
Ricoeur, Paul 1, 3, 24, 33, 217
rights and freedoms, implied protection of (see legality, principle of)
rights, reproductive 235
Rite of Spring, The (see Stravinsky, Igor)
ritual 10, 63, 111, 118ff, 153ff
ritual year, Church 111, 123
RNA 237

Robert-Houdin, Jean Eugène 55
Roe versus Wade 236, 243
Romanticism 28
Romilly, Jacqueline de 158f, 164f
Rothko Chapel 83–108
Rothko, Mark 83–108

sacrament 9f
sayable (see also: unsayable) 10ff
Scalia, Antonin 267
Scandinavia 111ff
schizophrenia 238
Schmitt, Florent 63
Schroeter, Jens Frederik 113
Schubert, Franz 94
scopic regime 161
screen memory (see memory, screen)
selfhood 156, 167ff
self-narrative 225
semantics 216, 269ff
sequences 47, 197, 228f, 146ff
Sernyl 200, 203
Shakespeare, William 11, 14, 143, 146ff
 Hamlet 11, 138, 143
 A Midsummer Night's Dream 11ff
 Bottom 14
 Peter Quince 14
 Theseus 11, 13
shaman 11
Shelley, Mary 56
 Frankenstein 56
shikin (Jap.) 286
signification 3, 86
 musical signification 106
Sigvatr Þórðarson 119
Sirius (star) 118f
skene (see also: stage) 163, 168
Smith, David L. 208
Smyth, Russell L. 272
Snow, Charles Percy 56
Sö 196 (runic inscription) 116
social context 268f, 272
socioeconomic status 65
sociotemporality (see under Fraser, J.T.)
Socrates 148
Solomon, Matthew 55
solstice 121
Sophocles 157, 165
space-time (see also: spatiotemporality) 56, 203

spatiotemporality (see temporality; see also: space-time)
spectator 88, 91, 97, 106, 159ff
sperm 241, 244
Spielraum 205f, 211
spring (season) 63, 67f, 71, 73, 75, 113, 115, 117, 123f, 155, 283, 293
stage (see also: *skene*) 25f, 31, 34, 55, 152, 154, 161, 163
starvation 238, 240, 245
state space 22, 29ff
stateless person 257, 263f
statutory construction (see also: statutory interpretation) 270
statutory interpretation 259, 265, 272f
Steineck, Raji C. 194
Stengers, Isabelle 22
Stenstrom, Philippe 211
Stern, Sacha 123
Steyn, Johan van Z. 51
Stiegler, Bernd 51
stimulus 158, 210
Stoppard, Tom 22ff
 Arcadia 22ff
 Indian Ink 26
 The Invention of Love 35
storage 45f, 215ff
 tradeoffs 218f
strange attractor 22ff
 Lorenz/butterfly attractor 29
 Rössler/funnel attractor 29
stratification 270ff
Stravinsky, Igor 61, 81
 The Rite of Spring 63
 Three Japanese Lyrics 61f, 68ff
Stress 241
 stress hormone receptor 239
subjective equivalence (in object formation) 204f, 211
subjectivity 47, 95, 161, 167ff
summer 30, 63, 113, 115ff, 283
Sun 53, 113, 117f, 142f
symbol, *symbolon* 10, 23, 65f, 69, 76
synesthesia 210
systemic functional linguistics (SFL) 268, 270, 272

tachistoscopic experiments 204
Tamino (see Mozart, Wolfgang Amadeus)
Telemachus (see Homer)

INDEX 307

temporal lobe 79, 210f
temporal trace 68, 197–214
temporality (see also entries for atemporality, biotemporality, eotemporality, nootemporality, prototemporality, sociotemporality under: Fraser, J.T)
 spatiotemporality 5, 66, 164
 transtemporality 25ff
tense logic 181ff, 189ff
terra incognita 13
testimony 3, 5
theater/theatre 24f, 31, 55, 152–177
theatron 159ff, 168ff
theoria 160f
Thermodynamics, Second Law of 22, 26, 35
Theseus (see Shakespeare, William)
Thietmar of Merseburg 119
thin red line (see branching time)
Thomas the Rhymer (see True Thomas)
Þórbjǫrn hornklofi 119
Three Japanese Lyrics (see Stravinsky, Igor)
Three Mallarmé Poems (see Ravel, Maurice)
Thucydides 154
time dilation 16
time (see also entries under: clock-time, branching time, temporality, as well as the entries under Fraser, J.T.)
 and being as correlates in Dōgen 285f
 and economy 49f, 295
 and space 14, 24, 36, 55f, 83–108, 122
 annihilation through 278
 A-series 183
 as passing and arriving in Dōgen 194, 282, 285ff
 B-series 183
 concepts of 165, 199ff
 dilation 16
 dream time 49f
 embedded time 57
 haunting time (see also: Pynchon, Thomas) 55f
 imagery 277, 279, 282, 284, 295f
 linear time 93f, 156, 159, 166ff, 185f, 204f, 278
 machine time 40, 57
 musical time 88f, 93
 noetic time 170
 non-reductive theory of 201
 orthogonal time (see also: Pynchon, Thomas) 49f

 river of 276, 279
 standard time 124
 task-oriented time 117
 timelessness 63, 198, 200f, 211
 timescape 25, 40ff, 47
 time-scheme 35, 112ff, 117f, 121f, 124
 time-tool 114f, 122, 124
 vertical time 94f
 video time (see also: Pynchon, Thomas) 49f, 57
timing, markets and fairs 114f, 121ff
 political and legal assemblies 116, 123
Tokaido, 53 stages of 68
Tosa Journal 65
Toulouse-Lautrec, Henri de 62
trace elements 1
Trachtenberg, Alan 52
track 2, 13, 41, 57, 192
tract 2, 8
Tractatus Logico-Philosophicus (see Wittgenstein, Ludwig)
tragedy 156ff, 164ff
trahere 8
trail 8–17, 205
transference 197
trans-generational 240f, 248
transience 155, 281, 283, 295
transtemporality (see temporality)
trauma 131, 209, 222, 227, 240
tree (see Mexican paradise tree, Mudyi tree) 2, 10, 14f, 66, 71, 76, 142, 144, 236, 293ff
True Thomas, Ballad of 14f
Tulving, Endel 220
Turner, Victor W. 9
Twining, William L. 267ff
two-dimensionality 6

uji (Jap.) 288
Ulysses (see Joyce, James)
umwelt, eotemporal 201
uncanny 201f
unconscious 197ff, 204, 209ff, 216f, 227, 229
 timelessness of 198, 200
unexplored 8, 12, 14
unhappy interpreter 267F
United States Supreme Court 266f
unknown (see also: known) 9f, 12, 14, 16, 280f
unlawful non-citizens 257
unprovable (see also: provable) 11, 13

unsayable (see also: sayable) 10f, 13f
utamakura 64ff

Vafðrúðnismál (poem) 117f
vagueness (see also: ambiguity) 258, 269
Van Gogh, Vincent 62, 69
Vanstone, Amanda E. 270
Vees-Gulani, Susanne 33
Vellekla (poem) 115
vestige 1, 3
Vestigium 1
Viking age 111–129
Virgil (Publius Vergilius Maro) 16, 144, 147
Virilio, Paul 55
visuality 93, 156, 159ff
Vita Anskarii 116
Vǫluspá (poem) 117

waka poetry 64–77
waste 276–297
 nuclear/radioactive waste 276, 279f
 persistent waste 289
 plastic microdebris 281
Webb, Ruth 85
Weber, Max 49

week, five-day 113
week, seven-day 117, 122ff
Wegner, Daniel M. 221, 223
Weissert, Thomas P. 32
White, Hayden 31ff
Whitner v. South Carolina 243
Widukind of Corvey 120
William of Ockham (see also: Ockhamistic model) 118
Williams, George J. 274
winter 71, 113, 115, 117, 119, 238, 283
Wittenberg, David 39
Wittgenstein, Ludwig 9, 11
 Tractatus Logico-Philosophicus 9
woodblock prints 62f, 77, 81
World Conference on Women (4th) 244ff

Yamanobe, Akahito 61, 64, 71
Yule (jul, *jól*) 119, 121

zeitgeber 114ff
Zen Buddhism 194, 282ff, 295
 and ecology 194, 292
Zen Master Dōgen (see Dōgen)
zoopraxiscope 52

Printed in the United States
By Bookmasters